italian drawings in the Albertina

Standard Book Number 8212-0473-4
Library of Congress Catalog Card Number 72-80899
© 1971 Silvana Editoriale d'Art Milan
Printed in Italy

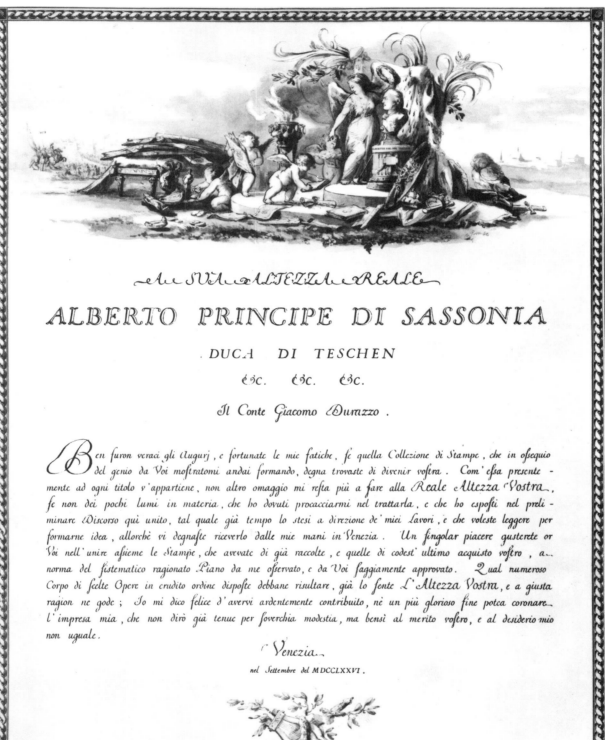

ALBERTO PRINCIPE DI SASSONIA

DUCA DI TESCHEN

&c. &c. &c.

Il Conte Giacomo Durazzo.

Ben furon veraci gli Augurj, e fortunate le mie fatiche, se quella Collezione di Stampe, che in osequio del genio da Voi mostratomi andai formando, degna trovaste di divenir vostra. Com'essa presente-mente ad ogni titolo v'appartiene, non altro omaggio mi resta più a fare alla Reale Altezza Vostra, se non dei pochi lumi in materia, che ho dovuti procacciarmi nel trattarla, e che ho esposti nel preli-minare Discorso qui unito, tal quale già tempo lo stesi a direzione de' miei Lavori, e che voleste leggere per formarne idea, allorchè vi degnaste riceverlo dalle mie mani in Venezia. Un singolar piacere gusterete or Voi nell'unire assieme le Stampe, che avvate di già raccolte, e quelle di codest'ultimo acquisto vostro, a norma del sistematico ragionato Piano da me osservato, e da Voi saggiamente approvato. Qual numeroso Corpo di scelte Opere in erudito ordine disposte debbane risultare, già lo sente L'Altezza Vostra, e a giusta ragion ne gode; Io mi dico felice d'avervi ardentemente contribuito, nè un più glorioso fine potea coronare l'impresa mia, che non dirò già tenue per soverchia modestia, ma bensì al merito vostro, e al desiderio mio non uguale.

Venezia

nel Settembre del MDCCLXXVI.

italian drawings
in the Albertina

Edited by :

Walter Koschatzky
Konrad Oberhuber
Eckhart Knab

New York Graphic Society Ltd.
Greenwich, Connecticut

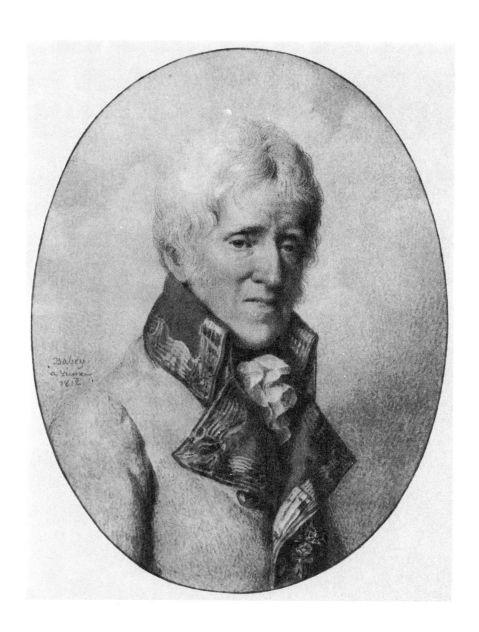

1. Jean-Baptiste Isabey. *Duke Albert von Saxe-Teschen* (1817).

The ALBERTINA:
The importance and history of the collection

When the founder of the world-famous collection now known as the Albertina, Duke Albert of Saxe-Teschen, died in his Vienna palace on February 10, 1822, at the age of eighty-four, he left his drawings and prints as an entail in trust to his nephew, Archduke Charles of Austria, Napoleon's conqueror in the battle of Aspern in 1809. Even at that time, the collection was an extremely comprehensive and famous assemblage of graphic works.

In a recently discovered document, the eminent connoisseur Franz Rechberger (1771-1841), former curator of the Count Moritz von Fries' collection in Vienna (1), stated that he found the Duke's collection in good order, consisting of more than 13,000 items, kept in 230 portfolios. It contained, he reported, sheets of the first rank by the most important artists of the four major schools, such as rarely appeared on the market and grew scarcer every day. Furthermore, there were a large number of sketches by the great masters, often only a few rapid lines, that bore the hallmark of their hand and delighted artists and connoissesurs alike. "The authenticity of a similarly large number of sheets is borne out by collector's marks or provenance from a well-known previous owner: Crozat, Mariette, Ploos van Amstel, Bianconi, and Reynolds, among others—all names that are revered in the world of art now and will continue to be so in times to come.

"It is characteristic of most collectors," Rechberger continues, "that they invariably seek to enrich their inventories with new names; and so it is unavoidable that gradually quite a few works of lesser quality will seep in, works whose significance, for the most part, will remain restricted to having enlarged the list of names. Finally, considering that the greatest masters were eagerly imitated, there will be no collection free from doubtful pieces and copies.

"The connoisseur marvels at the quantity of works that are extremely rare or quite impossible to come by, and finally he realizes that this collection is more than the sum-total of the huge sums expended upon it: it is the result of an almost miraculous combination of felicitous events. It is, so to speak, the aggregate of several famous collections that were broken up owing to circumstances prevailing at the time. Ultimately, it is the product of a long, fortunate life and a surpassing, unwavering love for the arts." (2)

Rechberger in his report outlined concisely the combination of features that continues to characterize the collection today: the large number of works of supreme rank; their provenance from famous old collections; the formative idea reflected in the collection as the creative concept of an uncommon man given rare opportunities by his status and means; and finally, the lasting mission entrusted to critical scholarly research.

In speaking of four schools basically forming the collection, Rechberger referred to the groups of works by German, Italian, Netherlandish, and French artists. In fact, however, the collection had originally been divided into two groups only: the *Scuole Italiane* on the one hand, and the *Oltramontane* on the other.

The former was divided into four sub-divisions, the Roman, Venetian, Bolognese, and Lombard. Tuscan, Neapolitan and Sicilian works were included in the Roman group,

whereas the *"Scuole Oltramontane"* comprised German and Swiss drawings as well as Dutch, Flemish, French, and others. The rather heavy preponderance of the Italian schools arises from the circumstances of the collection's origin and may be explained historically by the notion that all new artistic creativity had its source in the Italian Renaissance. This aspect, in fact, shows the paramount role that Italian drawings played in Duke Albert's conception from the very beginning of his collecting activities, for he was clearly guided by such ideas in planning his acquisitions.

The earliest surviving inventory, presumably drawn up when the trust was formed in 1822, immediately after the founder's death, itemizes 1,547 works of the Roman school; 578 of the Venetian; 645 of the Bolognese; 1,125 of the Lombard; that is to say, a total of 3,893 Italian drawings. Besides, there were 3,724 German drawings, 3,574 Flemish, 1,875 French, and 667 of "diverse" origin, as well as 447 drawings classified by subject matter and according to individual categories. In total, Duke Albert's primary collection consisted of 14,184 drawings. These were splendidly arranged in 230 portfolios of which fifty-eight, in three different formats, bound in red morocco and embossed in gold with the Duke's initials AS, were used for the Italian drawings. The process of extending the collection and researching into this vast cultural bequest has continued over the generations, but its very basis has always been and will remain the lifework of the founder.

Throughout the 18th century and largely through the late Neoclassical period, drawing was of secondary importance in the collector's estimation, for only in the Romantic period did the primary sketch come to be considered the form of expression most immediately preserving the original idea. Thus, to the historically oriented art lover, Duke Albert's collection will seem an even more astonishing achievement. His contemporaries regarded the finished work only—be it a painting, a sculpture, or an architectural structure—as the actual purpose of art. Drawing in general was considered merely a means of serving the realization of this aim, as a graphic notation, a study of detail, a preparatory sketch for a composition, a draft design for a commission, or a model for the execution of the intended work. The real work of art, however, was invariably the finished work. The graphic techniques, in particular engraving, were used to reproduce the finished work, and in the opinion of the time, they showed much more clearly its true essence, for the idea was reflected in final perfection rather than in an immature stage of formation. The perfect rendition of the "invention" was the foremost aim and, indeed, the re-creation of the "invention" was valued all the more highly the closer the reproduction came to the original. In any event, the modern depreciative view of "reproductive graphic art" was quite unknown, a view which will readily be understood, since only later discoveries, such as photographic reproduction and allied printing processes, provided the everyday illusion of a *"musée imaginaire"* including any desired work of art. It is owing to this technological advance that engraving and etching today are used exclusively in their original artistic function, as opposed to their application in Duke Albert's time.

Suitably for an *"érudit"* of his period, Albert began the realization of his collecting project in the category of prints. Thus numerically they always formed the main body of the collection. In 1821, shortly before the Duke's death, there were no fewer than 157,952 prints in 884 portfolios (3). Their arrangement, for well-considered reasons, followed the drawing schools.

Albert Kasimir was born at Schloss Moritzburg near Dresden on July 11, 1738. The eleventh son of the Elector August II of Saxony (later King of Poland) and the Austrian

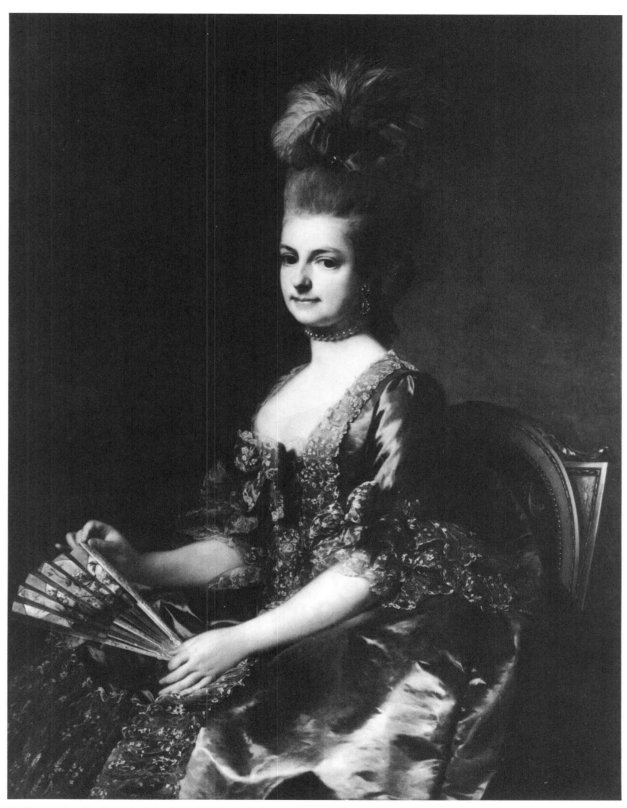

2. Alexander Roslin. *Archduchess Maria Cristina* (Private collection Stockholm).

Archduchess Maria Josepha, he was brought up with his youngest brother, Clemens, and his sister Kunigunde.

Toward the middle of the 18th century, Saxony, allied to Austria in the Seven Years War with Prussia, had been devastated by military campaigns, and the capital, Dresden, besieged and heavily damaged, was occupied by the enemy. Cultural prosperity and the magnificent flowering of fine arts, brought about by Albert's grandfather, Augustus the Strong, and his father, were overshadowed by the events of war, and the three youngest children grew up rather in seclusion. At the age of nineteen, Prince Albert decided to leave Dresden together with his brother Clemens to join the Austrian army. He obtained a modest command on the staff of Marshal Daun, and proved very capable and efficient. When the approach of winter interrupted campaigning, and the army moved into winter quarters, Clemens and Albert decided to present themselves at the Imperial Court in Vienna. They arrived on January 9, 1760, little dreaming that it would become Albert's second home. As early as his first day at Empress Maria Theresa's Court, the young Prince met the royal family's children at a concert, among them the seventeen-year old Archduchess Marie Christine. "Her enchanting appearance," he later noted in his *Mémoirs*, "her faultless figure, her charming face, combined with her vivacity of spirit and temperament seemed from the first designed to enthrall me." His affection for her, which was to change the course of his life, was most tenderly reciprocated and he gained the Empress's firm support. In spite of all his drawbacks—Albert was as good as penniless and of neither hierarchical nor political interest as a marriage partner—the wedding was celebrated on April 8, 1766, at Schlosshof, one of the Court's finest palaces in the Marchfeld.

Maria Theresa's affection for Albert was truly maternal. His thoughtful character, his interest in the arts, and his high ideals inspired by the principles of Enlightenment combined to win favor. Wishing to see the husband of her favorite daughter brilliantly established, and her daughter's future secure regardless of contingencies of fate, the Empress assigned the young couple to the position of Imperial Vice-Governors of Hungary. The splendidly appointed Palace of Bratislava became their residence. With it went a fortune hard to assess today: it included estates that diligent cultivation and wise administration had turned into some of the old monarchy's most profitable possessions, such as Schloss Ungarisch-Altenburg and, particularly, the Duchy of Teschen in Bohemia. Its name was to have been featured in the title borne by eventual children of the marriage, who were to be known as "von Saxe-Teschen." However, none materialized; the union remained childless after a miscarriage that almost cost the mother's life. In addition to the dowry representing more than four million florins—unprecedented riches at the Imperial Court, which was always run on economical and sometimes spartan lines—there was the not inconsiderable amount of 660,000 florins in ready money, largely from the private Lorraine fortune of Francis Stephen, Maria Theresa's late husband, which thus formed the initial financial basis of the future Albertina.

Albert experienced considerable difficulties as "locum tenens" in Hungary. The Theresian Reforms stipulated the abolition of serfdom, the lessening of traditional privileges of rank, and the resignation, in part, of the virtually autonomous power of the influential magnates over the peasantry. It was Albert's task to enforce these changes, but it soon became evident that idealism and the long-held convictions of a man brought up to believe in the feasibility of reason and the education of a better mankind in harmony with the

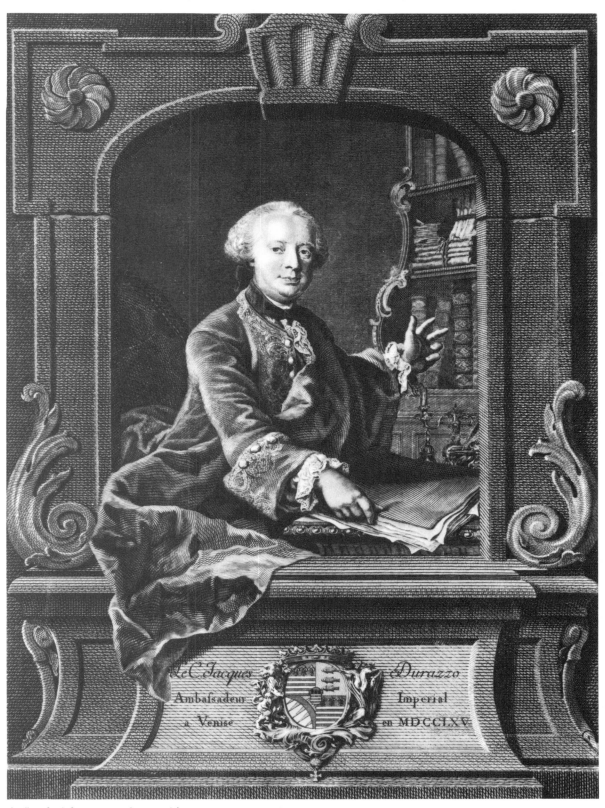

3. Jacob Schmutzer. *Count Giacomo Durazzo* (1765).

principles of Enlightenment and Freemasonry—were not sufficient to accomplish his aims in the face of the powerful Hungarian nobility. Serious conflicts unavoidably arose, but the Empress remained his staunch supporter.

These years, from 1765 to 1770, saw Albert's beginnings as a collector. Although the Palace was appointed with many quite important paintings from the Imperial Court Gallery, and a large library had been created, the young Duke's interest was ever-more strongly veering toward the graphic arts.

We may be certain that his engagement in this direction was stimulated by the Archduchess Marie Christine. Her talent and enthusiasm for drawing had been evident from childhood, and a portrait by Liotard indeed shows her working with brush and watercolors. On a larger scale she even decorated an entire *salon* at Schönbrunn Palace. When Jacob Schmuzer (1733-1811), after his studies in France as a protégé of State Chancellor Kaunitz, returned to Austria to found the Vienna Engravers' Academy, he visited his family in Bratislava, in 1766. At this time he may well have drawn the Imperial Vice-Governors' attention to the belief of Johann Georg Wille, his teacher in Paris, that the art of engraving was a unique means of disseminating and propagating the fine arts, and a medium ideally suited to making accessible to a broader world the works created by the genius of the great masters.

Duke Albert soon recognized this prospect as opening up new possibilities for the realization of his aims as a collector. Having taken an interest already in the promotion of the Vienna Engravers' Academy, of which he had become an honorary member in 1768, he resolved in the same year to approach Wille, the engraver and dealer, to acquire the latest prints obtainable in Paris. However, all this might not have amounted to more than a gesture of encouragement toward fine arts and cultural development, and it would not have gone beyond the limited undertaking of setting up a small collection, had it not been for a decisive meeting with Count Durazzo in 1773.

Giacomo Count Durazzo (1717-1794), descendant of an important Genoese family, son of Erno Durazzo and brother of the Doge Marcello, had come to Vienna in 1749 on a diplomatic mission for his native city. A man of breeding, with cultivated tastes and talents, he quickly became a popular member of society in Vienna, where he showed a great variety of interests, including brilliant appearances in amateur theatricals. His enlightened way of thinking, rooted in his many connections with French cultural life, won him the faithful friendship of Wenzel Count Kaunitz, later State Chancellor (1711-1794). When Durazzo fell in love with one of the most beautiful women in Vienna, the Countess Ernestine von Weissenwolff, and married her in the Cathedral of St. Stephen on May 17, 1750, it was hardly surprising that he ended his diplomatic career and looked for a position at Court.

In 1752 the Empress made him a Privy Councillor, with a special brief to reform the Court Theater. There, to his lasting credit, his activities resulted in the appointments of Christoph Willibald Gluck, Goldoni, and Metastasio, the introduction of French opera, the engagement of prominent artists, and the principle of strict insistence in theatrical and operatic performances on the highest standard of quality, a tradition that has endured in Vienna to this day. He was also instrumental in arranging Mozart's debut in the Austrian capital.

The various involvements which, ten years later, led to Durazzo's fall need not be discussed in this connection. An ostensible reason was his alleged relationship with the prima

12

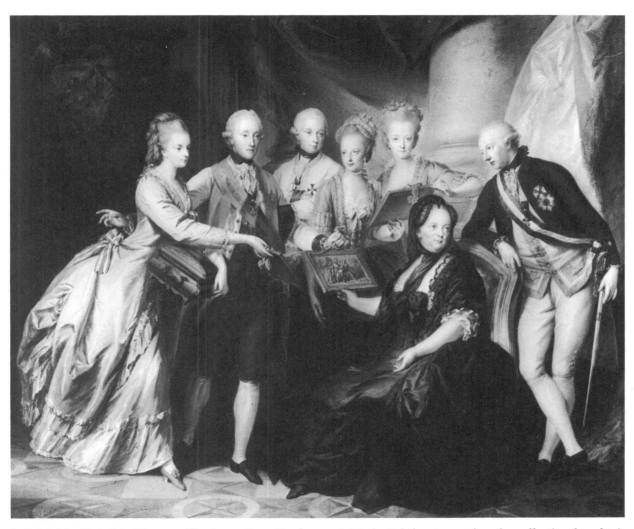

4. Friedrich Heinrich Füger. *Albert von Saxe-Teschen and Maria Cristina presenting the collection bought in Italy to the Empress Maria Teresa.* (Österreichische Gallery, Vienna).

ballerina Louise Bodin, which was adroitly exposed in a calculated provocation of Empress Maria Theresa's severity in questions of conduct. The real cause of his removal seems rather to have been far-reaching court intrigues, as well as the wish of the young Emperor, Joseph II, to create a German National Theater.

State Chancellor Kaunitz, meanwhile raised to the rank of Prince and at the height of his political influence and power, took a sovereign decision to save his friend from distress and disaster by appointing him Imperial Envoy to the Republic of Venice. In his new position, with his official seat in Palazzo Loredan, Durazzo fully developed his lordly aspirations and, acquiring villas in Mestre, Padua, and Treviso, played a far from insignificant part socially and politically.

Culturally, however, he found nothing to replace the interest he had had in the Court Theater. Thus, he was practically driven to spending more and more time on collecting art, trying to define the problems and the meaning of such activity. Furthering his

involvement in this direction was his opportunity to consult Domenico Louisa, one of the great connoisseurs, whose gallery by the Rialto was famous for its fine prints.

After almost ten years of absence from the scene of his onetime successes in the Imperial capital, Durazzo and his wife revisited Vienna; their journey extended from August 18, 1773, to May 18, 1774. The Ambassador was received at Schönbrunn, made his reports to the Chancellor, called on friends and acquaintances, and, in September 1773, visited Albert, whom he had met in the Kaunitz circle. He waited on him in Pressburg, only a few hours from Vienna, and there, as he later recalled in his "Discorso Preliminare" of 1776, he was privileged

". . . to observe the Prince's scholarly pursuits, among them the beginnings of a fine print collection, which, though rich in treasures and admirable in the works of diligent French and English artists, altogether lacked equally valuable works of earlier days, when Germany and Italy competed to surpass all other nations.

"During our conversation," Durazzo continues, "the Prince was pleased to recognize how old prints serve to combine the eye's delight with the enrichment of the spirit. From these observations grew the project of creating a collection to serve a higher purpose, and in this to be distinguished from all others."

Count Durazzo returned to Venice, where his activities in organizing, researching, and purchasing must have been most intensive, as he was able, only two years later, to present to the Duke as the fruit of his efforts 1,400 artists' *vitae*, work-lists, and about 30,000 prints, including superb specimens, chiefly by Italian masters.

Albert's and Marie Christine's tour of Italy, from December 1775 to July 1776, though essentially political in objective, was motivated also by family affairs and their interest in sightseeing, with highspots provided by impressions of natural scenery and places of historical significance. For Albert, however, by far the greatest moment came in Venice, in early July 1776, when he received the collection from Durazzo. The latter had specially requested State Chancellor Kaunitz to arrange the Vice-Governors' journey so as to give him an opportunity of personally handing it over to the Duke:

"Indipendentemente dal motivo troppo per me interessante di far la mia corte alle Reali altezze loro, desidero di umiliare al Principe Alberto la quasi terminata Raccolta di Stampe, che ho riunita per servirlo e compiacerlo in seguito della corrispondenza meco intavolatane subito doppo il mio ritorno da Vienna. E' questo un'oggetto assai considerabile in cui oltre la spesa non ho risparmiata pena alcuna, affine di renderlo degno delle aggradevoli, e dotte occupazioni di questo Principe, e dell'Augusta sua sposa ed Ambedue nel brevissimo Loro soggiorno parvemi rimanessero contente leggiera idea, che poterono prendere della Raccolta medesima avendo il principe continuato a scrivermene anche ultimamente da Roma."

Albert's and Marie Christine's Italian journey makes one of the most fascinating travelogues of the 18th century, particularly as the source material recently was substantially enriched by the discovery of unknown notes, instructions, and descriptions relevant to the Vice-Governors' tour. Its importance for the Albertina lies in the fact that it immensely widened the appreciation of the Duke and his art-loving wife of the art treasures of Italy. They enthusiastically admired the Uffizi Galleries, where the Grand Duke Leopold, Marie Christine's brother, was untiring in personally showing them the matchless collections; the Palazzo Pitti, where they were lodged; the Vatican Galleries in Rome; and, at the Royal Palace in Naples, the Pompeian finds. The knowledgeable Sir William Hamilton conducted them over these excavations on various occasions.

14

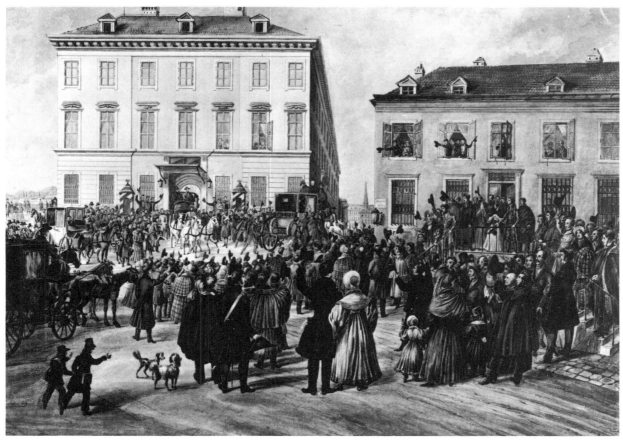

5. Sebastian Warmuth. *The old Silva-Taronca Palace, present site of the Albertina Gallery.*

Albert absorbed all he saw with the liveliest interest. Marvelling at historical sites, seeing all that the cities, churches, and palaces had to offer, he came to make comparisons and critical judgments, and to clarify his opinions on questions of art. Thus, the Italian journey became the decisive intellectual foundation upon which the "Albertina" collection was to grow in the years to come.

The ground was now prepared, but in addition to the favorable circumstances providing the preconditions, the means, the knowledge, and the system, fate had to take a hand before the project could be realized. On July 4, 1780, death came to Duke Charles of Lorraine, whom Albert and Marie Christine, by their marriage contract of 1766, were jointly to succeed as Governors of the Austrian Netherlands—the area that is Belgium today.

They were still in Vienna when the Empress, too, died, on November 29, but then they left Bratislava for Brussels, where a splendid court atmosphere awaited them at the Palais Royal and the Chateaux of Marimont and Scoonenberg. Life became extremely social; hunting, visits, and outings filled the days. Owing to the dubious introduction of a central system of administration—soon to end in disaster—the responsibilities of government were light and undemanding.

Albert had little alternative but to give full rein to his passion for collecting. Brussels was ideally situated for his purpose. It was close enough to Paris for him to foster con-

tacts with all the dealers and many of the collectors, and he increasingly looked to France for communication and inspiration as his interest in drawings heightened. The strongest stimulus was probably provided by a friend and neighbor, the liberally educated, highly talented young Prince Charles de Ligne (1759-1792). The Prince's garden at Beloeil gave Albert his first sight of English landscaping and became the model for his own *"jardin anglais"* in his building project at Laeken. Most likely the Duke was similarly attracted and impressed by the Prince's collection of rare drawings, in which he had managed, by acquisitions in Paris, to unite the cream of such collections as Crozat's, Gouvernet's, Mariette's, and Julien de Parme's. However, of no less importance to the Duke was the closeness of Holland, where Cornelis Ploos van Amstel evidently rendered much invaluable assistance to him in the acquisition of drawings of the first rank. Finally, the art market's traditional center in London was easily accessible from Brussels, and there, too, Albert had his permanent agents to purchase rare works of excellence.

Adding to these favorable opportunities for the Vice-Governor, whose initiative combined with almost unlimited funds, was another factor: pre-revolutionary conditions in France had enforced much emigration, caused the break-up of family possessions, and brought many treasures onto the market. Albert succeeded in acquiring works of the finest quality. At first he was able to buy in Paris: we know, for instance, of purchases from J. D. Lempereur in 1790 (Lugt 1740), and at the Chabot sale of 1782, and the sales lists also show that Johann Georg Wille supplied the Duke during those years—although the first important purchase of Italian drawings seems to have been made from the Dresden collector W. G. Becker (Lugt 324), who had spent much time gathering superb works in Italy. In the year of that purchase, 1784, the Duke's books for the first time show an unusually large expenditure, 12,616 florins. The outbreak in 1792 of the war between France and Austria abruptly ended this lucky phase of the Duke's collecting activities.

After the Austrian defeat at Jemappes, the Governors Albert and Marie Christine fled up the Rhine. The collections, the library, and the furniture were sent in three boatloads to Hamburg via Rotterdam, one of them being lost in a shipwreck—a blow from which the Duke would never entirely recover. However, the main body of the rescued treasures safely reached Dresden, as did the Governors, who remained there until they received an invitation in 1794 from the young Emperor Francis II (later Francis I of Austria) to live in Vienna. The monarch offered Albert and Marie Christine the palace on the *Augustine Bastion,* built between 1745 and 1747 by the Portuguese Ambassador and Imperial Minister Manuel Count Silva-Tarouca. The building today is known as the Albertina. This offer was the deciding factor in the final move of the Duke's precious collection to Vienna. Removal began in 1801 and extended up to 1805.

One of the first Austrian staff casualties in the French Revolutionary wars was the Prince de Ligne, killed in action on November 14, 1792, at Croix de Bois. According to the instructions in his will, his collection was to be kept intact and offered for auction only in its entirety. Adam von Bartsch, curator of the Imperial Print Collection, who had met the Prince de Ligne on his travels in 1783 and apparently instructed him in etching and engraving, drew up a comprehensive catalogue for the occasion. It appears from the catalogue that the de Ligne collection came into Albert's possession as early as 1794, and evidently the Albertina thus acquired some of its most important Italian sheets.

The final important event in the early annals of the Albertina, which this survey reviews with special regard to the collection's gradual growth and organization, occurred with the

death of the Archduchess Marie Christine. She had been in Vienna for only a few years—the reconstruction of the Palace by Louis de Montoyer was still in its first stage—when she fell gravely ill. She was brought to the Palais Kaunitz, then particularly peaceful in the salubrious air of the Mariahilf suburban district, and given every care, which, however, included such contemporary remedies as bleeding and other medical tortures. She died on June 24, 1798, and the Duke, deeply affected by the blow, retired into solitude.

The Archduchess had expressed her love for him in a final letter, a moving document to be opened by her widower on the day after her death. *"Vous étiez le seul objet pour qui je vivais et auquel je désirais être digne de lui appartenir,"* reads one passage, and in commemoration of this loving bond, Albert set to fulfilling all her instructions: among other provisions and dispositions, these concerned the education of their nephew and adopted son, the Archduke Charles, future victor of Aspern; the construction of a drinking-water supply for Vienna; a donation of 50,000 florins to a home for the blind; and the project for a canal in Hungary that would transform over 8,000 acres of morass into fertile farmland.

Albert himself sought to perpetuate Marie Christine's memory by commissioning Canova, whom he considered to be the greatest living artist, with the design of her tomb. Antonio

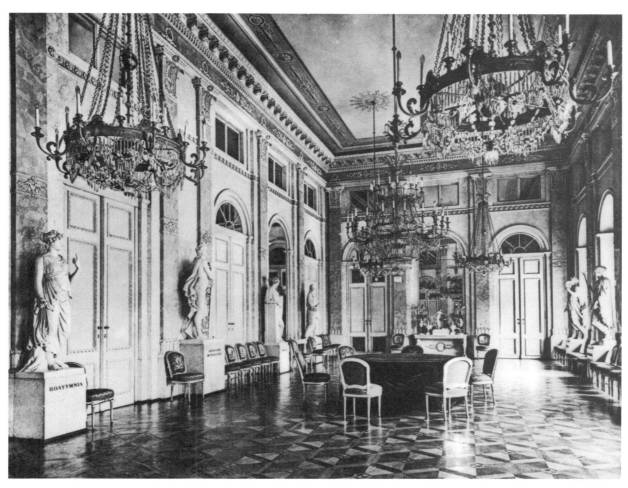

6. *The ballroom in Duke Albert von Saxe-Teschen's palace, now transformed into a study room.*

Canova followed the Duke's invitation to Vienna and agreed, at a price of 80,000 florins, to create in his workshops at Possagno a memorial in finest Carrara marble, to be set up in the Augustine Church in Vienna; there it was later to be admired by Napoleon.

Duke Albert had withdrawn from official functions and henceforth only wished to be left alone in the peace of his house. It was of the greatest significance for the Albertina that the period of his seclusion, fruitfully used for the enrichment of the collection, was to last for twenty-four years.

Eyewitness reports tell how "the old man would spend each day from the early hours of the morning until late at night in those hallowed rooms, allowing himself only as much leisure as was necessary for meals and walks, and to be at home to travelling scholars and artists, who would invariably find him occupied in arranging and enlarging his treasures." Others describe him as "a slender old man in a white Empire wig, blue tailcoat and high boots, with a kind face, but sad and tired eyes; a lonely figure, followed by a small white dog when pacing his rooms to inspect his books and art treasures."

Albert's annual expenditure on the collection reached astonishing dimensions, and surviving accounts show that a fortune was used in a grand manner for the realization of his life's ambition to "create a collection to serve a higher purpose." The total of appropriations for the collection amounted to 1,265,992 florins, which today would be equivalent to over six million dollars. The Duke thus spent approximately a quarter of the money at his disposal on purchases of drawings. For the sake of reference, this figure can be compared with other expenditures of this kind, such as the Imperial Court's expenditure of 101,882 florins for the acquisition of paintings between 1792 and 1811—an indisputable and frequently emphasized contribution to civilization, to the credit of Austria as a cultural initiative taken in the worst years of war; but Albert, as a private collector, spent 744,808 florins over the same period. This is, then, all the more noteworthy, and should be remembered in this day and age, when official bodies the world over imagine that cultural achievements happen—or fail to happen—automatically and without much help from them, but that they are nevertheless entitled to revenues from museum charges and the tourist trade. That those unwilling or unable to give grants of considerable size to the arts can expect no lasting achievements should again be stressed.

From the year 1782, Albert employed two men as curators of his collection: van Boeckhout, in charge of the prints, and François Lefèbvre, to look after the drawings. The appointment of two curators in itself demonstrates the increased importance of the drawings. The times were long past when they were considered only unfinished preliminaries for paintings or sculptures; they were now regarded as works of art in their own right, and even as artists' most direct communications.

Shortly after 1800, visitors began to call on the collection and to write about it, as it already had become a famous institution; and such contracts indeed contributed to the fulfillment of its proper purpose: the dissemination and propagation of art. The gallery once received as guests Czar Alexander and the deposed Viceroy of Italy, Eugène de Beauharnais, during the Congress of Vienna in 1815, when victor and vanquished held their famous civilized conversation about the fluctuating fortunes of history and the eternal values of art.

If the Duke made his collection accessible to visitors, he did his best to encourage the interest of artists, and for the young generation of German Romantics the encounter with the drawings of Dürer and Raphael—the Albertina's special strength—became an almost

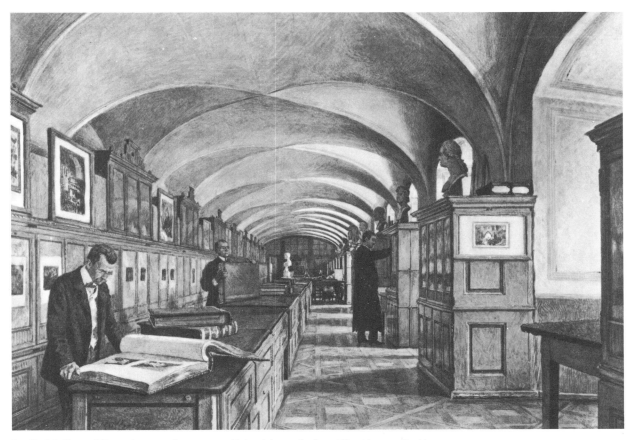

7. C. Muller. *The nineteenth-century disposition of the Albertina collection.*

symbolic experience. The fusion of *Germania* and *Italia*, an image expressed in Overbeck's well-known picture, became the guiding idea inspiring the revolt against the New Classicism that had gradually degenerated into a bloodless conception: members of the *Lukasbund*, a group at the Vienna Academy, united in rebellion and—in the spirit of their symbol—set off for Rome. The Albertina's effect on artists as a source of new initiative can be traced to the present generation.

During the final stages of his life, Duke Albert's connections extended to all Europe. Great art dealers—Domenico Artaria in Mannheim and Rotterdam, who had left Vienna where his family maintained its activities, or Frauenholz in Nuremberg, and Zanna in Brussels—sent their lists and consignments for selection and approval. Albert consulted his curators and other advisers, among them chiefly Adam von Bartsch, one of the greatest connoisseurs of graphic art, and the renowned painter Heinrich Friedrich Fuger, Director of the Academy and the Imperial Gallery. Considering all aspects and observations, he made his own very careful choice and, as his letters show, minutely examined prices and values. Thus, what came into being was no chance collection, but, work for work, a systematic survey of the artistic achievements of each period, each school, and each major artist, which indeed represented the realization of the *"storia pratica"* whose priciples had formed the basis of his collecting project so long ago. Albert used to mark items that interested him in sales catalogues, and give short, clear instructions. His acquisitions

19

were economical and well-considered, and the collection steadily increased in an organic, unostentatious way.

But then came the momentous turns of events. In 1796, the Emperor Francis II (later known as Francis I of Austria) agreed to transfer the stock of Dürer drawings, dating back to Rudolf II, from the Imperial Library to the Duke in the form of an exchange which, in addition to approximately 370 sheets by Albrecht Dürer, also involved works by Rembrandt and other masters.

Further progress was made in the sales of Zanna, Brussels (1797); Charles Rogers, London (1799); Ploos van Amstel, Amsterdam (1800); Conte Gelosi, Turin (1803); and Saint-Ives, Paris (1805). But almost nothing enriched the collection as much as the purchase of drawings from the collection of Moritz Count Fries (1777-1826), who had been forced by the failure of his banking house to sell his works of art. It was thanks to the good offices of the curator of this collection, Franz Rechberger (1771-1841), that Albert had first choice before the auction-sale. The greater part of the Fries pieces, the finest drawings by Pisanello, Tomaso, and Primaticcio, had been acquired from the Marquis de Lagoy in Paris before 1810, and then brought to Vienna; but all these purchases are difficult to trace back in detail, since as early as 1795 the Albertina had obtained a very important group of Italian drawings from the Dresden collector W. G. Becker, while the most important Titian drawings are supposed to have been secured in London only during the last period of acquisitions before the Duke's death.

At any event, up to the date of his death on February 10, 1822, the Duke was striving for extensive expansion. In 1821 his annual expenditure amounted to 81,163 florins, and even in January 1822 he spent 3,179 florins on drawings alone.

According to his will, drawn up in comprehensive detail on June 16, 1816, the collection went to his nephew and adopted son, the Archduke Charles of Austria, who was his sole heir. The great art lover had left instructions that the collection be vested in a trust, that it was never to leave Austrian soil, and that its contents were never to be sold singly, in part, or as a whole. These forward-looking conditions both created and preserved the institution of the Albertina during two centuries of stormy European history that often threatened it.

The French occupation of Vienna and the confiscatory activities of Dominique Vivant Denon in 1809 may have had their effects, as did the connoisseur-ship of General Antoine François Count Andreossy, the city's commandant: a considerable part of the Dürer collection vanished on that occasion. But the Albertina's subsequent fate was all the more fortunate. The revolutionary turmoil of 1848 left it unscathed. The directors' appeal to "the laudable National Guards Supreme Command" for special protection of the house which contained "a collection unequalled anywhere else in the world, of inestimable value, and attracting the admiration of natives and foreigners alike" had evidently been successful. In 1866, after the battle Königgrätz, when Vienna was threatened by Prussian occupation and all that this meant, the collection was hastily packed up and moved to Hungary. From 1914 to 1918 it was securely stored in official strongrooms, and from 1939 to 1945 kept in various carefully protected places. Not a single sheet was harmed, though the Palace in Vienna suffered bomb damage in an air raid on March 13, 1944.

Historical tribulations were not only due to war. By Article 197 of the Peace Treaty of St. Germain, the whole of Austria's art treasures was pledged in security for reparation claims, and an Allied Commission of experts appeared in Vienna to begin valuations on

20

November 19, 1919. Fortuitous turns of events and much good will averted the final consequence, and when in the thirties a sale was threatened, that danger also passed. Thus, after two hundred years of existence, the collection is still preserved "in good order," open to the public, students, and friends of the arts and sciences.

Rechberger in his assessment of 1822, from which we quoted earlier, observed that the chief requirements for the collection were its critical examination and the scholarly classification of its holdings. However, these main tasks for a long time remained unfulfilled, and almost a full century was to pass before research in this direction began. True, Moritz von Thausing (1838-1884), an enthusiastic, in many respects billiant young historian, had inaugurated a new art-historical era in Vienna in his capacity as Director of the Albertina. But all of his efforts were spent on his standard work on Albrecht Dürer, which appeared in two volumes in 1876. Thausing's life was all too short: After many months in Venice, where he hoped to recover from a nervous disease, he committed suicide at the age of forty-six on August 11, 1884. On that day, he had written to Franz Wickhoff on the subject of some Michelangelo drawings, and had added: "...it may be you who will be able to realize what I dreamt of as my final work, in the days when I could still consider an analytical catalogue of the Albertina drawings." This bequest, Wickhoff believed, made it his duty to devote himself to this task. He published the results of his research in the *Jahrbuch des Allerhöchsten Kaiserhauses,* 1891-1892, and it was indeed to become the basis of future work, not only in its perceptive detail, but in establishing the principle of the *catalogue raisonné,* which is followed today by almost all great collections of drawings. Wickhoff had to rely almost wholly on his own research. In the spring of 1900, in a series of six lectures in the Albertina against the background of the original drawings of the Italian schools, he once again presented the essence of his findings. A few years before, Giovanni Morelli, during a working visit of some duration, had annotated a certain number of the mounts. This practice since has become fashionable, often without approval or invitation; but not all observations thus recorded are equal in significance to Morelli's remarks. Considering Cavalcaselle's comments, or even the classifications in B. F. Waagen's register in Volume II of *Die vornehmsten Kunstdenkmäler in Wien* (Vienna 1867), pp. 129-157—with which, Wickhoff notes, he was only very rarely able to agree—it becomes apparent that hardly any serious, critical standards existed. Wickhoff's introduction to his publication on the Schools of Venice, Lombardy, and Bologna, aside from questions of attribution, has long since become a classic, especially in the general section: anyone occupied with drawings would be well advised to absorb the wisdom of his words.

Sheets appearing in a collection under names they do not bear out are not likely to have been consciously misclassified. They may not have been recognized, or may have been misplaced, or, more often—and this is not unusual in old collections—assigned according to a different understanding of what is conceived as an "original." A drawing *after* an artist, usually one of the great masters, would simply be attributed to him, as his invention, after all, is the original achievement. Apart from being wrongly named, sheets may have been misascribed through false tradition, or through inadequate knowledge of some collectors. The opposite, of course, applies to such great and famous connoisseurs as the Mariette, Crozat, Julien de Parme, d'Argenville, Richardson, and de Ligne, in whose collections attributions argue strongly for authenticity of sheets concerned.

In these basic obesrvations, too, Wickhoff's lasting accomplishment cannot be over-

estimated. It is of course self-evident that technological advances, such as the photographic reproduction of nearly every work of art in the world, lavish publications, and scientific research have produced an apparatus for comparative study unthinkable in Wickhoff's day. Criticism now can build on new foundations. It is therefore high time to survey the scene once more, to establish new ideas and confirm old ones.

The *catalogue raisonné*, as demanded by Rechberger, dreamt of by Thausing, attempted by Wickhoff, adopted and maintained as a principle by Stix together with Fröhlich-Bum, and continued in various research projects over the generations, is still a distant goal. It will remain one of the major tasks to be realized at the Albertina. A collection such as this, however, in its very essence presents a constantly renewed challenge to accept historical responsibility, to review the ideas of past generations in critical or approving reappraisal, and to reaffirm the purpose for which the collection's holdings were assembled by acknowledging their function and existence as works of art, created for mankind, and ready to serve the higher education of man. We, too, believe we are called upon to carry on the lifework of that great collector, Albert von Saxe-Teschen, who was so deeply convinced of the formative role of art in shaping the future of man.

WALTER KOSCHATZKY

Notes

(1) See *Albertina Studien* vol. 2, 1963, p. 87 sq.

(2) *Habsburgisches Familien-Archiv*: State Archive, Budapest, p. 1490, Nos. 19 ff.

(3) *F.H. Böckh, Wiens lebende Schriftsteller* (Vienna 1821).

(4) *Mémoires de ma Vie*: 4 vols, Hungarian National Archive, Budapest, Habsburg Fam. Arch., p. 298. See also Koschatzky-Strobl, p. 9 ff. and 441 ff.

THE EARLY RENAISSANCE DRAWINGS

The Albertina's selection of early Italian drawings owes its character to historical circumstances. The collection was a comparative late-comer among the princely collections, and it was very deliberately assembled with the object of embracing and reflecting the development of drawing, in every facet, from the time it had become detached from the codex. Giorgio Vasari had pursued a similar aim in creating his own collection. Cardinal Leopoldo de' Medici's efforts for his 17th-century collection—the nucleus of the present graphic collection of the Uffizi—are supported by the art historians Baldinucci and Malvasia. Collecting and art historical scholarship usually went together. But Leopoldo and, contemporaneously, both Everard Jabach and Louis XIV (who took over much of Jabach's collection and so founded the famous Cabinet des Dessins of the Louvre) were still able to get hold of entire inventories of old artists' workshops. In this way they acquired extraordinary quantities of drawings, early ones among them: a wealth of treasures that similarly characterizes, for the Baroque period, the collections at Windsor Castle and Dusseldorf.

Albert, on the other hand, and the collectors from whose stocks he drew, were with few exceptions already confined to acquiring single pieces or small lots, secured in a sophisticated, widely branching art market, dominated by keen competition, so that the Albertina's treasures excel more in their quality than in their number. Albert went without a share even when a large body of drawings became available during the turbulent post-revolutionary period in Italy—including numerous Raphaels from the collection of J. B. Wicar that went to English collections, in particular the superlative one of Sir Thomas Lawrence. In consequence, Albert's collection, in its systemization and limitation of artists' œuvres, already resembles modern collections formed from an art historical point of view; for the same reason, the contemporary state of scholarship and the owner's taste considerably affected the result.

We have a good idea of the character of Albert's Italian collection because the 1891-92 catalogue compiled by Wickhoff tallies in numbers and details with the inventory drawn up, in some parts summarily, at Albert's death. During the 19th century the collection expanded mainly in the direction of modern art, chiefly in contemporary Austrian art. As for the earlier sheets, those which Joseph Meder had purchased in the period before the first world war had to be handed over to the Archduke Frederick, the Albertina's last private owner, in 1919. Therefore, the only new accessions to enter the body of the old collection were the acquisitions made between World War I and World War II, and while they were not large in number, they were of such individual importance as to alter its character.

Albert's spirit as a collector, it appears—although it is risky to generalize—was still determined largely by the predeliction for drawings of thoroughly finished form and detail: a taste for substantive perfection that had prevailed since the Renaissance. He admitted freer sketches only when the artist was particularly important or rare. The bulk of the magnificent spontaneously invented and executed designs that are of such great interest today was acquired in the period between the two world wars.

It was inevitable that Albert's collection, in spite of highest selectivity, would contain a fair number of copies—as Franz Rechberger recognized in his early description. Of the

fifty-eight sheets attributed to Leonardo, only two are today acknowledged as genuine for certain; of the thirty-seven Michelangelos, only eight; and of the 127 drawings by Raphael and his school, no more than thirty-four are definitely authentic. Three of twenty-two sheets classified as drawings of the 13th and 14th centuries are still recognized as Trecento works (Pl. 1-3). Of the others, two are 15th-century works by Netherlandish artists, several are 16th-century copies of early frescoes, and the rest mostly Quattrocento works (e.g., Pl. 6).

Frightening as these figures may seem, the situation is much the same in all 17th and 18th-century collections; in the Louvre and the Uffizi, with their vast numbers of drawings, it appears indeed almost worse. Moreover, the particulars given above apply only to the masters of the Roman and Florentine circles. Vasari's appraisal had marked the inauguration of an enduring tradition in the judgment of their drawings, and the attributions which Albert took over from earlier collections, and which remained the basis for classification until the end of the 19th and even into the second decade of the 20th century, were on the whole more reliable than those in other schools.

It was not until our day that the first really fundamental catalogue of Correggio drawings was compiled; none of Albert's twenty-six attributions stood in the face of research. The one certain Correggio in the Albertina was originally considered a Raphael: an opinion significantly reflecting the stylistic stage to which it belongs—it is one of the works clearly showing the effect of the master's stay in Rome.

Mantegna's graphic œuvre is also only now emerging in its true extent and limitation. Here, Albert had at least one original sheet among the twelve attributions, almost all of which were, incidentally, good drawings produced in Mantegna's period and in his sphere of influence. In this way, Albert came to possess two splendid sheets by Francesco Francia (among them Pl. 22), which he might never have bought without the original Mantegna ascription.

Particularly crucial was the situation in the Venetian School. Only one out of thirty-seven Titian attributions stands up to criticism; but no completely satisfactory catalogue of Titian's drawings has yet been compiled. Not one of the six Giorgiones is authentic—small wonder, when altogether there are only two fairly certain drawing attributions to that master. None of the twenty-eight sheets attributed to Tintoretto is authentic either; indeed, his freely drawn charcoal studies of nudes with their strong abstractions would hardly have been to Albert's taste. Only two of twenty-three Veroneses remain, but minor masters—Pordenone, Bassano, Battista Franco, Paolo Farinato—fare better.

It is in those regions of Italian art of the 16th century where artists produced few finished drawings and drawing was mainly limited to free sketches and preparatory designs for paintings, that the scholarly judgment in the late 18th century was particularly uncertain. Typical free Venetian studies by masters such as Campagnola, Veronese and Tintoretto were added to the Albertina's treasures only during the present century (Pl. 61 & fig. 21). Coming off better, in consequence, were Quattrocento Venetians, who produced some finished portrait drawings that still rank among the Albertina's most outstanding masterpieces. Of all the North Italians, Cambiaso and Parmigianino fared best. Both used to draw for drawing's sake and made their drawings look desirable in their own right.

Thus the foibles and strong points of Albert's collection reflect to some degree the state of knowledge of graphic art in his period, and in this feature—the misattributions—the collection holds a particular attraction for the present-day connoisseur. When a sheet is verified to be not a Raphael, as supposed, but a Correggio or Lorenzo Costa (Pl. 12);

not a Bassano, but a Tintoretto (Pl. 65); not a Michelangelo, but a Rosso Fiorentino; not a Bandinelli, but a Raphael; and when, finally, the number of really poor sheets turns out to be astonishingly small—then the experience of going through these treasures and working on them is truly rewarding. Thus, our present selection represents new conclusions, and so becomes an integral part of the ever-changing spectacle presented by this collection. But if the Albertina today has thirty-five Raphaels and only one Correggio and two Titians, this is also because infinitely more drawings by Raphael survived than by the other two masters. Chance in the market also influenced the collection's holdings.

The strong points of Albert's collection rest precisely on those of the two great collections that he was able to incorporate, entirely or in large part, into his own. The possessions of Albert's collector-friend, Charles Prince de Ligne, are invariably and rightly pointed out in this connection, as they constitute the foundation of the greatness of the Italian drawings department of the Albertina. The de Ligne collection, based on the great French stocks of Pierre Crozat, Pierre-Jean Mariette, and Julien de Parme, consisted mostly of sheets of the very first rank. Although twenty-three of the Albertina's Quattrocento sheets came from this source, it comprised comparatively few early sheets, but many by the great classic masters. A few figures may illustrate the situation: of de Ligne provenance are all of the Albertina's Leonardo sheets—beside the two recognized drawings, perhaps six others on a Vasari mount; furthermore, five of the eight authentic sheets by Michelangelo (to whom eleven drawings altogether were attributed in the de Ligne collection) are from de Ligne; and finally, the same collection is the source of twenty-three genuine Raphaels—thus, most of the Albertina's genuine Raphaels come from de Ligne and represent nearly half of the total of forty-eight Raphaels originally listed in the Beloeil collection. High quality, then, was more concentrated in the de Ligne collection than later in that of Albert, but even his holdings contained no authentic Titians, Veroneses, or Tintorettos.

Adam Bartsch, drawing teacher to the Prince de Ligne and later Director of the Printroom in the Vienna Court Library, justly described the collection as unusually splendid. Valued at 100,000 gilders in the Prince's last will, it had come to Albert in its entirety, probably as a present from his wife, and remained intact except for a few sheets he gave his Swedish adjutant, Count de la Gardie.

The second collection of high quality, though it did not include such great masters, belonged to Count Moritz von Fries, for whom it had been assembled by Franz Rechberger, his keeper, who later joined the Albertina as a curator. Unfortunately, Albert did not acquire this treasure in its entirety, but purchased only a group of selected sheets before the public auction. The Fries collection must have been a connoisseur's collection in the highest degree. The quality is excellent almost throughout, and sheets bearing his collector's mark, a blind-embossed Maltese Cross, may be relied on as authentic even today. This collection was the source of most of Albert's Quattrocento sheets, and of many drawings by later masters.

Also from the Fries collection come fifteen sheets from a group totalling fifty-five drawings, chiefly from the 15th century, but including as well two of the Albertina's 14th-century sheets (Pl. 2 & 3), among the most important specimens of the period. These sheets, still united in the collections of Count Fries and Marquis de Lagoy around 1800, have since been dispersed into collections all over Europe. This group Degenhart and Schmitt believe to be the remainder of old workshop holdings, preserved in one of the earliest collections; this had probably been begun by the great master of the early 15th century,

Gentile da Fabriano, was later augmented by Pisanello, and was finally graced with imaginary signatures of old Tuscan masters selected from Vasari by a 17th-century collector who wanted to give the sheets a semblance of venerable age. Thus, Albert was under the impression that he owned works by Nicolò Pisano, Cimabue, Simone Martini, and others, while in reality most of the sheets were works of Pisanello and his circle (e.g. Pl. 6). In fact, they formed the basis of the Albertina's very important collection of Veronese drawings, which in this century was further enlarged by other workshop holdings. Many of these more recent acquisitions still bear an old inscription by a 15th-century collector: *Questo desegno fo de Fillipo* (Pl. 4). They later came into the possession of Conte Moscardo's family in Verona, then went to the Marchese de Calceolari, and finally to Luigi Grassi. Aided by the great collector Frits Lugt, who purchased a part himself, the Albertina in 1923 acquired large numbers of early drawings from this stock. Among these were: the splendid sheets by Stefano da Zevio and Pisanello (Pl. 4 & 5); the unique sketch by Lorenzo Ghiberti (Pl. 9)—one of the most important early drawings in the Albertina; the marvelous, impressive sheet by Ercole de' Roberti (Pl. 20); and significant, free Venetian drawings such as the sheet by Michele Giambono (fig. 9).

Substantially adding to these treasures from the Fries and Luigi Grassi collections is a considerable number of early sheets from Giorgio Vasari's album of drawings, his famous "Libro," which had been secured through Fries and Charles de Ligne, or had possibly been acquired through other channels. Partly still distinguishable in the Albertina by their interesting framing, quite a few of them were unfortunately taken out of their mounts in accordance with Albert's modern system, or perhaps even re-mounted before his time. Ten of them qualified for publication in the corpus of Tuscan drawings before 1450 by Degenhart and Schmitt (including Pl. 7, 8 & 10); others are of the later 15th century.

Acquisitions from these three important early collections, which came to the Albertina in such large numbers, were supplemented by single purchases, largely made in Albert's day and their origin is more difficult to trace. It is interesting, however, that the Albertina's earliest drawing (Pl. 1) was purchased in March 1800 at the auction of Ploos van Amstel, the great Dutch collector. The drawing, attributed to Giotto at the time, was bought together with a number of early and late sheets. These included, in particular, the marvellous Beccafumi in this selection (Pl. 33), beautiful drawings by Nicolò dell'Abate and Parmigianino, the delectable landscape with the three Apostles, Peter, James, and John, attributed to Marco Basaiti (fig. 12), and two fine sheets by Paolo Farinato. A drawing labeled Taddeo Gaddi revealed itself—typically perhaps for the Dutch collector—as a Netherlandish work of the 15th century.

Regardless of onesided development, as explained by the collection's history during the early, more notable, phase under Albert von Saxe-Teschen and by the possibly more selective approach to collecting in our own century, the Albertina holdings allow the complete reconstruction of the history of Italian Renaissance drawing in its essential features, so that the founder's wish in this respect indeed has been fulfilled.

Drawing is one of the most basic human experiences—a child will draw almost as early as it will speak, if given the opportunity. Thus, even in the earliest periods of civilization, drawings are a medium of spontaneous expression, whether they are scratched onto stone or bone or applied in softer materials on the walls of prehistoric caves. Greek vase paintings and Etruscan engraved decorations on mirrors are, in essence, drawings. It is precisely in the concentrated simplicity of their design that we enjoy the sure handling of lines and the magic capturing of external and internal events. The tradition of

masterly suggestive line or clearly defining line leads from Antiquity to the Middle Ages and beyond; to the illustrative drawings in codices and to modern times. Time and again, book illuminators either renounced the use of color or contented themselves with a delicate wash, as a tribute to the art of drawing. Even today we find particular perfection in the pure linear drawings, antique in spirit, of Picasso or Matisse. During the Renaissance, many of the 15th-century Florentines used to cultivate clear, linear design to the degree of virtuosity (often these were in close connection with book illumination, like Botticelli's Dante illustrations), and later 16th-century masters, such as Luca Cambiaso, created sheets of a similar kind, already appreciated as independent drawings. Line drawing was soon translated into prints, mainly into woodcuts, and then, in modern times, into lithographs and engravings.

However, from the master of the Utrecht Psalter, whose work was based on antique tradition, to the work of Kokoschka, virtuoso evocative sketches have also been esteemed, both in the art of the book and in their own right, as the expression of creative inspiration. Few examples for this are, however, to be found in the Italian Renaissance and Baroque. Bandinelli's masterly nude drawings (fig. 15), which were certainly considered for their own value, belong rather to the category of simple linear design, while the ideal of free and suggestive rendering seems to be realized in a closer sense by Domenico Beccafumi (Pl. 33) and Andrea Schiavone (Pl. 63) in marvellous chiaroscuro sheets with flickering light and swift stroke. Many of their drawings certainly were considered as independent works of art, as may be gathered from the fact that Schiavone used color and Beccafumi made replicas of his sheets. The prints by both masters—Beccafumi's chiaroscuro woodcuts and Schiavone's etchings, often heightened with color—have the same characteristics. With such exceptions, in the Renaissance and also in the Baroque, drawings were thought to be superb when elaborated with the exactness of miniatures, or consummately modelled in finest plastic detail: in this selection, the drawings—reminiscent of engravings—by Francia and Montagna (Pl. 22 & 17), or the superbly finished portraits by Bonsignori and an anonymous Venetian (Pl. 18 & 19). Works of similar character are connected with names such as Raphael, Michelangelo, and Paolo Veronese (for example, Pl. 66). Many of Parmigianino's sheets can probably be regarded as "finished" in the sense of Renaissance intention (Pl. 53).

Drawings finished in form and detail were, for example, presented as gifts to friends and important patrons, or served, in the case of commissions, to convey an idea of the executed work. In addition, finished drawings also had the function of preparatory designs when providing patterns for the work of other artists or craftsmen. Occasionally, artists would prepare their own work by means of such sheets—a practice traditionally followed in Raphael's workshop, for instance.

It is in such finished sheets, or those that were regarded as such, that the transition from medieval book illumination to modern drawing can most clearly be traced. Parchment or vellum remained in use off and on for work of this kind until the 16th century, but paper—white or colored—increasingly replaced it. The continuity of graphic development particularly shows in the sample books: pattern books for artists and craftsmen that contained works, or parts of works, thought to be exemplary, by other artists, preferably the user's teacher. Originally featuring head-types, animals, and the like, later these books primarily contained drawings of antique statues and reliefs, and also occasionally included personal observations of people, costumes, plants, buildings, and animate life in general:

all were recorded with the greatest care and fidelity. Such patterns, copied over and over again, formed a tradition lasting throughout decades and even centuries. Many of the Albertina's very early sheets come from such sample books (e.g. Pl. 1, 3, 6, 7, 8). These drawings tend to be difficult to date because the draughtsman's personality is often concealed behind the pattern. It makes for a great contrast between the minor artists (e.g. Pl. 7 & 8) and the creative masters who by their own observations contributed to the establishment of traditions, like Michelino da Besozzo (Pl. 3) and Pisanello (Pl. 5, 6). In the North of Italy, and in Lombardy especially, the development of drawing in today's sense is particularly well demonstrated by designs in sample books which are often executed in miniature-like subtlety. Here, scientific concern with nature and artistic concept are often closely interrelated; the modern-minded Renaissance artist attempts in quite a new and independent way to explore the laws of nature governing flora, fauna, and the anatomy of human beings. Leonardo's studies, of which the Albertina owns only a few reflecting his preoccupation with human physiognomy, are among the most spectacular examples of the advance over such early sample collections, though he too sometimes used and developed older motifs. The boundary between book illumination in the form of scholarly illustration and artists' samples for their albums gradually became diffused, as did the borderline between drawing as preparatory designs or research and drawing as a free, autonomous graphic activity, an end in itself. Thus, in the case of obsessive draughtsmen, like Parmigianino, the artistic intention in their sheets is often impossible to determine, as it frequently appears to be a sheer eruption of exuberant fantasy. On many occasions artists used to copy their own studies after life into their sample books, thus preserving their original experience at some loss of immediacy (Pl. 6), and it is in the assessment of just these sheets that the present-day spectator, valuing most highly the free, inspired moment, should exercise particular caution.

Only in a late phase of cultural development in Europe, with the rise of Renaissance in the 14th century, do drawings appear that by their blend of complexity and spontaneity allow the viewer to relive the creative act of the artist's invention, specifically drawings originated as preparations for works of painting, sculpture, architecture, or decorative craft. The fact that paper was becoming more widely available may have been a factor, but the chief reason for these new methods of preparing works of art was the emergence of the artist as an independent personality who, as he began to detach himself from the workshop, looked for individual solutions to artistic tasks and problems. Observations of life and allied technical aspects played as large a part as the high regard for personal invention, which was often also related to the discovery of new literary horizons.

This kind of drawing, therefore, did not grow from book illumination intended as a finished work of art in itself, but indeed it has its origin in the sphere of preparatory design. In some cases, preparatory drawings remain uncompleted in codices, some perhaps left unfinished deliberately. As for art on a larger scale, early artists drew preliminary sketches directly onto the surface to be painted, a practice that persisted well into the Renaissance. In rare instances it has been possible to remove paintings from their supports, usually wood or canvas, and to find preliminary sketches underneath. Especially in recent years, many frescoes have been stripped off their walls so that draft designs, called *sinopias* after the pigment used in their drawing, a reddish earth from Sinope, became visible on the ground layer of mortar beneath. Irretrievably lost, however, are the *"primo pensiero"* sketches which, according to Cennino Cennini, the early theoretician and author of the famous *"Trattato della Pittura,"* a treatise on 14th-century painting and artistic techniques,

were drawn in silverpoint on small tablets coated with powdered bone, and were successively effaced as new motifs came up to be delineated in tentative "first concepts."

Indeed, even the large number of spontaneous drawings on parchment, vellum, or paper were never intended for posterity, nor meant for appraisal other than professional. They were the artist's private expressions, his stock in trade, and as valuable to him as the scholar's or writer's first drafts, excerpts, and references. They might be preserved or thrown away according to the temperament of the master, and occasionally perished during the process of work. Pupils often incorporated such workshop holdings into their own sample albums and thus preserved them until they were finally dispersed or lost after all, or, in fortuitous circumstances, reached one of the graphic collections that were beginning to be formed in the 16th century in a new development in which artists like Vasari played leading roles. However, as we already observed, throughout the 15th, 16th, and 17th centuries, and even until the time of Albert of Saxe-Teschen, drawings of perfectly finished form and detail, though often works of lesser force and spirit, remained more desirable as collectors' items than animated sketches of original immediacy.

Sinopias gradually disappeared with developments toward greater refinement and differentiation in the graphic preparation of murals and paintings in general. Standard working methods came into being over the years, and reached a supreme degree of refinement in the workshop of Raphael. Few other artists produced such an abundance of preliminary stages. The process began with the first sketches, which outlined the basic idea as well as the principles of figural composition and action in the form of a summary abstract, usually only with the merest indication of the surrounding space. The work's first visualization in such initial sketches (e.g. Pl. 35) was further developed in a series of larger drawings that, as necessary, elaborated the entire composition, carried out parts of it, or treated only single figures, until an overall design was achieved in which emphasis was placed on relationships of light and dark. This then became the basis for life-studies that might be drawn after studio assistants wearing studio garments, or after nude models (Pl. 37) or lay figures specially carved in wood or molded in clay. As for the disposition of draperies, detailed studies were aided by small arrangements of stiffened cloth, but frequently real garments were used, arranged on wooden stands. It is said of Raphael that he always drew draperies worn by the living model so as to render proper movement even in the robes. All these studies after nature, which occasionally were further extended to include animals and the like, finally were combined in the so-called *"modello,"* the finished drawing showing the composition in full detail and with accurate light and shade values. In the last phase of preparatory work, these drawings were usually overlaid with a grid for their transfer in proportional enlargement to the cartoon; the cartoon, marked off into similar squares, corresponded in size to the dimensions of the projected painting or fresco and to attain the required format was often made up of several sheets. Directly from this original-size design, or with the aid of yet another cartoon that usually perished in the process, the contours were transferred onto the painting ground by a stenciling method: the so-called *"spolvero."* For this purpose the cartoon was pricked and a bag filled with charcoal dust tapped against it, so that the pigment, penetrating the holes, produced tiny black dots on the surface underneath. Alternatively, the main outlines might be retraced with a stylus, either by pressing its point on the paper of the cartoon, previously colored on the reverse, or by simply cutting through it, incising the lines of the design into the soft mortar base of the mural. Such intensive preparations had become necessary through a variety of circumstances: first, the new discoveries in pers-

pective led to complicated spatial conceptions; secondly, a factor of perhaps even greater consequence, the increasingly elaborate modelling of the figure and form, in conjunction with an advanced differentation of light and shade, involved particular difficulties to be mastered; further, there was increased striving for heightened surface realism; and finally, there was the demand for naturalness in movement and expression. Cartoons not only served to transfer the main outlines, but were consulted throughout the working process. In special cases, artists like Raphael would use additional studies, in the size of the original, for details of heads and hands—so-called auxiliary cartoons (Pl. 41).

As early as the middle of the 15th century we encounter cartoons for the transfer of single figures used along with *sinopias* for the overall composition in the work of Castagno, marked by bold foreshortenings and powerful modelling. Similarly, paintings by Piero della Francesca show frequent evidence of recourse to cartoons, while *sinopias,* from that time, gradually fell into disuse. The Venetians, however, who rarely painted frescoes and thus seldom worked on wet ground, which required extra speed and particularly thorough preparation, may have carried on oil painting without cartoons for a long time: old and new techniques continued parallel for many years.

During the 15th and 16th centuries, drawing for sample books continued alongside preparatory drawing. Indeed, its scope was even extended with the rise of Renaissance, above all by the widespread incorporation of important pattern designs after classical statues and reliefs (Pl. 16). The beginning of this development has been traced by Annegrit Schmitt particularly, studying the work of Gentile da Fabriano in the early 15th century. As paper became cheaper, the pupil's drawing gained ground with studies and copies after classical models and the great masters, and, finally, academic life-drawing grew into a firm institution, although this occurred outside the period covered by this chapter. Only the most outstanding of such school-copies, such as the young Michelangelo's drawing after works by his teacher Ghirlandaio, will concern us here (Pl. 24). A great variety of techniques developed. At first, parchment and vellum were still frequently used (Pl. 1). But there was increasing use of paper, coated with powdered bone or chalk, but also prepared with a colored ground (Pl. 3 & 12) in an effort either to provide a more suitable surface for the fine silverpoint line, or to create a higher contrast with the white heightenings in brush drawings. Silverpoint (Pl. 3 & 14), as a well as leadpoint and goldpoint were popular for drawing, in addition to the pen used with bistre, a soot-base ink, (Pl. 1 & 36), or gall-apple ink, which in the course of time later corrodes the paper. Furthermore, the brush in pen-and-wash drawings (Pl. 15 & 48) was employed to indicate shadows, or to lay on white heightening, which sometimes was also applied with white chalk. Or the brush simply took on the function of the pen in drawing lines (Pl. 2), as for instance in Venice, especially in the 15th and the early 16th century (Pl. 60). Charcoal and chalk were first used in the preparation of pen-and-ink drawings, but later appear as independent media, particularly on larger sheets, mostly in portraits (Pl. 18 & 19). Red chalk began to be used as a subtler material toward the end of the 15th century (Pl. 26 & 38). In Lombardy, in Leonardo's circle, appeared the first colored pastels, mainly applied to enhance pictorial effects in portraits.

*

The earliest works of graphic art, outside codex illuminations, to survive in Italy are consummately finished drawings. The Albertina owns none of these miniature-like, elaborate *"chiaroscuro"* sheets, worked in pen or brush with colored washes on tinted paper,

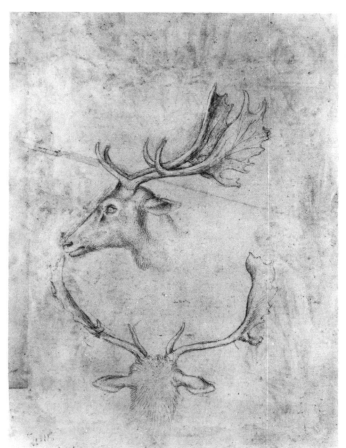

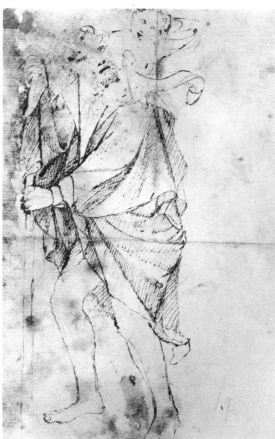

8. Michelino da Besozzo. *Stag's head.* 9. Michele Giambono. *Saint Christopher.*

like the famous drawing by Taddeo Gaddi in the Louvre, or the slightly later Martyr-dom of St. Miniatus in the Pierpont Morgan Library in New York. Both clearly reveal the Tuscan sense of forceful light and shade contrasts in the modelling of the figures. Such drawings represent a tradition in Tuscany until the end of the 15th century (cf. for example Pl. 12 & 14). The lucid simplification of plastic volume, the weight creating bodily substantiality, and the clarity of action and psychological expression in a visually comprehensible setting, as introduced by Giotto, are significantly apparent in the earliest drawing of the Albertina (Pl. 1). Drawn on parchment, it is still a typical sheet of a sample-collection, thematically belonging to a group of copies after the famous frescoes in the Lower Church of St. Francis in Assisi. But it clearly demonstrates the specific Florentine ability to suggest volume within simple outlines by a few strokes following the main train of movement. Every line is there for a purpose, with a clear distinction observed between contour and interior drawing. All that is not essential is avoided. Giotto's spirit living on in this sheet is strong enough to justify its old misattribution to this great ancestor.

The second of the early drawings selected from the Albertina collection (Pl. 2) probably originated, like the first, about the middle of the 14th century. Different in character, a rather swift sketch of several scenes, figures, and pieces of architecture, partly appearing

in separate studies, it may already be a working-design in which the artist visualized a sequence of scenes for a fresco cycle or an altar-panel. The line is more static and tends to define forms in their block-like fullness. Subtle shadows create a surface of higher sensitivity and richness than that produced by the more abstract lines of the Florentine master, whose main concern had been with function and geometric volume. This and other reasons suggest that the drawing comes from the North of Italy, presumably from Bologna.

The third 14th-century drawing in our selection (Pl. 3) leads away from Giotto's sphere of influence into Lombardy, where around 1400, in close connection with the artistic activities at the French and Burgundian Courts, graphic art began to flower on a large scale. Our sheet is probably the most beautiful drawing by one of the major masters in that region of the so-called International Style, Michelino da Besozzo. It not only shows the playfully rounded folds and delicately moving figures that are characteristic of this courtly style, but is also graced with a radiance of gentle, flowing light that imperceptibly accentuates the forms, giving them a soft, almost ethereal volume—traits readily recognized and remaining typical of the art of Milan. The sheet probably comes from a sketchbook in which the artist recorded various motifs, among them the animal studies for which he is famous. The studies of a stag's head on the verso most subtly vary the effect of fleeting light on the animal's hide (fig. 8). Lombardy has produced many of the period's most beautiful animal and nature studies, notably in the work of Giovannino de' Grassi.

The International Style, with its taste for a beautiful, calligraphic harmony of line, combined with a faculty of sensitive observation of nature and awareness of the sensual charm of surface, also spread to other Italian art centers. In nearby Verona, Stefano da Zevio was exploring this style, particularly in its graphic aspects. His Angel (Pl. 4) is of tenser corporality and is more expressive than Michelino's images. His line is controlled and concentrated on the essential indication of relations between light and shade, while crosshatching is effectively used to form the deepest shadows. Significantly, his drawing at times renounces the embracing function of outline altogether. Pisanello, who worked at almost every one of the Italian courts, ranks as Verona's greatest master. His allegory of Luxuria (Pl. 5) is one of his most enchanting creations. The line positively caresses the woman's body, follows the emotional undulation of skin and robe, and indeed sheds a glory of light on the animate surface. One feels almost that the lines matter less than the vibrant space between the strokes, which are drawn only to diffuse the rays of light over skin and hair. In this, Pisanello is closely related to Michelino, but his bodies are more compact and plastic than the ethereal creations of the Lombard artist, and not unlike the conception of Stefano da Zevio.

<p style="text-align:center">*</p>

Lorenzo Ghiberti, the great Florentine sculptor, also received impulses from the International Style. Only two drawings can be attributed to him with any degree of probability. The sheet in the Albertina (Pl. 9) is altogether one of the most important early sheets, as it enables us for the first time to observe an artist at work on a motif of movement, diversified not only in a sequence of figures but, through the wide range of differentiation within the single figure, even varied in the design of the single pose. Movement here, to a high degree, becomes a visual experience, illustrated by a wealth of intermittently "phased" lines that produce a stream of fascinating rhythm. The intrinsic purpose of the line is quite different from that in drawings by North Italians. The point here is the

interpretation of bodily structure and the imaginative representation of plastic form. Light does not flow, but flickers so as to give volume to the figures by contrasting values, and the direction of movement in the limbs always remains superior in importance to exterior design and surface characterization. This is typical not only of the sculptor but equally of the Tuscan artist. No greater difference from the working-methods of contemporary Venetian masters is conceivable. A sheet of free sketches in the Albertina is probably the work of Michele Giambono (fig. 9), who was active in the Serenissima Republica in the early 15th century. There is no similarity even compositionally. While the Lombard Michelino is chiefly concerned with the solution of the artistic problem in terms of rhythm and flow of movement—as were Stefano da Zevio and Pisanello—Ghiberti concentrates on lucid geometric organization and on clear distribution of the individual figures, which are placed in invisible compartments. The Venetian Giambono, on the other hand, arranges his figures according to a kind of visual balance, one might say by weight: the richly draped figure moving towards the left stands in a live relationship to the white of the blank paper at the right. Giambono's concern lies not with the beauty of line, as shown by the impulsive freedom of his stroke, nor with the immediate communication of meaning and movement: his primary interest is the disposition of masses of light and dark—of color values that retain their effect even in the merely suggestive form of a free graphic translation into black and white. This must be understood before the quality of the sheet, which otherwise would seem impaired by an absence of organic order, can be fully and readily appreciated.

Bernhard Degenhart, the great authority on early drawings, was the first to recognize and describe the characteristically different graphic styles of the various regions of Italian art. In an important paper he showed the constancy over centuries of the basic approach to artistic problems by graphic means in the most important art centers—an effect similar to the continuity of local accent and way of life basically distinguishing the inhabitants of different cities. External forms may alter with ever-changing circumstances, but fundamental behavior remains the same.

In the period shortly after 1400 there was a flowering of drawing in all of Italy and especially in the Northern art centers. Leading this development were the artists poised on the threshold between the late Middle Ages and Renaissance, with Pisanello as the greatest genius emerging from this transitional period. Of the founders of the early Renaissance, hardly any drawings have survived. There is no entirely certain drawing by Masaccio; only recently was an impressive sheet attributed to Donatello by Degenhart and Schmitt; a group of drawings that they linked with this sheet will need further critical examination.

Of the Florentine masters of this early generation, the Albertina's chief possession is Fra Angelico's marvellous Crucifixion, in the tradition of miniature-painting (Pl. 10); this is a work characteristic of his early years, which in spite of the delicate drawing, still related to the International Style, already reveals early Renaissance spirit both in the clarity of form and color and in the free, individual expression of religious feeling. The artistic message conveyed in pages from a Tuscan sketchbook (Pl. 7 & 8) appears less free. Vasari's attribution to Uccello is untenable in the face of undoubtedly established sheets characterized by clear geometric certainty. On the other hand, the large head studies to which Degenhart and Schmitt recently drew attention, although they are not very well preserved, may more likely be by that master.

The zenith of the development of drawing in all parts of Italy was reached only in the second

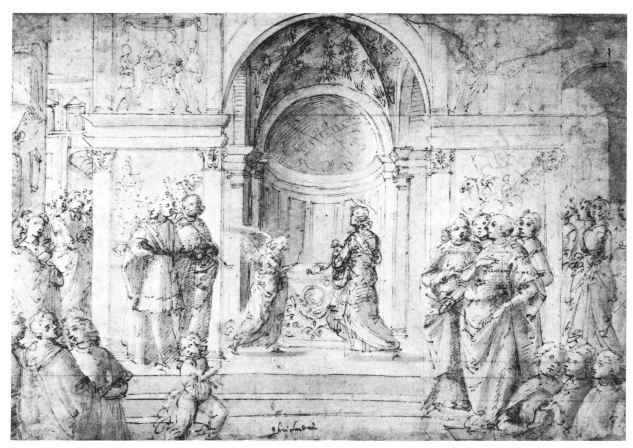

10. Domenico Ghirlandaio. *The Angel's appearance to Zachariah in the temple.*

half of the 15th century. The Albertina collection contains but a small share of the vast treasures of Florentine graphic works that are listed in Berenson's monumental publication. Pl. 11 is a fine example of the concentration on beauty of contour that is to be found in a number of artists after the middle of the century: in graphic art, particularly in the two Pollaiuolos. Our sheet, however, is closer to Alessio Baldovinetti. A drawing by the important sculptor-architect Giuliano da Sangallo (Pl. 15), whose figure studies distinctly approach Botticelli, embodies something of the fluid grace of that great Florentine master of rhythm. Verrocchio's workshop, like that of the Pollaiuoli, was one of the most productive in the domain of Florentine art. His own drawings are extremely rare, but his pupils belong to the most prolific painters and draughtsmen. The central position is occupied by Leonardo, who far outreached his teacher. Drawing, to him, appears to have been the arch-element of his creative power and scientific thinking. Drawing translated his deep knowledge of the world's vital forces into visible reality. His genius was concerned with the laws of mechanics, the dynamics of atmosphere and water, the growth of plants, and the animate movement and structure of living bodies, human and animal, as well as with the inner life of man, revealing itself in the various types and the emotional expression and actions of his figures. Of the wealth of his studies, mostly preserved in the Royal Library at Windsor Castle, only a small section, unfortunately, has reached the Albertina. The marvellous study of an Apostle (Pl. 12) for his chief work, the Last Supper

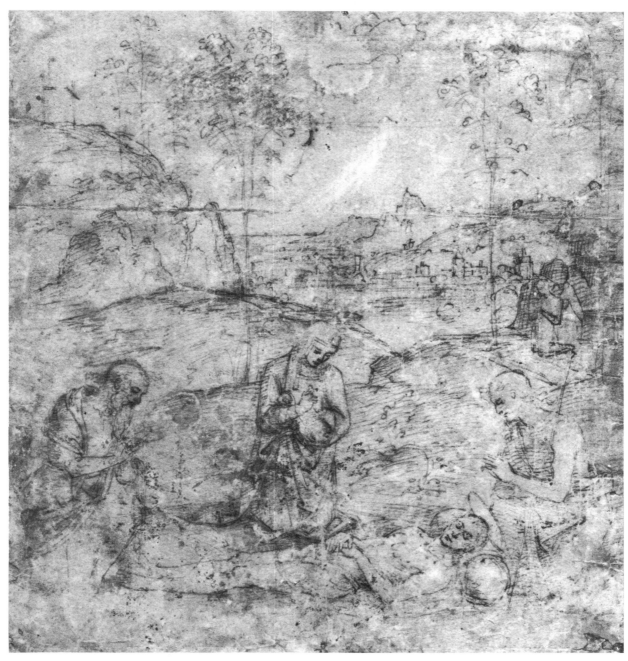

11. Pietro Vannucci called Perugino. *Christ mourned by the Madonna and Saints.*

in Milan, nevertheless illustrates the powerfully heightened idealization of expression and rich endowment with life in his figures.

A reflection of the gentle works of his early period and their delicate loveliness appears in a drawing by Lorenzo Credi (Pl. 13), which indeed once was attributed to the great master himself. Something of that subtle shimmering light is present also in works by other contemporary Florentines, for instance Raffaellino del Garbo (Pl. 36).

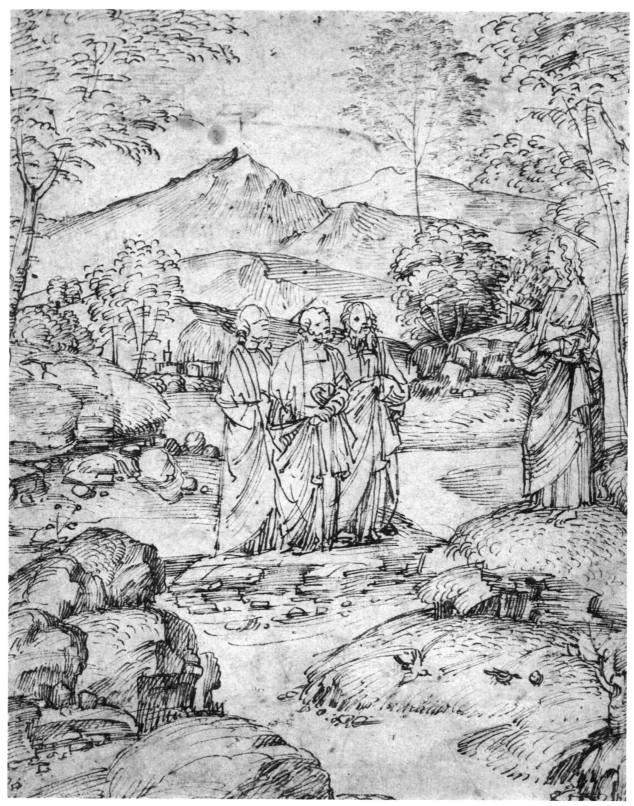

12. Marco Basaiti (?). *Christ talking to three Apostles.*

Domenico Ghirlandaio, by contrast, attracts through monumentality in his architectural construction, clarity in his composition, and substantiality of his figures. The Albertina owns, among others, a preliminary drawing for the large fresco cycle he painted in the choir of S. Maria Novella. Like other drawings by Ghirlandaio, this study, the Annunciation to Zacchariah (fig. 10), shows the Florentine master's eminent faculty of concentration, almost a tendency toward geometrical abstraction, on the essential functions of movement or drapery, and his typically Florentine use of sharp contrasts of light to emphasize the plastic structure of the figures. The elaboration of details, including the portraits, which even at this stage are partly inscribed with names for identification, is left to subsequent studies. It is not surprising that this school of geometrical, functional lucidity was to become so important to the development of Michelangelo's sculptural style in graphic art.

Among his pupils, Verrocchio included the actual founder of the Umbrian school, Pietro Perugino, teacher of Raphael. In Perugino's drawings (fig. 11) the conscious emphasis on activity and the flickering quality of light are abandoned in favor of a calm presentation of static figures in still contemplation, embedded in a wide landscape. His principal object is the quiet integration of the body into spatial relations. The contour is not thought of in its embracing function, but rather conceived as a means of indicating figural volume by rounded lines. Richly curved hatching, most often forming a dense network of crossing lines, models the figures by creating atmosphere around them as a way of incorporating them into the natural whole of surrounding space. Raphael later was to develop every aspect of this Umbrian-Roman style to its full potential.

In Northern Italy, the leading master was Andrea Mantegna. Few remained immune to his influence. In his own schooling he received not inconsiderable impulses from Florentines like Donatello, who worked in Padua. It was from this source that he derived the concept of clear construction in perspective, powerful plastic modelling, and highly dramatic action. But he combined these ideas with the static light- and color-scheme originating in the Venetian-Byzantine tradition. Through the resulting effect, virtually freezing all movement, action and expression seem to be entirely bound within the plastic form. The light, setting off the figures from each other and the background in large masses and volumes, creates an aura of stony monumentality, which accounts for Mantegna's affinity for antique sculpture; his drawing reproduced here is in fact a study after a classical relief (Pl. 16). He is not concerned with the sensual splendor of objects but with the glow of the color-substance on the painted panel, and with the beauty of linear structure in his drawing. Hence, the incredible precision of the parallel hatching, with its rich potential for capturing light, and the utter refinement of the graphism, which made him the most important draughtsman in Northern Italy.

The portrait head by the Veronese Bonsignori (Pl. 18) is entirely under Mantegnesque influence, while in the drawing of Bartolomeo Montagna, the principal master of Vicenza (Pl. 17), there is a quality of softer light gently playing about the figures in the manner developed meanwhile in Venice by Giovanni Bellini (who himself had been influenced by Mantegna in his youth). More Venetian in character and freer in the play of light, though using similar means, is the anonymous Portrait of a Youth (Pl. 19), which reveals the impact of the great South Italian Antonello da Messina, through whom the achievements of Netherlandish art had been transmitted to the Venetians. Quite alienated from Mantegna's stony world is a drawing that has tentatively been attributed to Marco Basaiti (fig. 12). It is already entirely under the influence of Bellini's landscapes that unfold in

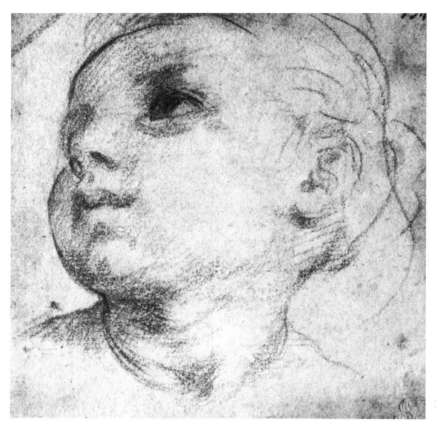

13. Andrea del Sarto. *Head of the Infant Jesus.*

light and color, and into which figures are placed in a manner essentially different from Perugino's plastic volumes in a wide, still space: they appear as patches of light and color correlated to other masses of light and shade, which are in turn interrelated as spatial phenomena by gentle contrasts.

The drawing by Ercole de' Roberti (Pl. 20) also originated under Mantegna's influence, but pervading the entire concept of the image is a free rhythmization of the figure, which is elongated, expressively pointed, and without the great teacher's petrification. Flowing light indicates a greater sense of mobility which serves to mirror inner life. Feeling for surface charm and for plastic modelling of the body in space clearly reveals itself in the sheet by Francesco Francia, created later in Bologna (Pl. 22). One senses the artistic connection between Bologna and Perugia that was to make Francia's greatest pupil, Marc-antonio Raimondi, such a perfect interpreter of Raphael.

Also Mantegnesque in the widest sense is Bramantino's figure of Christ (Pl. 23). It certainly embraces something of the great Paduan in the constantly interrupted outline, which is entirely determined by the emphatic light. But here again a different solution is aimed at. The gentle radiance extending over the broad form of the body makes for ethereal softness and an image seemingly wrought of light alone, which in its almost sweet ideality is typical of the concept of art in Milan.

The 16th century brings new freedoms, not only to painting and sculpture, but also to drawing. Figures begin to separate from the background to move in factual space that has lost its problems and take their place in organic compositions. The artist has risen to

38

a new degree of mastery in dealing with the elements of the visible world and with his materials so as to be able to realize his ideas in a convincing, natural-looking way.

In Florence, Michelangelo formed his sculptural style on the basis of Ghirlandaio's technique of cross-hatching (Pl. 24 - 27). In a typical Florentine manner, his figures remain bound up within their contours, almost isolated in the expanse of the sheet, while contrasting with the background as monumental, though finely structured, blocks of immense weight. Michelangelo's delineation of body- and drapery-surfaces is supreme; a true sculptor, he invariably began at the lightest spots, on a plane closest to the spectator, to work his way progressively deeper into the shadows where the body recedes from view. Not one of his many imitators ever equalled him in intensity of observation and draughtsmanship. Their effects, however virtuoso in presentation, remain superficial, as in the nude studies by Baccio Bandinelli (fig. 15), his rival for Florentine state commissions. Only Raphael occasionally found a true access to the greatness of his art.

Unlike Michelangelo, who concentrated mainly on substantial figures, Fra Bartolomeo strove in his paintings for compositional harmony to make his figures part of a greater entity. The Albertina owns several of his single studies, which in their spirited approach indicate wider connections. Fra Bartolomeo took over Leonardo's verve of line and, particularly, the extensive range of chiaroscuro, which plays over Fra Bartolomeo's figures in rich contrasts, giving high drama to his sketches (Pl. 29). His landscape studies similarly show an enchanting delicacy in the observation of light that heightens natural forms to almost abstract clarity (Pl. 28).

Andrea del Sarto differentiates light and form in a manner that is positively paradigmatic for Florence by using groups of parallel straight lines that effectively dissect the surface into geometric components (Pl. 30). His graphic penetration of substance would suggest the austerity of carved wooden figures, if there were not an animation from within and a play of light and shade, keeping the surface in constant movement. Andrea del Sarto is almost unsurpassed in his mastery of the glowing tones of red chalk, a material especially receptive to the instantaneous force of light (fig. 13).

The next generation, like del Sarto's pupil Rosso Fiorentino, who later worked at the French court in Fontainebleau, went still further in the geometric dissection of form (fig. 14). Rosso and most of his contemporaries, commonly labelled "Mannerists" today, were less interested than their predecessors in the exuberant development of form and the sensual interpretation of surface, but more truly concerned with the functional principles of the plane, as well as with the abstract or direct, and usually very individual, expression of ideas; thus, in the evolution of their concept, stylization reached greater extremes than was ever attained by the High Renaissance masters. Similarly, in the work of Baccio Bandinelli, the authoritative formula of line is derived largely form a geometric and formal point of view; this—in combination with a certain self-indulgence—brings forth in his figures an element of emptiness and vanity that tastes of virtuosity seeking admiration for its own sake (fig. 15).

From the beginning of the 14th century and even earlier, a variant of Tuscan art had developed in Siena, close to Florence. Although Siena's political and artistic significance declined from the latter part of the century, it continued to produce artists of great attractiveness and charm. One of its natives who ranked among the most important architects of the High Renaissance and also won prominence as a painter was Baldassare Peruzzi (Pl. 32); however, he worked mostly in Rome. To the end of his career his delicate, nervous figural style, incorporating much of the antique spirit, remained linked—in a

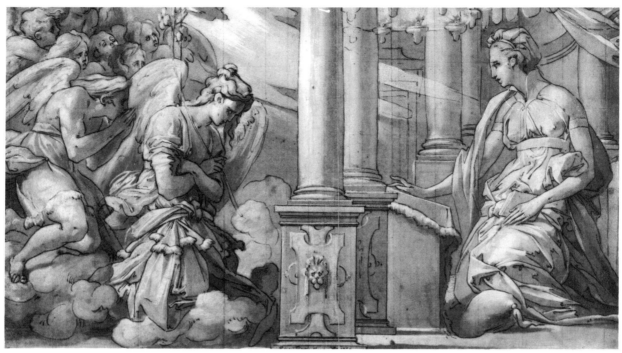

14. Il Rosso Fiorentino. *The Annunciation.*

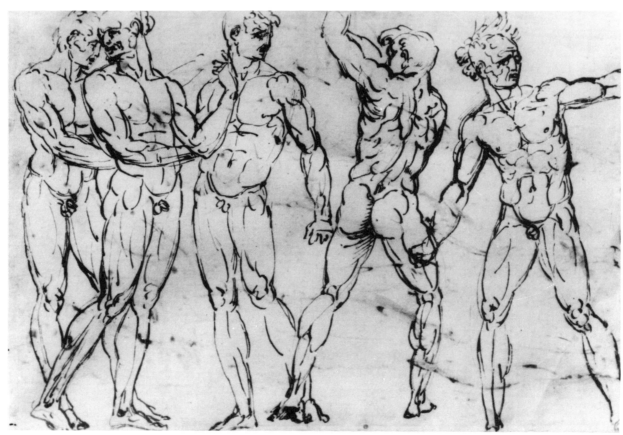

15. Baccio Bandinelli. *Five Male Nudes.*

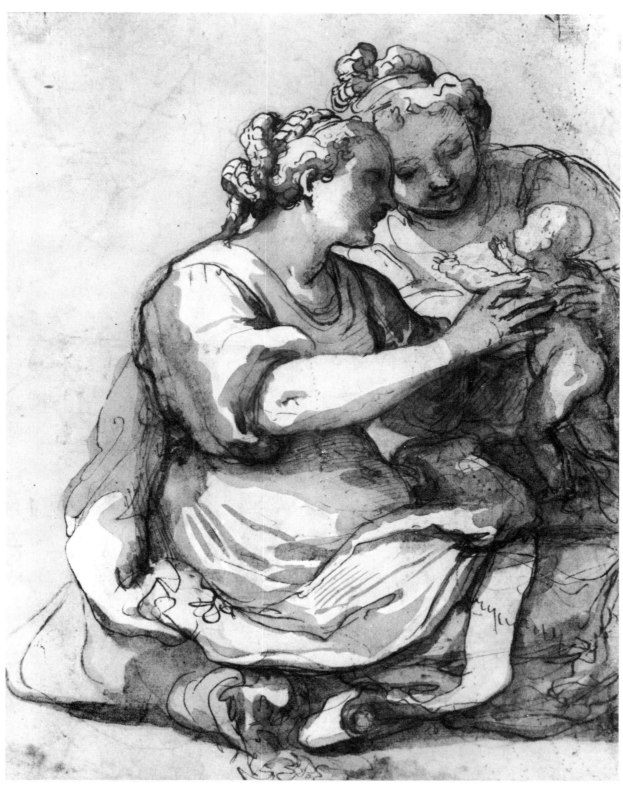

16. Taddeo Zuccari. *Two Women with a Child.*

way—to the sophisticated and knowledgeable work of Francesco di Giorgio, his great teacher. With less sense of scale than his Florentine contemporaries, Peruzzi cultivated a graphic style of abandonment to extravagant, playful hoops and whorls, appropriate to his decorative tendencies. Possibly the most important personality in 16th-century Siena was Domenico Beccafumi (Pl. 33). He went further than any other Tuscan in creating effects of oscillating light that in a nearly abstract way dissolved plastic form into chiaroscuro contrasts. Thus his figures, whether ascetically frail or, as sometimes under the influence of Michelangelo, athletically powerful, seem to be of an almost immaterial corporality. In contrast to the hard geometry of Tuscan drawings, Raphael's Umbro-Roman art tends toward a full, free display of rounded form in a setting charged with tension (Pl. 34-41). His fluid, differentiated, flexibly swelling or contracting line is capable of producing volume by the outline alone. Light and shade strive to emphasize the figures' plastic harmony and to create atmosphere around them, thus supporting their space-conscious pose and gesture. Geometric clarity with Raphael means clarity of a cosmo-dynamic, stereometric quality. Much of the freedom of movement and vitality in his imagery came to him from Leonardo, much of his figures' sculptural monumentality from Michelangelo, but he always translates Florentine vision, close to abstraction, into more sensual terms, corresponding to the gentler, lighter, more undulating character of Latian landscape. The tendency to rounded, organic form also distinguished his pupils, who were streaming to him from every part of Italy and later were dispersed to all quarters when the Sack of Rome in 1527 finally destroyed the flower of Roman High Renaissance civilization. Giulio Romano, whose style also received impulses from antique reliefs, showed his talent in an infinite stream of gracefully animated figures (Pl. 42); the Lombard Polidoro da Caravaggio, structuring his figures mainly in light and shade, tried to give them a more compact plasticity (Pl. 43); the Florentine Perino del Vaga endowed his abstract figures, though antique-minded in the Roman way, with the most impressive rotundity (Pl. 44). Of these masters of Raphael's Roman circle, the Albertina has an abundance of representative drawings.

Around the middle of the century, the artistic scene in Rome was strongly dominated by Florentine artists, most important among them Francesco Salviati and Giorgio Vasari (Pl. 45). In contrast to the more elegant or expressive artists of the preceding generation, these brought a broader two-dimensional development of the figure, deactivating it by a certain weightiness and defining it without truly convincing depth. In Vasari's case, the abstract character of the Florentine line, mainly concerned with surface pattern, is particularly plain. However, Taddeo Zuccari, who like Raphael came from the Marches, restored Roman volume (fig. 16) in vivid, softly rounded lines and washes, producing an atmosphere of fluid light. Even his brother Federico's more abstract and intellectual designs have to a degree this sense of organic Roman composition and a genuine feeling for the connection between figures and space. His predilection for a combination of red and black chalk gives a special attractiveness to many of his sheets. The delicacy and weightlessness of his figures is typical of the generation that followed Salviati's and Vasari's. The most refined master was Federico Barocci. He had come from the Marches to create his first great pictures in Rome and returned to Urbino to supply all Italy with his paintings. His work shows the confluence of diverse trends: Roman feeling for large, substantial form in free spatial development forms a counterpart to the North Italian tendency toward animating, freely flowing light, a quality he had acquired mainly from Correggio. Barocci's volatile compositional studies (Pl. 48) and his pastel studies of indi-

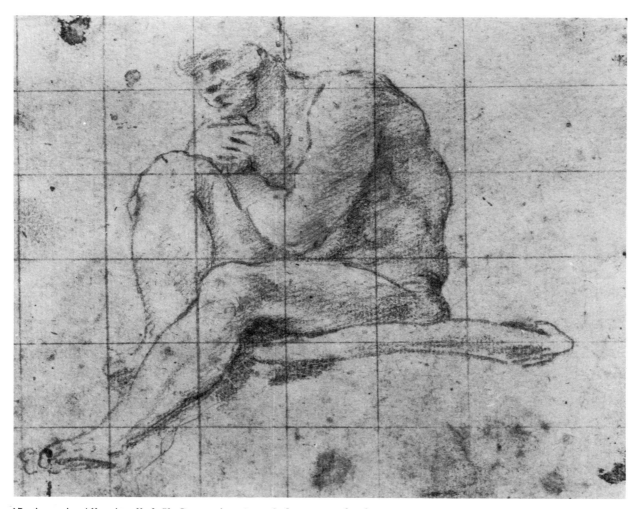

17. Antonio Allegri called Il Correggio. *Seated figure on clouds.*

vidual heads, probably stimulated by Lombard influences, are well represented in the Albertina through a group of fine sheets that belong to the most attractive products of the late 16th century and indeed have inspired many artists. The Albertina's rich holdings in Roman and Tuscan Mannerism cannot, unfortunately, be considered here.

Parma was one of the art centers that developed a high rate of creative activity in the early 16th century, following a lengthy period of oblivion. Like Rome a meeting place for artists from the most diverse schools, Parma nevertheless gave rise to a style of its own, marked by expressive sensitivity, gracefulness, and a feeling for fluid animation. It was to have long-lasting effects on European art, just like larger centers such as Florence, Rome, and Venice.

The Albertina owns only a single sheet by the founder of this school, Antonio Allegri, commonly called Correggio. It comes from his more mature period, when he already had absorbed the lessons of Roman art (fig. 17). His figural style shows no trace of his training with Mantegna. Yet evidence of connection with Mantegna and of links to Venetian circles distinctly appears in the specific manner of his drawing. There are those hesitant outlines and the balancing of separate elements that derive their modelling only through

18. Luca Cambiaso. *God the Father among Angels and Clouds.*

static patches of light and dark. A sumptuous play of light and shade gives his figures a high degree of animation in close relation to the expression of emotion.

Parmigianino's drawings also reveal some of this North Italian feeling for harmoniously balanced masses of light and shade, and for outlines that, rather than denoting boundaries, themselves play a part in the scheme of light and dark. However, Degenhart is surely correct in suggesting a connection between his streaming lines and gliding light that embrace and circumscribe plastic volume, and the concept of early North Italian art, as

44

represented by Pisanello or even Michelino da Besozzo. There is also a certain urgent quality of corporeal design, probably of Emilian origin—a style often noticeably related to the Umbrian-Roman sphere which so greatly attracted Parmigianino.

No wonder that Parmigianino, along with Raphael's pupil Giulio Romano, strongly influenced the eminent Bolognese Francesco Primaticcio (Pl. 57). In Primaticcio's art, the facility and grace of Parmigianino combine with the inherent, more intensive sensuality of both Bologna and Rome. Working chiefly in Fontainebleau, Primaticcio of course received inspiration from Rosso, the great Florentine. Nicolò dell'Abate (cf. Pl. 58), on the other hand, kept closer links with Parmigianino, but in him we also find that tendency to more strongly modelled form and greater surface sensuality characteristic of the art of Bologna, which is itself a mixture of many other influences.

Parma lies between Bologna and Milan. In Milan, even after Leonardo's departure about 1499, abundant artistic activity continued. The subtle, ethereally delicate style that had always been typical of the masters from this region is evident even in the work of Andrea Solario, who adopted a feeling for forceful modelling and sensitive surface from 15th-century Venice, and also owed impulses to France, then under Netherlandish influence (Pl. 51). The Milanese ideal is visible at its best in the superb light and the delicate coloring of Bernardo Luini's magnificent Portrait of a Young Lady (Pl. 52), an image that seems to be formed of filmy clouds. Even the antiquarian style of the late 15th century, so frequently bizarre, becomes airy and colorful in Milan, as in the fireplace design by the sculptor Bambaia (Pl. 50), who in his deeply incised drawing of the architectural ornament aims chiefly for the play of light, disembodying the stone.

The great port city of Genoa, to which important artists from all parts of Italy came to work temporarily, produced only one graphic artist of significance in the 16th century, the renowned Luca Cambiaso (fig. 18). His characteristic talent for reducing and transposing plastic volume into simple geometric forms and clear lines must have won him a wide reputation as an exemplary draughtsman, for even in the 16th century his sheets were frequently copied. To our century, he appears as precursor of contemporary tendencies.

Italy's other great maritime city, Venice, on the other hand, was one of the leading 16th-century art centers and an important witness to contemporary developments, even though very little has survived of the major masters' work from the first half of the century. There is one verified Giorgione drawing, the incredibly luminous sheet in Rotterdam, while one in Windsor Castle is at any rate connected with an authentic painting. Perhaps there are still other sheets belonging to him. Unfortunately, the Albertina has no work by this great magician, unequalled in the beauty of his moody landscapes and in the classic homogeneity of his calm, contemplative figures. Titian's drawings are also rare, numbering perhaps fifty—if that. The Albertina counts among its treasures no more than two sheets, of which one is attributed here for the first time to the master (Pl. 60). It is a perfect example of purely pictorial concept, of modelling achieved solely on the basis of color-values indicated in patches of light and dark. Such a drawing instantly evokes a sensation of color heightened into glowing splendor. Rarely has the Venetian character been as explicitly expressed as in the drawings of this greatest of all masters. Strangely enough, Domenico Campagnola, who owes so much to Titian (Pl. 61), in his basic outlook, displays a certain affinity with Florentine art. Perhaps an influence came through an early contact with drawings by Leonardo da Vinci, whose stay in Venice on his flight from Milan in 1499 also left a deep impression on Giorgione. Campagnola worked mainly in Padua, where Titian had executed frescoes in his youth.

19. Giovanni Girolamo Savoldo. *Resting Pilgrim.*　　20. Girolamo da Treviso. *The Archangel Gabriel.*

However, the influence of Titian and Giorgione reached farther, spreading over almost the entire eastern area of Northern Italy. One of the great masters of the Veneto, in fact the most dramatic painter of the area, was the Friulian Pordenone, who liked to think of himself as Titian's rival. His sumptuous line, restless and often aggregating to create dense areas of light and shade, mirrors something of the nervous but energetic character of his figures (Pl. 62). Pordenone, whose blood-relationship to Lombardy is expressed in his intense feeling for the mobile play of light, is, so to speak, the opposite of Girolamo Savoldo, the most important master of Brescia (fig. 19). Characteristically represented in his work are Venetian monumentality and weight, combining with Lombard interest in nature, as well as Venetian pleasure in glowing color, related to Lombard feeling for the fleeting quality of light. His powerful figures, drawn from observation of life, are filled with a dark fire as they emerge from deep-colored backgrounds, often dressed in robes of a strange, silky sheen. The figure of a pilgrim in the Albertina (fig. 19) is a perfect example of the translation of this technique into black and white chalk, while the greenish background proves an important factor in the setting of mood.

46

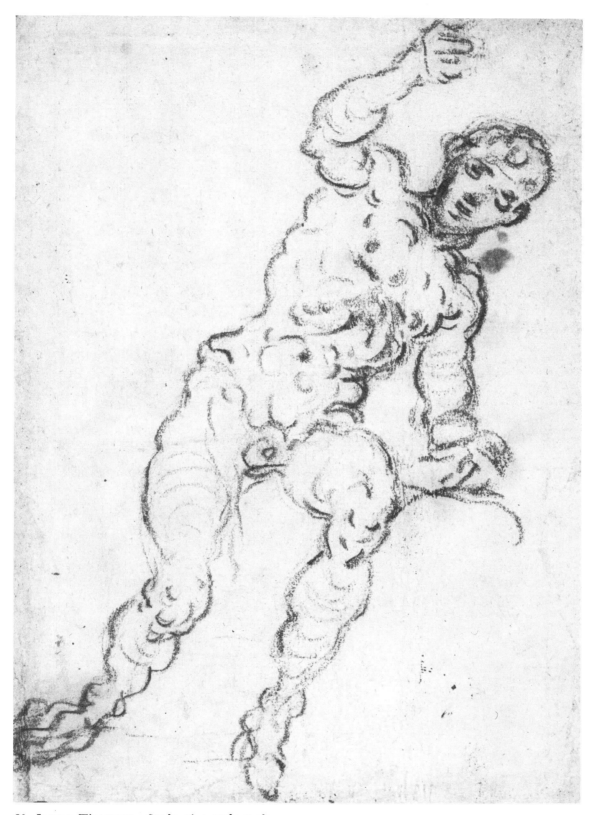

21. Jacopo Tintoretto. *Study of a male nude.*

Roman and Bolognese, Florentine and Parmesan influences cross intensely in the Veneto in the middle of the century. Adding to the scene are itinerant artists no longer recognizable as Venetians at all, like Girolamo da Treviso, who spent a large part of his life outside his native region, chiefly in Bologna, where he came under the influence of an imitator of Raphael, Innocenzo da Imola. His strange drawing of the Archangel Gabriel (fig. 20) is a typical example of Raphael imitation in Northern Italy. The Slovene Andrea Schiavone, chiefly influenced by Parma, repeatedly appropriated inventions of Parmigianino as well as of Raphael for conversion into Venetian style. Jacopo Bassano did not remain unaffected by "Mannerist" tendencies, nor did Jacopo Tintoretto, or, for some brief instants, even Titian. However, Bassano's Head of an Apostle in the Albertina (Pl. 64) remains a monument to Venetian graphic art in its interwoven construction of glowing color. Tintoretto's strongly modelled nudes (fig. 21), even though intended as graphic work, appear to be built up of separate color patches, merely indicated by rounded hooks. In spite of his studies after Michelangelo, nothing could be in greater contrast to Florentine drawing, with its straight, continuous line. Tintoretto, not surprisingly, was one of the first to draw in oils on paper, a technique particularly cultivated by his son Domenico. The splendid Portrait of a Woman in the Albertina, nevertheless, may ascribe to the greater talent of the father (Pl. 65).

Among the different centers of the Veneto and its surroundings—Padua, Bassano, Brescia and Cremona—nearby Verona has a special place as the native city of the master who, in his old age, along with Tintoretto and Titian, clearly dominated Venetian art in the second half of the 16th century: Paolo Veronese. He too drew inspiration in the Veneto around the middle of the century from the confluence of the most diverse trends. No lesser artists than Parmigianino, Giulio Romano, and Nicolò dell'Abate, in equal measure, affected the formation of his style, which relies essentially, however, on the harmoniously balanced interrelation of patches of light and shade. His greater lack of weight and the fluid quality of his light are traits that, as Degenhart saw, recall the delicacy and the magical light of an earlier great artist from Verona: Pisanello. Like Schiavone, Veronese belongs to the handful of artists in the Venetian territory who created drawings as independent works of art (Pl. 66). We know little about his other contemporaries in Verona, by whom the Albertina has a group of interesting sheets. To mention a single example, Battista Angolo del Moro, hardly known even to connoisseurs, endowed his drawings with fascinating charm by his gentle tonality (Pl. 68). Thus, the Albertina still offers the art-lover rich opportunities of discovering new treasures among the superb sheets by well-known and less well-known Italian masters, of whom the 16th century produced so large a number. In the small selection presented here, we could not hope to capture the entire range of Italian artistic dialects or every personal idiom.

KONRAD OBERHUBER

48

(8) Michelino da Besozzo, verso of Pl. 3.

(9) Michele di Taddeo Bono, called Giambono. Documented Venice 1420-62. Saint Christopher (verso). Pen and brown ink, white paper, 199 x 134. Coll. Luigi Grassi, L 1923, V 15, Inv. 24017; Tietze 1944, no 702; Benesch 1961, no 2. Attribution by Stix on the basis of a comparison with the Polyptych in the Accademia in Venice and the picture in the church of S. Trovaso in Venice.

(10) Domenico Ghirlandaio (Florence 1449 - 1494). The angel appearing to Zacchariah in the temple. Pen and brown ink, wash, 257 x 374, inscr. Giuliano, Giovanni Francesco. More recent inscr. Ghirlandaio; coll. Mariette, L 2097; Fries L 2903; R 26; Inv. 4860; S.R. 102; Benesch 1962, no 9. Design for the fresco in the choir of S. Maria Novella.

(11) Pietro Vannucci, called Perugino (Castel della Pieve, documented Perugia 1475 - 1523 Fontigano). Christ mourned by the Madonna and Saints. Metalpoint. Pen and brown ink, yellowish prepared paper, 220 x 197; R 37; inv. 34; S.R. 38.

(12) Marco Basaiti (?) (documentable 1500 - 1521). Christ talking to three Apostles in a landscape. Pen and brown ink, white paper, 257 x 197; inscr. Jean Bellin; V 22; inv. 1455; S.V. 15; Tietze 1944, no 353; Benesch 1961, no 7. Attribution by Wickhoff on grounds of comparison with pictures.

(13) Andrea d'Agnolo di Francesco, called Andrea del Sarto (Florence 1486 - 1531). Head of the infant Jesus. Red chalk, white paper, 122 x 106; R 126A; inv. 17627; P. Pouncey, Burlington Magazine XCV 1953, p. 97; Berenson, no 106A; J. Shearman, Andrea del Sarto, Oxford 1965, p. 384; preliminary drawing for the Madonna de' Medici.

(14) Rosso de' Rossi, called Rosso Fiorentino (Florence 1495 - 1540 Fontainebleau). Annunciation. Pen and brown ink; wash, white heightening, white paper, 256 x 442; S.R. 503; inv. 415; E.A. Carrol, Burlington Magazine 103, 1961, p. 453 f. Preliminary drawing for the engraving by René Boivin, R.D. 5.

(15) Bartolomeo Bandinelli, called Baccio Bandinelli (Florence 1493 - 1560). Five male nudes. Pen and gall-apple ink, 422 x 279, R. 213v, inv. 130; S.R. 165.

(16) Taddeo Zuccari (S. Angelo in Vado 1529 - 1566 Rome). Two women with a child. Red chalk, pen and brown ink, wash, accents in black chalk, 304 x 233, S.V. 301, inv. 1711; J.A. Gere, Taddeo Zuccari, London 1969, no 246. Attribution to Zuccari by John Gere, based on comparison with other drawings. Probably a preliminary drawing for a Birth of the Virgin.

(17) Antonio Allegri, called Correggio (Correggio 1489 - 1534). Seated figure on clouds. Red chalk, grid, 138 x 162, B. 351, inv. 238, S.R. 288; A. E. Popham, Correggio's drawings, London 1957, no 11, Study for an Apostle, commonly thought to be St. Paul, in S. Giovanni Evangelista in Parma.

(18) Luca Cambiaso (Moneglia 1527 - 1585 Madrid). God the Father among angels and clouds. Pen and brown ink, wash, white paper, 270 x 250, S.L. 174; inv. 2742.

(19) Giovanni Savoldo (Brescia before 1480 - 1548 Venice). Resting Pilgrim. Black and white chalk on green-grey paper, 273 x 168, V 52, inv. 22982; Tietze 1944, no 1418; Benesch 1961, no 30.

(20) Girolamo Pennachi, called Girolamo da Treviso (1499 - 1544 Boulogne). Archangel Gabriel. Pen and brown ink, white wash heightening, grey-blue paper, 379 x 231, Coll. Gelosi, L. 545; V. 99. Inv. 1516; S.V. 92; Tietze 1944, no 745; Benesch 1961, no 24.

(21) Jacopo Tintoretto (Venice 1518 - 1594). Study of a male nude. Charcoal, white paper, 328 x 227; inscr. G. Tintoretto; Coll. Sir Joshua Reynolds, L 2364, V. 90; inv. 24475; Tietze 1944, no 1752; Benesch 1961, no 35.

SEICENTO AND SETTECENTO

A hundred years ago Moritz von Thausing, scholar and director of the Albertina, characterized the drawings department of the collection in the following words: *"Ce n'est pas le chiffre si respectable de 16,000 dessins, et ce n'est pas le choix si judicieux de ses pièces qui assignent à l'Albertina ce rang éminent, c'est encore la proportion vraiment étonnante qui règne entre les différentes écoles."* (Gazette des Beaux-Arts, 1870-71).

Today the Albertina's drawings number approximately 40,000, but that harmonious balance within the body of the earlier works is still preserved. This particularly applies to the Italian drawings from the schools of the 17th and 18th centuries which the Duke acquired from contemporary or earlier collections, such as those of Mignard, Crozat, Mariette, Lempereur, the Prince de Ligne, Fries, and others.

These schools are extraordinarily well represented. Even if a particular master is not well represented, any lack is amply compensated by the wealth of works by contemporaries, students and followers that reveal his spirit. Think of Lorenzo Bernini—does not the enormous stock of more than 500 drawings by his great rival Francesco Borromini, bought by the Vienna Court Library from the estate of Philipp Baron von Stosch, the learned scholar, in 1757 and incorporated into the Albertina in 1920—provide an equivalent? Certainly there are collections with a greater number of Italian Baroque drawings. At the same time, these collections may hold a larger volume of works by individual artists. In some cases, numbers will reach the hundreds, or there may be complete or partial artist's legacies, as in the collection in the Royal Library, Windsor Castle (Carracci, Domenichino, Maratta, Castiglione, Ricci); the Uffizi (Cortona, Franceschini, etc.); the Louvre (Carracci); the Kunstmuseum in Düsseldorf (Sacchi, Maratta, Gaulli, and Guglielmo Cortese); the Academy and the Correr Museum in Venice (Ricci, Tiepolo, Longhi, Guardi); and the Academy San Fernando and the Prado in Madrid (Maratta). But the Albertina's more than two and a half thousand sheets of Baroque drawings can hardly be bettered for quality, meaningful choice or completeness.

The first arrangement in catalogue form was due to Franz Wickhoff, whose work also dealt with Italian drawings of earlier schools: it was one of the first catalogues in this field and a model of organization and of the evaluation of traditional attributions. Wickhoff's catalogue, published in the 1891-1892 volumes of the *Jahrbuch der Kunsthistorischen Sammlungen des Allerhöchsten Kaiserhauses*, became the basis for subsequent illustrated catalogues by Alfred Stix, Lili Fröhlich-Bum, and Anna Spitzmüller, but in the grouping of the schools these depart from Wickhoff, who had still followed traditional usage. Numerous important sheets, relegated by the authors in an excess of critical or subjective judgment to the ranks of minor works that otherwise comprise old copies or imitative derivations, are missing from the illustrated catalogues; we shall nevertheless mainly refer to these (BRV) in the observations that follow.

Almost each of the works shown here stands for a group of its peers by the same or, often, by a similar artist, equally well represented in the collection but not yet, or no longer, as celebrated as his "stand-in." This selection emphasizes the collection's high-spots and strong points, but even scholars and connoisseurs may make some new discoveries.

51

The art of the Baroque is distinguished from that of the late Renaissance and the Mannerist period by the deliberately readopted and intensified observation of life, as well as by the new appreciation of direct visual experience that had developed during the final decades of the 16th century in and outside Italy and especially in the Netherlands. These studies were most effectively pursued in the studios of the Carracci—the *"Accademia degli Incamminati"* founded in 1585 in Bologna—and a little later by Caravaggio and his pupils in Rome and Naples, although in the freer form which characterized these circles. At first these groups, both Lombard in origin, resembled each other in this aspect, but their encounter in Rome revealed and increased the differences in their ideas.

The Carracci followed the principle previously laid down by Lomazzo in the period of Mannerism—that of "art selecting from life"—even if they followed it more loosely and liberally. Giulio Mancini (Siena 1558-1630), contemporary amateur of the arts, historiographer and physician to Pope Urban VIII writes: *"Questa ha per proprio l'intelligenza dell'arte con gratia et espression d'affetto, proprietà e composition d'historia, havendo congionto insieme la maniera di Raffaello con quella di Lombardia, perchè vede il naturale, lo possiede, ne piglia il buono, lascia il cattivo, lo migliora, et con lume naturale gli dà il colore, e l'ombra, con le movenze e gratie."* (I, p. 109).

This principle was to become the guideline of all Academicians, to be codified by Pietro Bellori and, a century later, in terms of Neoclassicism by Johann Joachim Winckelmann. Caravaggio deliberately rejected the law of selection of the "Good and the Beautiful"; Bellori called him a *"fido, unico imitatore della natura che non riconobbe altro maestro che il modello, e senza elletione delle migliori forme naturali."*

Together with a fresh look at life came a revaluation and partial reinterpretation of the concept of "disegno"— regarding both outline delineation and interior drawing, as modelling the plastic form in the sense of Woelfflin—a concept ruling in Rome and Florence since the days of Cennino Cennini. Such revaluation also took effect in the intellectual, creative sense of what formed *"disegno interno"* (*"speculation divina"*: Benedetto Varchi), as distinguished by Federico Zuccari from *"disegno esterno,"* the visible, actual drawing, at the end of the 16th century (1).

Even the 16th-century Venetian art experts Paolo Pino and Lodovico Dolce never fail to point out the importance of the *"colorito"* besides *"inventione"* and linear, contour-giving *"disegno";* while earlier the Florentine Leonardo da Vinci, leaning toward interpretation of the North, rejected line as such, in both theory and practice. He would allow it only shaded in appearance, *"sfumato,"* but solved the problem in true Florentine style when he wrote: *"La linia non à in se materia o sustantia ma si può nominare più presto cosa spirituale che sustantia, e per essere lei così conditionata essa non occupa loco"* (Grassi, p. 17). In view of the working methods of the Lombards and Venetians, with their emphasis on light and color (*"sfumato"* and *"chiaroscuro"*), during the 17th century the terms *"macchia,"* *"schizzo,"* and *"abozzo"* (*"bozzo"*) came to acquire a formal significance almost equalling that of *"disegno."* Giulio Mancini, experienced observer and connoisseur, makes a clear distinction between the pictorial and linear way of drawing, that is, between *"disegno pittoresco"* and *"disegno scoltorio"* (Grassi pp. 31-59).

Marco Boschini, the admirer of Palma Giovane, unequivocally sided with the Venetian-Lombard point of view: *"Alcuni credono, che il Dissegno consista solamente nei lineamenti (come ho di già detto) ma io dico che i lineamenti sono bensì necessarij al Dissegno, ma bisogna valersene come fa lo scrittore della falsa riga, che sino che scrive, se ne vale;*

52

ma doppo hauer scritto, la getta da parte: poiché la pittura vuole essere rapresentata tenera, pastosa, come il naturale dimostra." (Grassi p. 37)

Boschini insisted on *"l'artifizio del chiaroscuro,"* and observed as a Venetian: *"ciò al colpo di penello s'aspetta nel colorire artificiosamente il naturale"* (Ricche Minere) and *"el colorito contiene in sé la macchia e il trato"* (Carta del Navegar pitoresco). In the dispute about *"disegno toscano"* and *"colore veneziano,"* which also included the terms light-and-shade (*"chiaroscuro"*), light (*"lume"*) and shade (*"ombra"*) that usually denote color values in drawings, the meaning of *"disegno"* applied to the realm of beauty and the idea, while *"colore"* was understood to characterize nature and reality.

Thus, from the beginning of the 17th century, the pendulum moved increasingly towards the pictorial concept, represented by *"disegno pittoresco"* and *"macchie,"* as even in Tuscany itself the *"disegno"* autothesis had time and again been put to test from the days of Leonardo and Raphael by artists such as Andrea del Sarto, Beccafumi, Salviati, Perino del Vaga, Cigoli, or Barocci and Zuccari, from Urbino.

To be sure, Florence continued to regard linear drawing as the basis of all creative work, as we hear from Filippo Baldinucci, the historiographer; Domenichino, the Carracci-pupil; Bellori, the spokesman of Classicism; and Carlo Maratta, who all, however, also gave the pictorial concept its due, in theory as well as in practice. But Ribera complained of Domenichino *"che non era pittore, perché non coloriva al naturale, ma solo un semplice e buon disegnatore."* (Passeri-Hess p. 60).

At the turn of the 17th century, Roger de Piles, partisan of the *Rubenistes* in France, explained: *"Les dessins touchés et peu finis ont plus d'esprit et plaisent beaucoup plus que s'il étaient achevés pourun qu'ils aient un bon caractère et qu'ils mettent l'idée du spectateur sur un bon chemin."* And elsewhere: *"Dans quelle partie est comprise l'intelligence des lumières et des ombres? Dans les coloris."* (Ivanoff p. XVIII and XIX).

The Carracci, as their contemporaries Agucchi and Mancini recognized at the time, played a connecting role in the rivalry between *disegno* and *colore* (2). Also, their artistic principles provided common ground for the two extreme viewpoints, as far as these could persist beyond the differing practices of the schools in that period of strong mutual stimulation and pronounced personal development. In this era, Domenichino was the most emphatic advocate of *disegno*, as Guercino was as defender of the picturesque concept, which explains Luigi Lanci's statement that the Carracci and their followers pointed the way for Italian painting over the next two hundred years. It was owing to their appearance that Florence and Venice lost their position of leadership in Italian art—leaving it for three decades to the Bolognese—and had to share it with Bologna, Milan, Genoa and Naples, or occasionally even with smaller centers. As in the 16th century, Rome with its flourishing art—*"quella Regia d'ogni arte più sublime"* (Baldinucci)—again played an important part. The Roman school proper, promoted by the Accademia di San Luca, which in 1577 had been formed by Titian's pupil Girolamo Muziano, came increasingly to the fore. And in Rome, foreign artists, working there for longer or shorter periods—the *forastieri* and *oltremontani*, including Netherlanders, Germans, Frenchmen, and Spaniards—began to play an ever more important role, as they also did in the other art centers.

The Carracci took an enthusiastic interest in drawing. They drew from life to exercise their skill and enlarge their experience and, as is reported of Annibale, to relax and recuperate. They also practiced careful and conscientious, occasionally somewhat mechanical, preparatory drawing for their paintings and frescoes. This method of graphic prepara-

tion not only was adopted by their immediate successors, such as Domenichino, but became the pattern for Academic art education as a whole. Malvasia reports on their intense artistic concentration: "*Mangiavano, e nello stesso tempo disegnavano — il pane in una mano, nell'altra la matita o il carbone.*" (Roli p. XIV)

This step-by-step approach to painting by way of sketches, studies, and preliminaries, also reported of such older artists as Federigo Barocci or the Zuccaris, was in total contrast to the methods of Caravaggio. Model in sight, he attacked the canvas directly, "*non istudiando ne' fondamenti de Disegno e della profondità dell'arte solamente del colorito appagansi*" (Baglione). Whether Caravaggio in fact sketched only directly onto the canvas is a question that cannot be finally settled—Ivanoff suspects that there are "*macchie*" by his hand—but the very small numbers of surviving drawings by his pupils support this point of view. At the same time, these few sheets reveal their master's and model's pronounced pictorial realism (fig. 25). Later on, Caravaggio's followers, Feti, Ribera, Preti and others, were to take to drawing, while the Carracci, on the other hand, came to recognize the disadvantages of exaggerated graphic preliminaries—"*che tanti disegni sia un rompicapo che stanca l'intelletto*" (Malvasia: Grassi p. 40 sq). And of the Mantuan painter Giuseppe Bazzani, who lived a century later and had little in common with Caravaggio, it is reported that before beginning a painting, he would burn his preparatory sketches and draft designs "*poiché ne li soleva chiamare ostacoli allo slancio dell'ingegno.*" (Coddé) It is true, however, that his way of *impasto* and *alla prima* painting contains much of

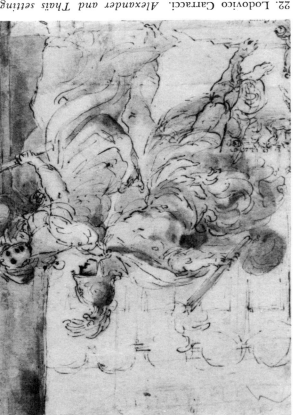

22. Lodovico Carracci. *Alexander and Thais setting fire to Persepolis.*

23. Annibale Carracci. *Madonna with Child and Angels over the city of Bologna.*

that lively, graphic improvisation and sketchiness that had spread during the 17th century, so that drawing and painting often came close in form and expression.

The three Carracci, Lodovico (b. Bologna 1555 - d. 1619) and his younger cousins, Agostino (b. Bologna 1557 - d. Parma 1602) and Annibale (b. Bologna 1560 - d. Rome 1609), are all appropriately represented in the Albertina. Lodovico's talent and his style that foreshadows the future are clearly seen in "Alexander and Thais setting fire to Persepolis" (fig. 22 B. 73), a sketch for the 1591 fresco in Palazzo Lucchino, later called Angellini, Zambeccari, today Palazzo Francia (3).

The figures are imbued with noble pathos and heightened movement, typical elements of the Baroque. The buoyant, pictorially loose brush- and pen-strokes, the blob-like indication of facial features foreshadow Guercino, who learned so much from Lodovico, and also Lanfranco, Canuti, Burini and other masters of the late Bolognese school. The characteristic, formal beauty of Lodovico's fluid line and movement—also clearly apparent in this drawing—link him with such masters of Mannerist art as Parmigianino, Primaticcio, Tibaldi, Nicolo dell'Abate, and also with Procacini (Pl. 70). The visionary character of many of his works appears to owe a debt to Barocci (Cf. Wittkower, Cat. 28, fig. 4). In later work this tendency is still more pronounced, and sometimes is expressed in a linear discipline that recalls his beginnings (B. 78, 81, 82, 112).

Palma Giovane, his contemporary in Venice, travelled in the opposite direction. No innovator like the Carracci, he based his work chiefly on Veronese and Tintoretto, though he extended their imagery into the area of life-like realism, especially in his drawing (Pl. 69) and etching. But ultimately, as in the Albertina's Assunta sketch of 1627 (V. 199) for the side altar of San Giuliano in Venice, he arrived at a thoroughly Baroque style.

Annibale Carracci's influence was the most enduring. His "Mascheroni" (Pl. 71), now in Dresden, became a milestone of Baroque art. It asserts a new consciousness of reality and feeling for life, a monumental conception, of which Annibale had already become a master before his call in 1595 to Rome, where the picture was painted. The pen drawing in Windsor Castle and the superb red chalk drawing in the Albertina are both charged with sensual joy and fluidity reminiscent of studies by Peter Paul Rubens, whose *"esprit de contour,"* in the words of Roger de Piles, *"lui donne l'âme et fait que ce coups paroît, véritablement, de chair, qu'il est plein de sang et de vie."* Annibale's nude studies (Pl. 72), admired already in his lifetime, have a similar impact. Equally monumental and vivid is the rendering of the "Madonna with Child and Angels over Bologna" (fig. 23 B. 101). (3a) There are four known preparatory drawings for this work which Annibale also painted before moving to Rome, and which is at Christ Church College, Oxford, today. Two of the drawings are at Chatsworth, and two in the Albertina (B. 101 and B. 102).

The drawing shown here is closest to the painting, while at the same time excelling it in vitality and depth of expression. There is a more organic interrelation between sky and landscape, with the latter, in its balanced extension of breadth and depth, from which the city's towers rise, and in its essentially horizontal stratification, already foreshadowing classical landscape composition of the 17th century as developed further by Domenichino, Poussin, and Claude. The Carracci also pioneered in the field of religious painting by treating subjects in a way that was close to life and generally understandable, and thereby differed from the Mannerists' concept. The expression of strong emotion—which Cardinal Gabriele Paleotti had demanded from artists as early as 1583 (*"immagini dalle quali si vedrà spirare pietà, modestia, santità, devozione"*) was to inspire and transport the faithful (4).

Artistically, Agostino stands between the more traditional Lodovico and the innovator

thereby sharpened the contrast to Caravaggio's Lombard naturalism, but did not fail to
Their painting also corresponded more closely to the Roman-Tuscan point of view. They
simo." Both artists followed Agostino rather than Annibale in their style of drawing.
herald of the Carracci and their Academy, already praised these for their "*disegno finis-*
handled with extraordinary discipline and clarity, especially in his pen drawings. Agucchi,
Both clung to the priority of *disegno*, the defining and formative line, which Domenichino
while Domenichino preferred its variation in the sense of pathos and drama.
of Raphael, which Reni, as Lodovico's pupil, adopted in a lyrical interpretation (Pl. 73),
1641) formed themselves mainly on the Carracci's Roman style, and directly on the model
Guido Reni (b. Bologna 1575 - d. 1642) and Domenichino (b. Bologna 1581 - d. Naples
altri Dipintori habbiano da parlar con le mani." (6).
sculpture from memory onto a wall. Asked what he had to say, Annibale replied: "*Noi*
on the subject of the Laocoön group, Annibale, present though silent, drew the famous
signor Agucchi is highly characteristic: while Agostino was conducting a learned discussion
the best educated and most articulate of the Carracci. The well-known anecdote of Mon-
Albertina by some important landscapes (5). According to contemporary reports, he was
Only occasionally did he reach Annibale's fluid liveliness. He, too, is represented in the
ink and only rarely in chalk, although then, too, he emphasized the clearly defined form.
others—especially of the great Venetians—he usually executed his drawings in pen and
Annibale. A successful engraver, after his own subjects as well as after the invention of

24. Domenico Zampieri called Il Domenichino. *Landscape and building.*

pay tribute both to observable reality and to the atmospheric fluidum of life. Domenichino, whom Poussin called the greatest master since Raphael—but who himself bestowed the palm on Reni—was also a great landscape painter. He followed Annibale in the direction of classical idealization, in which Claude and Poussin were later to reach the heights. Besides, he had, like Claude, a sharp eye for substantive realism in motifs of the Roman Campagna, which through its solemn character especially appealed to him. The drawing of a landscape with a palatial villa (fig. 24) used to be attributed to Lodovico or Annibale, but its "*disegno finissimo*" argues for their pupil and collaborator Domenichino. Similar drawings are to be found at Windsor Castle among the 1800 or so Domenichinos preserved there, five-sixths of his total graphic oeuvre. Especially close are the preparatory drawings for the frescoes of the Apollo legends at the Villa Aldobrandini (Belvedere) in Frascati, Domenichino's first major work, painted in 1608. These frescoes later found their way to the Palais Lanckoronski in Vienna, and are now in the National Gallery in London. The National Gallery of Scotland also owns a related sheet (7).

Guercino, after Annibale probably the most important graphic artist of the Bolognese School, continued the Carracci's naturalistic style of painting, that is to say, their Lombard-Venetian legacy, at the same time adopting Caravaggio's chiaroscuro so that some of his drawings and paintings could almost be said to belong to that school. However, except for his explicitly realistic genre pieces and caricatures, his work is informed with an

25. Bartolomeo Manfredi. *Soldiers playing cards and drinking.*

ennobling intention that increases in later years, to some extent under the influence of Guido Reni. The gentle expression of human feeling in the works of Correggio and Lodovico also influenced his drawing style (Pl. 74). The liveliness and lightness of his drawing and his wide range of expression foreshadow Tiepolo and his age, a period during which Guercino was much esteemed, as shown by Bartolozzi's drawings and prints after his work. Guercino is represented by many important works in the Albertina.

*

Caravaggio's relentless realism, his hard, dramatic candle- and cellar-light imagery, is reflected in a drawing (8) by Manfredi (b. circa 1580 in Ustiano near Mantua - d. 1620 Rome), "Soldiers playing cards and drinking at an Inn" (fig. 25, R. 489). The composition was frequently borrowed in Caravaggio's immediate and wider circle, as well as by the *oltremontani* among his followers (Honthorst, Terbrugghen, Liss, Valentin and others). It comes from Caravaggio's "Calling of St. Matthew" in the Cappella Contarelli in San Luigi dei Francesi in Rome (1599), the work that created such a stir at the time it was painted—though Federico Zuccari would say only *"Il pensiero di Giorgione"* (Baglione), despite its attraction, which had already caused the Neapolitan Belisario Corenzio to copy it in a drawing (9). Manfredi was a prolific painter whose pictures, as Sandrart notes, were especially popular and much bought in Holland. His "Guard Room" in Dresden (Voss, pp. 76, 98), related in idea and structure to the sheet in the Albertina, was the probable basis for a picture that inspired Rembrandt in the composition of "The Supper of Claudius Civilis," which he painted for the Town Hall in Amsterdam and which is now in the National Museum of Stockholm. The drawing relies primarily on the brush, which is also employed to apply the highlights in white body color. Pen strokes provide additional decorative extras and are not used in the defining sense of *disegno*.

One of the most important and individual draughtsmen and engravers among Caravaggio's followers was Giuseppe de Ribera, *"Lo Spagnoletto,"* from Játiba near Valencia (b. 1588 - d. Naples 1652), a pupil of Ribalta's, who himself had been a student of Caravaggio's. Ribera, who had also studied Correggio, the Venetians, Raphael, and the Carracci before settling in Naples in 1616, is so much creative part of Italian artistic activity, especially of the Neapolitan School, that a place must be reserved to him in this survey. He was, as it were, a "Guercino" in the domain of Caravaggio, from whom he differs, however, in his individual striving for the concentration of light in the *"tenebroso"* sphere. His austere realism, aimed at material effects, influenced artists from Aniello Falcone, Salvator Rosa, Mattia Preti, Luca Giordano to Solimena, and also the painters of the Spanish Baroque (Velasquez, Murillo, and others). The harsh, forceful interplay of light and shade is seen to great effect especially in his drawings and etchings, which are reminiscent of Goya. The Albertina's "Crucifixion of St. Peter" (fig. 26), is a fine example (10). Its very fluent, yet sharply defining brush and pen strokes created a school, as Salvator Rosa and Luca Giordano prove. In its interpretation of the theme and in its composition, the drawing is one of the most audacious renderings of the subject since Caravaggio's painting in S. Maria del Popolo and Guido Reni's early work in the Vatican Gallery.

Mancini, in "Considerationi sulla Pittura," divides the painters of his day into four groups or schools. After dealing with that of Caravaggio, whose chiaroscuro and realism he cannot, like Baglione, respect without strong reservations—*"molto osservanto del vero"*...

27. Giuseppe Cesari called Il Cavaliere d'Arpino. *Perseus and Andromeda.*

"Le lor figure, ancorché habin forza mancano di moto e d'affetti, di gratia..." he comes to consider the Carracci and their followers, whom he clearly prefers. The third place he allows to the school of the *"cavalier Giuseppe, anche la per proprio un spirito e proprietà di natura, con buone compositione e gratia et in particolare delle teste. E se bene non va osservando tanto esattamente il naturale come quella del Caravaggio nè quella gravità e sodezza di quella delli Carracci, nondimeno ha in sè quella vaghezza che in un tratto rapisce l'occhio e diletta, e d'essa mi ricordo haver sentito dire da Agostino Caracci: vi è il buon perché vi è il rapimento e diletto."*
In Rome—rather like Palma Giovane in Venice—Giuseppe Cesari, "Il Cavaliere d'Arpino" (b. Arpino 1568 - d. Rome 1640), was a prolific and versatile artist in the period of transition from Mannerism to Baroque. Rooted in the formula of *"disegno,"* of which his command was masterly, he strove to introduce decorative atmospheric effects in the Lombard-Venetian sense, as in "Perseus and Andromeda" (fig. 27, R. 454), a composition full of movement, and thoroughly Baroque in the depth of space and the contrasts of light, although it lays no claim to the realism demanded by Caravaggio (11). Could there be a connection with the painting by Domenico Feti in the Vienna Kunsthistorisches Museum (Cat. 1960, No. 532)? Annibale's fresco in the Palazzo Farnese in Rome possibly served as the model for both (Voss 174).
The disciples and collaborators of the Cavaliere d'Arpino included Caravaggio himself, although he stayed for only a few months; also, Martin Fréminet from Paris; the historiographer and painter Giovanni Baglione; and the future Caravaggio pupils Orazio and

60

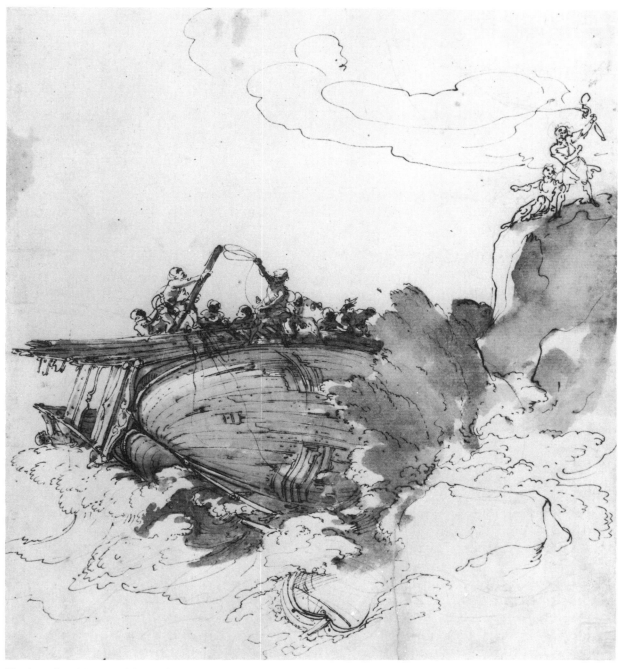

28. Agostino Tassi. *Shipwreck*.

Artemisia Gentileschi, as well as Agostino Tassi, who worked under d'Arpino together with the young Claude Lorrain in 1614.

Important portrait drawings and etchings, duly reflecting the new realism, were produced by the Roman Ottavio Leoni (1578-1630). The Albertina owns a considerable number of his portraits, which in part seem to carry a presentiment of Rembrandt.

In Florence and Tuscany, the Lombard-Venetian influence also grew stronger in the course of the 16th century, as pictorial, atmospheric representation, as it were, is joined with *disegno*. Thus, in the work of Lodovico Cardi, "Il Cigoli," the graphic form occasionally dissolves into a tangle of dynamic strokes reminiscent of Baldassare Franceschini, "Il Volterrano" (R. 326-28). The masters of Urbino, Federigo Barocci and both Zuccaris, of whom the younger, Federico worked in Florence, also furthered developments in this direction. Does not Federico's "Kitchen" in the Uffizi, with the picturesque family scene steeped in chiaroscuro, seem to anticipate Caravaggio or Manfredi, or more precisely, to provide counterpart to one of the Carracci's realistic domestic scenes (12)? Did not Andrea Boscoli, highly talented especially as an etcher, pupil of the Florentine reformer Santi di Tito, create in the Albertina's "Triumph of Bacchus and Ariadne" (R. 314) a thoroughly individual work which in the defining and formative power of its *disegno* is a truly Florentine counterpart to Annibale's famous fresco in the Palazzo Farnese? The flickering chiaroscuro and the strangely deformed figures also anticipate Callot's "Temptation of St. Anthony" (13).

Other pre-Baroque Florentine pioneers of the new return to reality are similarly well represented in the Albertina: Poccetti; Jacopo da Empoli; Christoforo Roncalli, "Il Pomarancio"; Allori; the successful etcher Antonio Tempesta; Domenico Cresti, "Il Passignano," who collaborated with Federico Zuccari on the frescoes in the cupola of the cathedral in Florence and studied Titian and Tintoretto in Venice; Matteo Rosselli, a superb draughtsman and a good teacher; Biliverti; Giovanni da San Giovanni; and Lorenzo Lippi: they all imbued the concept of *disegno* with a new Baroque feeling for life. Their work may be taken as the Florentine answer to the creative endeavor of the other schools. It was in their circle that Jacques Callot's talent developed, although he in fact derived from the school of Parigi and Remigio Cantagallina. Parigi was an architect and designer of fêtes, a master of perspective, from whom Callot learned *"il segreto dell'aqua forte, e il bel modo di segnar con penna, e far piccole figure,"* but who also constantly urged Callot (14) to draw from life (Baldinucci). Cantagallina engraved and drew landscapes: a minor artist, who concentrated on the then-flourishing so-called cabinet painting, practiced mainly by Adam Elsheimer and Paul Bril, and their circle in Rome and Florence. Callot was to become one of the great heralds of Florentine *disegno*, which he most skillfully combined with pictorial chiaroscuro.

Another pupil in the versatile workshop of Parigi and Cantagallina was Agostino Tassi (Rome 1580-1644), the teacher of Claude Lorrain. Tassi, whose works have only lately been rediscovered, was a painter of perspective and quadrature. In that domain, he created illusionary-architecture frescoes for Domenichino in the Palazzo Costaguti and for Guercino in the Palazzo Ludovisi. He also painted landscapes, but his specialty was marine pieces, *"boscaglie marittime"* (Passeri), *"tempeste"* (Mancini), and *"vedute."* His drawings are rare and appear under different names: his "Shipwreck" (fig. 28, R. 516), for instance, was carried under his nickname "Smargiasso"—the boaster—passed on by Passerini. Under this nickname incurred by conceit he also appears in the minutes of the court, where he appeared frequently—like Caravaggio, whom he resembled in temperament (15). "Shipwreck" is masterly both in its light effects and in the power of its audacious, truly Tuscan line. The contrast between the sharp graphic stroke and the dark patches of bistre movingly embodies man's peril and impotence in the face of the elements; pictures such as these inspired the early work of Claude (16).

Parigi's circle, and particularly Callot in his etchings, had a formative influence on Stefano

62

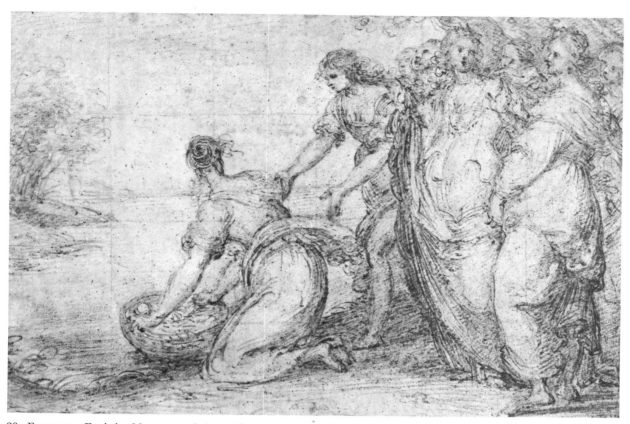

29. Francesco Furini. *Moses saved from the water.*

della Bella, the most important follower of the master of Nancy. Later, under the impact of Claude and Rembrandt, and attracted by the picturesque qualities of Bernini's and Cortona's High Baroque style, he turned from Callot's forceful clarity of expression, the *"taglia cosi pulita,"* to a more atmospheric technique of drawing and etching (Pl. 81).

One of the most accomplished draughtsmen of the 17th-century Florentine School was Francesco Furini (Florence 1603-46), a pupil of Matteo Rosselli. He was also ranked among its most important painters, rivalling Cortona and Franceschini in the depth of vision and in the expressive force of color. His "Discovery of Moses" (fig. 29, R. 825) not only shows the bold, plastic, and yet pictorial handling of chalk that he had learned from his master, but reveals a thoroughly independent understanding of late Quattrocento style as represented by Ghirlandaio or Filippino Lippi, whose drapery and grace inspired this sheet (17). Rosselli's circle of students also included Francesco Montelatici, "il Cecco bravo," and Lorenzo Lippi. The Albertina has significant specimens of the work of both. Jacopo Vignali's "Pyramus and Thisbe," a masterpiece of chiaroscuro of which the Louvre owns another version, leans toward Caravaggio and Bramer (Roli, Pl. 90). Both versions were studies for a small picture in the Collection Rospigliosi at Pistoia. Vignali, too, was a pupil of Rosselli's and in turn taught Carlo Dolci, by whom the Albertina also has a drawing (R382).

The followers of *disegno* in Florence did not even in the succeeding years, abandon their principles, even if they practiced them, so to speak, in the disguise of a pictorial approach,

63

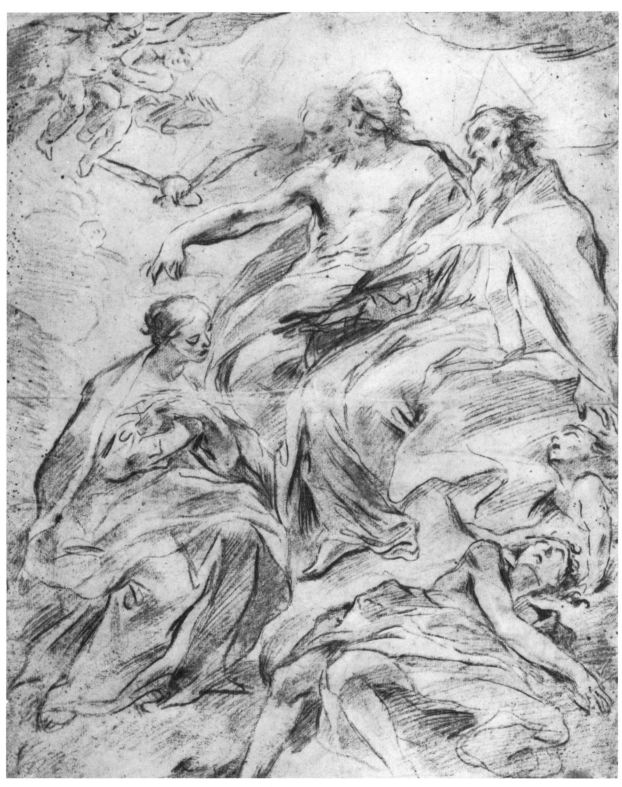

30. Giov. Batt. Beinaschi. *Coronation of the Virgin.*

64

or in a style characterized by a maze of fluid, yet forcefully moving lines, as in the work of Bernini, Cortona, or Baldassarre Franceschini.

*

The first decisive step toward High Baroque painting, with its powerful, heightened pathos and illusionism, was taken, once again, by a Lombard: Giovanni Lanfranco from Parma, pupil of Agostino Carracci and later, in Rome, of Annibale Carracci. However, he patterned his style mainly on the works of Correggio in his native town, adapting their soft, luminous fluency even in his drawings. Besides a lively sketch for the "Navicella" (Pl. 76), the Albertina possesses a study for an important early work, an assembly of gods, that Lanfranco painted for the ceiling in the main hall of the Casino Borghese in Rome about 1720 (B. 371): a composition of fairly reserved concept, still in the spirit of Annibale or Domenichino—his former fellow-student who later became a hated rival—but of much greater freedom atmospherically. In Naples, where Lanfranco worked for over a decade (1634-46), attracting notice as the founder of that influential school of decorative art which was to culminate in the work of Luca Giordano and Solimena, efforts in this direction were also made by Giovanni Battista Beinaschi (b. Cuneo 1636 - d. Naples 1688), whose drawings are often mistaken for those of Lanfranco (18); but the "Coronation of the Virgin," (fig. 30, B. 460), a drawing in chalk, a medium also preferred by Lanfranco, shows the parting of the ways. There is an almost Mannerist elongation of figure, not unlike that in drawings by Federigo Panza (B. 462-64) and other masters of Northern Lombardy, or later (19) in the work of Carlo Carlone (Pl. 93). In Rome, his style was followed by Giacinto Brandi (R. 760).
Lorenzo Bernini and Pietro da Cortona became the strongest pillars of the High Baroque

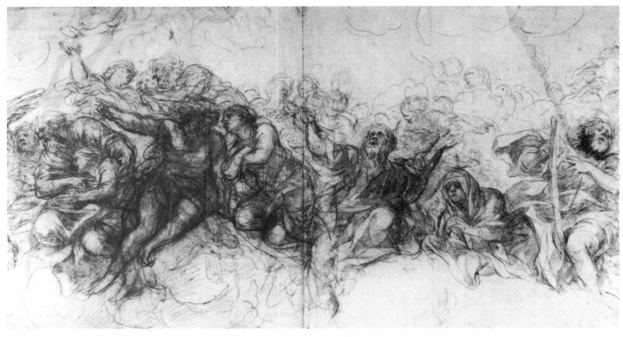

31. Pietro Berrettini called Pietro da Cortona. *Celestial Vision.*

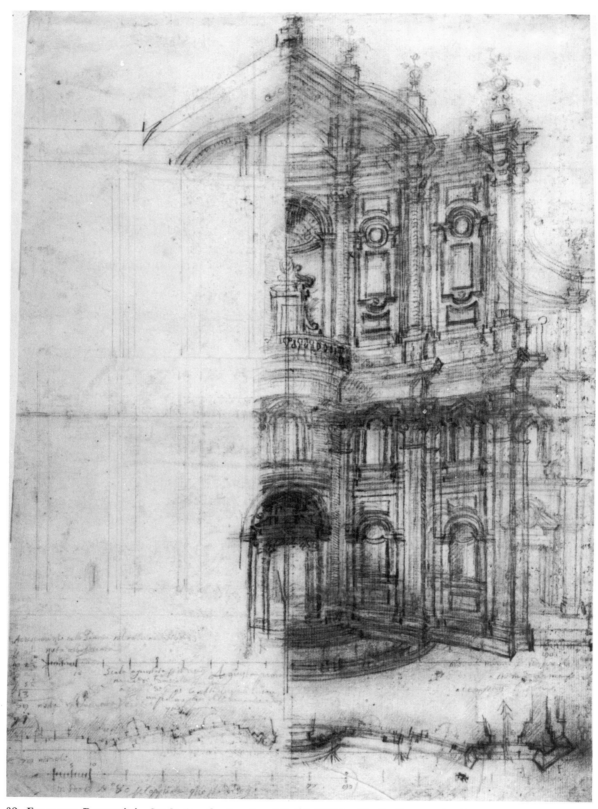

32. Francesco Borromini. *Study for the façade of Saint Filippo Neri's Oratory in Rome.*

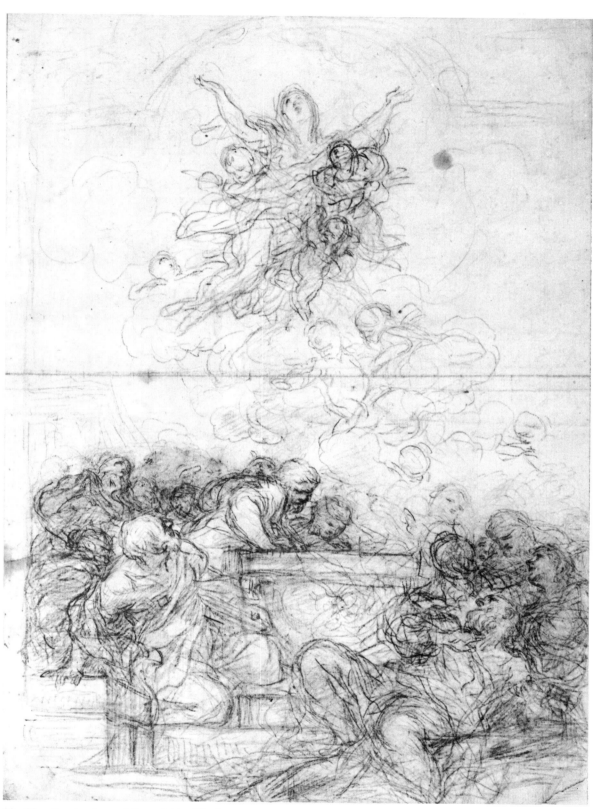

33. Ciro Ferri. *Assumption of the Virgin.*

movement. Bernini and Cortona were largely self-trained, the former mainly practicing sculpture and architecture (besides being a painter, poet, dramatist and musician), the latter architecture and painting. For both, the work of Annibale Carracci, especially his Galleria Farnese, was an important premise, in addition to the study of Classical antiquities and High and Late Renaissance masters at first hand. From the beginning of the 1630's, their work was marked by an intensification or emotional rhythmization and sensual passion or expression in their figures and compositions as well as by a heightening or emphasis on pictorial presentation. Cortona's paintings and frescoes determined and transformed the spatial character of the rooms they decorated in a way similar to Bernini's sculptures—an effect surpassed only when the artists designed the architectural surroundings as well, and so achieved a *"unisono,"* a supreme harmony of the arts. Cortona's free, impulsive style of painting and his intensity of color are evident, too, in his drawings, where pictorial grace in the easy flow of forms triumphs over linear definition. Like Rubens, whom he occasionally resembles in his paintings, or Bernini, he achieved in many of his drawings a specific *"esprit de contour"* (Roger de Piles) that seems to communicate life itself (Pl. 78).

Compared with Lanfranco, Cortona maintains at the base a pictorial fluency, a plastic-dramatic touch: a driving spark, as it were, of the Tuscan feeling for form. The same holds true, in spite of many differences, for the work of Bernini. Cortona's paintings and drawings, from the early work on, admit pronounced realistic features, such as he had studied in the works of Caravaggio and Guercino; and there is also that chiaroscuro which he later converted into a medium of special emotional expression: most impressively in "The Procession of St. Carlo Borromeo" (Pl. 79). Vulgar traits, in that sense, also characterize various figures in the frescoes of Santa Maria in Vallicella in Rome, which he began in 1647 and completed, after a lengthy interruption, in 1665. At his zenith (1647-1651), he painted the mighty cupola with the Glory of Heaven, the Holy Trinity, and a plethora of Old and New Testament Saints resting on clouds. High pathos, surpassing the intensity of Lanfranco in comparable works, also inspires the Albertina's large preparatory sketch (20) for a major group in this fresco (fig. 31, R. 712).

A surprising creative kinship, not only in the drawing technique but also in the plastic-pictorial feeling for form, is apparent in Francesco Borromini's design for the façade of the Oratory of St. Filippo Neri, situated next to the "Chiesa Nuova" (fig. 32). Cortona was also a practicing architect, and his work in this field reveals that same Baroque sense of dynamic plastic-pictorial rhythmization in his architectural form (21).

Cortona's pupils and followers are also fairly well represented in the Albertina. Some of these were inspired by his earlier works under the influence of the Carraccis and of Classical Antiquity—for example, Giovanni Francesco Romanelli (Viterbo 1611-1662) and Giacinto Gimignani (b. Pistoia 1611 - d. Rome 1681), both of whom were also pupils of Poussin and Andrea Sacchi (Romanelli had first studied with Domenichino). Others adhered to the emotional, tempestuous style of his High Baroque period: men like Lazzaro Baldi (b. Pistoia 1623 - d. Rome 1703), Guillaume Courtois (Cortese, b. Saint-Hyppolite 1628 - d. Rome 1679), and the highly productive Ciro Ferri (b. Rome 1634 - d. 1689). Ferri's Assunta sketch (fig. 33, R. 742) probably originated between 1659 and 1665 during the time he was in Florence, where he competed unsuccessfully with Franceschini to secure the commission for the ceiling of the Annunziata Church. In his later period, Ferri for some years lived and worked at Bergamo, spreading the style of Cortona in Lombardy. The Albertina also owns one of his sketches (22) for the Annunziata ceiling

68

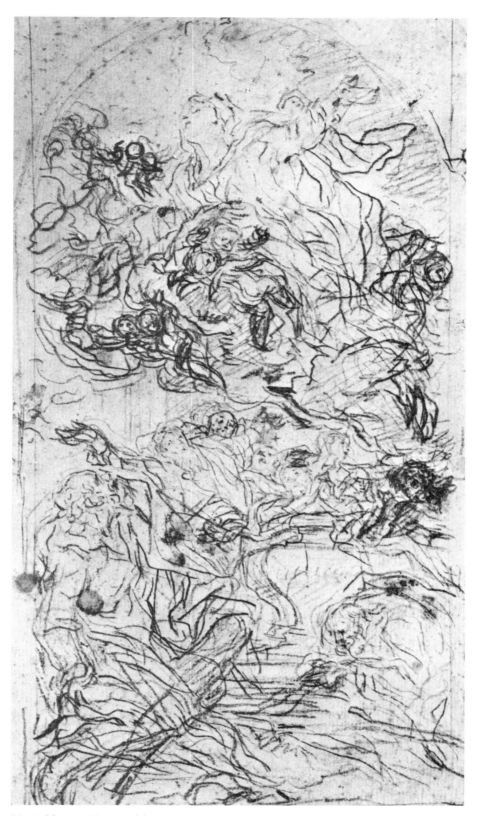

34. Baldassare Franceschini called Il Volterrano. *Assumption of the Virgin*.

—eventually painted by Franceschini—which is essentially tenser in composition and more plastic in effect (fig. 34, R. 648).

Baldassare Franceschini, pupil of Matteo Rosselli and Manozzi (Giovanni da S. Giovanni), received decisive impulses from Cortona that gave rise to his highly emotional, decorative style, which culminated formally in the tempestuous, pathos-laden Annunziata paintings and frescoes. This work largely occupied the last two decades of his creative life. The Albertina has numerous sketches and studies relating to projects of this phase (R. 645, 662, 668 et sqq., and to the fresco "The Coronation of the Virgin" painted between 1652 and 1660 for the Niccolini Chapel in Santa Croce. To these drawings also belongs a sheet (23) until now attributed to Domenichino (fig. 35, R. 165): a study of an angel with violin, designed to be seen from below; the verso shows a youth with flute, in a similar dancing motion. The more controlled stroke of this study still reflects Franceschini's earlier style of drawing. His later period is characterized by the drawing representing an allegorical vision of Golgotha, with its expressive emphasis on jerky, closely crowded lines and shapes (fig. 36, R. 646). A laurel-crowned female figure (Poesia), having just written "TU SPIRA / AL PETTO MIO / CELESTE / ARBORE" on a scroll, gazes up ecstatically at three crosses surrounded by putti with instruments of torture and symbolic figures alluding to the creation of vanquished pagan poetry and mythology (such as Pegasus). As suggested by two variants of this drawing—one in the Munich Graphic Collection; the other one, perhaps the most detailed and finished version of all, in the Louvre—the composition obviously was designed for a frontispiece. The inscription *"Fiori del Orto / di Gessemani e del Calvario / Sonetti / del Duca Salviati"* is in mirror-script on the Louvre sheet, and also on that in Munich; in the latter, the composition of the calvary scene is reversed right to left, in preparation for transfer to the copper plate, which, however, did not take place. The drawing in the Albertina may be regarded as a *primo pensiero* (24).

Giovanni Battista Gaulli's painting and drawing essentially bear the stamp of Bernini's later work. The sensual, burgeoning temperament of this native Genoese was extraordinarily akin to that of the great sculptor and architect, and he became, as it were, Bernini's interpreter in the pictorial domain, though without imitating him. Like Bernini's sculptures, for instance the Cathedra Petri, Gaulli's paintings and drawings, with their widely sweeping forms that appear to reach out into space, and their fluctuating chiaroscuro, have a dual claim by the intrinsic combination of plastic and pictorial values (Pl. 87). In this, they surpass Cortona and his school, if occasionally at the cost of harmonious balancing of light and color. At all events, Gaulli became a leading master of Late Baroque oil and fresco painting, fully aware of its intense emotive and expressive possibilities. Thus there was a significant antithesis between his art and the concept of Carlo Maratta, his contemporary, who followed more classical principles. Gaulli's tempestous pathos and *"sursum"* are evident in "The Flight into Egypt," where figures and landscape are vibrant with the same emotional rhythm (B. 555).

Under the aegis of Roman High Baroque, though not without opposition, even in the sense of literal protest, there also blossomed other painters who more quietly tended and transformed the artistic legacy of Caravaggio and the Carracci and in their style of composition preferred intense pictorial exploration to decorative, flamboyant motion.

Caravaggio's adherents in Rome were predominantly *oltremontani*, mostly Netherlanders and Frenchmen, the *"Bentvueghels"* who attracted much attention not only with their relentlessly realistic work, but by their free and easy behavior, their merry, wine-heated

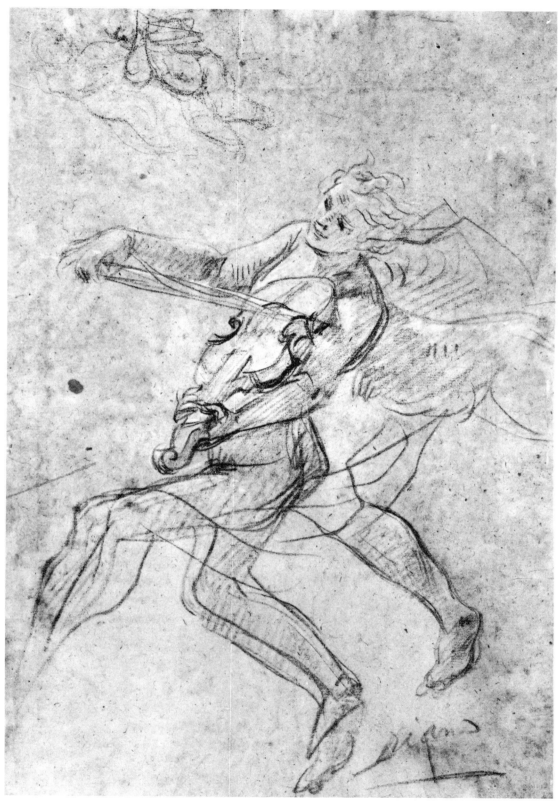

35. Baldassare Franceschini called Il Volterrano. *Angel Musician.*

celebrations, and their processions around town. Among them, the Bamboccianti, followers of Pieter van Laer—"Il Bamboccio"—formed a special group. Their small-figure compositions, mainly pictures of daily life and landscapes, greatly influenced Netherlandish-Roman landscape painting, as shown by the work of artists such as Swanevelt, Jan Both, Asselijn, Berchem, Du Jardin, and many others, including, in their early days, Claude Lorrain and Salvator Rosa. The Academicians, whether believers in High Baroque or Classical art, despised them, just as later Salvator Rosa scolded them in a famous sonnet. Even so, they had their supporters and collectors, as for instance the Marchese Vincenzo Giustiniani, an old admirer of Caravaggio's, and the Spanish Ambassador, the Duke of Alcala (25). A faithful adherent of Pieter van Laer and one of the few Italians who travelled the same artistic road, was Michelangelo Cerquozzi, commonly called "delle Battaglie," a native Roman (1620-1660). He later often painted *staffages* for the vedute and prospects of ruins by Viviano Codazzi in Naples and for Claude's pupil Angeluccio, filling their works with characteristic, vivid figures which were later to inspire Pannini. The Albertina has several battle scenes attributed to Cerquozzi; these, executed with energetic pen and brush strokes (R. 519-521), foreshadow Jacques Courtois (Bourguignon), the brother of Cortona's pupil Guillaume Courtois (Cortese), who is particularly well represented in the collection.

Andrea Sacchi, another native Roman (1599-1661), pupil of Francesco Albani, the lyricist among the Carracci disciples, was the leader of a group that looked backward to the Classical past, rejecting Cortona's excessive use of figures and movement and his alleged lack of clarity and dignity (26). Sacchi was a solid, thoughtful painter. He revived Titian's sophisticated treatment of color in Roman painting and was an excellent draughtsman, aiming to combine Raphael's harmonious fluidity of line with contemporary pictorial effects. In this, he was followed by Carlo Maratta, his greatest pupil. Sacchi's surviving drawings are, with few exceptions, shared by the Kunstmuseum in Düsseldorf and Windsor Castle. According to the results of latest research by Ann Sutherland-Harris, the Albertina's sheets which used to be attributed to Sacchi—as, for example, "Jupiter and Antiope" (R. 758)—are in fact the work of his collaborators or pupils, such as Andrea Camassei and Luigi Garzi. However, Sacchi may well be the author of a drawing so far ascribed to Maratta, a representation of the "Madonna of the Casa Santa" borne by angels (fig. 37, R. 779), which indeed is a work of radiant harmony and Raphaelesque melody of line. In contradistinction, Maratta's style of drawing, even during the years of his studies with Sacchi, was more articulated and energetic. It may be recalled in this connection that Sacchi had painted a *"Sposalizio"* for the Casa Santa at Loreto (later to be replaced by a mosaic copy), and it would not be far-fetched to suppose that he might have dealt with the legend of the Virgin's Sacred House and the miracle of its removal by angels from Nazareth to Loreto; Stefano della Bella took a similar approach to the theme in a series of etchings published in 1649 by Pierre Mariette in Paris (Jombert 143). Stylistically comparable drawings by Sacchi exist in Düsseldorf and at Windsor Castle (27). Of the work of Luigi Garzi (b. Pistoia 1638 - d. Rome 1721), who also studied with Poussin and Maratta, the Albertina preserves preparatory designs for an altar and a ceiling (R. 809, 810).

Nicholas Poussin stressed Classicism more firmly even than Sacchi, and more strictly in the sense of Domenichino and of Classical Antiquity, from which he constantly sought inspiration, while in the early 1630's he also cultivated the neo-Venetian palette. His work notably influenced French painting, rather than developments in Italy. As a draughtsman

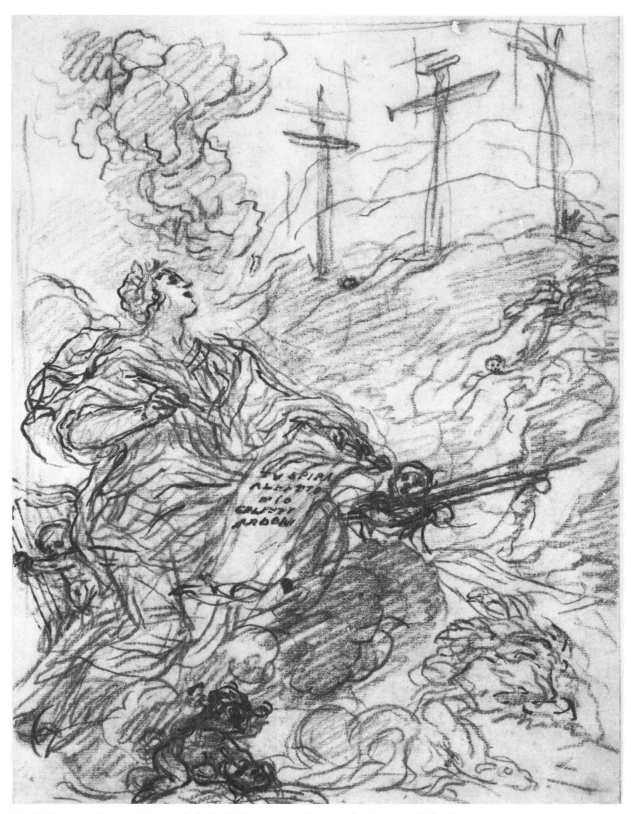

36. Baldassare Franceschini called Il Volterrano. *Allegorical vision of Golgotha.*

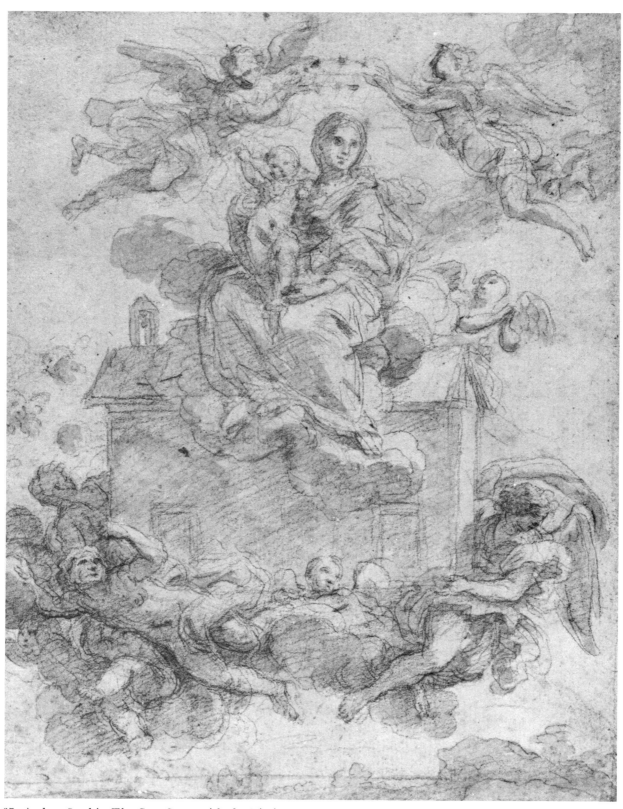

37. Andrea Sacchi. *The Casa Santa with the Virgin transported by Angels.*

38. Pietro Testa. *Study of a Tree.* 39. Pier Francesco Mola. *Pastoral scene.*

he had an extremely pictorial style, of far greater luminosity than that attained by the Carraccis.

Between Poussin and Cortona, and influenced by each in turn, stood Pietro Testa and Pier Francesco Mola, two friends who also painted landscapes and excelled in beautiful animal drawings. Testa, a Tuscan (b. Lucca 1611 - d. Rome 1650), first studied under Domenichino, who can certainly be supposed to have encouraged his native tendency to *disegno*. This inclination for clear definition was to lead him to engraving as a main form of artistic expression. A versatile artist, he learned, without being imitative, from Cortona and Poussin, and like the latter he attempted to write a treatise on painting. His works are distinguished by a special warmth and sensitivity (fig. 38, R. 527), and among his drawings and paintings are superb representations of animals as well as of putti. Marabottini hinted that in trying to penetrate and reconcile opposites Testa faced an insurmountable inner conflict: in 1650 he was found, drowned, in the Tiber (28).

His friend Mola shared his taste for solitary landscapes and mood-pictures; but his temperament as an artist and his pictorial concept was closer to Guercino and Cortona, and at times he was also influenced by Poussin. The difference between the two men's work becomes particularly apparent in a comparison of Testa's tree study (fig. 38, R. 527) with Mola's "Pastorale" (fig. 39, R. 280), which seems to be a true "macchia" (29). To the same circle belongs the Bolognese landscapist Giovanni Francesco Grimaldi, who had come to Rome in his early years and studied chiefly under Domenichino. He later worked also with Gaspard Dughet and Pietro Testa (30).

Carlo Maratta (Pl. 86), the greatest follower of Andrea Sacchi, was the leader of the Classical movement that aimed at restraint and solemnity in Roman painting during the second part of the 17th century. Throughout his life he was a prolific draughtsman, and

he took particular care in his drawing, in the spirit of the Carracci and their Academy. His graphic work is largely preserved, and comparable in volume to that of Domenichino, which Maratta himself owned and administered, together with sheets by the Carracci, Sacchi, and other masters. Maratta, like Domenichino, was pledged to the principles of *"disegno"* in the stricter sense: *"Non bisogna considerare il disegno come la sola quantità geometrica e materiale contenuta in termini circoscritti da semplici linee, ma come principio formale, e che informa le figure all'esempio della natura."* The artist prepared almost every part of his paintings in single or multiple sketches and studies, always wrestling with the problems of selection from nature, and struggling to achieve gracefulness (31). A sheet in the Albertina (fig. 40, R. 772) showing detail of studies of a kneeling female figure with her arms raised in admiration and ecstasy is a good example (32). Sacchi's influence is still clearly visible in the tender, radiant line and in the pictorial gradation of shading, but there is already evidence of Maratta's greater decisiveness and more plastic articulation. The drawing probably originated in the 1650's, at the same time as analagous, dateable drawings in Düsseldorf and Berlin (33). An example of later studies in a different style is the seated nun, drawn in red chalk with white heightenings on blue paper (fig. 41, R. 770): a figure drawn about or after 1670, which Maratta seems to have borrowed for his "Chaplet of Roses" painting of 1695 in the Oratory of St. Zita

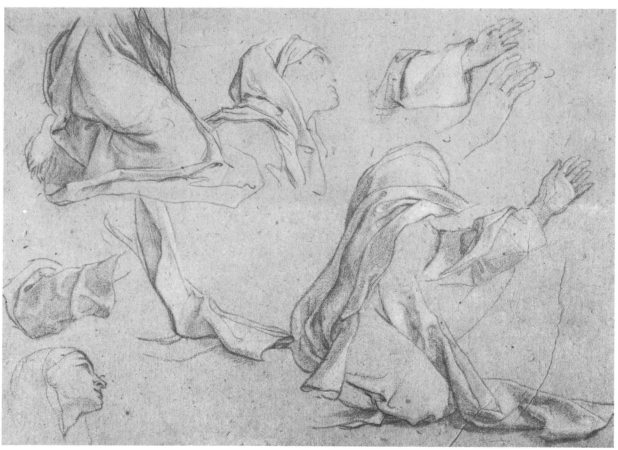

40. Carlo Maratta. *Kneeling Woman.*

76

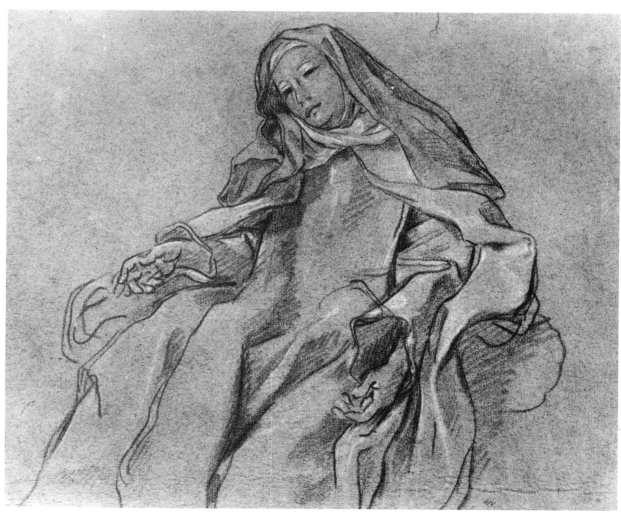

41. Carlo Maratta. *Study of a Nun*.

in Palermo. The actual drawing in this period stands out in higher contrast from the ground and is achieved by graphically simpler, but more vigorous lines (34). The stroke is more passionate and expressive, in the spirit of the High Baroque that Maratta embraced in many respects after Cortona's death (1669), especially in the many-figured, motion-filled compositions that he created during the final decades of the century. This trend is clearly borne out by compositional sketches of the period that appear to rival Ciro Ferri or Franceschini in their excited tangle of dissolving lines (35). This is also true of the preliminary designs for the allegorical pedentive frescoes in the main hall (*salone*) of Palazzo Altieri, of which the two in the Albertina represent the *"Coronation of Virtue"* (fig. 42). For compositions never carried out, these drawings were created in connection with the preparations for the famous ceiling (Voss 346) representing the apotheosis of Pope Clement X (Altieri), which Maratta painted between 1674 and 1677.

Maratta's influence on his own period and the following era up to Raphael Mengs and Johann Joachim Winckelmann was very considerable, even beyond the sphere of Rome and

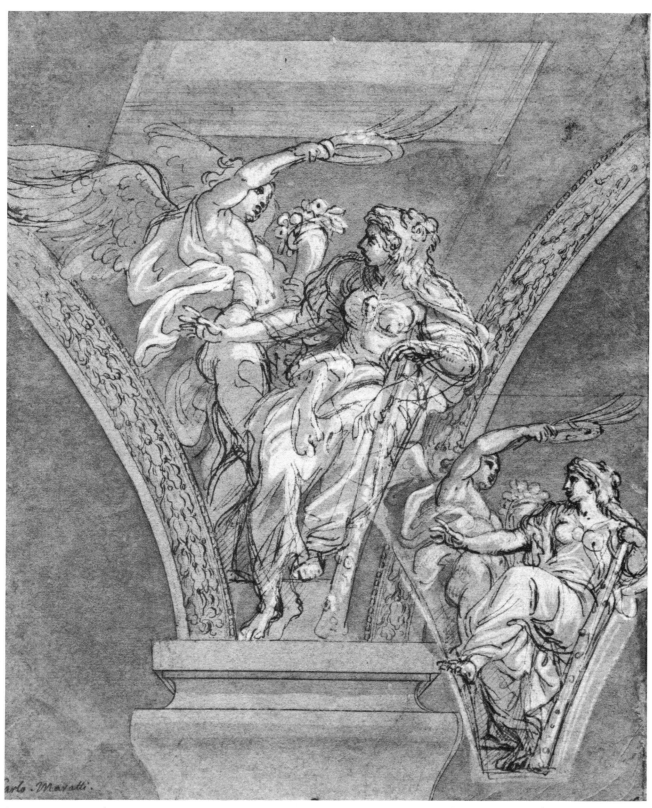

42. Carlo Maratta. *Coronation of Virtue.*

Italy. Among his numerous students and followers, most of whom are represented in the Albertina, were Giuseppe Chiari and Giuseppe Passeri, nephew of the renowned historiographer. Chiari (Rome 1654-1727), whose drawings are rare, adhered to his master's form and style fairly faithfully. His lute-playing angel in the Albertina (R. 800) shows dignity and decorative grace, combined with the expression of spiritual abandon to music; stronger still is the expression of musical delight in the half-length female figure (36) striking a chord on a stringed instrument, a figure that may be interpreted as St. Cecilia at the moment of her conversion.

Giuseppe Passeri (Rome 1654-1714), one of Maratta's favorite disciples, survived the master by only a year; next to Calandrucci, Passeri was the most individual and original talent among Maratta's immediate followers. He was encouraged by his teacher to devote himself primarily to the study of Lanfranco, but rather than an inclination for solemn representation, he acquired a sense of Baroque movement and passion, in the vein of Cortona and Gaulli, which also emerged as a dominant in Maratta's later work. Passeri's paintings are fascinating in their winged vitality and expressive power, as well as in the spontaneous, almost vibrant application of color. Similar characteristics are also found in the pictorial impetus and the bold sweeping lines of his drawings. He liked to prepare his sheets with a reddish or reddish-brown ground—*"dipigneva fino all'imbrunir della sera,"* Pascoli observed—so as to provide a surface from which the design stands out by tonal contrast, as in the "Ecstasy of St. Giacinta Marescotti" (fig. 43, R. 796), a sketch for the altarpiece of the Collegiata at Vignanella near Viterbo that was probably one of his last works. In 1726, the year of the Saint's beatification, the painting was reproduced in an engraving by Johann Jacob Frey; the painting departs from the original preliminary drawing only in the group of angels, the appearance of the cross by the nun's feet, and a few trivial details. A rich red chalk study for the figure of the Saint is in the Kunstmuseum in Düsseldorf (37).

Rome was the fountainhead of decisive impulses determining the rise of Italian Art in the latter part of the 17th century—Bernini, Borromini, Lanfranco, Cortona, Gaulli, Maratta, as well as Poussin and Claude Lorrain, who settled there in their early years, all contributed to important developments in the capital. The only native Roman among the leading masters was Sacchi. Thus, the Roman School was accorded special attention in this survey. The other art centers and their achievement and influence can be dealt with only on a smaller scale in this context, although with few exceptions they are equally well represented in the drawings department of the Albertina.

*

The leading artists of the Venetian School are Palma Giovane and his close contemporaries: Andrea Vicentino, Alessandro Maganza, Aliense, Alvise del Friso, Domenico Tintoretto, Leonardo Corona and Varotari (Padovanino), to mention only a few. All more or less found their starting point in the work of the great masters of the 16th century—Titian, Tintoretto, Veronese—and only gradually came to the new sense of reality of the Baroque age. Palma Giovane, who might be called a Venetian "Fa Presto," surpasses the others in volume of work as well as in its quality, particularly as regards his drawings (Pl. 69) and etchings, which are superb examples of free pictorial and atmospheric rendering of natural scenery. He influenced many artists, among them the Carracci, Guercino, and even Ribera, whose School of Drawing was later published along with Palma's Manual of Design (38).

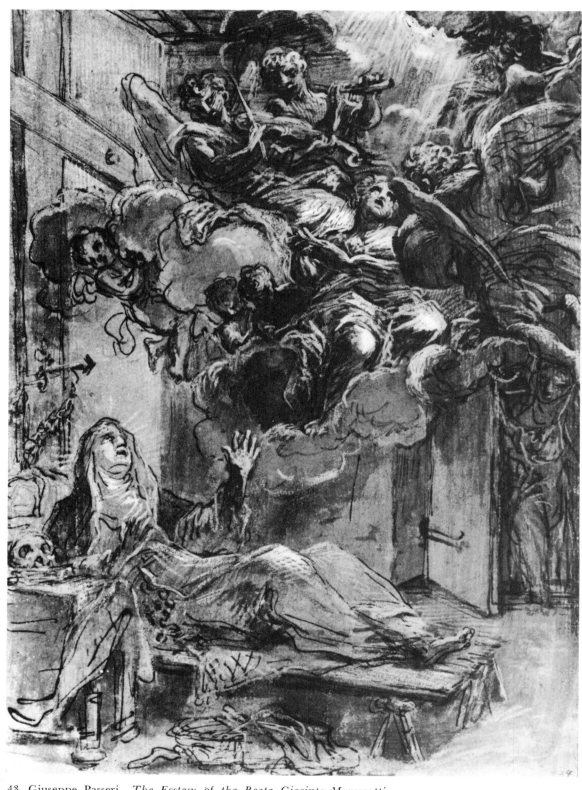

43. Giuseppe Passeri. *The Ecstasy of the Beata Giacinta Marescotti.*

Several non-Venetians or artists who had studied outside the Republic also gained significance for Venetian art in the 17th century. They included masters like Domenico Feti, Jan Liss from Oldenburg, Saraceni, Basetti, and Alessandro Turchi, who together introduced in Venice the style of realism inaugurated by Caravaggio and Elsheimer, and their Netherlandish and French followers. Their drawings are rare, but are represented, up to a point, in the collection. Rare, also, are specimens by Tiberio Tinelli, whose lively portrait of a lady might rival one by Ottavio Leoni or Claude Mellan (V. 223). The drawings of Jacopo Ligozzi, on the other hand, really belong to the School of Florence, where he attained his zenith and died in 1632; he represents a retrospective art with fine sheets, fascinating in their chiaroscuro line gradation of brown and gold (V. 209-220), inspired by late Quattrocento and earlier German Masters, such as Hans Baldung.

The Albertina possesses several sheets by the painter-etchers Giulio Carpioni and Giuseppe Diamantini, who both carry on traditions of Classicism, being disciples of Guido Reni and Cantarini in Bologna, while Carpioni also studied the works of Poussin.

On the other hand, the Albertina has only a few examples of drawings by Bernardo Strozzi (fig. 44), who worked in Venice only in his later years but whose sensual and sensitive realism and colorful chiaroscuro had a lasting effect on Venetian painting. His paintings seem to have inspired two drawings, a Holy Night and an Epiphany, that are remarkable for their shimmering light; these are attributed to Niccolò Bambini (V. 236, 237). The other "tenebrosi" of the second half of the 17th century, like Antonio Zanchi, are hardly represented, except for Johann Carl Loth, whose sheets are placed with the German

44. Bernardo Strozzi. *Study of heads, helmets etc.*

81

Schools. As yet, however, there has not been much research into the work of these artists (39). One important drawing is the nativity scene (*"presepe"*) by the Maratta pupil Antonio Balestra, which recalls the poetry of the early nativity pictures of his Roman teacher.

*

Masters of the Milanese and Lombard School in the transitional period between Mannerism and early Baroque include, beside the Procaccini, artists (40) such as Giovanni Battista Trotti (Malosso), Guglielmo Caccia (Moncalvo), and Morazzone (B. 441-457). As in Venice, the Mannerist tradition lingered on in Lombardy, even in late 17th-century masters like Beinaschi (fig. 30) and Federigo Panza (d. 1713), both represented by several superb drawings (41). An interesting project for a cupola, drawn in a highly pictorial style, shows the "Adoration of the Holy Trinity." As the sheet bears the old inscription "del Padre Pozzi," it could be a work of this great painter-architect (B. 471). Another architectural project attributed to him, though relegated to the ranks of the "reserve gallery" and different in style, is probably also of Lombard origin (Wickhoff, S.V. 33).

The Genoese School, closely connected with that of Lombardy, became important in its own right only with the advent of Luca Cambiaso (b. Moneglia 1527 - d. Madrid 1583). As a draughtsman—and he is well represented in the Albertina in that capacity—he was of lasting influence. This was less for his cubist abstractions—which are over-rated today, and which served him primarily for spatial geometric orientation—than for the versatile idiom of his graphic expression, and the pictorial combination of his ambivalent media of audacious line and light wash. His sketches, through their animation by luminous transparency of chiaroscuro effects, bring both visionary-mannerist and realistic values into play and surprise by a freshness and vitality that seems thoroughly Baroque. This vitality was to become a lasting feature of the Genoese School, even before the Roman High Baroque made its appearance. Drawing, which he practiced from early childhood according to Soprani, was as much a passion with Cambiaso as with the Carracci or Palma Giovane (42).

The Genoese School further blossomed in the productive activities of the Procaccini, Rubens, Van Dyck, and some lesser Flemish masters who settled for longer or shorter periods in the flourishing Ligurian seaport and strengthened the native sense of engagement in the expression of heightened emotion and enjoyment of life. This juncture of favorable circumstances and the resource of creative impulses was a prerequisite for the continued link with Genoese artists who worked mainly, or entirely, away from their native city, like Benedetto Castiglione (Pl. 84) and Giovanni Battista Gaulli (Pl. 87). The achievements of these artists unmistakably depend on the same preconditions as those of Bernardo Strozzi, Valerio Castello, Biscaino, Piola, and Gregorio de Ferrari, right up to Magnasco. As in Venice and Milan, the effect of Mannerism lingered on, influencing the work of Strozzi, Castello and Biscaino, where it expressively combined with a joyful, sensual Baroque spirit. We should also not forget that Caravaggio stayed in Genoa in 1605 and may have given support to the realistic tendencies. The Albertina owns characteristic sheets by Cambiaso's immediate followers, such as Giovanni Battista Paggi, Bernardo Castello, Andrea Ansaldo, and their pupils Giulio Benso and Orazio de Ferrari.

There is a considerable body of Castiglione drawings in the Albertina, while the collection, on the other hand, includes only a single, though important, sheet of studies by Bernardo Strozzi, a very recent acquisition (fig. 44, B. 503). It presents on recto and

verso several studies—of heads, helmets, arms and legs—for the figures of Horatius Cocles and an Etruscan adversary, preliminary designs for the fresco of the Battle on the Bridge between Romans and Etruscans, which the artist began in 1623 in the Palazzo Centurione di Campineto at Sampierdarena. The verso also shows the figure of the Roman hero in a fine full-length drawing.

Other drawings, so far attributed to Strozzi, have to be reassigned (43). Valerio Castello, whose drawings are as rare as Strozzi's, is represented by his pupil Bartolo Biscaino, a gentler, more lyrical spirit (B. 545-547, 549). The Albertina also includes drawings by Domenico Piola and Alessandro Magnasco, whose work belongs to the final flowering of Genoese painting.

*

Malvasia's proud password *"Bologna docet"* does not apply to its original extent in the later decades of the 17th century. After Guido Reni's death (1642), the influence of the School of Bologna was confined to its own domain, and remained influential only for those artists from other regions who were particularly attracted and temporarily settled there, like Pier Francesco Mola and Mattia Preti, or others, like Simone Cantarini or Pier Francesco Cittadini, who maintained a link with Bologna. The school of the Carracci, by graphic training alone, pointed the way for several generations of artists and their influence is variously expressed in later work. Certainly, Bolognese taste was essentially determined by Guido Reni's lyrical Classicism, and by Francesco Albani's idyllic version of it. But Reni's style in painting and drawing, both because of and in spite of its idealization, was capable of many interpretations and contained a strong feeling for visual reality which did not escape his followers. Thus, Cantarini, Torri, and Cittadini, whose wider range of interest also embraced the work of Stefano della Bella and the Netherlandish-Roman painters of landscapes and popular life, as well as Pasinelli and his pupil Donato Creti (fig. 45, B. 300), drew more in Reni's linear manner, which by its freedom of flow and rhythm provided for an easy reconciliation with the luministic "Lombard" style. Elisabetta Sirani, the Albani pupil Cignani, and the latter's pupil Marcantonio Franceschino, on the other hand, mainly used broad brush strokes and washes, with soft chalk applications, a style no less typical of Reni and Albani.

As for the immediate contemporaries and followers of the Carraci, the Albertina preserves important sheets of those who remained in Bologna: Ippolito Scarcella from Ferrara, a pupil of Veronese's (B. 12); the independent, short-lived realist and rival of the *"incamminati,"* Pietro Faccini, who drew vital inspiration from Barrocci (B. 134); Alessandro Tiarini; Francesco Brizzi (Brizio); and Giacomo Cavedone, whose work reveals a particular affinity to Lodovico Carracci; Sisto Badalocchio, and others. Similarly well represented are Denys Calvaert, the first teacher of Domenichino, Reni and Albani, and Calvaert's pupil Giovanni Giacomo Sementi (B. 145, 148).

Of the few Bolognese standard-bearers of High Baroque art, Domenico Maria Canuti (1620-84), his pupil Giuseppe Rolli, and Giovan Antonio Burrini, the Albertina has significant sheets by Canuti and Burrini (B. 159, 203-208, 303). Canuti, who stayed in Rome for two periods, in 1651 and between 1672 and 1675, rivalled Lanfranco and Gaulli in his animated fresco style. His sharp delineations of lively movements, emphasized in wash, are reminiscent of Reni, whose pupil he was, whereas other impulses may have come from the early work of Guercino. Canuti's sketches and studies for ceilings like Mattia Preti's, show by figural proportion and perspective that the compositons were

conceived systematically to be seen from below (44). Burrini's scene of an ancient massacre (B. 290) recalls Faccini's drawings in its small-scale animation.

<p style="text-align:center">*</p>

In Naples and the Kingdom of the Two Sicilys, as in Genoa, a proper, continuous school of painting came into being only in the early 17th century, one destined for a widely influential role during the ensuing decades. The first impetus was provided by Caravaggio's activity in Naples, Malta, and Sicily during the years between 1607 and 1610. His influence can be traced through the history of Neapolitan painting until far into the 18th century. But neither he nor his immediate followers, Carracciolo and Cavallino, could properly be called draughtsmen (45). Thus, Giuseppe Ribera—a superb artist as an engraver also—deserves the credit for inaugurating the Neapolitan school of drawing. In many respects the counterpart to Veneto-Lombard trends, Ribera's drawing style is on the whole marked by a harsher and sterner realism and is less restrained in the dissolution of form.

Ribera's drawing technique, his lightly accenting pictorial stroke (fig. 26), was taken up by Mico Spadaro, Aniello Falcone, Salvator Rosa, and, lastly, by Luca Giordano; Giordano, however, combines a tender delineation with an often almost aggressive boldness of wash. Francesco Francanzano, who apparently also studied with Domenico Feti and Bassetti in Venice, is another follower to be noted in this connection (B. 579-81). The drawings of Massimo Stanzione, hailed by Dominici as "Guido Napolitano," are similarly related in line to the drawings of Ribera. The Albertina has one of his sketches for an "Epiphany" (B. 595). Stanzione's fluid Classicism may well have influenced Salvator Rosa. Rosa's river landscape with bathers who seem to be an organic part of the countryside is, in its sparse and expressive pen strokes, a spirited counterpart (46) to Rembrandt's later landscape drawings (fig. 56, B. 592). Its classical composition, on the other hand, forms a link to the Carracci, Claude, Poussin, Testa, Mola, and Dughet. Rosa's repertoire and manner of expression is versatile, unrestrained, and full of surprises. The "Contest between Apollo and Marsyas" (Pl. 85), an excellent example of his free brush technique, reveals his pagan poesy in which he approaches Castiglione.

Painting in Naples received another impetus from outside through Lanfranco, who, as a result of his twelve years there (1634-1646), formed a school based on his frescoes with their High Baroque, space-filling emotion and graceful animation. Among the native artists, his style inspired particularly Mattia Preti and Luca Giordano.

Preti had studied with Cortona in Rome and worked with Guercino in Bologna. He was one of the most productive of Caravaggio's and Ribera's successors, enriching the range of their realism by a differentiation of color; also, he was one of the first to transfer Caravaggio's style to large-scale decorative fresco painting. His drawing style, combining pictorial and plastic effects, significantly differs from Ribera's and Rosa's in an intensification of form and rhythm. Its spontaneous sensuality is reminiscent of Guercino and Cortona, but appears even more impulsive (Pl. 83). Luca Giordano and Francesco Solimena were repeatedly influenced by his manner.

Luca Giordano was as versatile a draughtsman as he was a painter, so that attributions are often difficult. His work resembles, and is often mistaken for, that of Ribera, Salvator Rosa, Lanfranco and Preti, but also that of Guercino, Mola, and Cortona, and even Cambiaso. The carefree character of his presentation and the quickness of his spirit are most aptly reflected in his epithet "Fa Presto." Quite a few of his rapid *"pensieri"* and

45. Donato Creti. *Little Concert.*

"*macchie*" unconsciously anticipate Ricci and Tiepolo. The Albertina has many of his drawings in their different styles, some of them under the names of other artists. A number of sheets were recently eliminated by Walter Vitzthum as the work of Francesco Lamarra, a late 16th-century draughtsman and engraver (47).

The "Celestial Vision" (fig. 47, B. 700) probably originated in Giordano's later years when, as Dominici noted, he showed interest in the graphic art of Preti. The design for a ceiling, which is fascinating in its atmospheric breadth, shows the Virgin, Angels and Saint in adoration of the Child, above them God the Father and the Dove of the Holy Ghost in a radiant nimbus (48). The conception of this sheet was apparently preceded by the drawing of a Guardian Angel (B.698), also intended for a ceiling, and by the design for a dramatic ceiling fresco of the Last Judgment in the Church of San Lorenzo in the Escorial (B.697), of which there is a larger, signed version in the Krautheimer Collection in New York (49). Luca Giordano was called to Madrid in 1692 and worked there until 1702. The drawings mentioned, which in their spatial and atmosphe-

46. Salvator Rosa. *Riverside scene with swimmers.*

47. Luca Giordano. *Celestial Vision.*

86

ric development and their *"bella, vaga e capricciosa maniera"* (Dominici) resemble the late paintings of "Luca Fa Presto," foreshadow the art of the 18th century.

In the 18th century the main centers of Baroque, late Baroque, and Rococo in Italy were Naples and Venice. Artists in quest of knowledge came there from regions as far away as the North of Europe, but mostly from France, South and Central Germany, Switzerland, Austria, Bohemia, Moravia, and Silesia. It was in Naples and Venice that the most desirable commissions were awarded, and it was from there that the leading masters were called to courts in Italy and abroad to paint frescoes and important pictures. In the field of music, too, Venice and Naples had risen to eminence.

In Naples, Francesco Solimena (b. 1657 Canale di Serino in the Province of Avellino - d. Naples 1747) continued to travel the road first taken by Lanfranco, Preti, and Luca Giordano in the creation of a large-scale decorative Baroque style. In contrast to his predecessors, especially to Luca Giordano, to whom he owes a great deal artistically, Solimena —*mirabile dictu*—kept to *disegno* both in his drawings proper and in his paintings, in which linear treatment prevails and the basic law of composition is clearly discernible in rhythmic diagonals and patterns movement following lozenge-diagrams. Of course, Solimena was no designer in the earlier Tuscan sense. His father Angelo, a local painter in the environs of Salerno, directed his very talented and largely self-taught son toward the principles of his own teacher Francesco Guarini—himself a pupil of Massimo Stanzione (the "Guido Napolitano")—and prevented Solimena from one-sided indulgence in the *"bella, vaga e capricciosa maniera"* of Luca Giordano. The brief period—only a few days —that Solimena spent with the Domenichino pupil Francesco di Maria, whose *"buon disegno"* was much admired, may have had a similar effect, though Solimena immediately quarreled with him, as Maria rejected the generally accepted contemporary concept of painting. In Naples, unlike Rome and Bologna, Caravaggio's artistic heritage—however much transformed by Preti and Luca Giordano—remained outstanding. Solimena continued to model his style on works by Cortona and on engravings after his paintings in Naples, which furthered the "Tuscan line" in his drawing. He also patterned himself on Preti and Lanfranco: *"Operando continuamente"*—Dominici observes—*"Francesco venne a stabilirsi un fondato disegno ed un ottimo chiaroscuro, osservato più che d'ogni gran maestro del cavalier Calabrese, a da Lanfranco, le di cui opere egli sovente andava considerando, e questo furono i due poli, ove si aggirò sempre lo studio della sua mente."* As it was to Cortona, *disegno* to Solimena was a factor imparting firmness and stability to his painting and drawing, however pictorial the total effect. In this, probably, lay his power to create a school, and it made him one of the most sought-after teachers of his time (50). The Albertina has twenty-three sheets by Solimena, some with drawings on both recto and verso (B. 622, 624-645). Only one highly significant example, however, has been selected here to characterize the artist and his wide-ranging school (fig. 48, B. 633): a design for the Apotheosis of Louis XIV, painted in 1701 for the Papal Nuncio Gualtieri as a present for the Sun King. This picture duly raised Solimena's reputation among contemporary princes. The chalk and charcoal drawing with a light bistre wash is of high atmospheric quality. The representation of the scene, in the guise of a monument, shows the King's likeness held and viewed by the Royal Virtues. Below, Pallas Athena directs Historiography to immortalize the hero's deeds in the Book of History that rests against the head of Chronos, while an allegory of Eros vanquished in the background completes the composition. In the painting, later in the Stroganoff Collection and from there transferred to the Hermitage, the contrast of lights is stronger, whereas the rendering of

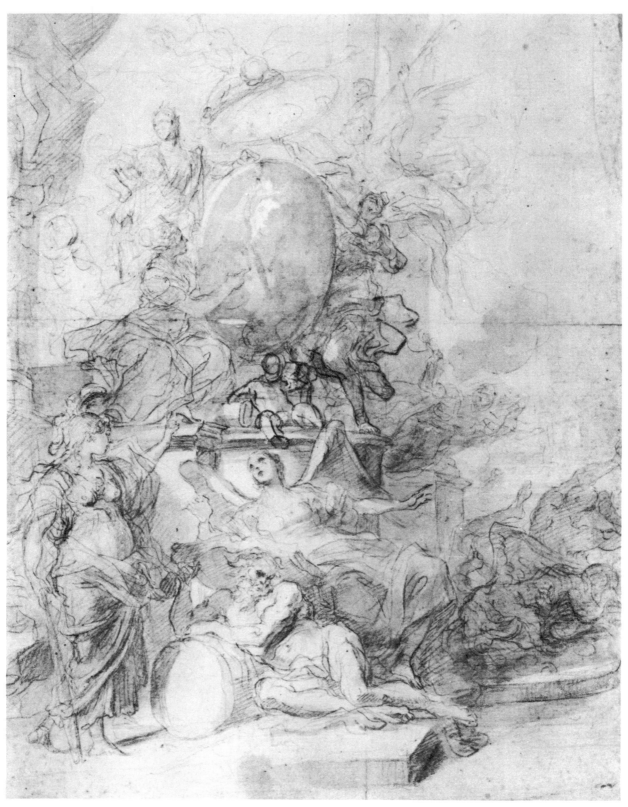

48. Francesco Solimena. *The Apotheosis of Louis XIV.*

49. Pietro Leone Ghezzi. *The Painter portraying a group of friends.*

50. Domenico Ferretti. *Coronation of Flora.*

the figures is simplified and more clearly defined plastically. For this Apotheosis, a frequent subject of the day, Solimena had the examples of Rubens, Bernini, and Le Brun. Prince Stroganoff in his time had Louis' portrait overpainted with that of Catherine I (51).

One of Solimena's colleagues in Naples was a pupil of Luca Giordano: Paolo de Matteis (1662-1728) who, highly praised by the English philosopher Shaftesbury, later studied in Rome under Maratta and then in Paris. Matteis' "Queen of Sheba before Solomon," an important sheet dated 1697 (B. 619), differs widely from Solimena's temperamental style in its purely pictorial construction and almost classically balanced composition. A closer relation to Solimena is apparent in the work of Giacomo del Po (1654-1726) who, trained under Maratta's influence, anticipated Rococo art with a predilection for bright colors ("*vaghi e vivi colori*": Dominici). His "Education of the Holy Virgin" (B. 615) is reminiscent of Solimena in the vivacity of the graphic stroke, but lacks his fascinating quality. Solimena's school and the immediate as well as the wider circle of his followers are abundantly represented in the Albertina collection: Sebastiano Conca (b. Gaeta 1608- d. 1674 Naples), one of his first pupils, who studied and worked under him for sixteen years—"*sotto la rigorosa disciplina di esso apprese egregiamente l'arte del bel disegnare,*" Dominici notes—later worked mainly in Rome, where, without being unfaithful to his master, he explored the works of Maratta, and over two periods, from 1729 to 1732 and from 1739 to 1741, was the head of the Accademia di San Luca. Corrado Giaquinto, Gregorio Guglielmi, Paul Troger, and Raphael Mengs were his most important pupils, Giaquinto also was taught by Solimena himself. Guglielmi, born in Rome in 1714, was active in Vienna as well as in Augsburg and other German cities, and finally worked in St. Petersburg, where he died in 1773. The Albertina has a superb series of his sheets (B. 673-679), mostly ceiling designs of unequalled beauty, in which Solimena's and Conca's expressiveness of line and pictorial élan are refined and intensified to the highest degree.

The Albertina also owns sheets by Solimena's most prominent pupil, Francesco de Mura (Naples 1692-1782), who continued his master's late style in a free, Rococo-like vein. The Albertina's holdings of Neapolitan Baroque drawings are rounded off by a group of multifigured ceiling designs by Fedele Fischetti, characterized by vibrant animation and a delicate sketching style in the manner of Diziani (cf. fig. 52), plus several highly spontaneous compositional sketches in pen and brush by Domenico Mondo, one of Solimena's last pupils, who in his freedom of graphic form follows Luca Giordano.

Like many of the great painters of Naples who perfected their art elsewhere, the native Neapolitan landscape artist Alessio de Marchis continued romantic-visionary landscape painting in the vein of Salvator Rosa, first in Rome and then, as his epithet indicates, in Umbria and the Marches.

*

After Maratta's death, Solimena's pupil, the Neapolitan Sebastiano Conca, became Rome's leading painter and draughtsman. Among the artists of the first half of the 17th century well represented in the Albertina is Bernardino Luti, a native Florentine (b. 1666- d. Rome 1724) and late follower of Maratta, whose pleasant, soft chiaroscuro style, as exemplified by his chalk and pastel drawings (R. 813-15), approaches the taste of French Rococo. Furthermore, there were Luti's pupil Placido Costanzi, and Marco Benefial (Rome 1684-1764), an important forerunner of Classicism, who schooled himself on the works of Do-

90

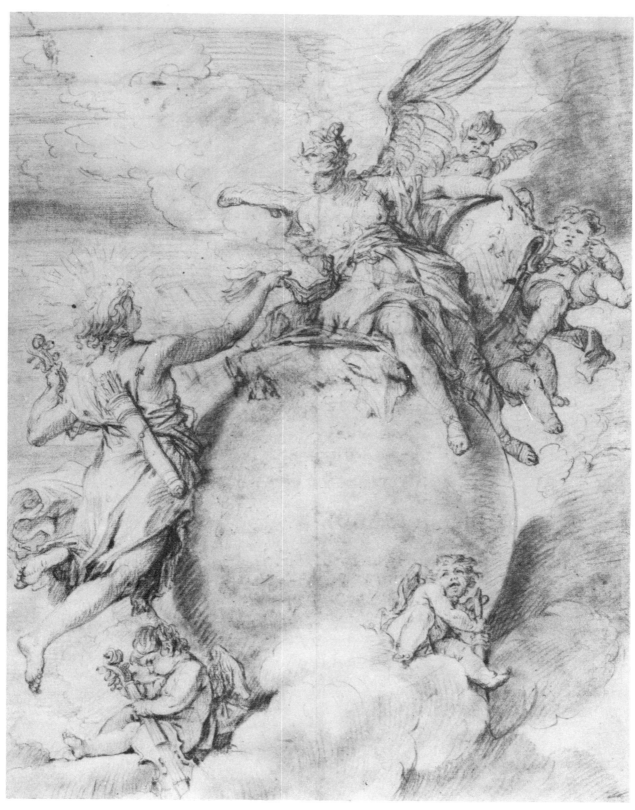

51. Sebastiano Ricci. *Allegory with Apollo.*

menichino and Poussin, insisting on the intensive study of natural form. Raphael Mengs, among others, learned life drawing from nude models in Benefial's school.

The collection is rich in caricatures by Pier Leone Ghezzi, to whom many famous personalities sat, for instance (52) the scholar-collector Philipp Baron Stosch, shown in the company of Roman antiquarians (fig. 49, R. 892). Ghezzi's achievement in disciplining the caricature style of Bernini, Guercino, and Mola into the strict graphic forms of Villamena and Callot secured a great future for this art form (R. 837-894). The Albertina also owns numerous sheets by his successor, Giovanni Battista Itinerari, who later worked in Dresden and in Warsaw, where he died in 1761.

Saxony and Poland were also the scene for the creative activity of the Roman architect Gaetano Chiaveri (b. Rome 1689-d. Foligno 1770), known as designer of the Court Church in Dresden, a posthumous follower of Borromini. Chiaveri entered the service of Czar Peter the Great and Catherine I, and prepared the designs—now in the Albertina—for the Church of The Holy Trinity in Korostino and for the St. Petersburg Academy of Sciences. The Albertina preserves, in addition, a considerably larger number of architectural drawings by Chiaveri's Florentine successor in Russia, Bartolomeo Francesco Rastrelli, chief master of "Russian Rococo" style. In 1715, he had moved together with his father, the sculptor Bartolomeo Carlo Rastrelli, from Paris to St. Petersburg, where he died in 1771, after an extremely productive life (cf. Batovsky and Denisov-Petrov).

The first half of the 18th century was also the most creative period for Giovanni Paolo Pannini, painter of vedute and ruins, whose achievement in fusing fact and fiction served as a model not only for his most important successor in Rome, the Venetian Giovanni Battista Piranesi, but also for Canaletto, Natoire, Hubert Robert, Fragonard, Weirotter, and other Northern masters of this branch of painting. One of his most prominent pupils, working in Paris, was Niccolò Servandoni.

The greatest Roman history and portrait painter in the second half of the 18th century was Pompeo Batoni from Lucca (b. 1708-d. Rome 1787), a friend of Winckelmann and Mengs, who continued, in a way, the work of Benefial. He turned away from the school of Conca and Masucci, a student of Maratta in the master's late period, to school himself mainly on the works of Raphael and on nature itself. His lyrical Classicism distinguishes him from Mengs and even more from Jacques Louis David, to whom in old age he left his palette. Batoni's ideas live on in the work of many of his Italian contemporaries and successors in Rome: Vincenzo Camuccini, Domenico Cavi, Giuseppe Cades, Giuseppe Battista Cipriani, Stefano Tofanelli, Felice Giani, and others (R. 944-73).

The most important figure of the 18th-century Florentine School was Domenico Ferretti (Florence 1692-1766), by whom the Albertina owns a self-portrait, a Harlequinade, and two larger compositional studies: a bacchic scene, of which the Uffizi has another version, and the design for a mural showing Flora crowned with wreaths by nymphs and satyrs. In these last two drawings (53), the rivalry between mood-creating wash and graphic definition is especially vivid and in the spirit of best Tuscan tradition (fig. 50, R. 111). Besides the sheets of Ferretti, the Albertina also preserves drawings representative of other artists still belonging to the Florentine sphere of Late Baroque style, like Filippo Gherardi, Sebastiano Galiotti—a pupil of Alessandro Gherardini's who worked in Genoa and Northern Italy from 1729, and died in 1746 in Vico near Mondovi—and the Sienese Giuseppe Nicola Nasini.

The Florentine School also produced Francesco Bartolozzi, well known for his classical portrait drawings, miniatures and engravings. Bartolozzi (b. 1727), like Batoni the son

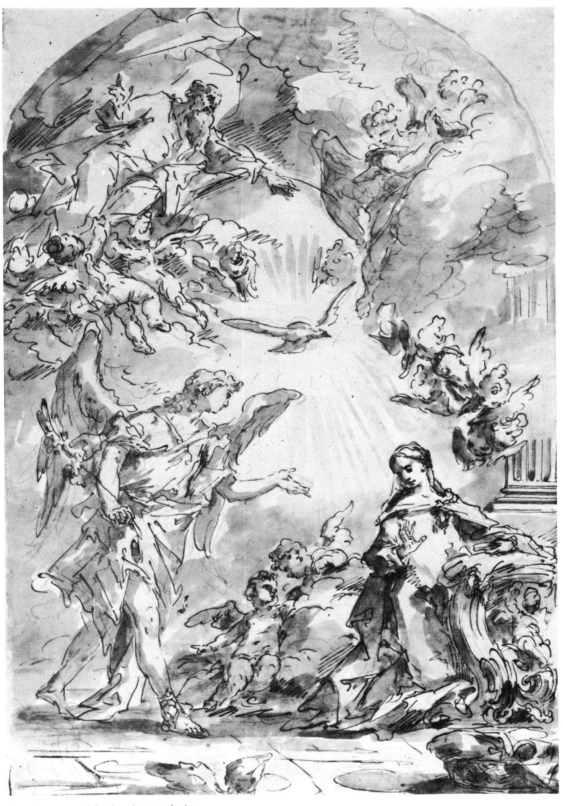

52. Gaspare Diziani. *Annunciation*.

of a goldsmith, went to Venice in 1745, moved to England in 1764, and in 1802 settled in Lisbon, where he died in 1815. As a native Florentine, he looked for clarity of line in the works of Venetian and Bolognese artists, which he often engraved. He is splendidly represented in the Albertina by a number of excellent specimens (V. 430-456).

<p style="text-align:center">*</p>

Donato Creti (b. Cremona 1671-d. Bologna 1749) ranks among the most gifted painters and draughtsmen of the Bolognese School at the end of the 17th and in the first half of the 18th century. A pupil of Pasinelli, he continued the lyrical Classicism and poesy of Guido Reni's school in historical, landscape, and genre painting as well as in frescoes, in a highly delicate and intimate style touched by the spirit of Rococo and awakening Neoclassicism, One of his most felicitous creations is the drawing of a concert scene with two youths and a girl playing flute and lute (fig. 45, B. 300). It is an early work, from 1687, vividly suggesting musical absorption and sensibility (54). Depth of feeling, a characteristic feature of Bolognese art from the days of Lodovico Carracci and Guido Reni, also marks the portrait of a child by Ubaldo Gandolfi (Pl. 100). Like his younger brother Gaetano, he was a successful painter of frescoes and historical scenes, artistically ranging between Canuti and Tiepolo (B. 326-46).

Francesco Simonini, painter of battle scenes and draughtsman, born in Parma in 1689, also worked in Bologna. The Albertina possesses a group of his sheets with great smokey battles (B. 377-385) that link him with Salvator Rosa and Jacques Courtois. Simonini later worked in Venice as Count Johann Matthias Schulenburg's painter and brother-in-arms, dying there in 1753.

The considerable body of architectural and theatrical drawings in the Albertina includes works by the well-known theater architects Ferdinando and Giuseppe Galli-Bibiena. The Galli-Bibienas had their headquarters in Bologna; their work flourished particularly at the Viennese imperial court and spread from there to almost every European court of any importance (55).

<p style="text-align:center">*</p>

In the 18th century, the arts in Venice came to a final great flowering which radiated far beyond the boundaries of the Old Republic. The "Settecento Veneziano," clearly distinguishable from the prevalent "tenebroso" of the 17th century by its open and predominently light palette, was inaugurated by Sebastiano Ricci, a versatile and highly talented virtuoso. He was, like Solimena, much sought as a teacher, but he was frequently abroad on long journeys to further his career: in Rome, Florence, Milan, Vienna, Paris, and London. The Albertina owns, besides the more usual pen-and-wash drawings, some of his chalk drawings, among them the allegorical scene (fig. 51, V. 243) of Apollo handing a libretto to an angel seated on a globe and holding a shield: possibly the preparatory design for an engraving intended as a title- or dedication-page in a book of poetry or music (56).

Ricci's circle and his contemporaries can be well studied at the Albertina: his nephew Marco Ricci, who revived Venetian landscape art (Pl. 90); the versatile Antonio Pellegrini (V. 247, 335, 417), who had worked with Paolo Pagani in Milan and met the Riccis in London on his own far-flung travels; Jacopo Amigoni, born in Naples (d. Madrid 1752) and at first schooled in Solimena's circle—rightly called "felicissimo nei soggetti arcadici (as shown by a drawing of Rebecca by the well (V. 318)... e nel ritratto" (Pignatti);

Giovanni Battista Pittoni (Venice 1687-1767), by whom the Albertina also has a major work (57), the sketch for the painting "St. Peter receiving the Keys" in the Louvre (V. 280); Mattia Bortoloni, Giovanni Battista Crosato, Brusaferro, Sante Piatti, Gian Antonio Guardi, and, last but not least, Gaspare Diziani (b. Belluno 1689-d. Venice 1767). Diziani was Sebastiano Ricci's most faithful pupil and follower. His Annunciation (fig. 52, V. 238) used to be attributed to Ricci himself, or to Fontebasso. Ricci's and Diziani's drawings are so similar that they were already mistaken for each other in the 18th century, as indicated by Temanza's remark in a letter to Mariette, published by Ivanoff: "*Quelli di Diziani che non vi sembrano di lui, sono della prima maniera, che ricorda quella del Ricci suo maestro...*" Diziani's line is stricter than Ricci's, and his figures, especially in his later work, are often elongated in a Mannerist or Rococo fashion—a feature also occurring in this sheet, which equals any of Ricci's in pictorial accomplishment; stylistically it is linked by Pignatti with a picture painted in the sixteen-fifties, now in the Museum of Belluno. The Museo Correr in Venice has two variants, apparently done before the Albertina drawing (58).

In contrast to the worldly Ricci, Giovanni Battista Piazzetta (Pl. 91) was an introvert who did not travel much, felt his artistic gifts to be a personal obligation, and like Caravaggio and Rembrandt, searched for psychological depth. Like his Dalmatian contemporary Federico Bencovich, who admittedly aimed at formality of expression (also represented in the Albertina; A. K. Venice 1961 No. 84/85), Piazzetta continued the chiaroscuro painting of the Venetian Seicento masters, who included his teacher Antonio Molinari. He achieved delicate differentiation by means of light and color, enriched through the constant study of life, which is also evident in his famous engravings and life-studies. Like Bencovich, Piazzetta studied in Bologna with a late follower of Guercino, Giuseppe Maria Crespi, who admired his youthful accomplishment. Bencovich's studies with Cignani probably influenced his stricter feeling for form. Besides an important 1735 self-portrait by Piazzetta (Pl. 91), the Albertina possesses a group of impressive studies, including the sheet with the figure of a shepherd or shepherdess (fig. 53, V. 249) which the artist used in his well-known painting "L'Indovina" of 1740, now in the Accademia in Venice. There are also several book illustrations and studies of heads by his pupil Maggiotto in the Albertina.

Piazzetta's influence stretched beyond the circle of his immediate pupils, among whom were *oltremontani* like Paul Troger and Franz Xavier Palko, and extended to such painters as Pittoni and Tiepolo. Pittoni appears to be indebted to Bencovich also in aspects of form.

Halfway between Ricci and Piazzetta comes the pleasant, sensual style of the Comachese Carlo Innocenzo Carlone (60), whose work spreads all over Northern Italy, Southern Germany and Austria (Pl. 93).

Tiepolo has roots both in Ricci and Piazzetta; their influence is seen most in the early works, but also pervades his later period in realistic moments. Tiepolo first studied under Gregorio Lazzerini, a minor artist, but one who tended towards the clearer palette. He was a good teacher and, among others, taught Diziani. Tiepolo was not only one of the most productive painters, but also, like Guercino, an indefatigable creator of drawings that never wavered in quality. They are extremely varied in content, style, and technique, and the Albertina has several important examples of different periods: a study of a head, in the manner of Piazzetta, only less dark and weighty in expression (V. 251, Venice 1961 No. 106); sheets intended for engraving on copper (Venice 1961 No. 107/108); and early and later drawings in red chalk and pen-and-brush (Pl. 95), among them a

53. Giov. Batt. Piazzetta. *Pastoral figure.*

group of very beautiful figure studies, seen from below, from the folio of sketches "*Sole figure per soffitti,*" that was found with other sketchbooks in Tiepolo's studio (Pl. 96). His vedute and landscapes are rare, but the Albertina has one example: a drawing of a group of houses (fig. 54, V. 301), highly individual, a counterpart to studies by Marco Ricci, Canaletto, or Francesco Guardi, Tiepolo's brother-in-law. Pignatti and Knox date similar studies at around 1759 (61). Tiepolo's younger son Domenico developed the outward-looking, nature-oriented side of his father's work and proved himself a thoroughly independent creative artist in the field of landscapes, genre and animal pieces, as well as in mythological subjects (Pl. 97). The Albertina also has drawings by Tiepolo's elder son Lorenzo (V. 287, 317: a portrait of Carlo Goldoni).

Francesco Fontebasso (Venice 1709-1769), a student of the mature Sebastiano Ricci, closely linked himself with Tiepolo. The Albertina owns several sheets by Fontebasso that are important for an understanding of his draughtsmanship, often taken for the hand of Diziani or others. Fontebasso has a pronounced leaning to linear, graphic drawing that points to the influence of Donati Creti, whom he may have met when he spent some time in Bologna after studying in Rome. He comes closest to Tiepolo in his grand pictorial drawings of historical subjects (62) that at the same time recall the paintings of Paolo Veronese (V. 331-334 E. C. Venice 1961 No. 95).

The masters of the Venetian vedute and landscapes are represented in the Albertina almost without exception, from Marco Ricci, who renewed the trend, to Francesco Guardi and Bison, who carried it forward into Classicism. Marco Ricci, who also had a gift for staffage and genre drawing, comparable in this to Stefano della Bella and Ghezzi, influenced two major fields: natural landscape painting—with a predilection for the motifs of the Venetian foot hills once beloved by Titian and Campagnola—and the painting of ruins. His landscapes, serene, dissolved in light, and deliberately enlivened by various figurative scenes, were developed in Rococo spirit by his pupil Giuseppe Zais (b. Forno di Canale 1709-d. Treviso 1784). Francesco Zuccarelli, who settled in Venice only after Ricci's death in 1730, sought to give Ricci's landscapes a more solemn musicality, corresponding to the Roman tradition with which he had been brought up. His turning towards the art of Claude was especially applauded in England, where he worked for many years. Giuseppe Zais also painted and drew battle scenes, thus following Francesco Simonini. Simonini also influenced Francesco Casanova (b. London 1727), brother of the famous adventurer, who grew up in Venice, moved to Paris in 1751, went to Dresden, returned to Paris for the years from 1757 to 1783, and then lived in Vienna, where he died in 1802 (at Brühl near Mödling). The Albertina owns some of his battle-pieces as well as arcadian scenes (V. 379, 388 B, 774) related to those of Zuccarelli.

Antonio Canale, called Canaletto, founded the worldwide fame of Venetian vedute (which in fact had existed in some form in Venice from the days of Gentile Bellini). This kind of townscape and animated scene of daily life was popularized by Canaletto

54. Giov. Batt. Tiepolo. *Landscape with a group of houses.*

97

55. Antonio Canal called Il Canaletto. *The Brenta Canal near Padua.*

all over Europe, especially through his activities in England (1746-53), and won him numerous followers. He surpassed his immediate predecessor, Luca Carlevaris, pupil of the Netherlandish-Roman vedutist Gaspard van Wittel, in his engaging and expressive vitality, qualities that Guardi was to enhance still further. "The Brenta Canal near Padua" (fig. 55, V. 358) demonstrates all the characteristics of his art: clarity of perspective and space, atmosphere and distance, as well as his particularly skillful calligraphic synopsis of detail which, in its sureness, recalls masters such as Callot, the early della Bella, or Canaletto's Roman contemporary Pier Leone Ghezzi, with whom he shared a liking for subjects lending themselves to caricature (63).

Francesco Guardi, younger brother and pupil of Antonio Guardi—expressive, color-loving painter of historical scenes that have only recently found appreciation again—worked with his brother but is linked with Canaletto. As for his "views," heightened images of daily life, he was almost unequalled in the distinctiveness of his simplifying pen- or brush-stroke and in the suggestion of mood and atmosphere; in later works this atmosphere rose to visionary force in form and color. The Grand Canal (Pl. 99) and the hall of a Baroque palace (fig. 56, V. 378)—reminiscent of the similar rendering of Ca' Rezzonico and Pesaro by Baldassare Longhena— clearly show this intense perception of vibrant atmosphere and space-dissolving light. A similar conception governs his later genre-pieces and scenes of social life, in which he transformed Pietro Longhi's world in the light of his own spirit.

Venetian art, as represented by Marco Ricci and Giuseppe Zais, who also composed ruin-fantasies, and by Tiepolo's "Capricci," provided the point of departure for the work of

98

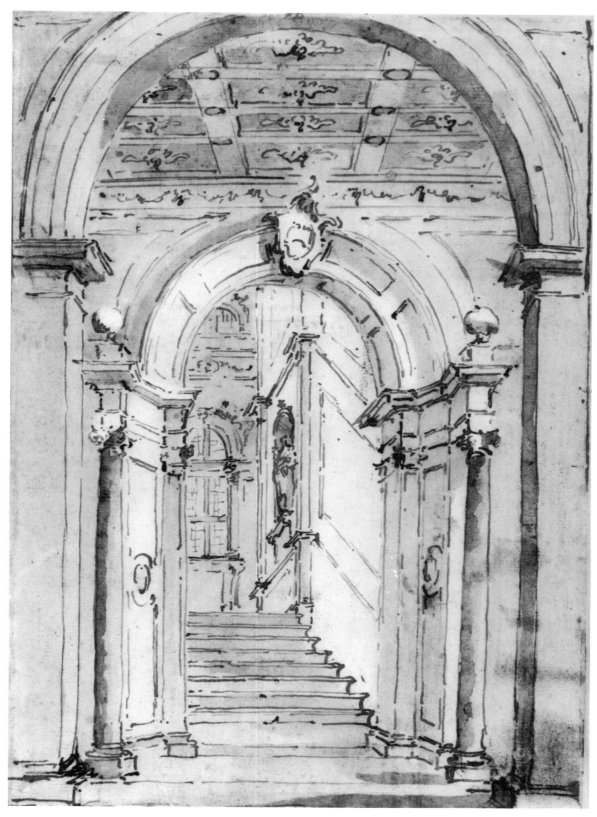

56. Francesco Guardi. *The hall of a baroque palace.*

Gian Battista Piranesi (b. Mogliano 1720), who developed in Rome under the influence of Panini and Classical antiquity and became the elegiac-theatrical witness of past splendors. The Albertina collection includes several of his drawings. Fantastic compositions with ruins and more-or-less sinister scenes, suggesting, though not directly inspired by Rome's past, are also reflected in drawings by Diziani and Francesco Guardi, and later by Giuseppe Bernardo Bison (b. 1762, Palma-d. 1844, Milan). In his atmospheric architectural drawings, he linked the fading Rococo with Classicism and Romanticism (V. 458-61).

Among the Venetian history and figure drawings of the second half of the 18th century, special mention should be made of those rapid pen-and-brush sketches attributed by Giuseppe Fiocco to Giustino Menescardi, a native of Milan, which in their suggestive rather than factual character recall the Neapolitan Domenico Mondo. Different in character is a group of compositional drawings by Pier Antonio Novelli (Venice 1729-1804), whose technique was definitely linear. He also engraved and painted and was active as an illustrator and writer. Novelli had the gift of working in the style of others—Rembrandt, Piazzetta, Tiepolo—and Bartolozzi, whom he may have met in Venice. Nevertheless, his drawings are more Rococo in line and open, although later in Bologna and Rome he more closely followed the art of the Carracci and Reni, and the Classicism of Battoni and Mengs (V. 235, 395-404). Alessandro Longhi (Venice 1733-1813), son of Pietro Longhi, worked chiefly in charcoal or chalk, like his father. The Albertina owns his fine study of a Cavalier (V. 394).

Four life studies by Antonio Canova (b. 1757 Possagno-d. 1822, Venice), the great sculptor of the Neoclassic period, and two designs of his masterpiece, the memorial for the Archduchess Marie Christine, wife of Albert of Saxe-Teschen, in the Augustiner Kirche in Vienna, mark the end of *Settecento Veneziano* and the beginning (65) of a new epoch (V. 462-65 - B. 768-769).

ECKHART KNAB

(1) See Grassi, Ivanoff and Roli, where text and full index of sources are published and discussed.

(2) Mancini I, p. 109 - Mahon, Studies, passim - E.C. Bologna 1956, p. 55, 62.

(3) Pen and ink, wash, over preliminary pencil drawing. 200 x 144. Inv. 2088. B. 73. - Wickhoff, S.B. 132. - E.C. Bologna 1956, No. 6. - Roli, Pl. 2. (3a) Pen and ink, wash. 305 x 226. Inv. 2135. B. 101. Prov: Mignard, Crozat, Mariette (Lugt 2097). E.C. Bologna 1956, No. 100 (see also 98, 99, 101).

(4) See Cesare Gnudi in E.C. Bologna 1956, p. 30 f. - Giulio Carlo Argan, La Rettorica e l'Arte barocca, Atti del III. Congresso Nazionale degli Studi Umanistici, Rome 1955.

(5) See B. 84-94, 97-99, 114. - Wittkower, passim. - E.C. Claude 1964, No. 9.

(6) Mahon, Studies, p. 252 f. - E.C. Bologna 1956, p. 54. - Wittkower, p. 13. Also quoted by Malvasia I, p. 480 (Edition 1678).

(7) Pen and bistre. 217 x 315. Inv. 2099, Prov.: Mariette (Lugt 2077). - Wickhoff, S.B. 143. - E.C. Claude 1964, No. 38 (and 39). - cf. Pope-Hennessy, No. 1099, 1110, Pl. 1, 2, 3. - E.C. Bologna, No. 161. - Keith-Andrews, Fig. 336.

(8) Chalk, pen and bistre, brush and ink, wash, white body color on buff prepared paper. 204 x 304. Inv. 2773. Old signature: "Manfrede" Prov.: Mignard and Fries (Lugt 2903). R. 489. - Wickhoff, S.L. 208. - Schönbrunner-Meder 787. - Meder, p. 636. - Axel Romdahl, in: Tidskrift for Konstvetenskap, Stockholm 1920, S. 116 ff. - E.C. Callot 1968, No. 745. - Mancini compares Manfredi to Caravaggio as follows: "...e convenir nella maniera del Caravaggio, ma con più fine unione e dolcezza" (I, p. 251).

(9) See Friedlaender, Caravaggio-Studies. - E.C. Rome 1969, No. 1 (Vitzthum).

(10) Signed: "Jusepe Rivera". Pen and ink, bistre wash. 331 x 222. Inv. 13072. - Schönbrunner-Meder 1206. - Benesch, No. 229. - E.C. Callot 1968, No. 748.

(11) Pencil, pen and ink, bistre wash. 167 x 270. Inv. 761. R. 454. - Wickhoff, S.R. 866. - See also Forlani and Herwarth Röttgen, Zs.f.Kunstgeschichte 27, Berlin 1964, p. 201 ff. (with Bibl.)

(12) See Forlani, Pl. 91 and E.C. Bologna 1956, Disegni, Pl. 75, 76.

(13) Lit.: Meaume 138, 139. - Lieure 188, 1416.

- Ternois, p. 160. - E.C. Callot 1968, No. 257, 519. - Forlani. - E.C. Boscoli, Florence 1959. (Forlani).

(14) See Ternois and E.C. Callot 1964.

(15) Also so called by Lodovico Cigoli. Lit.-: Passeri-Hess, p. 119. - Hess, Tassi. - E.C. Claude 1964, p. 39 ff. - E.C. Callot 1968, No. 788.

(16) Callot and Filippo Napoletano tried their hand in this area as well, as did Paul Bril and other Netherlanders (Vroom, Wieringen, Platte-Montagne).

(17) Chalk, white highlights, buff paper. 250 x 376. Inv. 932. R. 825. Prov.: Mariette (Lugt 1852). Wickhoff. S.R. 1042.

(18) For example B. 373. See also Bean - Vitzthum and Voss, passim. - The Albertina also has a study of a hermit by Lanfranco, of a later date, heightened with white chalk. Inv. 2816, Wickhoff, S.L. 254, related to the head-studies in the Collection Janos Scholz (E.C. New York, No. 32).

(19) Charcoal, white highlights. 425 x 316. Inv. 23 234. B. 460.

(20) Charcoal and chalk. 384 x 730. Inv. 14 217. R. 712. Prov.: Prince de Ligne. Wickhoff, S.R. 996.

(21) Graphite. 433 x 303. It. AN. Rome 291. Drawing to be engraved in copper in the "Opus Architectonicum Equitis Francisci Borromini" (Ed. Sebastiano Giammini, Rome 1925), approx. 1666. Lit. Hempel, 38. - E.C. Borromini, Rome 1958, No. 70 (Heinrich Thelm).

(22) R. 742: Chalk, 356 x 245. Inv. 1092. Wickhoff, S.R. 1205. Ferri's and Franceschini's oil sketches for the Annunziata ceiling are in the Galleria Corsini in Florence.

(23) Chalk, white highlights, blue/grey paper. 397 x 258. Inv. 23 375. B. 165 cf. R. 670.

(24) Red chalk; pen and ink. 287 x 206. Inv. 23 918. R. 646. cf. E.C. Mariette, Paris 1967, No. 146.

(25) Lit.: Hoogewerff. - Briganti, Proporzioni III, Florence 1950, p. 185 ff. - Knab, Die Anfänge des Claude Lorrain, passim. - E.C. Claude 1964, passim.

(26) See Posse, Sacchi, p. 35 ff.

(27) Blunt 1960 (Fig. 71, Pl. 24, 28). - E.C. Düsseldorf 1967 (Pl. 3, 8, 12). - E.C. New York 1967, No. 73 (Beispiel des malerischen Stils). Sacchi

also produced the altar scene attributed to Strozzi in the Albertina, Wickhoff, S.L. 264, as Walther Vitzthum recognized.

(28) Marabottini, Testa. - R. 527: pen, bistre and ink. 204 x 188. Inv. 975. Prov.: Mariette (Lugt 1852). - Wickhoff, S.R. 1086. - E.C. Claude 1964, No. 231.

(29) B. 280: Pen and ink, bistre wash. 190 x 185. Inv. 24 551. E.C. Claude 1964, No. 237.

(30) The main body of Grimaldi's drawings, which sometimes rival Claude's in presentation of atmospheric landscapes, is in the Teyler Museum in Haarlem. The Albertina chiefly owns sheets in a style that is close to engraving. (B. 129-132 a.o.).

(31) See Kutschera.

(32) Red chalk, heightened in white, blue/grey paper. Inv. 1082. R. 772. Prov.: Prince de Ligne, Wickhoff, S.R. 1194.

(33) See: Schaar, E.C. Düsseldorf 1967, Pl. 33, 46, 51. - Dreyer, E.C. Berlin 1969, Pl. 49 - 51, 53, 54.

(34) Red chalk, white heightenings, blue paper. 265 x 321. Inv. 23 372. R. 770. cf. Schaar, a.o., pl. 64 - 66, 76, 82, 95, 96. Dreyer, a.o., Pl. 50 (113), ·60-67.

(35) Wickhoff, S.R. 1190, 1191 (Fig. 42): Red chalk, pen and ink, grey wash, heightened in white body-color; blue paper. 341 x 263. Inv. 1079. Prov.: Mariette (Lugt, 1852). Lit.: Vitzthum Maratta. - See also: E.C. New York 1967, No. 111-115. - Roli, pl. 173, 174. - Schaar, a.o., ill. 21, 24, Pl. 57, 71, 72, 85.

(36) Chalk, white heightening, grey paper. 215 x 265. Inv. 1146. R. 799. Old inscription: "G. Chiari" (Signature). Wickhoff, S.R. 1265. - Schönbrunner-Meder 1291.

(37) Red chalk, pen and ink, red/brown prepared paper. 324 x 224. Inv. 1141. R. 796. - Wickhoff, S.R. 1260. A variation came on the Vienna art market in 1930. See also: E.C. Düsseldorf 1969, No. 97. Ill. 84. - Marco Benefial painted the same subject for the Roman church of San Lorenzo in Lucina, 1736 - there is a study for this picture in Düsseldorf (No. 108, Abb. 82) and two others in Berlin.

(38) Gerard Valck, Tabulae De Institutionibus praecipuis ad Picturam Necessariis (Amsterdam). See also Bartsch 2 - 27 and Nagler.

(39) See E.C. Venice 1959, passim.

(40) Moncalvo was also responsible for the drawings attributed to Paolo Farinati, V. 152-154. See also Fenyö, p. 98 ff., pl. 70, 71.

(41) See also E.C. Milan 1959, passim. Beinaschi is also the author of the sheet attributed to Lanfranco. 373.

(42) See Bertina Suida Manning and Wilhelm Suida, Luca Cambiaso, Milan 1958. - Robert L. Manning, Drawings of Luca Cambiaso, Finch College, New York 1967 (E.C.).

(43) B. 503: Baglione (D. Stephen Pepper, Master Drawings 1970/3). - B. 504: Guercino. - Wickhoff, S.L. 264: Sacchi (Vitzthum). - For B. 503a (Fig. 45): red chalk, chalk 265 x 407. Inv. 35672. Lit: Konrad Oberhuber in: Albertina Informationen 1963/3, p. 10, ill. S. 8. cf. Luisa Mortari, Bernardo Strozzi, Rome 1966, Fig. 243, 244.

(44) See: Erica Feinblatt, The Art Quarterly 1961. - Kurz, Windsor, Roli, passim.

(45) See: Ivanoff. - Vitzthum, E.C. Naples 1966, Florence 1967, Paris 1967, Rome 1969.

(46) Pen and ink on light buff paper. 122 x 226. Inv. 990. B. 592. - Wickhoff, S.R. 1101a. - E.C. Claude 1964, No. 238. - A related landscape is in the Louvre (Vitzthum, E.C. 1967, No. 42, Pl. XII).

(47) W. Vitzthum, Paragone (Arts) 183, Milan 1969, p. 64 ff.

(48) Charcoal, chalk, grey/brown wash, 278 x 405. Inv. 24.405. B. 700.

(49) The Albertina also has Giordano drawings in the style of Ribera and Rosa (B. 598, 601) besides those linked with Mola (B. 161, 158, 600). Among the drawings acquired from the late Lubojatzky Collection is a "Nativity," Inv. 34 204 (Benesch, Luca Giordano, Vienna 1923, Pl. 9), in the style of Cambiaso, like that in the Gabinetto Nazionale delle Stampe in the Villa Farnesina in Rome; there is also a preliminary drawing for the painting "Jesus among the Doctors" in the Galleria Corsini in Rome (Ferrari-Scavizzi, I, S. 195, Fig. III., II, S. 267. - E.C. Florence 1967, No. 85, Fig. 57). For B. 697: E.C. New York 1967, No. 124 (The version in the Albertina is not, however, a copy).

(50) See Bologna, Solimena. Among the Austrians, chiefly Daniel Gran and Bartholomäus Altomonte, but also Paul Troger, learned much from Solimena.

(51) Chalk and charcoal, bistre wash. 352 x 252. Inv. 24 375. B. 633. Verso: Sketch of the composition in reverse. Legat Kutschera-Woborsky. Lit.: Viktor Lasareff, Belvedere VII, 1925. p. 120 ff. - Bologna, Solimena, p. 255, Pl. 119, c.f. n.o. Daniel Seiters "Apotheosis of the Emperor Leopold I." (D. 1967. - Aurenhammer, passim).

(52) Pen and ink. 270 x 395. Inv. 1265. R. 892.- Wickhoff, S.R. 1399. Latin inscription with a list of the subjects' names. Ghezzi described himself as a draughtsman. An important part of the architectural drawings in the Collection, including the drawings by Borromini, come from the estate of Baron Stosch.

(53) Chalk, bistre wash, white body color on bistre prepared paper. 285 x 448. Inv. 1288. R. 911. Prov.: G.J. Schmidt; engraved by J.I. Prestel in Schmidt's Cabinet II. For R. 912 see E.C. Florence 1967, No. 85, Fig. 77. - Maser, Ferretti.

(54) Signed and dated (verso): "23 ... 1687 Donato Creti f.e. A°. FA:". Chalk and charcoal, heightened in white, buff paper. 235 x 270. Inv. 25 453. B. 300. Lit.: Roli, Creti, S. 15, III, Fig. 104. See also Kurz, Windsor, passim.

(55) This also applies to the other members of this family, all of whom designed for the theater. See: A. H. Mayor, The Bibiena Family, New York 1945. - J. Gregor, Denkmäler des Theaters, Vienna 1924 - 31, 1954 ff. - F. Hadamovsky, Die Familie Galli-Bibiena in Wien, Vienna 1962. - Maria T. Muraro e Elena Povoledo, Disegni teatrali dei Bibiena, E.C. Venice (Fondazione Cini) 1970.

(56) Chalk; 311 x 234. Inv. 1754. V. 243. Old signature: "Bast. Ricci." Wickhoff, S.V. 345. E.C. Venice 1961, No. 80.

(57) For Pittoni, see also Rodolfo Palluchini, I Disegni di G.B. Pittoni, Venice 1945.

(58) Pencil, pen and ink, bistre wash. 441 x 290. Inv. 1746. V. 238. Wickhoff, S.V. 337, E.C. Venice 1961, No. 96 (as Fontebasso). See: Pignatti, p. 161, No. 29. - E.C. Venice 1969, No. 109. Diziani also originated the drawings, V. 327, 330, 336, 337, that are classified under the name of Fontebasso.

(59) V. 249: Charcoal on buff paper. 280 x 282. Inv. 1796. Prov.: Fagan and Comte Saint-Germain (Lugt 2347). Wickhoff, S.V. 390. - Pallucchini 1956, p. 52, Pl. 134. E.C. Venice 1961, No. 90.

(60) Carlone's drawings are stored in the Albertina under various names. Sheets B. 560 and V. 413-416 are also by him.

(61) Pen and ink, watercolor wash. 100 x 242, Inv. 24 077, V. 301.

(62) Sheets V. 242 ascribed to Seb. Ricci, and 328, 329, 339, B. 558 are more linear and sketchy. ("Genoese"). See Byam Shaw, Arte Veneta VIII, 1954, p. 317 ff. - Fenyö. - E.C. Venice 1961, No. 99. - Pignatti, p. 183 f. (with Bibl.).

(63) V. 358. Pen and ink, brush and watercolor, wash. 333 x 529. Inv. 1856. Wickhoff, S.V. 451. - Hadeln, p. 30. - Parker, Windsor, No. 28. - E.C. Venice 1961, No. 115.

(64) Pen and bistre, wash. 394 x 273. Inv. 24 078. V. 378. E.C. Venice 1961, No. 117. On the verso a sketch of S. Elena with gondolas by Giacomo Guardi, son of Francesco, after his painting "The return of the Bucintoro from the Lido" in the Collection Alessandro Brass in Venice, painted in the final decade of his creative life. (Goering, Pl. 147).

(65) Selma Krasa, Antonio Canova's memorial for the Archduchess Maria Christine, Albertina-Studien 1967/68, p. 67 ff.

ABBREVIATIONS AND SELECTED BIBLIOGRAPHY

E.C.: Exhibition Catalogue.

E.C. Bassano, 1963: Marco Ricci, edited by Giuseppe Maria Pilo and Rodolfo Pallucchini.

E.C. Berlin, 1969: Peter Dreyer, Römische Barockzeichnungen aus dem Berliner Kupferstichkabinett.

E.C. Bologna, 1956: Mostra dei Carracci, edited by Cesare Gnudi, Gian Carlo Cavalli, Francesco Arcangeli, Andrea Emiliani, Maurizio Calvese and Denis Mahon (Drawings).

E.C. Bologna, 1962: L'Ideale Classico del Seicento in Italia e la Pittura del Paesaggio, edited by Cesare Gnudi, Francesco Arcangeli, Gian Carlo Cavalli, Andrea Emiliani, Michael Kitson, Denis Mahon, Amalia Mezzetti, Carlo Volpe.

E.C. Budapest, 1966: Ivàn Fenyö, Remekmüvek a Bécsi Albertinaból.

E.C. Callot, 1968: Eckhart Knab, Jacques Callot und sein Kreis, Vienna, Albertina 1968 (Die Kunst der Graphik V with Contributions by Konrad Oberhuber).

E.C. Claude, 1964: Eckhart Knab, Claude Lorrain und die Meister der römischen Landschaft im XVII. Jahrhundert, Vienna, Albertina 1964 (Introduction by Walter Koschatzky).

E.C. Düsseldorf, 1964: Eckhard Schaar, Italienische Handzeichnungen des Barock.

E.C. Düsseldorf, 1967: Ann Sutherland Harris and Eckhard Schaar, Die Handzeichnungen von Andrea Sacchi und Carlo Maratta.

E.C. Düsseldorf, 1969: Eckhard Schaar and Dieter Graf, Meisterzeichnungen der Sammlung Lambert Krahe.

E.C. Florence, 1953: Michelangelo Muraro, Mostra di disegni veneziani del Sei e Settecento (Gabinetto Disegni, Uffizi).

E.C. Florence, 1964: Paola Barocchi and Giorgio Chiarini, Michelangelo, Mostra di Disegni, Manoscritti e Documenti (Casa Buonarotti e Biblioteca Laurenziana).

E.C. Florenz, 1967: Walter Vitzthum, Cento Disegni Napoletani (Uffizi).

E.C. Guardi, 1965: Pietro Zampetti, Mostra dei Guardi, Venezia.

E.C. Herzog Albert, 1969: Walter Koschatzky, Zweihundert Jahre Albertina, Vienna 1969.

E.C. Louvre, 1959: Jacob Bean, Dessin Romain du XVIIᵉ siècle, Paris, Musée du Louvre.

E.C. Louvre, 1961: Roseline Bacou, Dessins des Carrache, Paris, Musée du Louvre.

E.C. Mariette, 1967: Le Cabinet d'un Grand Amateur, P.J. Mariette, Paris, Musée du Louvre 1967 (edited by Roseline Bacou, Maurice Serullaz, Françoise Viatte, Marie Montembault a.o., Introduction by Frits Lugt).

E.C. Milan, 1958: Arte Lombarda dai Visconti agli Sforza, edited by Gian Alberto dell'Acqua, Roberto Longhi, Gian Guido Belloni, Renata Cipriani, Maria Luisa Ferrari, Franco Mazzoni and Franco Russoli.

E.C. Milan, 1959: Emma Spina Barelli, Disegni di Maestri Lombardi del primo Seicento (Ambrosiana).

E.C. Naples, 1966: Walter Vitzthum and Raffaello Causa, Disegni napoletani del Sei e Settecento nel Museo di Capodimonte.

E.C. New York, 1967: Felice Stampfle and Jacob Bean, Drawings from New York Collections, The 17th Century in Italy.

E.C. Paris: see E.C. Louvre.

E.C. Paris, 1967: Walter Vitzthum and Cathérine Montbeig-Goguel, Le Dessin à Naples du XVIᵉ siècle au XVIIIᵉ siècle (Louvre).

E.C. Reni, 1954: Cesare Gnudi e Gian Carlo Cavalli, Mostra di Guido Reni, Bologna 1954.

E.C. Rom, 1950: Giulio Briganti, I Bamboccianti.

E.C. Rom, 1969: Walter Vitzthum and Raffaello Causa, Disegni Napoletani del Seicento e del Settecento.

E.C. Udine, 1965: Antonio Morassi and Aldo Rizzi, Disegni del Tiepolo.

E.C. Venice, 1951: Giulio Lorenzetti, Mostra del Tiepolo.

E.C. Venice, 1959: La pittura del Seicento a Venezia, catalogue by Pietro Zampetti, Terisio Pignatti and others.

E.C. Venice, 1961: Otto Benesch and Konrad Oberhuber, Disegni veneti dell'Albertina di Vienna (Foundation Cini).

E.C. Venice, 1962: K.T. Parker and Byam Shaw, Mostra Canaletto e Guardi (Foundation Cini).

E.C. Venice, 1967: Pietro Zampetti, I Vedutisti veneziani del Settecento.

E.C. Venice, 1969: Pietro Zampetti, Dal Ricci al Tiepolo.

E.C. Venice, 1958: Licisco Magagnato, Da Altichiero a Pisanello (Museo di Castelvecchio).

E.C. Vienna, 1962: Europäische Kunst um 1400, Vienna Kunsthistorisches Museum, edited by Vincenz Oberhammer and others (graphics by Otto Benesch and Erwin Mitch).

Algarotti: Francesco Conte Algarotti, Opere, Venice 1791.

Andrews: see Keith Andrews.

Arisi: Ferdinando Arisi, Gian Paolo Panini, Piacenza 1961.

Aurenhammer: Gertrude Aurenhammer, Die Handzeichnung des 17. Jahrhunderts in Österreich, Vienna 1958.

Aurenhammer: Hans Aurenhammer, Martin Altomonte, Vienna 1965.

B.: Alfred Stix and Anna Spitzmüller, Die Schulen von Ferrara, Bologna, Parma und Modena, der Lombardei, Genuas, Neapels und Siziliens mit einem Nachtrag zu allen italienischen Schulen, Albertina - Cat. VI, Wien 1941.

Bacci: Mina Bacci, Jacopo Ligozzi e la sua posizione nella pittura fiorentina, Proporzioni IV, Florence 1963, p. 46 ff.

Bacci-Forlani: Mina Bacci and Anna Forlani, Mostra di Disegni di Jacopo Ligozzi, E.C. Florence (Uffizi) 1961.

Bacou, Louvre 1961: Roseline Bacou, Dessins des Carrache, E.C. Paris 1961.

Bacou 1968: Roseline Bacou, Meisterzeichnungen des Louvre, Die italienischen Zeichnungen, Munich 1968 (with the collaboration of Françoise Viatte).

Baglione: Giovanni Baglione, Le Vite de' Pittori, Scultori, et Architetti, Roma 1642. Annotated edition by Jacob Hess in preparation.

Baldinucci: Filippo Baldinucci, Notizie de' Professori del disegno da Cimabue in qua, Florence 1681-1728. Editions by Domenico Maria Manni, Florence 1767-1774 and F. Ranalli, Florence 1845-47.

Barocchi: Paola Barocchi, Vasari Pittore, Milan 1964.

Bartsch: Adam Bartsch, Le Peintre-Graveur, Vienna 1803-1821.

Bartsch, Ligne: Adam Bartsch, Catalogue raisonné des Dessins originaux du Cabinet de Feu Le Prince Charles de Ligne, Vienna 1794.

Basan Mariette: F. Basan, Catalogue raisonné des differents objets de curiosités dans les Sciences et Arts, qui composaient le Cabinet de feu Mr. Mariette, Paris 1775.

Batowski: Z. Batowski, Rastrelli, Lwow 1939.

Bean 1960: Jacob Bean, Bayonne, Musée Bonnat, Les Dessins Italiens de la Collection Bonnat. Paris 1960.

Bean-Vitzthum: Jacob Bean-Walter Vitzthum, Disegni del Lanfranco e del Beinaschi, Bollettino d'Arte 46, Rome 1961, p. 106 ff.

Bellori: Pietro Bellori, Le vite de' Pittori, Scultori and Architetti moderni, Roma 1672. *Idem*, Vita del Maratta, Rome 1732.

Benesch, Meisterzeichnungen: Otto Benesch, Meisterzeichnungen der Albertina, Salzburg 1964. English edition, Greenwich, Conn., 1967.

Benesch 1947: Otto Benesch, Venetian Drawings of the 18th Century in America, New York 1947.

Berenson 1956: Bernard Berenson, Lorenzo Lotto, London 1956.

Berenson 1961: Bernard Berenson, I Disegni dei Pittori Fiorentini, Milan 1961.

Bergamo: Palma il Giovane, Disegni inediti, dell'Accademia Carrara di Bergamo e del Museo Fantoni di Rovetta, Bergamo 1964 (Ed. Monumenta Bergamasca).

Bie, Cornelis de: Het Gulden Cabinet, Antwerp 1661.

Blunt 1957: Anthony Blunt and Edward Croft Murray, Venetian Drawings of the 17th and 18th Centuries at Windsor Castle, London 1957.

Blunt 1960: Anthony Blunt and Hereward Lester Cooke, The Roman Drawings of the 17th and 18th Centuries at Windsor Castle, London 1960.

Blunt, Castiglione: Anthony Blunt, The Drawings of G.B. Castiglione and Stefano della Bella at Windsor Castle, London (1954).

106

Bodmer: Hans Bodmer, Leonardo da Vinci, Leipzig 1931 (Klassiker der Kunst, Bd. 37) and Lodovico Carracci, Burg near Magdeburg 1939.

Bologna: Fernando Bologna, Francesco Solimena, Naples 1958.

Borenius: Tancred Borenius, I pittori di Vicenza, Vicenza 1912.

Boschini: Marco Boschini, La Carta del navegar pitoresco, Venice 1660. *Idem,* Le (riche) Minere della Pittura (Veneziana), Venice 1664 (1674). *Idem,* I gioielli pittorici di Vicenza, Vicenza 1676.

Bottari: Giovanni Gaetano Bottari, Raccolta di lettere sulla pittura, Rome 1754-1783. Edizione da Stefano Ticozzi, Milano 1822-25.

Briganti: Giuliano Briganti, Pietro da Cortona (Firenze 1962).

Brini-Garas: Amalia Barigozzi-Brini e Klara Garas, Carlo Innocenzo Carloni, Milano (1967).

Bushart: Bruno Bushart, Die deutsche Ölskizze des 18. Jahrhunderts, Münchner Jahrbuch der bildenden Kunst, 1964, p. 145 ff.

Byam Shaw: J. Byam Shaw, The Drawings of Francesco Guardi, London (1949).

Byam Shaw 1931: J. Byam Shaw, Seven Sheets from a Sketch-Book by Antonio da Sangallo the Elder, Old Master Drawings VI, December 1931, p. 39 ff.

Chantelou: Paul-Fréart Sieur de Chantelou, Journal de Voyage du Cavalier Bernin en France, Manuscript, edited by Ludovic Lafanne, in: G.B.A. 1877-1885.

Clark: Anthony M. Clark, The Portraits of Artists drawn for Nicolo Pio, Master Drawings 1967-1, p. 3 ff.

Cochin: Nicolas Cochin, Voyage d'Italie, Paris 1756, 1758.

Coddè: Memorie biografiche dei Pittori... Mantovani, Mantova 1837.

Coletti: Luigi Coletti, L'Arte di Tomaso da Modena, Bologna 1933 (Ars viva II).

Constable: W.G. Constable, Canaletto, Oxford 1962 (2 vol.).

Cox-Rearick: Janet Cox-Rearick, The Drawings of Pontormo, Cambridge, Massachusetts, 1964.

Croft-Murray: see Blunt 1957.

Crosato: Luciana Crosato, Gli affreschi nelle Ville Venete del Cinquecento, Treviso 1962.

Dalli Regoli: Gigetta dalli Regoli, Lorenzo di Credi, Milan 1966 (Raccolta Pisana di Saggi e Studi 19).

D'Argenville: A.J. Dézallier d'Argenville, Abrégé de la vie des plus fameux peintres, Paris 1745-1752 (1762).

Davidson: Bernice F. Davidson, Mostra di Disegni di Perino del Vaga e la sua cerchia, Florence 1966 (Uffizi).

Davies 1961: Martin Davies, National Gallery Catalogues, The Earlier Italian Schools, London 1961.

De Dominici: Bernardo de Dominici, Vite dei Pittori, Scultori ed Architetti Napoletani, Naples 1742-43. *Idem,* La Vita di Luca Giordano, Naples 1720 (also appeared in the vitae by Bellori, 1728).

Degenhart 1937: Bernhard Degenhart, Stefano di Giovanni da Verona, Thieme-Becker XXXI, p. 526 ff.

Degenhart 1941: Bernhard Degenhart, Antonio Pisanello, Vienna 1941.

Degenhart 1950: Bernhard Degenhart, Autonome Zeichnungen bei mittelitalienischen Künstlern, Münchener Jahrbuch I, 1950, p. 93 ff.

Degenhart 1955: Bernhard Degenhart, Dante, Leonardo und Sangallo, Römisches Jahrbuch für Kunstgeschichte VII, Vienna Munich 1955, p. 103 ff.

Degenhart-Schmitt: Bernhard Degenhart- Annegrit Schmitt, Corpus der italienischen Handzeichnungen 1300-1450, Berlin 1958.

Degenhart-Schmitt 1960: Bernhard Degenhart und Annegrit Schmitt, Gentile da Fabriano in Rom und die Anfänge des Antikenstudiums, Münchener Jahrbuch XI, 1960, p. 59 ff.

Della Pergola: Paola della Pergola, Galleria Borghese, I Dipinti, Rome 1955.

Delogu: Giuseppe Delogu, G.B. Castiglione, Bologna 1928.

Delogu 1931: Pittori veneziani minori del Settecento, Venezia 1951. *Idem,* Pittori minori Liguri, Lombardi, Piemontesi del Seicento e del Settecento, Venice 1931.

Denisow-Petrow: J. Denisow-A. Petrow, Rastrelli, Leningrad 1963 (Russian).

Derschau: Joachim von Derschau, Sebastiano Ricci, Heidelberg 1922.

Dreyer: Peter Dreyer, Römische Barockzeichnungen aus dem Berliner Kupferstichkabinett (E.C.), Berlin 1969.

Dreyer-Winner: Peter Dreyer und Martin Winner, Der Meister von 1515 und das Bamberger Skizzenbuch in Berlin, Jahrbuch der Berliner Museen VI, 1964, p. 53 ff.

Dussler 1966: Luitpold Dussler, Raffael, Kritisches Verzeichnis der Gemälde, Wandbilder und Bildteppiche, Munich 1966.

Dussler Michelangelo: Luitpold Dussler, Die Zeichnungen des Michelangelo, Kritischer Katalog, Berlin 1959.

Enggass: Robert Enggass, The Painting of Baciccio, University Park, Pennsylvania 1964.

Fabriczy: Cornel von Fabriczy, Giulianos da Sangallos figürliche Kompositionen, Jahrbuch der Preussischen Kunstsammlungen 23, Berlin 1902, p. 197 ff.

Fenyö: Ivan Fenyö, Norditalienische Handzeichnungen aus dem Museum der bildenden Künste in Budapest, 1965. See also Albertina-Studien 1966, p. 40 ff. (Knab).

Fenyö, Carracci: Ivan Fenyö, Dessins inconnus des Carracci, Bulletin du Musée National Hongrois des Beaux-Arts 17, Budapest 1960.

Ferrari-Scavizzi: Oreste Ferrari - Giuseppe Scavizzi, Luca Giordano, Naples 1966 (3 vol.).

Fiocco 1923: Giuseppe Fiocco, Francesco Guardi, Florence 1923.

Fiocco 1928: Giuseppe Fiocco, Paolo Veronese, Bologna 1928.

Fiocco 1950: Giuseppe Fiocco, Disegni di Stefano da Verona, Proporzioni 3, Florence 1950, p. 56 ff.

Fiocco 1961: Giuseppe Fiocco, la Mostra dei Disegni Veneti dell'Albertina di Vienna, Arte Veneta XV, 1961, p. 318 ff.

Fischel 1898: Otto Fischel, Raphaels Zeichnungen, Versuch einer Kritik der bisher veröffentlichen Blätter, Strassburg 1898.

Fischel 1913: Otto Fischel, Raphaels Zeichnungen, Berlin 1913.

Forlani: Anna Forlani, I Disegni Italiani del Cinquecento, Venice (1962).

Forlani 1958: Anna Forlani, Mostra di Disegni di Jacopo Palma il Giovane, Florence (E.C. Uffizi).

Fossi-Todorow: Maria Fossi-Todorow, I Disegni del Pisanello e della sua cerchia, Florence 1966.

Fossi-Todorow 1926: Maria Fossi-Todorow, Un Taccuino di Viaggio del Pisanello e della sua bottega. Scritti di Storia dell'Arte in Onore di Mario Salmi, Rome 1962, vol. II, p. 133 ff.

Fossi-Todorow 1970: Maria Fossi-Todorow, L'Italia dalle origini a Pisanello, Milan 1970.

Freedberg: Sydney J. Freedberg, Parmigianino, His Works in Painting, Cambridge, Mass. 1950.

Friedlaender, Caravaggio: Walter Friedlaender, Caravaggio Studies, Princeton, New Jersey 1955.

Frommel: Christoph Luitpold Frommel, Baldassare Peruzzi als Maler und Zeichner, Beiheft zum Römischen Jahrbuch für Kunstgeschichte XI, Vienna-Munich 1967/68.

Fröhlich-Bum 1913/14: Lilli Fröhlich-Bum, Andrea Meldola, gen. Schiavone, Jahrbuch der Kunsthistorischen Sammlungen des Allerhöchsten Kaiserhauses XXXI, Vienna 1913/14.

Füssli: J.C. Füssli, Geschichte und Abbildung der besten Künstler in der Schweiz, Zürich 1779.

Gabelentz: Hans von der Gabelentz, Fra Bartolommeo und die Florentiner Renaissance, Leipzig 1922.

Garas: see Brini.

Garzarolli: Karl Gazarolli von Thurnlackh, Die barocke Handzeichnung in Österreich, Vienna 1928.

G.B.A.: Gazette des Beaux-Arts, Paris.

Gould 1962: Cecil Gould, The Sixteenth-Century Italian Schools, National Gallery Catalogues, London 1962.

Goering: Max Goering, Francesco Guardi, Wien 1944.

Goldscheider 1960: L. Goldscheider, Leonardo da Vinci, Leben und Werk, Gemälde und Zeichnungen, Köln 1960.

Graph. Künste: Die Graphischen Künste, Wien Beiheft: Mitteilungen der Gesellschaft für vervielfältigende Kunst.

108

Grassi: Luigi Grassi, Storia del Disegno, Rome 1947.

Grassi 1961: Luigi Grassi, I Disegni Italiani del Trecento e Quattrocento, Venice (1961).

Sturla J. Gudlangsson: De Komedianten bij Jan Steen en zijn tijdgenenoten, 's Gravenhage 1945.

Hadeln 1924: Detlev Freiherr von Hadeln, Zeichnungen des Tizian, Berlin 1924.

Hadeln 1925: Detlev Freiherr von Hadeln, Venezianische Zeichnungen des Quattrocento, Berlin 1925.

Hadeln 1926: Detlev Freiherr von Hadeln, Venezianische Zeichnungen der Spätrenaissance, Berlin 1926.

Hadeln 1927: Detlev Freiherr von Hadeln, Handzeichnungen von Giovanni Battista Tiepolo, Florence-Munich 1927.

Hadeln 1930: Detlev Freiherr von Hadeln, Die Zeichnungen von Antonio Canal, gen. Canaletto, Vienna 1930.

Hartt 1958: Frederick Hartt, Giulio Romano, New Haven 1958.

Haskell: Francis Haskell, Patrons and Painters, London 1963.

Heikamp: Detlef Heikamp, Federico Zuccari a Firenze, Paragone, Arte, Anno XVIII, Milan, March 1967, p. 44 ff.

Heil: Walther Heil, Palma Giovane als Zeichner, Jahrbuch der Preussischen Kunstsammlungen 47, Berlin 1926, p. 58 ff.

Heller: Joseph Heller, Das Leben und die Werke Albrecht Dürers, vol. II, Leipzig 1831.

Hempel: Eberhard Hempel, Francesco Borromini, Wien 1924, also, Gaetani Chiaveri, Dresden 1955.

Hess, Tassi: Jacob Hess, Agostino Tassi, der Lehrer des Claude Lorrain, Munich 1935.

Hirst: M. Hirst, The Chigi Chapel in S. Maria della Pace, in: Journal of the Warburg and Courtauld Institutes XXIV, London 1961, p. 161 ff.

Hoogewerff: G.J. Hoogewerff, Pieter van Laer en zijn vrienden, in: Oud Holland, 49, p. 1 ff., 205 ff., and 50, p. 103 ff., 250 ff. Idem, De Bentvueghel, 's Gravenhage 1957; also Neederlandsche Kunstenaars te Rome, in: Studies van het Neederl. Historische Instituut te Rome, 's Gravenhage 1942-43; also Via Margutta, centro di vita artistica, Rome 1945.

Ivanoff: Nicola Ivanoff, I Disegni italiani del Seicento. Scuole Veneta, Lombarda, Ligure, Napoletana. Venezia (ca. 1960).

Jombert: Charles Antoine Jombert, Essai d'un catalogue de l'œuvre d'Etienne de la Belle, Paris 1772.

Keith Andrews: Keith Andrews, National Gallery of Scotland (Edinburgh), Catalogue of Italian Drawings, Cambridge 1968.

Knab, Callot: see E.C. Callot, 1968.

Knab, Die Anfänge des Claude Lorrain: Eckhart Knab, Jahrbuch der kunsthistorischen Sammlungen in Wien 56, Vienna 1960, p. 63 ff. See also E.C. Claude, 1964.

Knab, Eckhart, Über Bernini, Poussin und Le Brun, Albertina-Studien 1967-68, P. 3 ff.

Knapp: Fritz Knapp, Fra Bartolommeo della Porta und die Schule von San Marco, Halle on the Saale 1903.

Knox: George Knox, Catalogue of the Tiepolo Drawings in the Victoria and Albert Museum, London 1960. See also Zeitschrift für Kunst- und Denkmalpflege XIV, Vienna 1960, p. 140 ff. (Knab).

Koschatzky: Walter Koschatzky, Die Gründung der Kunstsammlung des Herzogs Albert von Sachsen-Teschen, Albertina-Studien 1963-64. See also E.C. Herzog Albert, 1969.

Koschatzky-Strobl: Walter Koschatzky, Alice Strobl, Die Albertina in Wien, Salzburg 1969.

Krautheimer 1956: Richard Krautheimer und Trude Krautheimer-Hess, Lorenzo Ghiberti, Princeton 1956.

Kurz: Otto Kurz, Giorgio Vasari's "Libro de' Disegni," Old Master Drawings, June 1937, p. I ff., December 1937, p. 32 ff. Also, Guido Reni, Jahrbuch der Kunsthistorischen Sammlungen in Vienna, N.F.XI, 1937, p. 189 ff.

Kurz, Windsor: Otto Kurz, Bolognese Drawings of the 17th and 18th Centuries at Windsor Castle, London 1955.

Kutschera: Oswald Kutschera-Woborsky, Ein kunsthistorisches Thesenblatt Carlo Marattas und seine ästhetischen Anschauungen, Graph. Künste 1919, Mitteilungen, p. 9 ff.

Lanzi: Luigi Lanzi, Storia pittorica d'Italia, Bassano 1795.

Lester Cooke: see Blunt 1960.

Levey: Michael Levey, Francesco Zuccarelli in England, Italian Studies XIV, 1959.

Levey: Michael Levey, Painting in 18th Century Venice, London 1959.

Lipparini: Giuseppe Lipparini, Francesco Francia, Bergamo 1913.

Longhi: Alessandro Longhi, Compendio delle vite de' pittori veneziani, Venice 1762.

Lomazzo: Giampaolo Lomazzo, Trattato dell'Arte della Pittura, Milan 1584. Also, Idea del Tempio della Pittura, Milan 1590. Also, Della forma delle Muse, Milan 1595.

Lugt: Frits Lugt, Les Marques de Collections de Dessin et d'Estampes, Amsterdam 1921 (Supplément, The Hague 1956).

Lugt 1962: Frits Lugt, J.G. van Regteren Altena, J.C. Ebbinge Wübben, Le Dessin italien dans les Collections hollandaises, E.C. Paris - Rotterdam - Haarlem 1962.

Mahon, Guercino: Denis Mahon, Il Guercino, E.C. Bologna 1968 (2 vol., Dipinti e Disegni. Introduced by Cesare Gnudi).

Mahon, Studies: Denis Mahon, Studies in Seicento Art and Theory, London 1947 (Studies of the Warburg Institute XVI).

Malvasia: Carlo Cesare Malvasia, La Felsina Pittrice, Bologna 1678 (1841, 2 vol.).

Mancini: Giulio Mancini, Considerazioni sulla Pittura, by Adriana Marucchi and Luigi Salerno, Rome 1956-57 (2 vol.).

Marabottini: Alessandro Marabottini, Polidoro da Caravaggio, Rome 1969. Also, Novita sul Lucchesino (Testa), Commentari V, Rome 1954, p. 116 ff., 217 ff.

Mariette, Abecedario: Pierre-Jean Mariette, Abecedario, Published by Ph. Chennevières and A. de Montaiglon, Archives de l'Art français, Paris 1851-1860. See also E.C. Mariette, 1967.

Mariette, Crozat: Pierre-Jean Mariette, Description sommaire des desseins des grands maistres du Cabinet de Feu M. Crozat, Paris 1741.

Maser: Edward A. Maser, Domenico Ferretti, Florence 1968.

Meder: Joseph Meder, Die Handzeichnung, ihre Technik und Entwicklung, Vienna 1919, 1923.

Missaglia: V. Missaglia, Bibliografia XXVI, Venice 1826.

Molmenti: Pompeo Molmenti, G.B. Tiepolo, Milan (1909).

Morassi: Antonio Morassi, G.B. Tiepolo, London-Florence 1955. Also, A Complete Catalogue of the Paintings of G.B. Tiepolo, London 1962.

Morassi 1942: Antonio Morassi, Giorgione, Milan 1942.

Morassi 1954: Antonio Morassi, Esordi di Tiziano, Arte Veneta VIII, 1954, p. 178 ff.

Moschini: Gian Antonio Moschini, Della Litteratura veneziana del secolo XVIII, Venice 1806.

Müller-Hofstede 1964: Justus Müller-Hofstede, Ein Frühwerk Jacopo Bassanos und eine Komposition Raffaels, Münchener Jahrbuch für bildende Kunst XV, 1964, p. 131 ff.

Münz, Goethe: Ludwig Münz, Die Kunst Rembrandts und Goethes Sehen, Leipzig 1934. Also, Goethes Zeichnungen und Radierungen, Wien 1949.

Muraro: see E.C. Florenz 1953.

Muraro 1949: Novità per Francesco Guardi, Arte Veneta 1949, p. 123 ff. See also Atti del I Convegno internazionale per le arti figurative, Florence 1948 and Burlington Mag. 1958, p. 3 ff.

Muraro 1967: Asterischi Guardeschi, "Problemi Guardeschi," Venice 1967, p. 161 ff.

Nagler: G.K. Nagler, Neues allgemeines Künstlerlexikon, Munich 1835-1852.

Oberhuber 1962: Konrad Oberhuber, Die Fresken der Stanza dell'Incendio im Werk Raffaels, Jahrbuch der Kunsthistorischen Sammlungen in Wien, N.F. XXII, 1962, p. 23 ff.

Oberhuber 1963: Konrad Oberhuber, Parmigianino und sein Kreis, E.C., Albertina, Vienna 1963.

Oberhuber 1966: Konrad Oberhuber, Eine unbekannte Zeichnung Raffaels in den Uffizien, Mitteilungen des Kunsthistorischen Institutes in Florenz, XII, 1966, p. 225.

Oberhuber, Transfiguration: Konrad Oberhuber, Vorzeichnungen zu Raffaels "Transfiguration", Jahrbuch der Berliner Museen IV, 1962, p. 116 ff.

Oertel: Robert Oertel, Wandmalerei und Zeichnung in Italien, Mitteilungen des Kunsthistorischen Institutes in Florenz, V, 1937-40, p. 216 ff.

Ojetti: Ugo Ojetti, Il Settecento italiano, Milan-Rome 1932.

Olsen: Harald Olsen, Federico Barocci, Copenhagen 1962.

Orlandi: Pellegrino Antonio Orlandi-Pietro Guarienti, Abecedario pittorico, Venice 1753.

Ortolani: Sergio Ortolani, Cosimo Tura, Francesco del Cossa, Ercole de' Roberti, Milano, n.d. (Coll. "Valori Plastici").

Ozzola: Leandro Ozzola, Gian Paolo Pannini, Torino 1921. Also L'Arte 12, Rome 1909, pp. 15 ff., 365 ff. (Opere del Pannini a Vienna).

Pächt 1950: Otto Pächt, Early Italian Nature Studies and the early Calendar Landscape, Journal of the Warburg and Courtauld Institutes XIII 1950, p. 13 ff.

Pallucchini I: Rodolfo Pallucchini, Studi Ricceschi I, Arte Veneta VI, 1952, p. 76 ff.

Pallucchini II: as above, Studi Ricceschi II, Arte Veneta IX, 1955, p. 171 ff.

Pallucchini 1943: Rodolfo Pallucchini, I disegni del Guardi al Museo Correr di Venezia, Venice 1942 (Florenze 1943).

Pallucchini 1956: Rodolfo Pallucchini, G.B. Piazzetta, Milan 1956 (earlier edition Bologna 1934).

Pallucchini 1969: Rodolfo Pallucchini, Tiziano, Florence 1969.

Pallucchini, Vivarini: Rodolfo Pallucchini, I Vivarini, Venezia, n.d.

Panofsky 1948: Erwin Panofsky, Albrecht Dürer, 3rd ed., Princeton 1948.

Parker: K.T. Parker, Catalogue of the Collection of Drawings in the Ashmolean Museum, Oxford 1938 and 1956 (vol. I und II).

Parker, Windsor: K.T. Parker, The Drawings of Antonio Canaletto at Windsor Castle, London 1948.

Pascoli: Lione Pascoli, Vite de' Pittori, Scultori ed Architetti moderni (Roma 1730). Facsimile edition, Rome 1935.

Passeri-Hess: Jacob Hess, Die Künstlerbiographien von Giovanni Battista Passeri, Leipzig and Vienna 1934.

Pignatti: Terisio Pignatti, I disegni veneziani del Settecento (Treviso 1966). Also, Le acqueforti dei Tiepolo, Florence 1965.

Pignatti 1967: Terisio Pignatti, Disegni dei Guardi, Florence 1967.

Pignatti 1970: Terisio Pignatti, La Scuola Veneta, I disegni dei Maestri, Milan 1970.

Piles: see Roger de Piles.

Pope-Hennessy: John Pope-Hennessy, The Drawings of Domenichino at Windsor Castle, London (1948). - Also: Raphael, London.

Pope-Hennessy 1950: John Pope-Hennessy, The Complete Work of Paolo Uccello, London 1950.

Pope-Hennessy 1952: John Pope-Hennessy, Fra Angelico, London 1952.

Popham: A.E. Popham, The Drawings of Parmigianino, London, n.d.

Popham 1947: A.E. Popham, The Drawings of Leonardo da Vinci, London 1947.

Popham and Wilde: A.E. Popham and Johannes Wilde, The Italian Drawings of the 15th and 16th Centuries at Windsor Castle, London 1949.

Popp 1928: A.E. Popham, Leonardo da Vinci, Zeichnungen, Munich 1928.

Posse: Hans Posse, Andrea Sacchi, Leipzig 1925 (Italienische Forschungen, NF. I).

Pouncey and Gere: Philip Pouncey and John Gere, Italian Drawings in the Department of Prints and Drawings in the British Museum: Raphael and his Circle, London 1962.

Prov.: Provenance.

Puppi: Lionello Puppi, Bartolomeo Montagna, Venice 1962 (Profili 2).

Quintavalle: Augusta Ghidiglia Quintavalle, Una serie di ritratti, l'autobiografia del Parmigianino, Paragone, Arte, Anno XX, September 1969, p. 53 ff.

R.: Alfred Stix and L. Fröhlich-Bum, Die Zeichungen der toskanischen, umbrischen und römischen Schulen, Albertina cat. III, Vienna 1932.

Regteren Altena: see Lugt 1962.

Ridolfi: Carlo Ridolfi, Le Maraviglie dell'arte overo le Vite degli illustri Pittori Veneti e dello stato, Venice 1648, Ed. Detlev von Hadeln, Berlin 1914-1924 (2 vol.).

Rinaldis: Aldo de Rinaldis, Die süditalienische Malerei des 17. Jahrhunderts, Florence-Munich 1929.

Robertson: Giles Robertson, Giovanni Bellini, Oxford 1968.

Roger de Piles: Roger de Piles, Dissertations sur les ouvrages des plus fameux peintres, Paris 1681. - Also Dialogue sur les Coloris, Paris 1673. See also Schlosser, on "Piles."

Roli: Renato Roli, I Disegni italiani del Seicento, Treviso 1969 (Ed. Canova).

Roli, Creti: Renato Roli, Donato Creti, Milan 1967.

Ruhmer 1962: Eberhard Ruhmer, Ergänzendes zur Zeichenkunst des Ercole de' Roberti, Pantheon, 20, Munich 1962, p. 241 ff.

S.B.: Scuola Bolognese, see Wickhoff.

S.L.: Scuola Lombarda, see Wickhoff.

S.R.: Scuola Romana, see Wickhoff.

S.V.: Scuola Veneziana, see Wickhoff.

Sack: Eduard Sack, Giambattista und Domenico Tiepolo, Hamburg 1910.

Salmi 1960: Mario Salmi, Ercole de' Roberti, Milan 1960.

Sanminiatelli: Donato Sanminiatelli, Domenico Beccafumi, Milan 1967.

Scavizzi: see Ferrari.

Schaar: see E.C. Düsseldorf, 1964.

Schaar, Maratta: see E.C. Düsseldorf, 1967.

Schendel: see Van Schendel.

Schilling: Rosy Schilling, Ein Gebetbuch des Michelino da Besozzo, Münchener Jahrbuch der bildenden Kunst VIII, 1957, p. 65 ff.

Schlosser: Julius von Schlosser, Die Kunstliteratur, Vienna 1924. Italian edition: La letteratura artistica, Florence-Vienna 1956 (with enlarged Bibliography by Otto Kurz). - Also, Leben und Meinungen des florentinischen Bildhauers Lorenzo Ghiberti, Basel 1941.

Schmarsow: August Schmarsow, Federigo Baroccis Zeichnungen III, Abhandlungen der Kgl. Sächsischen Gesellschaft der Wissenschaften, phil.-hist. Klasse XXVI. Leipzig 1909.

Schmitt: Ursula Schmitt, Francesco Bonsignori, Münchner Jahrbuch der bildenden Kunst XII, 1961, p. 73 ff.

Schönbrunner-Meder: Josef Schönbrunner- Josef Meder, Handzeichnungen alter Meister in der Albertina und anderen Sammlungen, Vienna 1895-1908.

Schubring: Paul Schubring, Cassoni, Leipzig 1915.

Shearman 1959: John Shearman, Rendiconto di Hartt, Burlington Mag. CI, London 1959, p. 456 ff.

Soprani-Ratti: Rafaele Soprani, Le Vite de Pittori, Scultori et Architetti Genovesi e de' Forestieri, che in Genova operarono. Genova 1674. Ed. di Giuseppe Ratti, Genoa 1768.

Spitzmüller: see B.

Sutton: Denys Sutton, Gaspard Dughet, G.B.A. LX, Paris 1962, p. 269 ff. - Also: Denis Mahon-Denys Sutton, Artists in 17th Century Rome, E.C. London 1955 (Wildenstein).

Sutherland: Ann B. Sutherland, The Decoration of San Martino ai Monti, Burlington Mag. CVI, London 1964, p. 58 ff., 115 ff. - Also, Pier Francesco Mola, Burlington Mag. CVI, p. 363 ff.

Sutherland-Harris, Sacchi: see E.C. Düsseldorf 1967. Also, Notes on Pietro Testa, Paragone, Arte, Anno XVIII, November 1967, p. 35 ff.

Stampfle-Bean: see E.C. New York, 1967.

Stix, Albertina: Alfred Stix, Handzeichnungen aus der Albertina, begründet von J. Meder, N.F. II. Bd.: Italienische Meister des 14.-16. Jahrhunderts, Vienna 1925.

Stix-Spitzmüller: see B.

Strobl: see Koschatzky-Strobl.

Suida 1904: Wilhelm Suida, Die Jugendwerke des Bartolomeo Suardi, gen. Bramantino, Jb. der Kunsthistorischen Slgn. des Allerhöchsten Kaiserhauses XXV, Vienna 1904, p. 1 ff.

Suida 1953: Wilhelm Suida, Bramante Pittore e il Bramantino, Milan 1953.

Swoboda: Karl Maria Swoboda, Raffaels Madonna im Grünen, Kunst und Geschichte, Vienna 1969, p. 180 ff.

Temanza: Tommaso Temanza, Zibaldon di Memorie storiche appartenenti a Professori delle Belle Arti del Disegno, ed. by N. Ivanoff, Venice 1963.

Ternois: Daniel Ternois, L'Art de Jacques Callot, Paris 1962. - Also, Jacques Callot, Catalogue complet de son œuvre dessiné, Paris 1962.

Thelen: Heinrich Thelen, Settanta Disegni di Francesco Borromini dalle collezioni dell'Albertina di Vienna, E.C., Rome 1958 (Villa Far-

nesima, Gabinetto delle Stampe). Also, Francesco Borromini, Die Handzeichnungen, Graz 1967.

Thieme-Becker: Ulrich Thieme - Felix Becker, Allgemeines Lexikon der bildenden Künstler, Leipzig 1907-1950.

Tietze: Hans Tietze, Annibale Carraccis Galerie im Palazzo Farnese und seine römische Werkstätte, Jahrbuch der kunsthistorischen Sammlungen des Allerhöchsten Kaiserhauses.

Tietze 1944: Hans Tietze und Erika Tietze-Conrat, The Drawings of the Venetian Painters, New York 1944.

Van Schendel: Arthur van Schendel, Le Dessin en Lombardie, Brussels 1938.

Vasari: Giorgio Vasari, Le Vite de' più eccellenti Architetti, Pittori et Scultori Italiani... Florence 1550 (1568).

Venturi: Adolfo Venturi, Storia dell'arte italiana, Milan 1901-1940.

Vesme: Alessandro Baudi di Vesme, Le peintre-graveur italien, Milan 1906.

Vigni: Giorgio Vigni, Disegni del Tiepolo, Padua 1942.

Vitzthum: see Bean and E.C. Florence 1967, Naples 1966, Paris 1967, Rome 1969.

Vitzthum, Maratta: Walter Vitzthum, Drawings by Carlo Maratta for the Altieri Palace in Rome, Burlington Mag. CV, 1963/2, p. 367 ff.

Vitzthum, Oeil: Walter Vitzthum, Le Dessin baroque à Naples, Oeil 97, Paris, January 1963, p. 41 ff.

Voss (Barock): Hermann Voss, Die Malerei des Barock in Rom, Berlin 1924.

Voss 1920: Hermann Voss, Die Malerei der Spätrenaissance in Rom und Florenz, Berlin 1920.

Waagen 1867: Gustav Friedrich Waagen, Die vornehmsten Kunstdenkmäler in Wien, Vol. II, Vienna 1867.

Waterhouse: Ellis K. Waterhouse, Baroque Painting in Rome, London 1937. - Also, Italian Baroque Painting, London 1962.

Wibiral: Norbert Wibiral, Contributi alle ricerche sul Cortonismo in Roma, in: Bollettino d'Arte XLV, Rome 1960, p. 123 ff.

Wickhoff: Franz Wickhoff, Die italienischen Handzeichnungen der Albertina, Jahrbuch der Kunsthistorischen Sammlungen des Allerhöchsten Kaiserhauses, 12. Bd., Vienna 1891, p. CCV., 13 Bd., 1892, p. CLXXV ff.

Winckelmann: Johann Joachim von Winckelmann, Gedanken über die Nachahmung der griechischen Werke in der Malerei und Bildhauerkunst, Dresden 1755. - Also, Abhandlung von der Fähigkeit der Empfindung des Schönen in der Kunst, Dresden 1763.

Winner: see Dreyer-Winner.

Wittkower: Rudolf Wittkower, The Drawings of the Carracci at Windsor Castle, London (1952). - Also, Art and Architecture in Italy, 1600-1750, London 1958 (The Pelican History of Art 16).

Wölfflin: Heinrich Wölfflin, Kunstgeschichtliche Grundbegriffe, Munich 1915.

Zampetti: See E.C. Guardi 1965, E.C. Venice, 1959 and 1969.

Zanetti: Antonio M. Zanetti, Della Pittura Veneziana, Venice 1771 (1792). - Also, Descrizioni di tutte le pubbliche pitture della città di Venezia etc., Venice 1733.

Zentai: L. Zentai, Raffaello Emlékki állitas, Szépmüvészeti Museum, Budapest 1970.

Zuccari: Federigo Zuccaro, L'Idea de' scultori, pittori e architetti, Turin 1607.

113

PLATES

1 Christ taken Prisoner

Pen and bistre on parchment. Bottom left and right repaired and patched with paper. Patch inscribed: Giotto f. *131 x 273, Inv. 4.*

Orig.: *Reputedly owned by Leonardo; Albert von Saxe-Teschen, L. 174.*

Lit.: *S.R. 4; Degenhart-Schmitt No. 49.*

This early drawing in the Albertina belongs to a group of three other sheets in the same technique on parchment, at Chantilly, in the Uffizi in Florence and in the Pierpont Morgan Library in New York. All are copied from the frescoes in the Lower Church of S. Francesco at Assisi, and all are highly finished drawings that were considered to merit preservation because of their perfection.

Pen strokes describe the figures in clear contours and parallel lines, and follow the movement of drapery without hesitation, without correction, but also without the verve of inspiration. Rightly, Degenhart and Schmitt pointed to the parallel with Florentine painted gilded glass, which required similarly precise workmanship. Typically Florentine also are the clear large shapes, and the sense of weight and volume of the figures. It is quite understandable that this drawing came to be attributed to Giotto, although it represents a mural from the workshop of Pietro Lorenzetti: he also had been influenced by Giotto's new, simple and monumentally plastic forms. The beauty of the composition, well-understood by the copyist, can almost be appreciated better here than in the poorly preserved fresco; architecture and landscape may be missing, but this only heightens the density of the figure arrangement.

Roman soldiers with helmets, torches and spears crowd forward from the rock formation on the left. They are led by a prominent figure, probably a captain. He points towards Christ, who is standing in total calm, emphasized by his immobility, the halo that surrounds his head with a zone of light, and his gaze at the spectator. On one side he is framed by Judas, a massive stooping back-view, and on the other by one of the Roman henchmen, sword drawn, facing Peter, who is chopping off Malchus' ear. Above, Apostles escape through rocks; the man glancing back may be St John. What this sheet lacks in spontaneity, it gains in precision and linear quality.

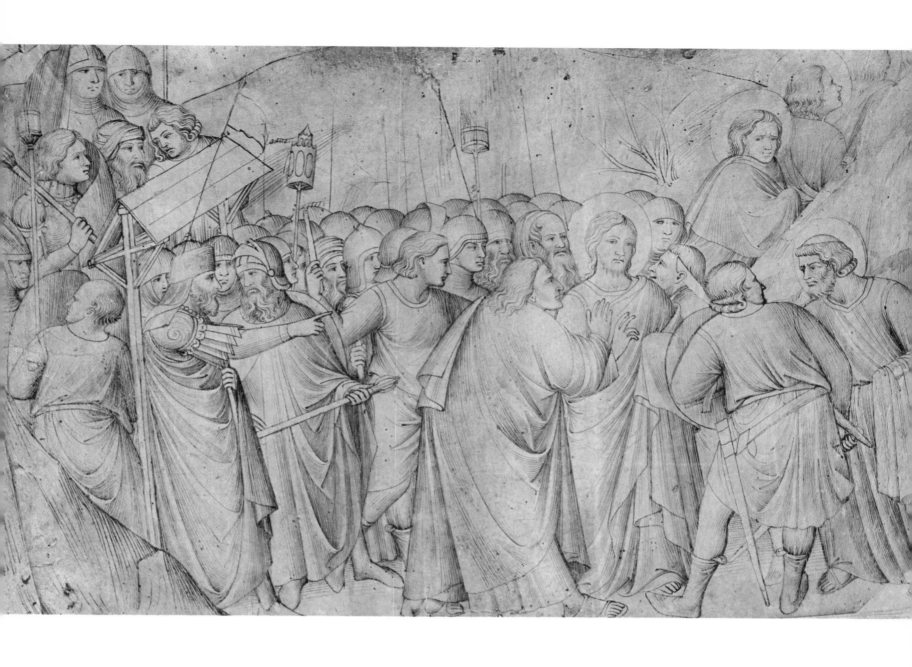

2 Study

Pen and bistre, brush, traces of stylus on parchment. 225 x 173.

Inscr. 17 cent. in pen: St Fiorentino 56. Inv. 19, B 348

Orig.: Gentile da Fabriano (?); Pisanello (?); Marquis de Lagoy, L. 1710; Graf Moritz von Fries, L. 2903; Albert von Saxe-Teschen, L. 174.

Lit.: S.R. 16, B 348, Coletti p. 54, LXII and LXIII, Oertel 1940, Degenhart 1950, p. 114. Degenhart-Schmitt p. 235 ff and p. 64.

This drawing originally came from a large group widely scattered today, but still partially intact in the collections of the Marquis de Lagoy and Graf Moritz von Fries. The sheets are all linked through inscriptions of an anonymous 17th century collector, who variously attributed them to famous early Florentine masters, — this one to Stefano Florentino. Degenhart and Schmitt have proposed that the core of this group had been a book of sketches assembled by Gentile da Fabriano in Rome towards the end of his life, and then inherited by Pisanello, who added to it. A further sheet from the same book, an Annunciation in the Louvre (RF 419, Degenhart 1950, Ill. 52) was considered by the collector to be the work of Giotto. There is another drawing closely related to ours in Rotterdam. It also originated from the Lagoy collection, and went via the Koenigs collection to the Museum Boymans van Beuningen (Lugt 1962, No. 2). That sheet shows scenes from the life of St. Ursula, as does our drawing. Top left, we seem to have the English ambassador offering the Saint the hand of the prince, i.e. a symbolic crown. Behind the ambassador are two courtiers, one with falcon. Beneath, we see the Saint in conversation with her father, and next to them a woman, probably the Saint's mother, disappearing through a door followed by a chamberlain carrying a key. Top right, there is a freer, sketchier drawing of a sick room or death scene, a young man on a bed surrounded by, presumably, doctors. It has no apparent connection with the Ursula legend; nevertheless, the separate scenes are composed as though they belong together. Because of the subject, and because of certain features, commonly Northern Italian, Co-letti attributed the drawings in Vienna and Rotterdam to Tommaso da Modena, master of the Ursula-frescoes in the Museum of Treviso. But this view is untenable: Narrative style and pictorial concept are quite dissimilar. Our artist takes great interest in the architectural features that surround each scene; one of them even remains unoccupied. It is a tabernacular structure affording a cross-section of a building complex, with many windowed rooms visible above the figures, and a glimpse of the outside roof. Such compartmental, highly abstract tabernacles occur in Italian painting chiefly in the first decades of the 14th century. The most beautiful and distinctive examples can be found in the Pala of St. Cecilia in the Uffizi. Like the work by the Cecilia Master, our sheet has many connections with Giotto himself — in the monumentality of the compact figures, in their direct relationship to each other, and in the arrangement of space; it was reasonable to attribute it to a Giotto follower. But the drawing does not seem Tuscan in the delicate sweep of a movement like that of the Ursula-figure top left, the flow of her gown, the palpable mellowness of the bodies, and the density of grouping of the figures, which lack the separateness and clarity of Tuscan composition. Peculiar, for instance, how the two courtiers crowd behind the ambassador, blocking each other's way. There is similar crowding in the sickroom.

This handling has probably its closest parallel in that of Emilia and Romagna in the first half of the 15th century.

Our drawing combines more and less highly finished portions, separate pieces of architecture and figures, including a lightly indicated frontal seated figure at the very bottom. On the sheet in Rotterdam, single figures are repeated in several variations; the sheet in the Louvre has no less than three variants of the Annunciation alone. Consequently, these sheets can be taken as true preparatory drawings for paintings: studies, not sheets from model-books, therefore, a kind of drawing only rarely preserved from so early a date; and the Albertina's drawing is particularly interesting in the wealth of scenes and techniques employed.

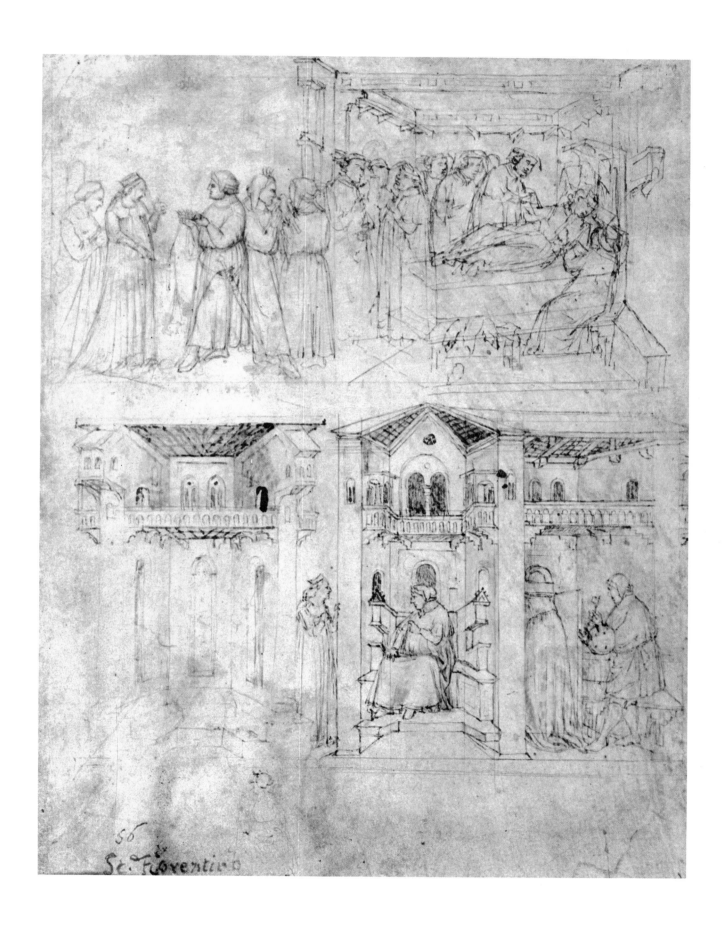

MICHELINO MOLINARI DA BESOZZO

First documented in Pavia 1388, where he executed a fresco cycle in the Cloister of San Pietro in Ciel d'Oro, and, in 1394, his Altarpiece was installed in Santa Mustiola. 1404, first mentioned in the annals of the Duomo in Milan; from that date, occasionally mentioned as painter, draughtsman and expert. 1410, traveled to Venice. Still practicing in 1445, still alive after 1450. Highly praised by contemporaries *'summus in arte pictorica et des(i)gnamenti'* and *'pictor excelentissimus inter omnes pictores mundi.'* One of the chief representatives of the late Gothic International Style, through combining extreme tenderness of expression with gentle, sensitive, rhythmic lines and a rich chiaroscuro. His nature studies, particularly of animals, were of the greatest importance. His influence spread not only to Verona but probably beyond the Alps.

3 Study sheet, Adoration of the Magi and other subjects

Silverpoint on paper with prepared beige ground. Inscribed: 39. Bottom right: Cimabue Fiorentinus. *273 x 204. Inv. 4855, V. 11.*

Orig.: *Gentile da Fabriano (?); Pisanello (?); Marquis de Lagoy, L. 1710; Graf Moritz von Fries, L. 2903; Albert von Saxe-Teschen, L. 174.*

Lit.: *S.R. 5, Schönbrunner-Meder 857; Toesca 1912; p. 443 ff., V. II; Schendel 1938 p. 74 and No. 64; Pächt 1950 p. 14 ff., Schilling p. 72; Degenhart-Schmitt: p. 641; Exh. Milan 1958, No. 162, Exh. Vienna 1962, No. 267; Benesch No. 1; Fossi-Todorow No. 463; Fossi-Todorow 1970, T. XII.*

This sheet belongs to the model book complex that Degenhart and Schmitt traced back to Gentile da Fabriano, and is itself a typical collection of model drawings. It includes, top, a Madonna and Child, two prophet figures, a figure possibly of God the Father, and a female saint; bottom, a St. Jerome. But the main feature is an ambitiously planned Adoration of the Magi, with the participation of a patron presented by a Saint. Additional figures, horses and monkeys are lightly indicated. According to Pächt, the first to recognize the relationship between this Adoration and two miniatures in Michelino's prayer books (in Avignon and the Bodmer Collection in Geneva), this artist was the first to introduce exotic animals from traditional Mystery plays into the Adoration of the Magi. Later, these animated this subject in the renderings of many other artists, including the brothers Limburg. Michelino's interest in animals is also demonstrated on the splendid verso, by two pen drawings of stags' heads that anticipate Pisanello's animal studies (Fig. 8). It was Toesca who first recognized the affinity between these delicately tilting, weightless figures and the famous funeral oration of 1403 by G. Galeazzo Visconti, in the Bibliothèque Nationale, Paris. Our sheet, too, belongs to the period around 1400, zenith of the courtly International Style. Not only in graphic style, in the rhythmic flow of dense interior modelling of the draperies, but also in the conception of the figures, there are connections with Gentile da Fabriano, whom Michelino probably met in Venice, and to Veronese masters, so that some authorities believe this drawing to have originated in Verona. But the tenderness and delicacy of the drawing, and the airy lightness of the figures, are so typically Lombard that one can hardly question Toesca's observations.

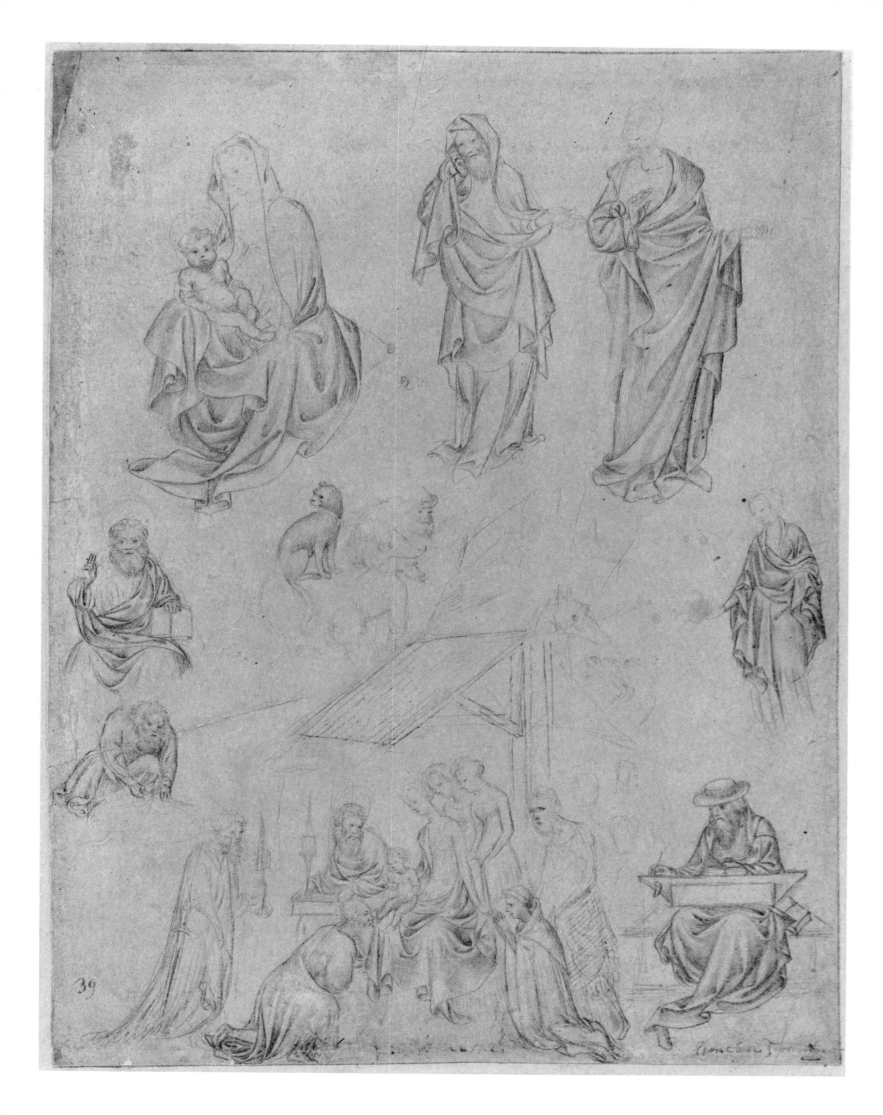

39

STEFANO DA VERONA (Stefano da Zevio)

Painter; born in Verona, probably 1374. Mentioned in Veronese documents of 1424, 1425 and 1438. His only signed and dated picture, the Adoration of the Magi, 1435, is in the Brera in Milan. Signed frescoes, much damaged, are in St. Eufemia in Verona. A Stefano signature that may be genuine appears on one of the drawings in the Collection of the Institut Néerlandais in Paris. These, and the sheets in the Albertina, which are closely related to the reliably attributed Stefano frescoes, should be taken as the starting point for any reconstruction of his graphic *œuvre* rather than the more freely drawn sheets in the Uffizi, London, the Ambrosiana, and Dresden, as Fiocco (1950, p. 520) and Fossi (1970, p. 17) suggest. Degenhart was surely right in recognizing those as Stefano's later work. Leading master of the International Style in Verona; early works still influenced by Altichiero, later probably by Michelino da Besozzo. Stefano differs from Michelino (notable for his elegance of line) in his strongly expressive quality and the predominantly graphic treatment of even his paintings and frescoes.

4 Flying angel

Pen and bistre, white paper, nearly effaced 15th century inscription: FC *(in circle surmounted by crown)* Questo desegno fo de Fillipo. *Late pencil inscription:* Pisanello. *234 x 172. Inv. 24016; V 5.*

Origin: *Anon. 15th century collector F.C., L. 2990a; Conte Lodovico Moscardo, Verona; Marquis de Calceolari; Luigi Grassi, L. 1117b; acquired 1923.*

Lit.: *Stix Albertina, No. 5; Degenhart 1937, p. 528; Fiocco 1950 p. 62; Exh. Verona, No. 41, Lugt 1962 No. 7.*

The same old collector's inscription as on our sheet appears on a drawing of identical provenance in the Institut Néerlandais in Paris (Lugt 1962 No. 6), which is signed with an S. The battle on our drawing's verso, lightly traced in silverpoint and executed in pen, is closely related to a further drawing in that collection, which bears the old signature "Stefanus". In these battle scenes, the connection with Altichiero's work is still noticeable. Our angel, as Degenhart was the first to notice, can be linked with Stefano's charming Madonna del Rosario, generally considered an early work. There, twenty-four such delicate, long-winged disembodied little creatures animate the picture, typical apparitions of the early 15th century, when the bodies were always made to disappear behind the fine flow of draperies. Not only the contour, but also the light that plays on the folds is emphasized by virtuoso lines. Stefano gently models mantle and gown with beautifully moving parallel hatching and added cross-hatching, anticipating with his masterly technique what draughtsmen around 1500 were obliged to relearn, laboriously, from the Northerners, who had not lost the art. This by itself, the masterly sweep in which the wing circumscribes the figure, and the way in which it relates as an expressive arabesque to the white paper, which was probably once still larger, make it impossible to believe that it might be the work of a pupil.

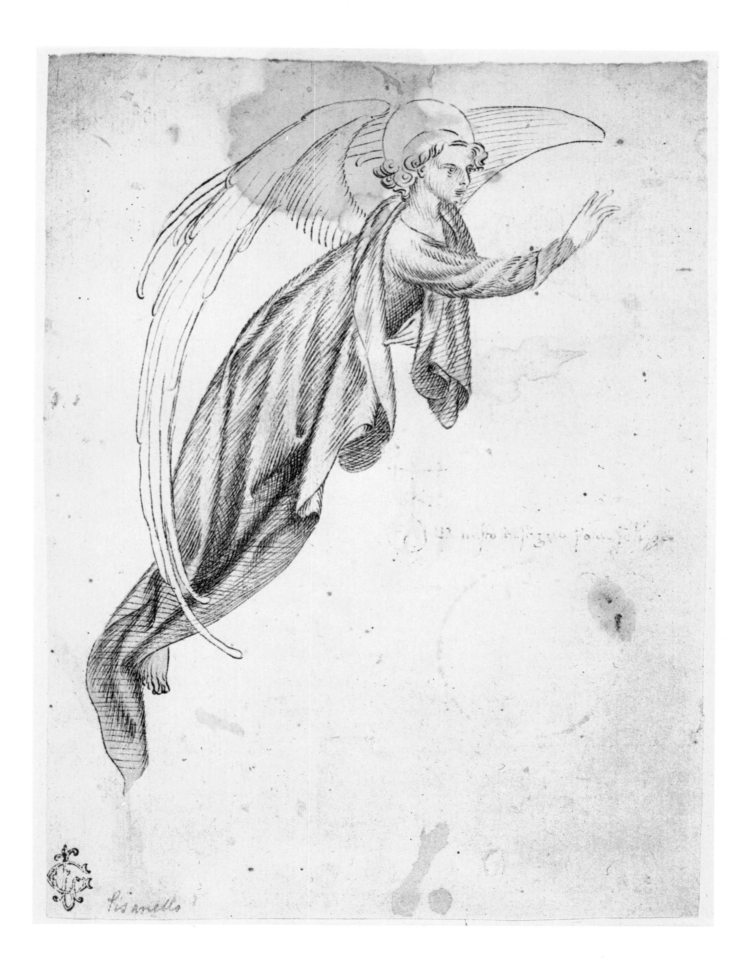

PISANELLO (Antonio Pisano)

Painter and medallist. Born in Pisa, son of Puccio di Giovanni de Cereta, before 22nd of November, 1395. Died 1455. From the beginning of the 15th century, lived with his mother in Verona. Between 1415 and 1420, called to Venice to help Gentile da Fabriano with the decorations of the Sala del Gran Consiglio in the Palazzo Ducale. 1422/23 perhaps in Florence with Gentile; 1424 in Pavia; 1424/5 in Mantua; 1426 Annunciation in S. Fermo in Verona; 1431 in Ferrara and 1431/32 in Rome, where he continues Gentile da Fabriano's frescoes in San Giovanni in Laterano. 1432 portrait of the Emperor Sigismund, who was in Italy at the time. 1438 numerous drawings of the Byzantine emperor John VIII Paleologus on the occasion of his appearance in Italy for the Council of Ferrara. Works in Verona before 1428 (Fresco of Saint Anastasia, his principal work) as well as Ferrara, Mantua and Milan. After 1440 exiled from the Venetian Republic, goes to Ferrara. On the basis of his dated medals, residence there can be assured in 1440, 1441 and 1448; in Milan 1444; Rimini 1445, Mantua 1447 and from 1449 in Naples. Typical court and itinerant artist. His work is based on that of Stefano da Verona and, especially, on Gentile da Fabriano. In its basic features, it remains linked with the International Style. But his intensive study of nature, to which his many surviving drawings testify, leads him to take a new direction. And through his understanding of the plastic and surface quality of things, and the wealth of natural objects which he painted, he was to become an important pioneer of the North Italian Renaissance. Both his drawings from life and his medals place him in a unique position within Italian art.

5 Allegory of Luxuria

Pen and bistre on paper prepared with red chalk, slight damage in woman's headdress. Later pencil inscription: Pisanello. *129 x 152; Inv. 24018, V9.*

Orig.: *Conte Lodovico Moscardo; Marchese Calceolari; Luigi Grassi, L. 1171 b; Acquired 1923.*

Lit.: *V9; Stix Albertina No. 8, 9; Degenhart 1941 p. 27;* Exh. Verona, *No. 95, Degenhart-Schmitt 1960, p. 114,* Exh. Vienna *1962, No. 279; Benesch No. 3; Fossi-Todorow No. 1.*

This sheet, like No. 4, from the old Veronese Moscardo collection, is regarded by all authorities as one of Pisanello's early works. It probably dates from the same period as the Annunciation in San Fermo in Verona (1426), which he painted after he had become familiar with the art of Gentile in Venice. The extreme elegance of line that follows the form in exquisite movement, and the modelling of the contours by a massing of finest lines that also indicate shadows, suggest indebtedness to both Stefano and Gentile. The woman's body, so fine-limbed and tense as to have a deer-like quality, the headdress richly entwined with flowers, and the cascading waves of hair that fuse with the drapery combine, with the hare, to form an ornamental design that occupies the paper with the inevitability of a Gothic initial. The naked body and the attributes that make the figure an allegory of lasciviousness still appear stereotyped and unnatural in spite of the exquisite surface treatment. The face, however, is charged with a direct, immediate vitality that imbues the whole drawing, for all its Gothic constraint, with a very personal expression in which the young artist's new convictions can be recognized. The drawing's very individual character does, however, throw some doubt on Degenhart and Schmitt's suggestion that it is a reinterpretation of an Antique original. On the verso of our sheet is the drawing of a little deer, showing Lombard influence.

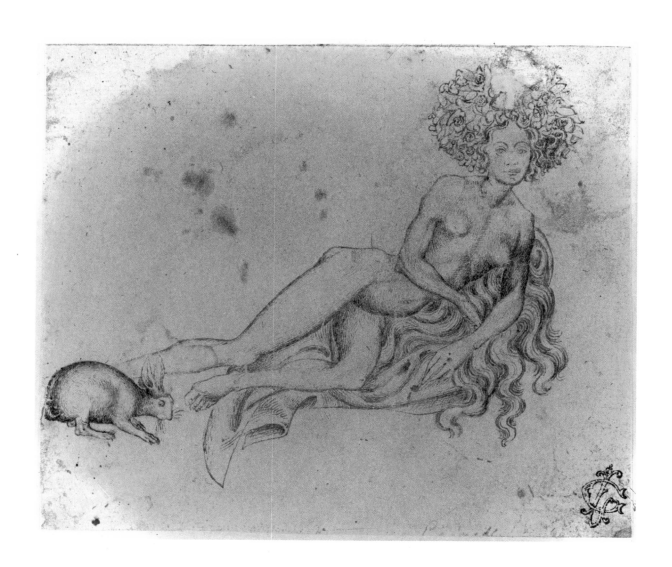

6 Sheet of Studies

Pen and bistre over silverpoint drawing on parchment. 17th century inscription: Nicolò Pisano. *211 x 160. Inv. 5; V10.*

Origin: *Marquis de Lagoy; Graf Moritz von Fries; Albert von Saxe-Teschen.*

Lit.: *S.R. 7; V 10; Bean 1960, No. 223; Degenhart-Schmitt 1960, p. 81, p. 143, n. 69; Fossi-Todorow 1962, p. 156;* Exh. Vienna *1962, No. 282; Fossi-Todorow, No. 205; Degenhart-Schmitt, p. 641.*

This sheet belongs to a model book of drawings, mostly on parchment, after various masters of the Trecento and Quattrocento in Rome, Florence, and Northern Italy. It contains costume studies and, mainly, studies after Antique originals, and is regarded by Jacob Bean and Maria Fossi-Todorow as the work of a mid-15th century artist who had connections with Pisanello's studio. Fossi specifically ascribes our sheet to an anonymous Lombard who prettified Pisanello's forms. The full extent of this model book, which also contained other masters' drawings, such as our Nos 2 and 3, documented through inscription by a subsequent collector, was recognized only by Degenhart and Schmitt. They regard it as a body of work originally assembled by Gentile da Fabriano, then bequeathed to Pisanello and completed by him. They suggest that our drawing, for example, was a sheet that Pisanello drew after his stay in Rome of 1431/32, and in which he systematically, by symmetric reversal and change of detail, elaborated a fashion *motif* he had previously used in his fresco in S. Anastasia in Verona. The head of the child Jesus, beneath, is similarly varied. The Evangelist cutting a pen may have been copied from an earlier work of art. This sheet is closely akin to a related sheet in the Rothschild Collection in the Louvre (Fossi-Todorow No. 200), where the motifs are still further varied. On the verso are studies of hermits by a different hand. The delicacy, elegance and economy of line on these sheets does indeed argue for Pisanello, who would, of course, present himself differently in such finished drawings for a model book than in his freer drawings from life or in preliminary studies for his frescoes or pictures. In spite of all idealisation, the fine variation of expression in the three heads by minute alterations of facial proportion, position of eyes, and shape of nose and chin is, after all, nothing short of masterly, as is the exquisite modelling of the draperies and the curve of the rich coiffures.

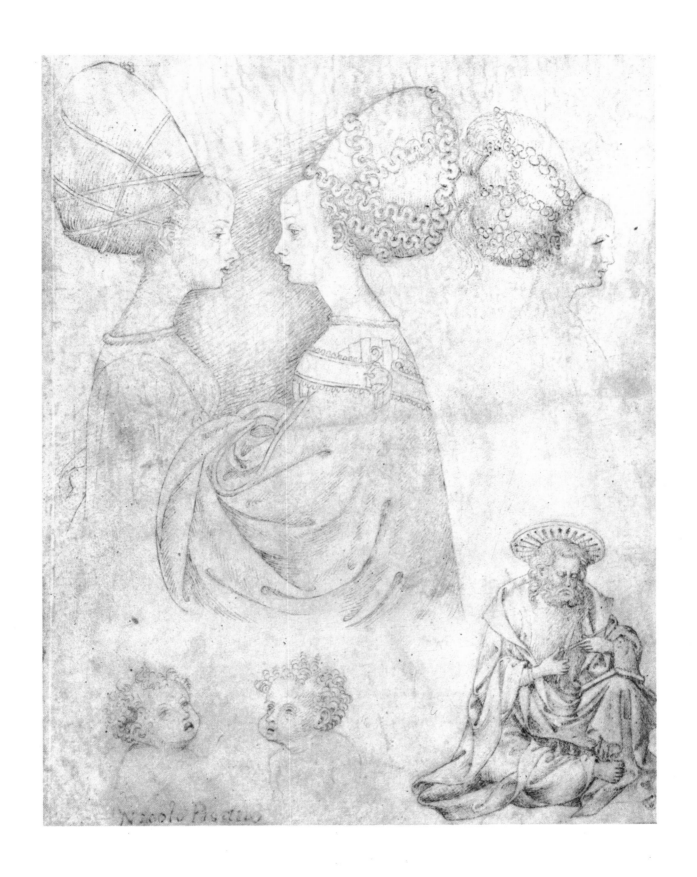

7 Four portrait heads

Pen and bistre, brush, on brownish paper prepared with red chalk.

Fra Andrea
Inscr.: top: frate Andrea de Servi; bottom: La carnacio(ne) frescha e chiara/ l'occhio piccholo tondo la lucie nera/ la barba rasa cenerogniola ben rasato dinanz(i). *111 x 88. Inv. 28 R.*

Prior of San Michele Berteldi, Florence
Inscr.: il priore di san michele berteldi prop(r)io. *35 x 101. Inv. 30 R. 2.*

Monk
Inscr. on added paper: (c)hiara/ ... e fescha e gentile/ ... co vestito di nero. *111 x 89. Inv. 29 R. 3.*

Poet (?)
136 x 99; Inv. 31 R. 4.

Orig.: *G. Vasari; P. J. Mariette, L. 1852; Graf Moritz von Fries, L. 2903; Albert von Saxe-Teschen, L. 174.*

Lit.: *S.R. 31-34; R. 1-4; Berenson, 1938, II, No. 560a; Parker 1956, No. 1; Degenhart-Schmitt 297-300.*

These four sheets belong to a group of portrait heads of which there is another in Oxford and one in Paris (Degenhart-Schmitt 296 and 301). Vasari ascribed them to Uccello, under whose name they were kept at the Albertina until Wickhoff rejected the attribution. Stix and Fröhlich-Bum then assigned them to the late 14th century, while Berenson suggested Bicci di Lorenzo. Degenhart and Schmitt latterly again support the old Uccello attribution. They argue that the heads are related in origin to the animal studies in No. 8 in the hesitant line and the fine wash. Such sheets as these once formed part of model books, based on long-established traditional examples. The heads can be traced back to originals of the Trecento; they approach in costume and expression portraits in frescoes like those by Andrea da Firenze in the Spanish Chapel of S. Maria Novella in Florence. Of course, the more modern artist tried to give them a little more life, but they nevertheless remain rather stereotyped. As the inscriptions show, the artist's main concern lay in the exact reproduction of surface detail and head-structure, rather than personal and individual expression. A comparison with Uccello's documented portraits show how that master even refrains from realism of detail in order to emphasize the force of the sitter's personality. Therefore both here and in the case of the related animal studies, we must be dealing with a minor Tuscan artist (No. 8), whose personality might be difficult to establish.

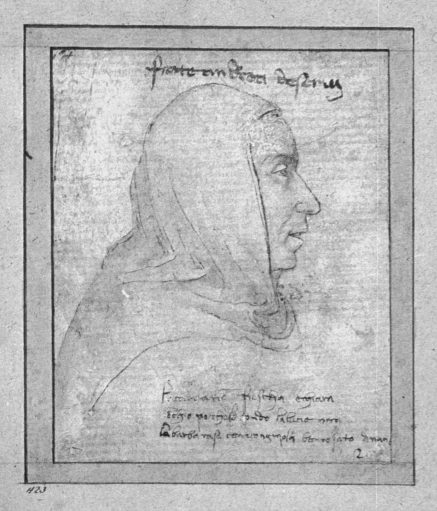

frate andrea desenu

humaniu flustya engan
ditio yarefalo sando hatina nra
La barba rasa conuengmofa bonrofato amari

2

423

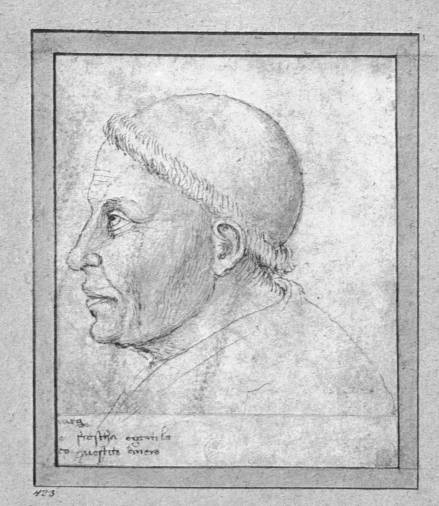

aug
e prestya euuutile
to questite emero

423

iborgore dfan michele baretelo
prophi

18

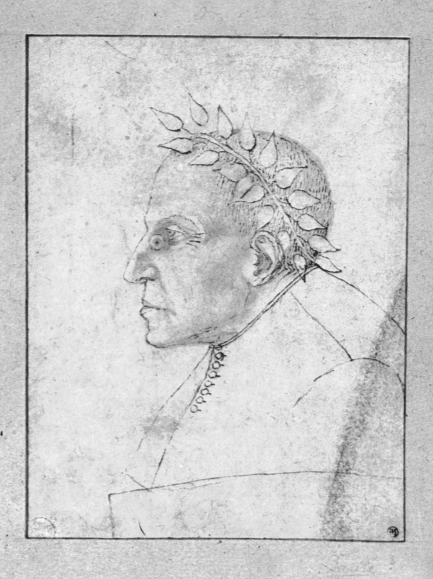

8 Animal studies

Pen and brush, bistre on paper, unevenly pre-
pared with red chalk, repaired in several places.
Old pen inscr.: Lunza ov(vero) gatto/ leopardo.
230 x 172. Inv. 27, V. B.

Orig.: *Giorgio Vasari; P. J. Mariette, L. 1852;*
Graf Moritz von Fries, L. 2903; Albert von Saxe-
Teschen, L. 174.

Lit.: *S.R. 31; V 13; Kurz, p. 10; Pope-Hennessy*
1950, p. 168; Degenhart-Schmitt, No. 311.

The animal studies appear on the verso of a
sheet showing a rider with lance and the heads
of eagles; it apparently had been the right-hand
page of the center spread in a sketchbook. The
left-hand page, showing fighting soldiers, with
more fighting animals on the verso, is today in
the Museum in Dijon. Both drawings in turn
belong to further model pages now in Stockholm,
with animal studies and motifs from the An-
tique. Some of Vasari's old mounts are inscribed
with Paolo Uccello's name, to whom the Alber-
tina's sheet was also traditionally attributed. It
was then relegated to Pisanello's circle, but re-
cently reacknowledged by Degenhart and Schmitt
as the work of the great Florentine. The sheets
of this model-book, at least those that are pre-
served, fit into the tradition of the typical
Tuscan sketchbook, which tended to contain
antique dramatic subjects, such as animals in
combat, rather than nature motifs of a quiet
character, as in the Lombard tradition.
Each of the motifs is found with slight devia-
tions in earlier or later sample books, frequently
even in a similar sequence on a sheet. Among
surviving pages of this kind, our group is distin-
guished by a special sensitivity of contour and
modelling, although there is no evidence of
direct observation from nature. The motifs of
hare and lynx — drawn, however, as a leopard

at the top of our sheet — and the belted monkey
were all used by Benozzo Gozzoli in his fres-
coes in the Campo Santo in Pisa (See Degenhart-
Schmitt, Ill. 367 and 528); the stag with his
head turned, though usually without the leopard,
belongs to the standard *repertoire* of the Flo-
rentine cassone painters, and indeed it was the
realm of secular painting that offered such world-
ly subjects their proper application. Vasari's
descriptions of pictures of fighting animals by
Uccello in the Palazzo Medici place these, too,
within our tradition. The motif of the fight
between a lion and a dragon already appears
in early representations of the Thebais, the idyl-
lic fellowship of monks in the desert (see Schu-
bring No. 37) and is still found in prints of
the late 16th century (Degenhart-Schmitt, Ill.
53). This may have been the reason why Vasari,
not always reliable in his attributions of early
sheets, ascribed this group of old-fashioned ani-
mal drawings to Uccello, famous Quattrocento
painter of animals. But if we compare Uccello's
magnificent, organically coherent, yet geometric-
ally abstract horses, as in the John Hawkwood
fresco or the equestrian study in the Uffizi
(Pope-Hennessy, Ill. 11 and 12), with the grace-
ful, sensitively drawn but almost unarticulated
fairy-tale horse on the recto of our sheet, we
see that here we are dealing with an artist of an
entirely different tradition. This rider-and-horse
too, belong to the cassone-motif repertory and we
must look for the artist among painters who
devoted themselves chiefly to this pretty, world-
ly, decorative art. A drawing in Lille of St.
Galganus in a similar technique — ascribed to
Central Italy around 1430, by Degenhart and
Schmitt, who recognize Sienese influences in
this sheet, (Cat. 148, Pl. 183c) — might be by
the same artist, and could perhaps help an
unprejudiced attribution of the group.

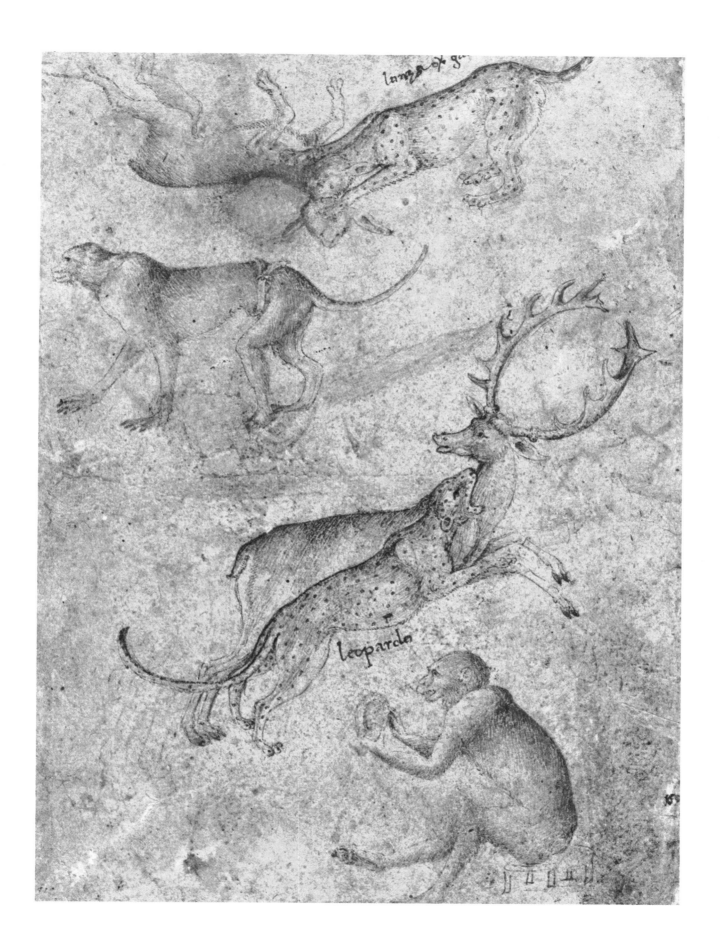

LORENZO GHIBERTI

Sculptor, architect, creator of stained glass and goldsmith's designs, writer. Born between 1378 and 1381, son of Cione di Ser Buonacorso, probably in Florence; died there December 1st, 1455. Pupil of Bartoluccio di Michele. 1401, won famous competition for North Door of the Baptistry. Worked on door with twenty-eight reliefs depicting scenes from the life of the Virgin Mary and Christ until 1424. Between 1425 and 1452 East Door with Old Testament stories, the "Door of Paradise," in a new, Renaissance-like style. Further works: Shrine of St. Zenobius (1432-1442), St. Mathew at Orsanmichele in Florence (1419-1422), and St. Stephen, Florence (1428). Author of the *Commentari,* an important theoretical treatise on art.

Ghiberti, a many-faceted artist and intellectual analyzer of problems, embodies the artist-ideal of the Renaissance. But more than the work of his Florentine contemporaries, his art is linked to the so-called International Style of late Gothic, from which he takes the gentle flow of line. But by virtue of his exploration of the Antique, his observation of natural life, and his great expertise in perspective, in which he pioneered (especially in the "Door of Paradise"), he was fully involved in the artistic endeavors of the early Renaissance. His highly developed sense of composition and linear beauty, as well as his craftsmanship, the quality of his work and his attention to even the most minute detail, earned the admiration of his contemporaries and of all who followed.

9 Five figure studies for a Flagellation of Christ

Pen and bistre on white paper, 216 x 166, Inv. 24409, R. 8.

Orig.: *Luigi Grassi, L. 1171 b; acquired 1923.*

Lit.: *A. Stix,* Kunstchronik und Kunstmarkt *59, 1925, p. 139 ff; Stix, Albertina, T 35; Schlosser, p. 100; Krautheimer 1956, p. 129, Pl. 46; Exh. Vienna 1962, No. 260; Benesch, No. 4; Degenhart- Schmitt, N 91.*

This drawing is one of the most important Italian drawings of the early 15th century. No earlier known sheet enables one to enter so intimately into an artist's exploration of a movement, or reveals the process with such a richness of means. Poses are varied by placing the legs differently, while the arms remain in the same position (below); or the various means of striking, e.g. with one hand or both are explored (above); the rich, varied line and the profuse *pentimenti* simultaneously express different phases of the movement within a single pose. At the same time, there is a deep sense of the body's harmony and organic structure, and the extremities are seen to evolve from a living center in spite of subjugation to ornamental shapes and abstract treatment. Balance is taken particularly seriously. The poses are based, as Krautheimer and Degenhart and Schmitt establish, on Sienese pictures of the Trecento. From these also comes the Tabernacle-architecture with coffered ceiling and central column, of which the left half is visible, above. But what is traditional formula there, is here charged with life. It has been plausibly suggested that this study is connected with Ghiberti's "Flagellation of Christ" on the North door of the Baptistry. Indeed, the left-hand figure in the relief is a development of the central figure in the upper row of our studies, which is marked as the result of the work on the sheet by more detailed shading and modelling. Of course, in execution the figure was developed further still, and became both more static, and more ornamental. In these respects, the relief differs greatly from our drawing, which might give rise to doubt regarding the attribution. Degenhart-Schmitt compare the sheet with mural drawings by Masolino, Ghiberti's contemporary, for the "The Beheading of St. Catherine" in San Clemente in Rome. Admittedly we find there related forms of movement and, moreover, a very similar graphic style that clearly marks our sheet as early 15th century Florentine; but we also find shapes there that are far broader and much less varied than those of our figures, which are more graceful, more differentiated and more thoroughly structured. Particularly the figure at bottom, left, shows a great sense of the essential body structure, as is often found in the drawings of sculptors. A comparison with the bailiff in Masaccio's "Beheading of St. Paul" in Berlin makes one aware of the ornamental qualities of our sheet typical for Ghiberti, whose art had strong ties to the International Gothic style. Indeed, similarly spontaneous figures occur in Ghiberti's later work, like his "Door of Paradise" and the Shrine of St. Xenobius. This drawing for one of the latest reliefs of the North door foreshadows the style that the artist would not or could not yet realize in sculpture, but to which he gave plastic form in the shallower, more pictorial treatment of the later reliefs.

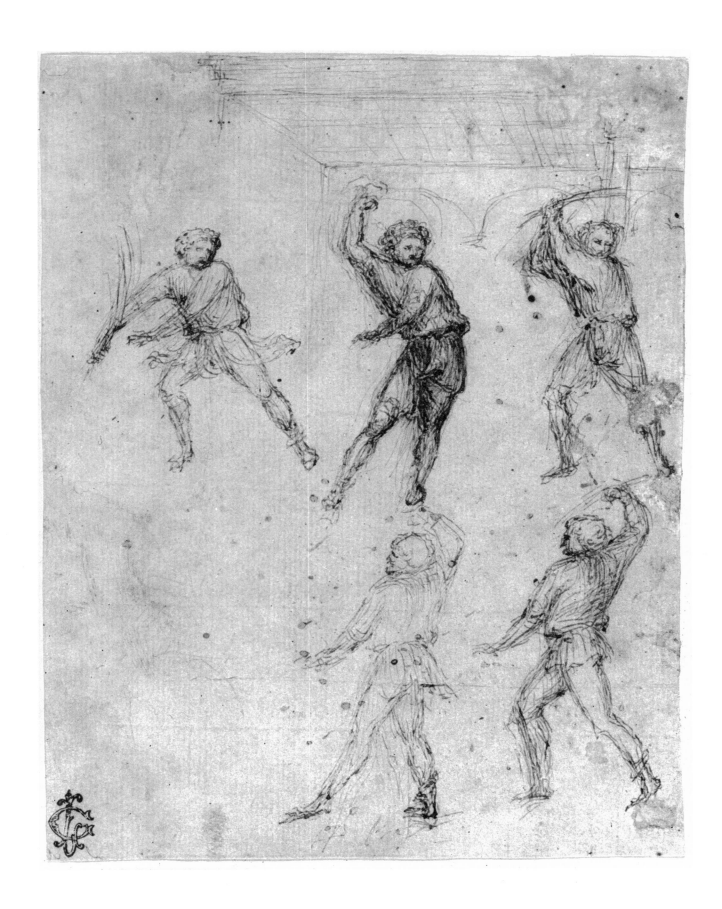

FRA ANGELICO, called BEATO ANGELICO (Fra Giovanni da Fiesole)

Miniaturist and painter; his secular name was Guido di Pietro. Born in Vicchio in the Mugello, at the beginning of the 15th century, died in Rome 1455. Named Fra Giovanni in the Dominican monastery in Fiesole where he took the vows in 1420-22. Among his earliest datable works is the Madonna with Saints, from S. Pietro Martire, 1429, now in San Marco, Florence. 1433, the Masaccesque Tabernacle of the Linaiuoli (San Marco). Frescoes in the Cloister of San Marco, Florence, painted between 1439 and 1445. From then until his death, with short interruptions during one of which he worked as a painter in Orvieto (1447), in Rome (Chapel Niccolo V). The point of departure of his style is miniature-painting, as practiced in the circle of Lorenzo Monaco. Formatively influenced by Masolino and Masaccio. Fra Angelico's achievement lies in the clarity and purity of form and color expressed in quiet, highly organized compositions, in the precise handling of perspective and proportion, the exact definition of plastic volume, in the fresh, much idealized local coloring with predominating light reds and blues, and finally in the presentation of deep emotion, especially in religious situations. This masterly application of early Renaissance achievement in presenting the world, with a tendency — arising from spiritual experience — to idealize form and color, sublimated and dematerialized, gives his work its great depth, its directness, and a mystic intensity, at which he arrived not through ecstasy, but through purity and lucidity. These attributes later earned him the name of Angelico.

10 Christ on the Cross

Pen and bistre, wash, red body-color and yellow watercolor on brown paper, strongly flecked, pen inscription of later date: obiit 1455. *Repairs at right edge, 293 x 190, Inv. 4863 R. 9.*

Origin: *Vasari (?); Graf Moritz von Fries, L. 2903; Albert von Saxe-Teschen, L. 174.*

Lit.: *S.R. 30; Schönbrunner-Meder VI, No. 702; Berenson No. 178; R. 9; Pope-Hennessy 1952, p. 205; Grassi 1861 p. 147, Benesch 1964, No. 5; Degenhart-Schmitt, No. 371.*

This sheet seems as self-contained as a miniature. Its stillness and subtleness, together with the intense red of the blood and the cross in the halo, still elicits — like almost all the Frate's paintings — an immediate spiritual absorption. All the same, it does not exist only for its own sake. The indication on the left of a window frame with a small, Gothic-looking respond suggests that it is a drawing for a mural, although this cannot be determined today. But it is certain that this architecture does not fit with the Renaissance building of the Monastery of San Marco, with the decoration of which this drawing has often been connected. None of the many Crucifixions painted there by the master himself, or under his direction, resemble ours. They are more monumental, more powerfully proportioned, more classical and Renaissance-like in expression. As a result, our sheet has been regarded as a beautiful imitation of our master. But the tender sensitivity with which, for example, the light models the surface of the slender arms, the sure touch with which the flowing blood is depicted, and particularly the very individual treatment of Christ's head, all clearly argue for the Master's own hand. The drapery, which Berenson considered not good enough for Fra Angelico, is much damaged on the right, thus causing confusion. The sheet should be pre-dated. It was already used, with only small deviations in the loincloth and the shape of the cross, for the Crucifixion in the center tympan of the triptych in San Domenico in Cortona, which in turn had been connected with prototypes in the work of Lorenzo Monaco by Mario Salmi (Il Beato Angelico, Edizione "Valori Plastici" 1958, pp. 6 and 25). This triptych is commonly dated between 1433 and 1437, but it is probable that our drawing was created shortly before the picture, and was used there only because the mural for which it had been planned was not executed. Thus we have before us one of the earliest, if not the very first, version of that mystic subject that occupied the religious master throughout his life.

11 Portrait of a Monk

Black and red chalk, pen and bistre, white paper, 298 x 197, Inv. 2. R. 14.

Orig.: *Albert von Saxe-Teschen, L. 174.*

Lit.: *S.R. 2; R. 14; Degenhart-Schmitt, p. 618.*

The quality of this sheet lies above all in the elegant lines of the contours that describe head and shoulders in confident curves, and also in the delicate, gentle modelling in black chalk and the touch of red on the lips. The folds, seemingly carved in wood, are arranged in beautiful movements, but a static calm is preserved — the figure is concentrated within itself and projects nothing.

Individuality of feature is only lightly indicated, more by the general facial proportions than by the animating calm smile. Portraits in profile of this type, like any such simplified drawings that are mostly outline, are difficult to attribute and date. Degenhart and Schmitt assign the sheet to the fringe of a group of drawings by various Florentine artists which they call the "Finniguerra" group, and date to around the sixties of the 15th century. Our drawing most probably also belongs to the third quarter of the century. It is closest in style to the work of Alessandro Baldovinetti, but presents no conclusive proof of his authorship. The great qualities of the sheet nevertheless merit attention.

LEONARDO DA VINCI

Painter, sculptor, engineer, architect, scientist. Born April 15th, 1452, in Anciano near Vinci, close to Florence; son of Ser Piero da Vinci and Catrina, a peasant girl. Died Amboise, May 2nd, 1519. From 1469 in studio of Verrocchio; still there after joining Guild of St. Luke in 1472. 1481, commissioned by the monks of San Donato in Scopeto to paint *Adoration of the Magi* for High Altar of their monastery; it was never finished, as Leonardo entered Lodovico Sforza's service in Milan. 1483, commission for "Madonna of the Rocks," and beginning of designs for equestrian statue of Francesco Sforza. 1493, large clay model on public exhibition. 1495-97 work on *Last Supper* in S. Maria delle Grazie. After the occupation of Milan by French troops in 1499, Leonardo went to Florence via Venice and Mantua. 1501, exhibition of cartoon for *St. Anne.* 1502 in the service of Cesare Borgia (eight months). October 1503, commissioned to paint *Battle of Anghiari* in the Palazzo della Signoria (unfinished and later destroyed). Creation of the *Mona Lisa.* June 1501, Leonardo returned to Milan, and then frequently traveled between Milan and Florence. From December 1st, 1513, he was in Rome and living in the Belvedere at the Vatican. End 1516, beginning 1517 went to France and the court of François I, staying at the Manoir de Cloux near Amboise. Leonardo, in the multiplicity of his activities and interests, represents the quintessential universal genius, and the Renaissance ideal of a painter schooled in the Sciences. His indefatigable search for knowledge led him to investigate the very roots of matter, cause and effect, and especially the laws of movement, growth and decay, and life in human and animal terms. By analysis, he arrived at archetypal forms and quintessential relationships in every area, which accounts for the mysterious, magic power of his few remaining pictures and frescoes, and above all for the abundance of his drawing and writing. Through his insight into the ideal laws of nature, he created it anew in the light of an ideal world. His work has an infinite radiance, and from the early days of his youth had a stimulating effect not only in the cities where he worked, but far beyond, in all Italy, the Netherlands and France. There is hardly one of the great men of the time — Michelangelo, Raphael, Giorgione, Correggio, Dürer, Quentin Massys — perhaps even Hieronymus Bosch — who did not at one time or another feel Leonardo's influence.

12 Apostle

Silverpoint. Pen and bistre on blue prepared paper. 146 x 113, Inv. 17614. R. 14.

Origin: *Charles Prince de Ligne; Albert von Saxe-Teschen, L. 174.*

Lit.: *S.R. 64; Schönbrunner-Meder 590; R. 18; Berenson No. 1113; Popp 1928, No. 33; Popham 1947, No. 164; Benesch Pl. 1; Goldscheider 1960, Pl. 14; Bodmer p. 257.*

The Last Supper in S. Maria delle Grazie made Leonardo famous for all time. Here, he contrasts the stillness and harmony of divine resignation with the multiplicity of human characters as they are displayed in the state of high emotion. With his unfailing gift for exploring the crucial elements in men, objects, actions and events, Leonardo created a picture that is the image of man's reaction to situations so extreme that they touch and put into question the very center of divinity in man. It took many studies in movement, physiognomy and agitated emotional expression before Leonardo finalized poses and characterization. Only a few remain — some compositional studies and some single heads. The Viennese sheet is unique in technique, format and type. It combines character and movement-study in a picture of spontaneous, excited reaction and most forceful expressiveness. Massed groups of parallel silverpoint hatchings, and an outline that is only lightly defined in pen and bistre, together create a flowing, diffuse impression that illustrates the sudden turning of the body and the immediacy of the gesture. We sense how the power of both movement and gesture is concentrated in the head — the actual focal point — and particularly in the mouth and in the great eyes beneath furrowed, bushy eyebrows. It is a summoning of strength bordering on passion that is presented here — indictment, resentment against treachery and its perpetrator, whom the apostle could, seemingly, name. The concentration in the expression is so strong that the closest relations of this drawing are found in Leonardo's so-called caricatures, perhaps in the Study of an Old Man in the Corsiniana (Bodmer, p. 220; Popham No. 138a), which seems to transform pose, movement and expression of our figure into the characteristics of dotage and lewd self-righteousness. Our figure in its divine wrath corresponds so closely with our image of St. Peter that it is usually taken to be a preliminary study for the figure of that apostle, although no actual evidence for this assumption exists either in the remaining studies or the finished work. St. Andrew is depicted as a bald man just as often as St. Peter is, if not more often, and in his figure, the third from the left, we are more likely to find a reflection of this study, even if the passionate accusation has changed into a more passive, dismissive two-handed gesture of indictment.

LORENZO DI CREDI

Sculptor (?) and painter. Born in Florence 1456 or 1459, died there 1537. Named Lorenzo Barducci, called di Credi after an uncle. From 1480 in Verrocchio's workshop together with Leonardo and Perugino. Collaborated perhaps with Verrocchio on one of his commissions, the Pala of the Madonna with Saints in the Duomo of Pistoia. Among his later important works is an Adoration of the Shepherds in the Uffizi. Credi's style is rooted in the stimuli he received during his training with Verrocchio, from Verrocchio himself and, especially, from Leonardo and Perugino. He remained faithful to the ideal of loveliness for the rest of his life, and is especially ingratiating in the quality of his craftsmanship and the smoothness of his work, which Vasari considered unsurpassable.

13 Boy's head

Silverpoint, some grey brush lines, touches of black and red chalk, white highlights on paper prepared with red chalk. 194 x 166; Inv. 4970, R 29.

Origin: *P. J. Mariette, L. 1852; Albert of Saxe-Teschen, L. 174.*

Lit.: *S.R. 105; Meder,* Albertina facsimile, *No. 4; Berenson 731; A. Venturi,* Per Leonardo da Vinci, *in L'Arte 25, 1922; pl. 1; R. 29; B. Degenhart,* Studien über Lorenzo di Credi, Credis Porträtsdarstellung, *in* Pantheon *VIII 1931 p. 465; Delli Regoli, No. 76, p. 137.*

This echanting drawing, which has sometimes been taken for the head of a girl, is traditionally thought to be by Lorenzo di Credi, and except for Venturi, no one ever doubted the attribution. Both type and posture of head often occur in Credi's work, and various authorities have suggested various destinations for the drawing: Berenson, for instance, thought of the St. Michael formerly in the collection of Lord Rosebery, Meder and Degenhart of an angel in the beautiful, late Adoration of the Shepherds in the Uffizi, and others of the Venus in the same collection. It remains difficult to say who was right. This delicate drawing differs technically from most of the other existing sheets by Credi, where the silverpoint delineates the contours more forcefully, eyes are more wide-open and a little more protuberant, and everything seems altogether more rounded. What distinguishes our sheet on the other hand, is the gentleness of light and the self-assured expression of the face. Degenhart accurately emphasizes its close relationship with Leonardo's early work. Venturi even attributed the drawing to the young Leonardo himself, comparing it with the head of the Virgin in the early Annunciation in the Uffizi. The nobility of that head, which resembles ours in many features, is absent, however. In comparison with the individual expression of that Madonna, our head appears vague. Our knowledge of Lorenzo di Credi's graphic style seems still too incomplete for this writer to be able to judge whether this drawing might already have been created while the artist was still working together with his greater colleague in Verrocchio's studio. At all events, it reflects that felicitous moment in the history of Florentine art when Leonardo began to blossom and Perugino was laying the foundation for his astonishing early works.

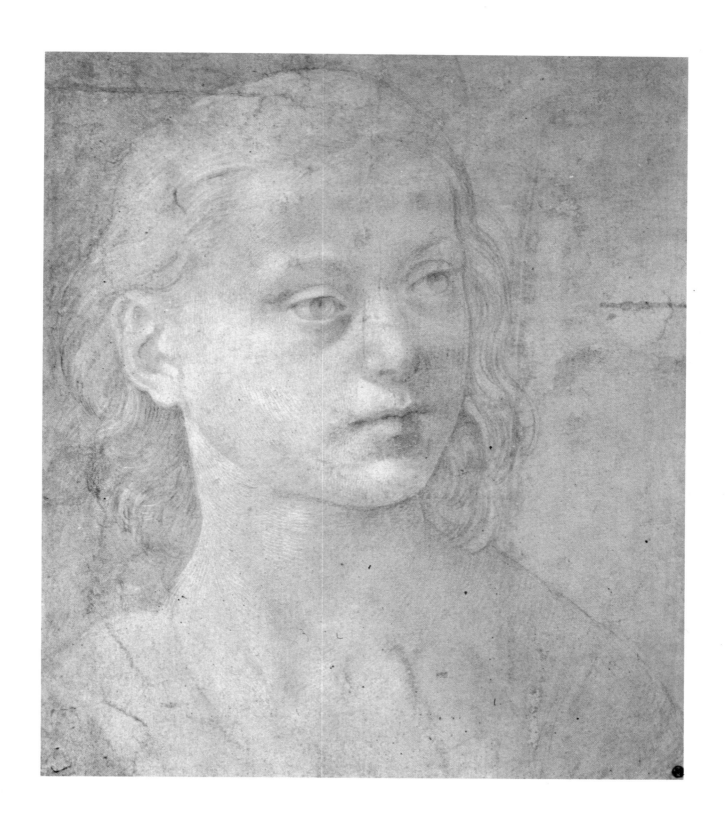

RAFFAELLINO DEL GARBO

Painter, called Raffaello di Bartolommeo di Giovanni Carli (also Karli, de Krolis or de Capponibus); born in Florence circa 1466, died after 1526. There is little information about his schooling. Rather eclectic, he is linked with Filippino Lippi as well as Ghirlandaio and Piero di Cosimo, and he was also subject to Umbrian influence. Vasari praises him as an uncommonly talented and dexterous draughtsman.

14 Hand Studies

Silverpoint, white highlights on grey prepared paper, three pieces of paper pasted together. 320 x 244; Inv. 4858; R. 36.

Orig.: *Giorgio Vasari; P.J. Mariette, L. 1852.*

Lit.: *S.R. 41; Schönbrunner-Meder 51, Berenson 771; R. 36.*

Vasari writes about Raffaellino dei Carli's drawings: "Costui nella sua gioventù disegnò tanto, quanto pittore che si sia mai esercitato in disegnare per venir perfetto; onde si veggono ancora gran numero di disegni per tutta l'arte, mandati fuora per vilissimo prezzo da un suo figliuolo, parte disegnato di stile, e parte di penna e d'aquarello: ma tutti sopra fogli tinti, lumeggiati di biacca, e fatti con una fierezza e pratica mirabile, come molti ne sono nel nostro libro di bellissima maniera." (Cf. Kurz, pp. 33 and 11).

Vasari indeed owned some marvellous drawings by this master, but apparently did not know that his sheets of hand studies — three in the Albertina which he pasted together on one mat, and two others in the British Museum (Popham and Pouncey No. 61 and 62) — were the work of Raffaellino; according to his inscription on the mount, he believed them to be by Filippo Lippi. (Of this mount in the Albertina, however, only the top study is preserved). Meder and Berenson were the first to recognize that they were the work of Filippo Lippi's successor, Raffaellino, and Berenson showed the three lower studies to be preliminary drawings for the hand of the Madonna with Child and St. John, in Dresden. The other hands have not yet been identified. When those at the top are turned horizontally, they recognizably emerge as hands placed on the breast; on the left is the hand of a male nude whose arm and body are also indicated — perhaps a St. John; on the right, the hand of a clothed figure. It is very similar to the Saint's hand in a large Santa Conversazione in the Louvre. Characteristically, Vasari mounted the sheets together from a purely decorative point of view, giving these hands totally false functions. But Raffaellino was himself concerned with decorative appeal when placing his studies, as the lower half of the paper, which is also attractive in the beautiful variation of differentiated motifs, clearly demonstrates.

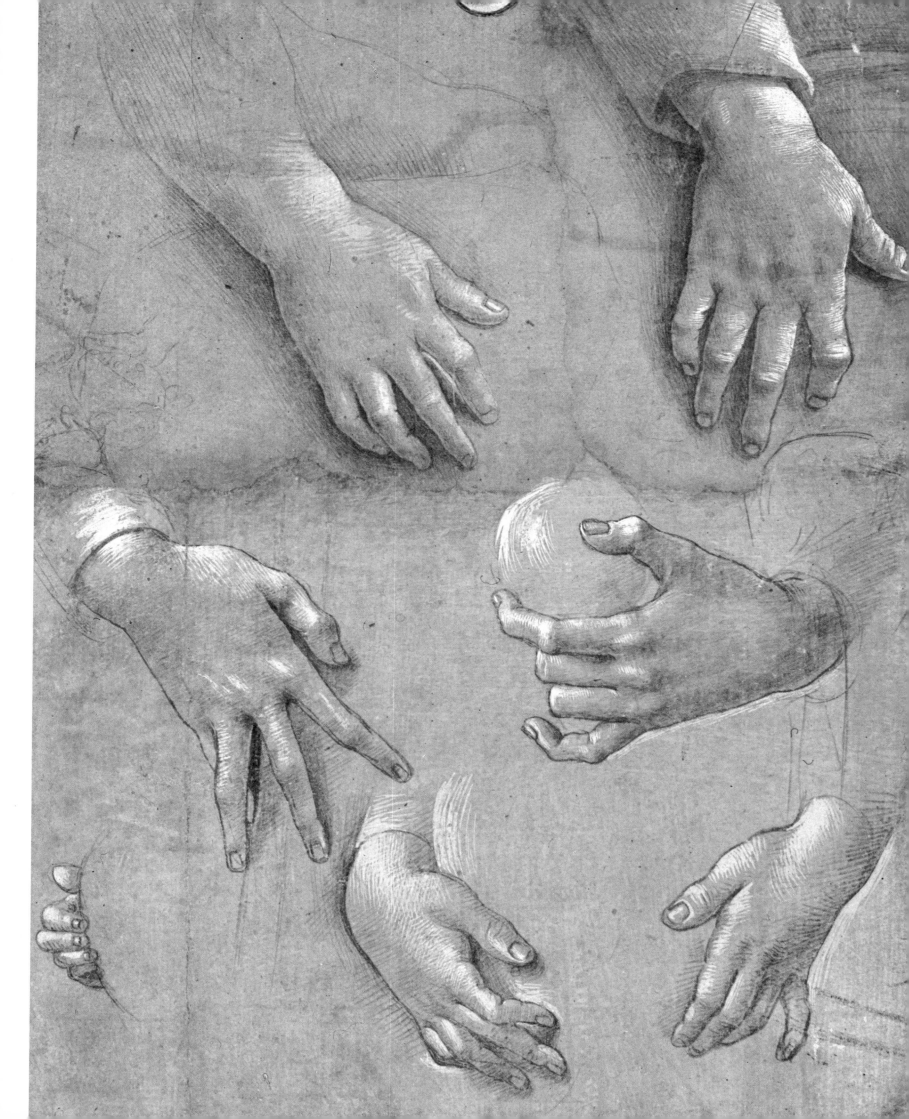

GIULIANO DA SANGALLO

Architect, sculptor and painter; born in Florence 1445, died there October 20th, 1516. Son of Francesco Giamberti and brother of Antonio the elder, who was his collaborator. Both trained as wood-carvers, probably in the workshop of Francesco di Giovanni di Francesco called Francione. Highly esteemed architect, practicing in Florence and all over Tuscany, Rome, Naples, and Milan. Principal work, the Church of the Madonna delle Carcere in Prato, and the Medici Villa in Poggio a Caiano. The style of his figurative painting was influenced mainly by Botticelli, but also by Filippino Lippi and Francesco di Giorgio. His preserved and reconstructed model-books are of great artistic and documentary importance.

15 Judith with the head of Holofernes

Chalk, brush, pen and bistre on white paper. 377 x 270; R. 20; Inv. 4862.

Orig.: *Prince Charles de Ligne; Albert von Saxe-Teschen, L. 174.*

Lit.: *Waagen II, 131; S.R. 54; Fabriczy p. 199; Schönbrunner-Meder I, No. 33; Berenson No. 24; R. 20; Byam Shaw 1931, p. 39 ff; Degenhart 1955, pp. 223 and 243.*

The splendid, turbulent drawing, richly sketched in chalk — only the principal figure is a little more precisely worked out in pen, brush and ink — has had a strange research history. The motif of Judith, inspired by the Venus Medici, so resembles various Botticelli figures — for instance his Minerva in the picture of Minerva and the Centaur, in the Uffizi, or the figure of Truth in the Calumny of Apelles, and yet another Judith in a small picture by that master, in the Collection von Rath in Amsterdam — that already Waagen, and later Schönbrunner-Meder, as well as Stix and Fröhlich-Blum, regarded this drawing as a sheet by the great Florentine painter. Fabriczy, however, recognized that this drawing, already attributed to Giuliano da Sangallo in the Prince de Ligne's Collection, perfectly matched a motif in the great architect's sketchbook at the Biblioteca Comunale di Siena. As only the pen was used for that drawing, and it is altogether more detailed and more flatly conceived, Fabriczy, and Berenson and Byam Shaw after him, suggested, that together with a whole group of drawings in the Albertina and the Uffizi that had once probably formed a sketchbook, it was the work of a different hand: that of Giuliano's brother Antonio. But, as Degenhart showed, it would be difficult to extract these sheets from the body of Giuliano's own work, as they are closely connected through various intermediate stages with Giuliano's documented sketchbooks. The difference between the two drawings may well be accounted for by the fact that here we have a free, original design, while the Siena sketchbook contains a model-book presentation, and in consequence a more rigid reiteration.

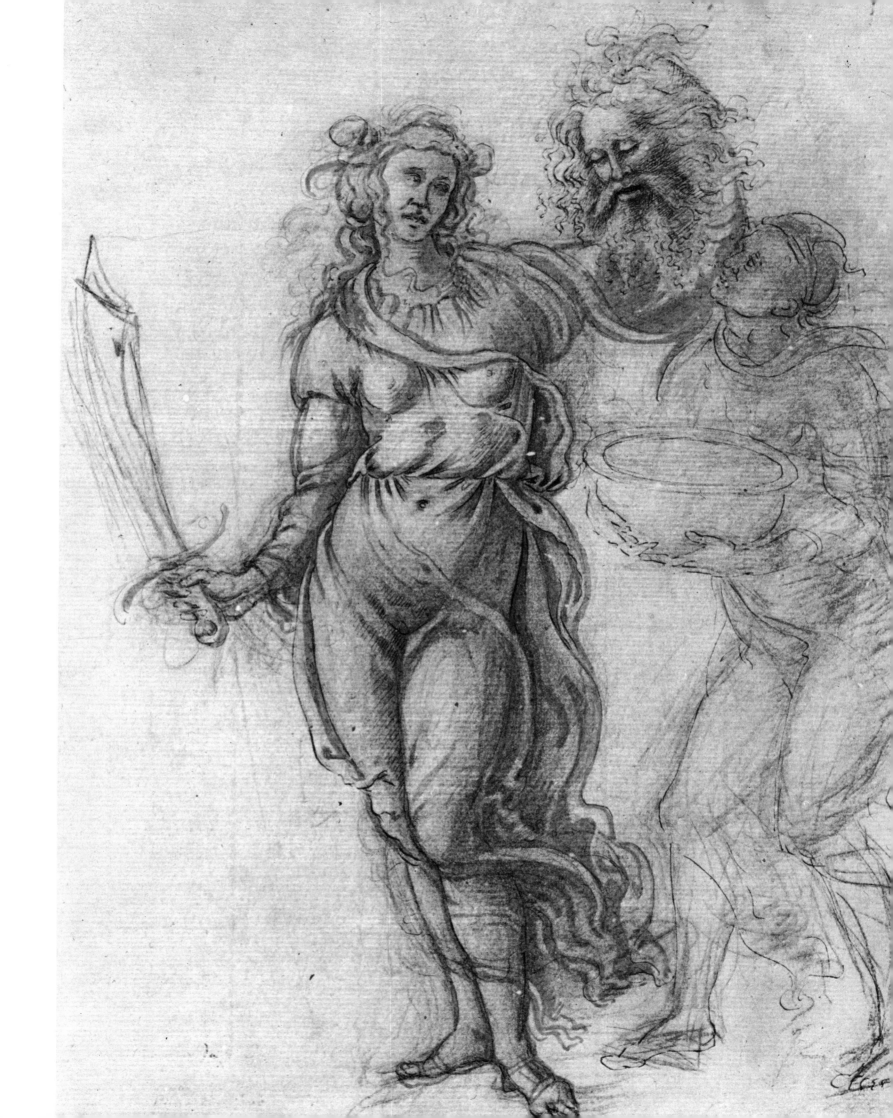

ANDREA MANTEGNA

Painter, engraver; born 1431, probably in Isola di Cartura, son of one Biagio, died September 13th, 1506 in Mantua. Registered in the Fraglia dei pittori in Padua, November 6th, 1441, as stepson of Squarcione. Worked at first chiefly in Padua, especially on the decorations in the Capella Ovetari in the Eremitani Church, together with Niccolò Pizzolo, who as collaborator of Filippo Lippi and Donatello passed on to Mantegna much of their stimulating influence. From 1457, in the service of the Gonzaga in Mantua, where he finally settled. Made *Comes palatinus*. His principal work in Mantua is the Camera degli Sposi, in the Castle (finished 1474). 1466/67, temporarily in Florence and Pisa. 1488/89 in Rome, working for Pope Innocent VIII in the Villa del Belvedere and the Palazzo Venezia.

Together with Jacopo and Giovanni Bellini, Mantegna is the most important artist of the early Renaissance in the north of Italy. Heir to the achievements of the Florentine Renaissance, he links it with the mosaic glow of traditional Venetian-Byzantine colors, and an extraordinarily strong sense for the grandeur of Antique form. With Pollaiuolo, he is probably the greatest Italian graphic artist of the 15th century.

16 Sheet of studies after a Trajanic relief on the Arch of Constantine in Rome

Chalk, pen and brown and black ink. Inscr.: Andrea Mantegna; verso: "a roma." 272 x 198, Inv. 2583, B. 17.

Origin: *Sir Peter Lely, L. 2092; Albert von Saxe-Teschen, L. 174.*

Lit.: *S.L. 8; B. 17; Oberhuber 1966, p. 227.*

Wickhoff had some doubts about the old attribution, and suggested one of Mantegna's contemporaries, while Stix and Spitzmüller attributed the sheet to the Bolognese Jacopo Ripanda, who worked for long periods in Rome, analyzing and absorbing Classical art. But Ripanda never had the understanding of the monumental force of ancient sculpture that appears on this sheet, the lucidity of form and intensity of expression which lead one straight to Mantegna's engravings. The closest parallel is to be found in his preparatory drawing for the *Battle of the Sea Gods* at Chatsworth — in the manner in which the light raises the figures from the ground of the relief, which is drawn in sensitive, finely differentiated parallel lines, in the rela-tionship between the sharp definition of contour and interior design, and in the controlled hatching that achieves maximum plasticity by the simplest means.

The expressions of the strangely sightless eyes and opened mouths, derived from Antique sculpture, showing suffering and inner concentration that is not individual but grows from a collective mood, is characteristic of Mantegna's work. It is important to note that the uncompleted drawing received several finishing touches — in the warrior on the left, and the shield on the right — from a clumsy though contemporary hand, which unfortunately disfigure it.

On the verso is another Roman motif, a seated bride, from a relief that Pietro Santi Bartoli saw in the Palazzo Valle in Rome and then engraved (cf. Giov. Batt. Bellori, Admiranda romanarum antiquitatum ac veteris sculpturae vestigia, Rome, J.J. de Rubeis 1693, No. 59) and which also interested Raphael. It seems that we may consider this drawing to be one of the few remaining works from Mantegna's sojourn in Rome of 1488/89.

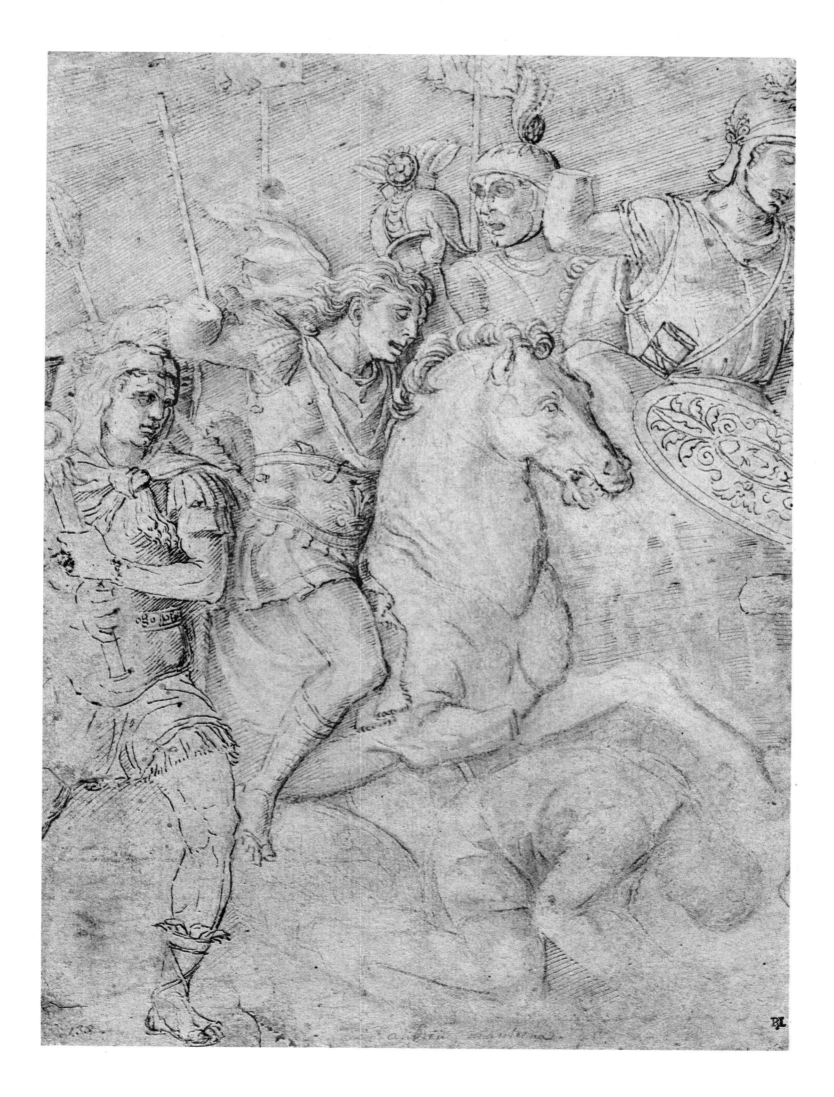

BARTOLOMEO MONTAGNA

Painter, real name Bartolomeo Cincani, born approximately 1450. Died October 11th, 1523, Vicenza. 1459 documented in Biron, near Vicenza; 1469, probably already adult, completed training in Venice. From 1474 traceable again in Vicenza, and returned there 1482. From 1483 practiced in Vicenza, Verona and Padua and the surrounding area. His departure-point is the Mantegnesque tradition (presumably transmitted by Bartolomeo Vivarini) and its development by Giovanni Bellini. Principal master in the School of Vicenza. Perpetuated the hard, angular drapery style of Bartolomeo Vivarini, but softened it through gentler handling of light in the tradition of Bellini. His best works are distinguished by powerful monumentality and glowing color.

17 The Drunkenness of Noah

Pen and bistre, brown paper, 253 x 374, Inv. 24437, V. 22 a.

Orig.: *Collection Dr Stephan Licht, acquired 1925.*

Lit.: *B. 712.*

The scene in which Noah, the first vintner drunk with the first of the wine, falls asleep, is transferred to a rocky landscape in Andrea Mantegna's style with a simple classical building in the background. Shem and Japheth respectfully cover Noah's nakedness while Ham, the younger son, points a mocking finger. Later, Noah is to place him under a curse, and the Hammites go their own way separated from the rest of mankind. Montagna symbolically suggests the vineyard by only one meagre tree entwined by a vine, and does not closely follow the Bible story, where the scene takes place in a hut, and where the covering of Noah is differently described. The artist's chief concern is to show the contrast between the reverence in the right-hand figures and the irreverence in the one on the left, whose bad, heathenish nature is further stressed by the costume. This sheet, extremely densely modelled and sensitively drawn, closely relates technically and especially in landscape detail to a drawing of a Resurrection in the Louvre (Puppi, fig. 36), later engraved by Benedetto Montagna. But our figures present even stronger evidence that Montagna was stimulated by Giovanni Bellini, especially in the gentler modelling and the delicate handling of light and shade in heads and hair. In composition, on the other hand, typically for Montagna, all the figures are placed on one plane, and at one level, in front of a background that is also constructed in planes, like theatrical scenery. Borenius (1912 p. 7, No. 3) is probably right in connecting a further version of this drawing, in the Pierpont Morgan Library — probably later than ours (Puppi p. 149, fig. 26) — with the work that Montagna did in 1482 for the Scuola grande di San Marco, where scenes of the Old Testament were specifically commissioned. Indeed, the monumental and didactic character of this composition would be quite appropriate for a large-scale painting.

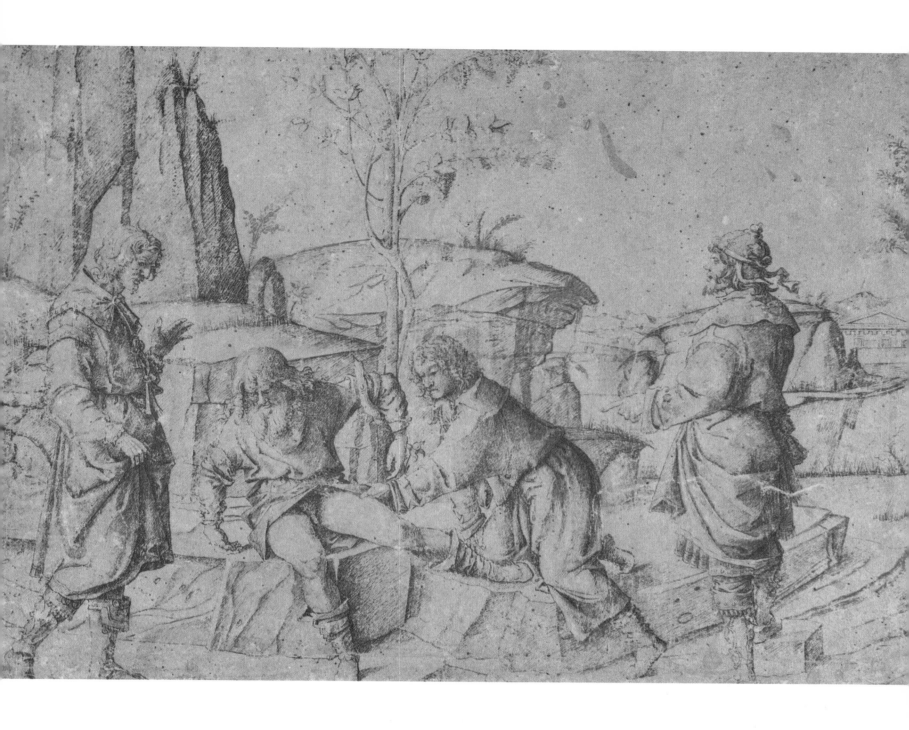

FRANCESCO BONSIGNORI

Painter; died, according to Vasari, July 2nd, 1519 in Verona. Born there approximately 1460. Entered the service of the court of Mantua approximately 1488, but documented there only from 1492. Departure point for his art, Alvise Vivarini; later probably influenced by the other Mantuan court painters. In his mature work, recognizable points of contact even with Lorenzo Costa. According to all sources, important portrait painter.

18 Portrait of a man

Black chalk, heightened in white, brownish paper, 360 x 262, Inv. 17672, V. 28.

Orig.: *Albert von Saxe-Teschen, L. 174.*

Lit.: *S.V. 5, Schönbrunner-Meder II, 203; V. 28; Davies 1961, p. 65; Ursula Schmitt 1961, p. 84, p. 125 incl. Bibl.*

Wickhoff reported that Crowe and Cavalcaselle had already noted that this sheet represents the sketch for the signed and dated (1487), first known portrait by Bonsignorini, now in The National Gallery, London. It is taken to be the portrait of a Venetian senator, but as Davies rightly argues, the costume is not specific enough to confirm this traditional view. At all events, the picture had once been owned by a Venetian nobleman. Painting and drawing match in almost every detail and each minute facial crease. The panel differs only in so far as it is extended to the right, and a parapet — a device common in Venetian paintings of the last quarter of the century — appears below the figure; from it hangs a little paper carrying the signature. This type of portrait painting, ultimately traceable to Jan van Eyck, was brought to Venice by Antonello da Messina, who also liked to pin his signature to the parapet by means of such pieces of paper. But Antonello's subjects look out at the viewer, and there is a vitality of feature and a mobility in the light-treatment that is absent from our portrait. Our head has a sculpted look, an almost stony plasticity, giving dignity, but also rigidity to the man; something monumental and solid that expresses social status more clearly than human quality. In this, the head is very closely related to portraits by Mantegna, for instance the many Gonzaga portraits in the Camera degli Sposi, and the question arises whether Vasari, who said that Bonsignori entered the service of the Gonzaga as early as 1487, was not right after all; thus we may see in this portrait the first signs of influence by the great Mantuan court painter.

19 Portrait of a youth

Charcoal, some stumping, brown paper, 330x269; Inv. 17611, V. 30.

Orig.: *Albert von Saxe-Teschen, L. 174.*

Lit.: *S.V. 11, Schönbrunner-Meder V. 594; A. Venturi, L'Arte 1921, p. 72; Hadeln 1925, T.53, V.30; Tietze 1944, No. A.51; Benesch 1961, No. 5; Fiocco 1961, p. 318; Benesch 1964, No. 12; Pignatti 1970, Pl. V; Pallucchini, Vivarini, p. 74.*

The attribution of this sheet, one of the most vivid portrait-drawings of the late Quattrocento has been much disputed. Both Wickhoff and Meder gave it to Bonsignori, but in spite of being of a similar portrait-type, it has nothing in common with the known drawings by this master (No. 18). Venturi then ascribed it to Antonello da Messina, an attribution with which Hadeln, Stix and Fröhlich-Bum, Benesch, and finally, reluctantly, Pignatti, agreed. Vitality of expression and clarity of form argue strongly for this attribution, yet we find that the portrait-heads by Jan van Eyck's great successor invariably look straight out at the viewer, with an individual gaze that is usually clearly and psychologically defined, whereas here we have an almost dreamy vagueness of expression. The treatment of the shoulders also is different from Antonello's; here, they freely extend to the right and the left beyond the edge of the paper, whereas Antonello, in the case of similar head-postures, defines the upper part of the body with sculptural clarity.

Finally, the lighting is different. In the case of Antonello, separate features are differently illuminated, and the eyes are almost always in bright light, whereas here the shadow spreads evenly over the cheek, embedding the left eye in a deep cavern of shade. Antonello's source of light is more frontal, on the left; here it comes from the side. All these are Venetian traits, more likely to be encountered in Antonello's successors. Although his arguments were inconclusive, Pallucchini was correct in rejecting Laut's and the Tietzes' proposed attribution to Alvise Vivarini or his circle; this drawing has no connection at all with the group of portraits attributed by the Tietzes to this master (No. 2244, 2246, 2249), by Berenson to Lotto (Berenson 1956 pp. 13, 31, 33, 34), and finally by Ursula Schmitt to Lauro Padovono. It is too soon for this writer to venture a definitive attribution, but the character of the work seems to him to point in the direction of Cima da Conegliano, or even the young Basaiti. At any rate, in Cima we find the strong shadow, the lively head movement and the same extraordinary rich relationship between head and upper body, even if only in renderings of the Madonna, while such mobility is quite uncommon in Venetian portraits of the period. Fiocco's proposed attribution of the sheet to Cristopher Casselli, successor of Antonello, fails to convince. The riddle of this magnificent sheet remains yet to be solved.

ERCOLE DE' ROBERTI

Born approximately 1456, died mid-1496 in Ferrara. The first proven and documented datable work, the large 1480/1 Altar panel of S. Maria in Porta, Ravenna, now in the Brera in Milan, shows influences of the School of Ferrara, e.g. Tura and Cossa, and also evidence of the artist's exploration of Venetian art. (The Altar panel once in Berlin, and now unfortunately destroyed, must have been created earlier.) 1479 Roberti documented in Ferrara; worked in Bologna in 1481 and at frequent intervals thereafter. From 1486 to his death employed by the house of Este, at a large salary, in Ferrara, and entrusted with many social commissions which took him to Mantua, Rome, and Hungary. Roberti is without doubt the most elegant and sophisticated, as well as the most mature, master of the expressive and spiritual threesome he forms with Tura and Cossa. From his early work, which scintillates with artificial and bizarre elements, he evolved a calmer manner, more classical in detail, under the influence of Cossa, Mantegna and Venice, but he never quite relinquished the harsh basic character of his art.

20 St. John the Baptist

Pen and bistre, white paper, 245 x 155, Inv. 23317, B. 1.

Orig.: *Luigi Grassi, acquired 1923.*

Lit.: *A. Stix, Albertina N.F. II, pl. 14; B. 1; Gronau, ad vocem,* Thieme-Becker *XXVIII, p. 427; Ortolani, p. 165, Pl. 170a; Salmi 1960, pp. 27, 55.*

The attribution to Ercole de' Roberti was first suggested by Alfred Stix and unanimously accepted by the critics, with the exception of E. Ruhmer, who ignored it. As Stix rightly saw, this sheet belongs to a similarly early period as the picture of the same theme in Berlin, which perhaps presents the highpoint of ascetic elegance in the artist's work: that strange mixture of highly expressive distortion of the human form for the sake of an ascetic ideal, the most sophisticated, artful execution of detail, and a virtuoso treatment of perspective, equalled only in some surrealist works of our own time. The drawing, on the other hand, has much in common with Mantegna in its general technical character. It is remarkable in the extremely subtle observation of light and the refinement of the modulation. Light drapery emerges from dark shadows, the outline of the shaded part of the body stands out against the darker folds of the gown. Equally impressive is the way in which contour is conducted in willful, sweeping lines often meeting in sharp points, that give the elongated body a harsh angularity and the draperies an abstract, thorny quality. Throughout, the drawing is extremely sensitive and delicate. The face and hands especially, less elaborately modelled, have an expressive mobility. The calm posture of the body, which has almost the character of a statue, is hard to reconcile with the more artificial, less stable pose of the Baptist in Berlin. Whether this sheet, with its different landscape, the traditional ledge of rock in the foreground, and the countryside stretching into the distance behind it, was Roberti's starting point — which he then extraordinarily deepened — or whether he had a different picture in mind (though one that cannot be far from the Berlin painting), is a question that remains unanswered.

LORENZO COSTA

Painter; born 1459/60 in Ferrara, died March 5th, 1535 in Mantua. 1483, probably settled in Bologna; short journeys to Ferrara, 1499, and Rome, 1503. From Spring 1507, court-painter to the house of Gonzaga in Mantua, successor to Andrea Mantegna, whose unfinished works he completed. Vasari mentions training in Florence, but early works bear clear evidence of Ferrarese influence, mainly Ercole de' Roberti but also Tura. Soon influenced by Venetian art, and then, not unlike Francia, with whom he has much in common, by the Umbrian School: this becomes particularly noticeable in his landscapes. Reached a calm, classical stage about 1500, more delicate in balance, if always remaining committed to the Quattrocento. His later work is less restrained, and dissolves in chiaroscuro and color, but Costa never really became a master of the High Renaissance.

21 Portrait of a man

Black chalk, 307 x 210, Inv. 7506, B. 4.

Orig.: *Albert von Saxe-Teschen, L. 174.*

Lit.: *S.R. 298; Schönbrunner-Meder, NF I, No. 2. B. 4.*

This delicate, sensitive portrait was once attributed to Raphael, until Wickhoff recognized that it must have been drawn by a North Italian artist, probably from Ferrara, while Meder suggested Florence. The attribution to Lorenzo Costa in the Albertina catalogue by Stix and Spitzmüller was based on a comparison with a sketch now in the Museum in Rotterdam (Catalogo della Esposizione della Pittura Ferrarese del Rinascimento, Ferrara 1933, No. 243, ill.) for the portrait of Battista Fiera in the National Gallery, London. The comparison cannot completely convince: especially as Fiera, whose head Costa modelled with unusually powerful plasticity, appears to have been a far more robust man. Here, on the other hand, we have a man of markedly delicate features, and a quiet gravity that is almost reminiscent of Netherlandish portraits. Nevertheless, the attribution to Costa is plausible just because of that artist's subtle self-effacement before the subject, and the sensitive handling of light on the face that never quite loses a slight harshness and angularity, an effect which is so typical for the Ferrarese. In any case, the portrait is a particularly subtle and typical product of that quiet form of art that Costa, as well as Perugino and Francia, represented, and that before and around 1500 was preparing the way for the classicism of Raphael and Fra Bartolomeo.

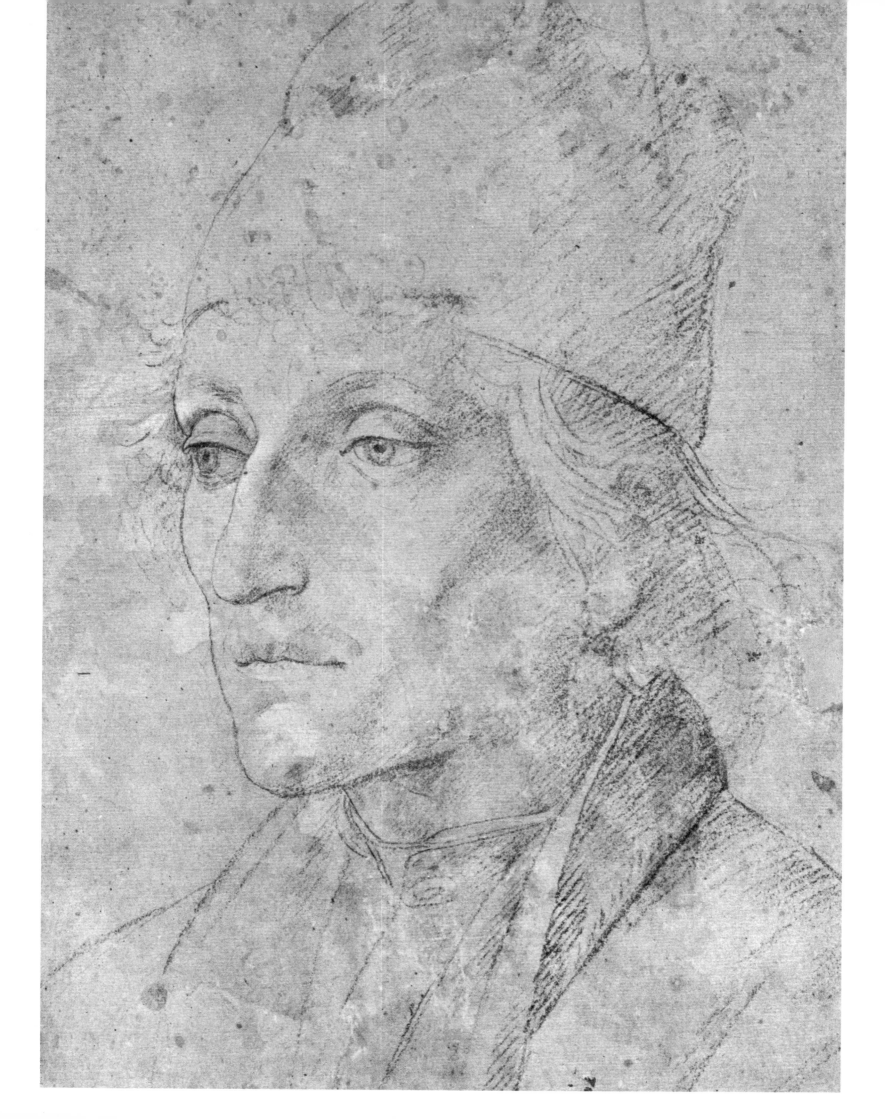

FRANCESCO FRANCIA

Goldsmith and painter; named Francesco di Marco di Giacomo Raibolini. Born circa 1450, died Bologna, January 5th, 1517. Began his creative life as a goldsmith, and according to Vasari also worked as a seal-engraver. Registered in the Goldsmith's guild on December 10th, 1482, but already referred to as *aurifex* in 1479. 1483, *Massaro* of the guild, consequently must have been at least thirty. 1503, registered in the guild *delle quattro arti*. Mentioned as painter as early as 1486, earliest dated picture originated 1492. Influenced principally by Lorenzo Costa, probably also by Ercole de' Roberti. Certainly the most important Bolognese painter at the end of the 15th and the beginning of the 16th century. In his tendency toward harmonious, clear composition, quiet figure-design, and in the subtly observed light that gives gentle plasticity to figures and glow to color, he is closely related to artists like Perugino.

22 Three figures making music

Pen, brush and bistre on parchment, 228 x 227, Inv. 2582, B. 15.

Orig.: *Albert von Saxe-Teschen, L. 174.*

Lit.: *S.L. 7, Schönbrunner-Meder I, No. 53; Lipparini, p. 14; B. 15.*

Francia painted religious pictures and portraits almost exclusively. Drawings which, like this one, were certainly considered as works of art in their own right — as the use of parchment alone would indicate — gave him the opportunity to explore a subject that was of equal interest to artists and the humanist scholars in the period about 1500: the classical Antique. Francia subsequently had such sheets engraved by his talented pupil, Marcantonio Raimondi. These early prints by this great engraver, such as the large sheet called "The young man with a torch" (B. 360) are extremely close to our drawing. What Marcantonio could learn from such sheets was not only the beautiful proportioning of the figures, clearly showing the influence of classical sculpture, but also the sense for gentle modelling by clear, rounded contours, and, especially by the subtle conduct of the light over bodies and background. The background itself is modelled with profuse crosshatching that gets darker until finally the dense shadows are worked with a brush, and the figures stand out in gentle relief. The silhouettes of the two male nudes make a particularly fine effect against the dark background, while the girl in rich drapery softly fuses with the play of delicate lines behind her. She gazes out at the spectator, drawing him into the romantic mood of the scene. It embodies the typical Arcadian dream that had contemporaneously survived in Florence, from the time of Lorenzo il Magnifico, in the paintings of Piero di Cosimo and many engravings by Robetta, and had its finest flowering in Venice with Giorgione. Mantegna's and Pollaiuolo's classical turbulence is here transformed into gentle melancholy. This sheet used to be called "Mantegna." Wickhoff and Meder had already recognized its connection with Francia, even if they did not regard it as his own drawing, but Lipparini must be right: only Francia could have created it. Chronologically, it stands between the very early drawing of the Constellations (B. 14) and the more mature "Judgment of Paris" (B. 13), both in the Albertina.

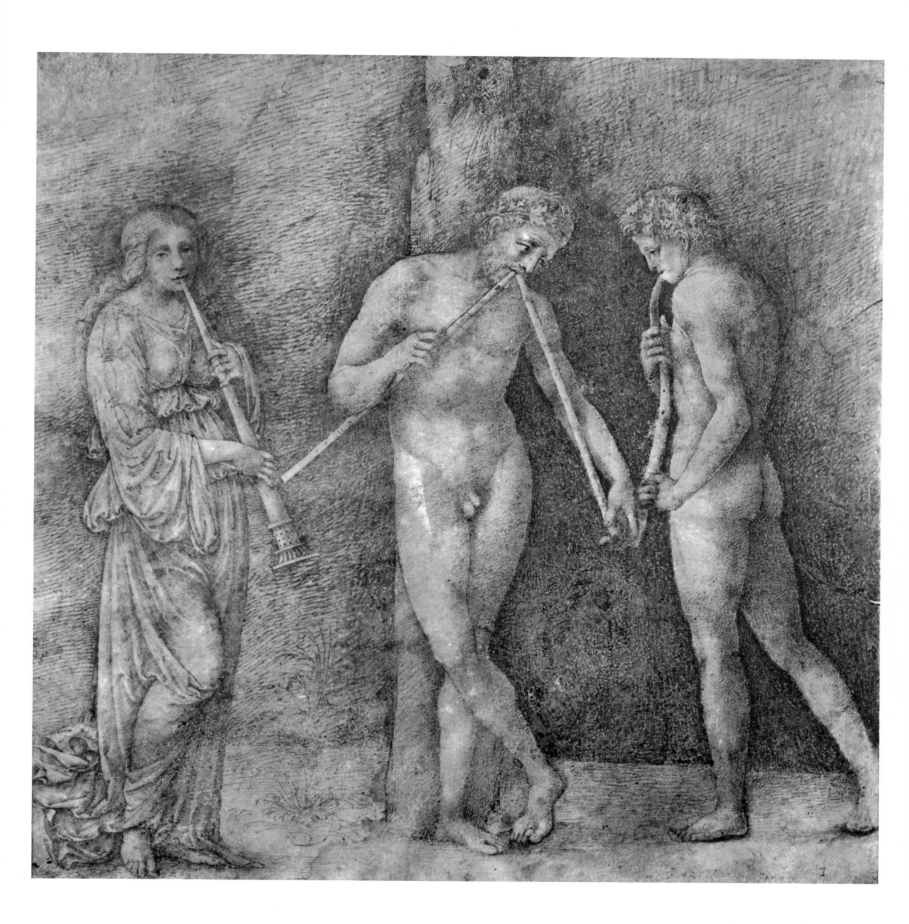

Architect and painter, named Bartolomeo Suardi, born circa 1465 and died 1530, in Milan. Pupil or imitator of Bramante, whose name he adopted. Practiced chiefly in Milan. December 4, 1508, temporarily documented in Rome at the Vatican, probably on Bramante's recommendation; also worked for Giangiacomo Trivulzio, for instance on the series of tapestry cartoons showing the months of the year in the Castello in Milan. Later became court-painter and architect to the Sforza, Francesco I and II. Early works reflect Milanese tradition — for example Butinone — and also influences of Ercole de' Roberti, who had visited Milan. Bramantino soon developed a very original classical style, in which great volumes are presented with graphic definition and geometric clarity, and yet appear ethereal because of the light on the surfaces and the delicate coloring. His style, developed quite independently from the Leonardesque trend, seems very abstract in consequence. Especially in the treatment of drapery and light, it greatly influenced subsequent Lombard art, particularly Gaudenzio Ferrari.

23　Christ standing by the Cross

Pen and bistre, heightened with white, brown paper, augmented at top.　253 x 154; old inscription, retouched out: Tura; *Inv. 40, B. 392.*

Origin: *Graf Moritz von Fries, L. 2903; Albert von Saxe-Teschen, L. 174.*

Lit.: *S.R. 45; Schönbrunner-Meder XII, No. 1384; Suida 1904, p. 33, Pl. IV; B. 392; Van Schendel p. 106; Suida 1963, p. 70, Pl. XXIII, 100.*

According to a note on the mount, Morelli was the first to attribute the drawing correctly to Bramantino; until then it had been called Tura. The old attribution to a Ferrarese is understandable in a sense, if one considers our Pl. 20, the St. John by Ercole de' Roberti. The geometric conception of the gown, dissected into separate facets, and the sensibility for light are related. Yet, an entirely different spirit emerges. Here, ascetic expression is transformed into dolorous sweetness. The draperies are given sensual width, as is the body that displays breadth and mass for all its grace of movement. The light divides the surface into facets investing the plastic form with airiness and delicate softness in spite of surface brilliance. All these features are to remain characteristics of Lombard art. Bramantino's sense for geometric volume, individual proportion and interesting foreshortening is already evident from this early work, created, according to Suida, even before 1500. It is revealed in the weighty torso of Christ, with which the delicate stance and small head are in almost mannerist relationship, and in the heavy cross. An anonymous artist subsequently painted this elegant figure — crudely, and translated into popular religious idiom — in a fresco in the church of Vimercate. But whether he based his work on this drawing or on a lost picture by Bramantino is hard to say — the latter seems more likely.

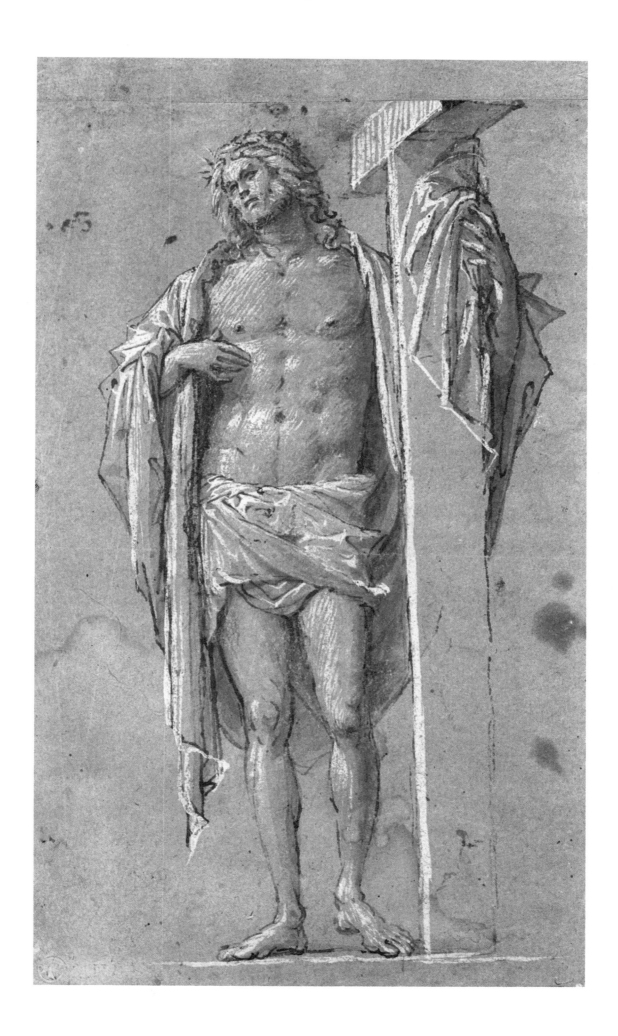

MICHELANGELO

Michelangelo Buonarroti, sculptor, painter, architect; born March 6th, 1475, in Caprese near Sansepolcro; died February 18, 1564, in Rome. Already in Florence in 1476. April 1st, 1488, enrolled with Domenico and David Ghirlandaio for a three year's apprenticeship, but soon left them for Bertoldo's school of sculpture in the Medici Gardens near San Marco. End of 1494, short stay in Bologna; June 1496 to Rome, created his famous Bacchus and the Pietà. Returned to Florence 1501, while Leonardo was staying there. March 1504, his David completed, began work on cartoon for Battle of Cascina in Palazzo della Signoria. Spring 1505, Julius II called Michelangelo to Rome and commissioned him with monument for his tomb. Began to quarry stone in Carrara, but April 17th, 1506, secret flight to Florence as Julius lost interest in project. End of November 1506, called to Bologna by Julius to execute his statue, which was destroyed soon after. End February, return to Florence and shortly afterward summoned to Rome for painting of Sistine ceiling, unveiled October 31st, 1512. After protracted work on the Julius II monument, Michelangelo returned to Florence July 8th, 1516. Commissioned to design facade of San Lorenzo. From 1520, began plans for Medici tombs in same church; 1524 commissioned to build library of San Lorenzo. May 17th, 1527, the Medicis left Florence and Michelangelo took part in the 1528/29 defence of the city. 21 September, flight to Venice; returned to Florence in November. August 12th, 1530, return of the Medici; Michelangelo continued work on tombs. April 29, 1532, back to Rome in connection with the Julius monument. June to November 1533, and August/September (?) 1534 again in Florence for a short period. From November 1536 work on the Last Judgment, completed October 31st. 1545 completion of the Julius Tomb. August 1542, started work on Pauline chapel. 1546, emerged as architect in Rome; Capitol plans, St. Peter, and continuance of Palazzo Farnese. 1550 completed Pauline Chapel; 1556, pilgrimage to Spoleto. In final years, designs for San Giovanni dei Fiorentini and the Porta Pia, work on the Pietà Rondanini. Besides the large commissions, much work for private commissions on smaller scale and — chiefly for his friends such as Tommaso Cavallieri and the poet Vittoria Colonna — marvellously finished gift-drawings. Michelangelo was rather a lonely figure, difficult to engage but then a committed friend, who passionately pursued his objectives and ideas. Attracted by the beauty in this world, he was overwhelmed by the immensity of the next, where terrible and terror-causing aspects loomed almost larger than ideal ones.

He was a sculptor first and foremost, even when painting or building. In painting and drawing, his over-ruling interest lay in the human figure, its movement and expressiveness, and it is always seen in terms of the block from which it was created. As an architect, he regarded the architectural elements and walls as sculpted mass. The tradition of his forms developed out of the Florentine Trecento and Quattrocento, the Pisani, Giotto, Donatello, Quercia, and Masaccio, but he also learned from the generation of his teachers, Ghirlandaio, Botticelli, and Signorelli. He analytically studied Leonardo and Raphael, but their effect was felt only later. Michelangelo created new human dimensions, a new visual image of spiritual greatness, translated into increased physical size. His new, entirely individual concept of beauty leaves classical idealization, with its calm composure, behind, and expresses itself in the struggling, suffering body, filled with energy and tension, where even stillness becomes active sweet surrender. From this seductive sweetness he spanned the scale to the hideous and demonic; his strength lay in the presentation of every emotion from melancholy to passion in man's inner conflict. Liberation and redemption are rarely encountered in his work. Still deeply committed to the Old Testament God of Judgment, a concept that dominated many currents of Christianity through the ages until modern times, Michelangelo found Christ the Redeemer only in the mystique of suffering. Through his deeply personal idiom, he enriched the arts by new visual means, and the effect of his creative work stretches into our own time.

24　Three standing figures

Pen and bistre, white paper, paper added at right and center, bottom. 290 x 197. Pen inscription: no. 6; chalk inscription: P.P.R.; Inv. 116; R. 219.

Orig.: *P.P. Rubens; P.J. Mariette, L. 2097; Prince Charles de Ligne; Albert von Saxe-Teschen, L. 174.*

Lit.: *S.R. 150; R. 129; Weinberger p. 17 ff.; Dussler, Michelangelo, No. 235; Benesch 1964, No. 20; Exh. Florence 1964, No. 3. Creighton Gilbert, The Drawings now associated with Masaccio's Sagra, in: Storia dell'Arte 1969, p. 260 ff.*

The two drawings on recto and verso of the Viennese sheet are the most mature of three copies by the young artist: the second is a copy after Giotto, in the Louvre, and the third copy is after the figure of St. Peter in Masaccio's "Tribute Money," in Munich. The group on the recto has long been thought to come from Masaccio's picture "The Consecration of S. Maria del Carmine" in Florence, the so-called "Sagra," but has recently been proved to be a copy of a drawing by Michelangelo's teacher Domenico Ghirlandaio. Ghirlandaio's monumentality and plastic force attracted Michelangelo, but he heightened the modelling to block-like hardness. Changes occur in the spatial character of the group. A fourth figure, that once looked out between the two on the left, is omitted. The heads of both the other figures recede, by means of hatching,

into the relief-like neutral background, from which the center figure emerges in forceful contrast. It is no longer part of the larger group, but the leading three-dimensional figure in high-relief, to whom background figures in lower relief are subordinated. If Michelangelo changed this group from a sculptor's point of view, he also worked on the details of the drapery, which interested him, in a sculptor's manner. He had learned his technique of cross-hatching from Ghirlandaio but had more intensively studied Martin Schongauer's copperengravings, which themselves show the sculptural technique in the graphic arts. He outstrips Ghirlandaio in density of line, and in the systematic cross-hatching, most clearly discernible in part of the man's back, and the troughs of the draperies.

The strongly expressive heads are reminiscent of but do not originate from Leonardo. They recall the bull-necked Senators in Mantegna's "Triumphal Procession." In comparison to Leonardo's similar, though more mobile, physiognomies, these faces seem turned to stone, petrified like those of the great Paduan. The main figure especially seems charged with strength of will and concentration of power. These qualities become inevitable complements to the expression of the mighty, draped body that Michelangelo is thereby endowing with new meaning, and already points forward to the Sistine Chapel prophets.

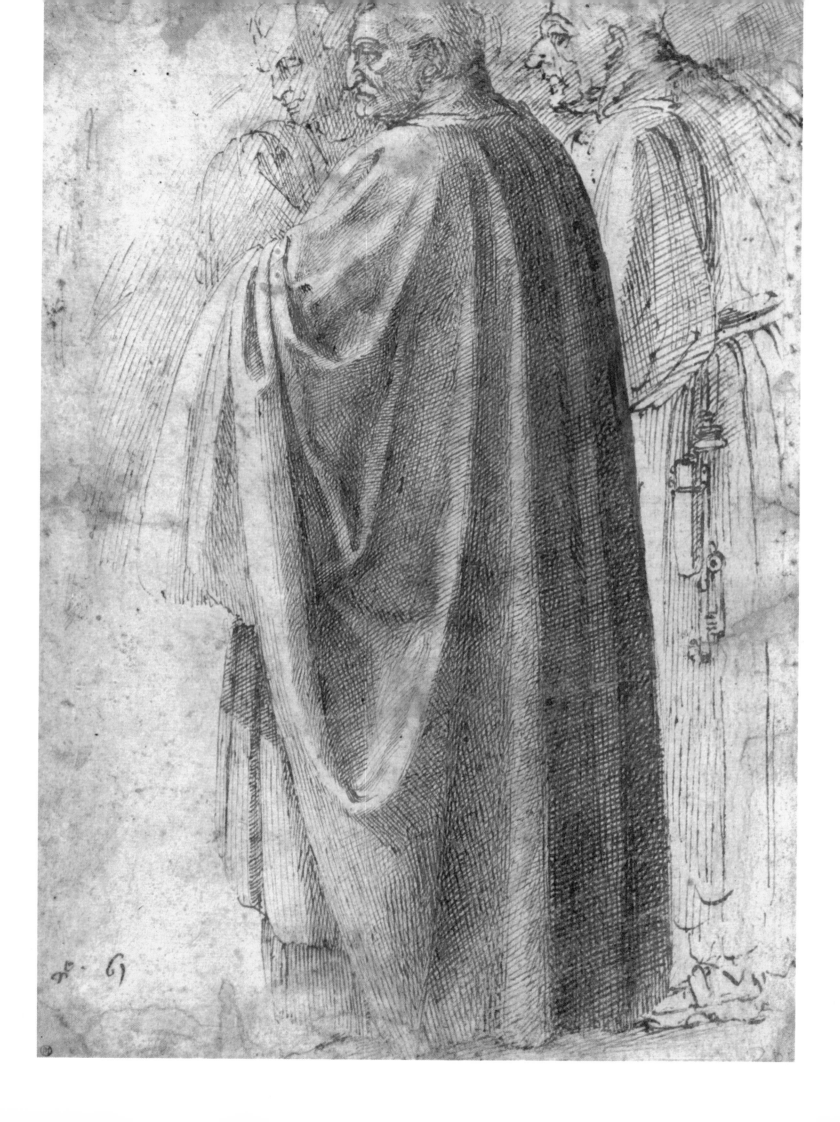

25 Male nude, back view

Black chalk, white highlights, paper worn in some places; inscription in black chalk: P.P. Rubens; *18th century pen and ink inscription,* "impossible de trouve plus beaux"; *188 x 262, Inv. 123; R. 130 v.*

Orig.: *P.P. Rubens; P.J. Mariette; Prince Charles de Ligne; Albert von Saxe-Teschen.*

Lit.: *S.R. 157; R. 130 v; Berenson 1604; Popham and Wilde, p. 263; Dussler Michelangelo, p. 195, No. 361.*

After the completion of "David," Michelangelo was regarded as the leading Florentine artist. In October 1504, he received a commission to paint the fresco of the Battle at Cascina for the Sala dei Cinquecento in the Palazzo della Signoria — in competition with Leonardo. Only part of the cartoon was completed, as Julius II called the artist away from Florence. The equestrian battle for the right hand side only exists in sketches. For the left, Michelangelo had planned an incident with larger-than-life figures: Florentine soldiers, surprised while bathing in the river, hurry into their clothes — an opportunity for the artist to show agitated nude figures in tense movement. On the recto of our drawing Michelangelo first drew, in charcoal, the central figure of the group, and another one next to it; he then minutely studied their bodies from life in pen and ink. The verso, shown here and unfortunately trimmed at the bottom, is entirely drawn in black chalk, and highlights in white body-color are applied to contrast sharply with the dark shadows in rapid brush-strokes. According to Vasari, such white highlights were also a feature of the much-copied, but now lost, cartoon. Our drawing is a preliminary study for one of the figures, center in the top row. *"Impossible de trouve plus beaux,"* wrote an enthusiastic 18th century connoisseur onto the sheet, which, like No. 24 and 26, once lent lustre to the collections of Rubens, Mariette and the Prince de Ligne. Compared with the early copy (No. 24), the line is more flexible, the contour marked, and the outline that is finally selected to describe the energetic body-forms is forcefully emphasized. Leonardo may have provided Michelangelo with that idea; but his personal visual concept remains: the right arm seems to sink into the block, the relief background. The figure positively detaches itself from the plane. The highest points are accented by light, the deepest are also the darkest — worked over in densest hatching. The light creates a varied landscape with tense hillocks of muscle, and models the strength-filled body. Towards the top, bottom and right, the artist's interest wanes — shoulder and hip areas were his chief concern, as was the difficult pose of the left arm. Today, such a drawing seems to represent a frozen moment in a modern dance, where each movement of the body, each controlled muscle, is employed to express a distinct emotion hard to define.

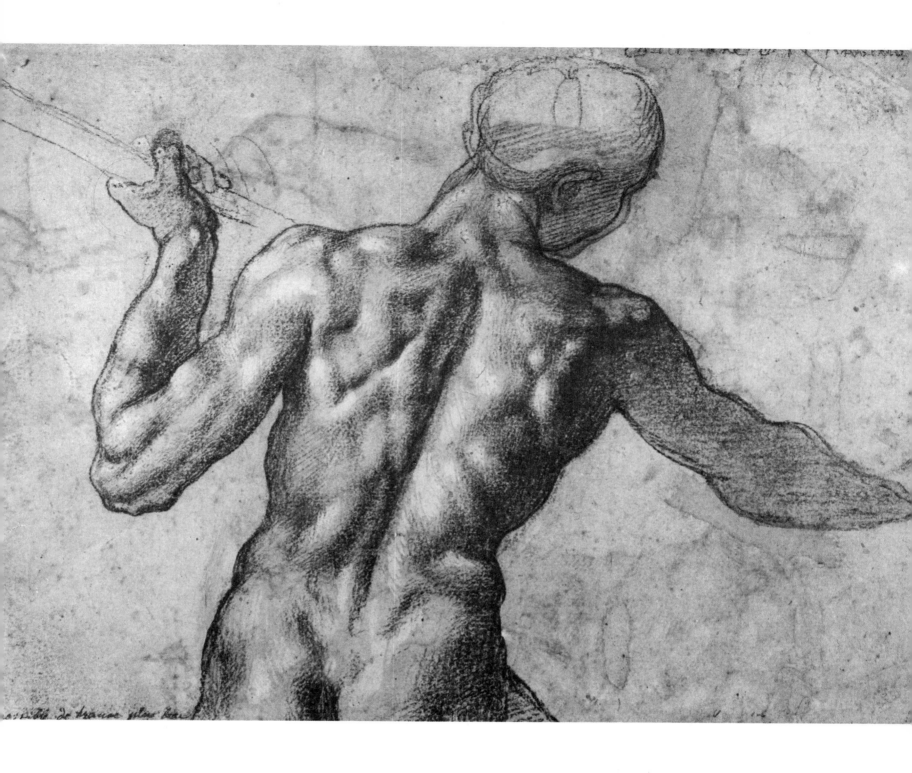

26 Nude, young man

Light and dark red chalk, heightened with white, some stylus marks, white paper, pen and ink inscription: 50, inscription in black chalk: C.P.P. Rubens, *268 x 188, Inv. 120, R. 142.*

Orig.: *P.P. Rubens; P.J. Mariette, L. 2097; Prince Charles de Ligne; Albert von Saxe-Teschen, L. 174.*

Lit.: *S.R. 153; R. 142; Wilde p. 19, note; Dussler, Michelangelo, 701.*

In spite of Michelangelo's previous refusal, he was again called upon by Julius II in Spring 1508 to paint the Sistine ceiling. The first half was completed by September 1510, but then Michelangelo had to wait until late Spring 1511, shortly before Julius II's return from the war in Bologna, for money with which to obtain paints and scaffolding for the second part. Throughout the winter of 1510/11 he worked on the sketches and cartoons, which still astonish by the magnificent unity of style and abundance of form. For this part of the ceiling there are more drawings preserved than for the earlier ones, so that in some cases we may see the idea developing stage by stage from the first sketch to the final execution. The nude studies after the model were essential in this process, probably the final stage before the cartoon. For these, Michelangelo exclusively used the precise, yet subtle red chalk which Leonardo had probably first made popular among the Italians.

Our sheet is a study for the Ignudo with the strange, far-away, almost arrogant expression, the figure above the Persica, opposite the rear view of the screaming figure, for which there are marvelous red chalk studies in Haarlem.

Here, Michelangelo monumentalized an elegiac concept for an early Ignudo in forceful dynamics and greater volume. The artist's concern in this drawing is torso and hands, which are drawn separately, bottom left. Head and feet must have been studied on a different sheet, lost today. But in the torso, he concentrates mainly on the foremost plane. The left arm, placed across the body, and both knees are brought into relief by white highlights, and are seen frontally like sculpture forms, not like parts of organic structures. Michelangelo treats the shadowed parts more summarily, and deepens the deepest shadows further by yet another darker application of red chalk. He is a master of differentiation even within the shadowed areas, and the structure of the rib-cage is wonderfully effective. On the verso are studies for a male torso, and of folded hands, which Johannes Wilde rightly assumed to be preliminary sketches for the Viterbo Pietà, which Sebastiano del Piombo painted after Michelangelo's cartoon.

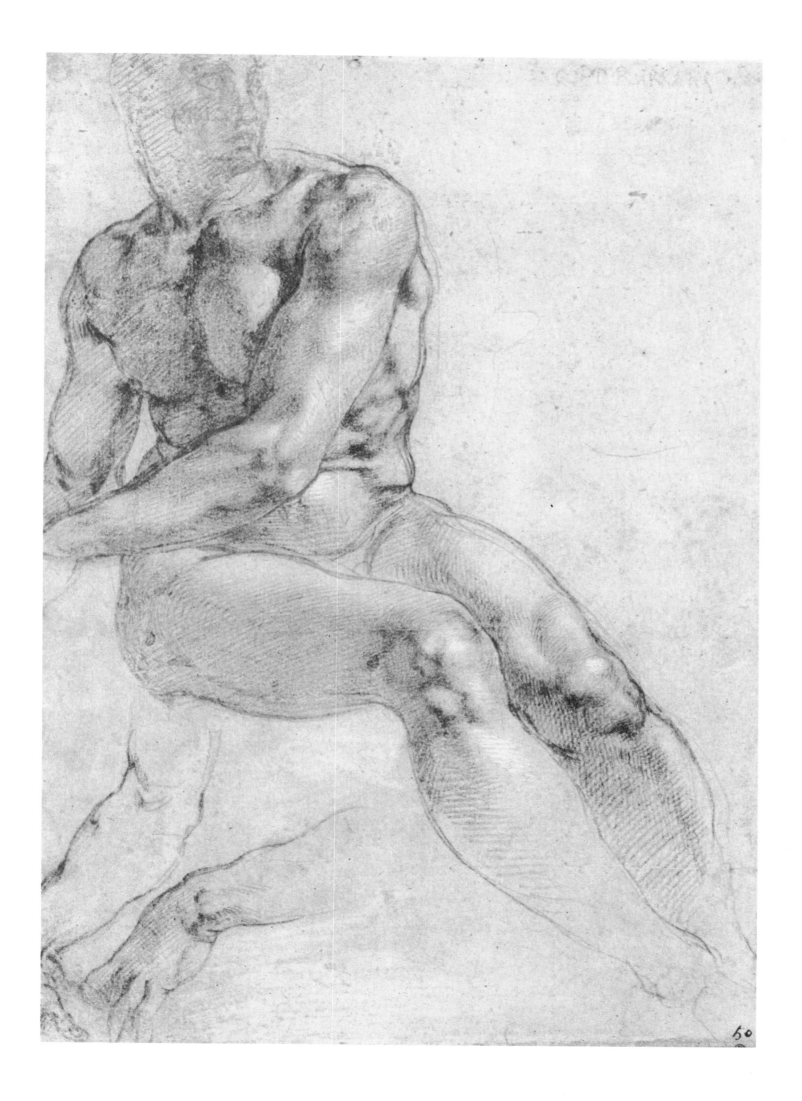

27 Pietà

Stylus, black chalk, red chalk, brownish paper, patched at right top and bottom corners, and at center, bottom. 404 x 233, pen and ink inscription: Michel Ange 58. Inv. 103, R. 134.

Origin: *Albert von Saxe-Teschen, L. 174.*

Lit.: *S.R. 137; R. 134; Wilde, p. 104; Dussler, Michelangelo, No. 697; Michele de Benedetti, Il cosidetto "non finito" di Michelangelo e la sua ultima "Pietà," Emporium 57, 1951, p. 9 ff.*

The subject of the Pietà and the Lamentation occupied Michelangelo throughout his life. In his first great masterpiece in Rome, he treated it in terms of Northern devotional images: Christ lying in the Virgin's lap. Sebastiano, in his picture in Viterbo, used a prototype common in Italy, one used also by Raphael and Perugino: the sacred body lying on the ground in front of the Madonna. Michelangelo had a preference for the rendering that had been common in the late Middle Ages: the lifeless, suspended body of Christ, presented to the devout by God the Father in pictures of the Holy Trinity, by Nicodemus in pictures of the Entombment, and by the Holy Virgin, other saints, or angels. This motif first appears in Michelangelo's early active scenes, such as the Entombment in the National Gallery, London, or in the margin of the drawing of Christ taken from the Cross, in Haarlem. Our drawing, which was once thought to be a preliminary study for the Rondanini Pietà, is close to this last group. Wilde correctly recognized that it has closest stylistic connections with other sheets of the same theme in the British Museum and in the Louvre. These probably were created after 1534 in Rome, when the Louvre sheet was used by Sebastiano del Piombo for a painting, now in Ubeda. The preliminary sketchier nude-study in the Casa Buonarroti in Florence already approaches the drawings for "The Last Judgment." In the elongated upper torso on our sheet we sense the echo of the more flowing and elegant figure-ideal of the previous period. Michelangelo's interest centered on Christ alone. First, with a stylus, he marked the general shapes on the paper; then, still in metalpoint, he worked out the principal problem, the lower torso and the edge of the rib-cage, in numerous fluid lines, the very parts of the body that had been his main concern in the other two drawings. He used black chalk for the chief contours and interior drawing, and only at the end, in red chalk, thoroughly modeled the body in finest dots and lines, producing a surface structure of highest refinement, glowing with soft, fluid, rounding light.

Here, Michelangelo achieves a delicacy in construction of body and flesh that is far removed from the muscular shapes in both earlier drawings. The rapidly sketched figure at the back was added only afterwards, as were the indications of drapery that Michelangelo invariably needed to provide a background, and from which the body of Christ could be thrown into relief. They also provided subsequent motivation for the position of the body with his elongated proportions traceable to medieval traditions for such figures, and for the stiffly extended right arm (cf. Tolnay V, fig. 362 ff.). In the combination of passive weight with a strong spiritual content, this drawing links the Entombment in London, where the body is still tense and spatially more complicated in concept, with the mature work in Milan, where Christ's body loses all material substance.

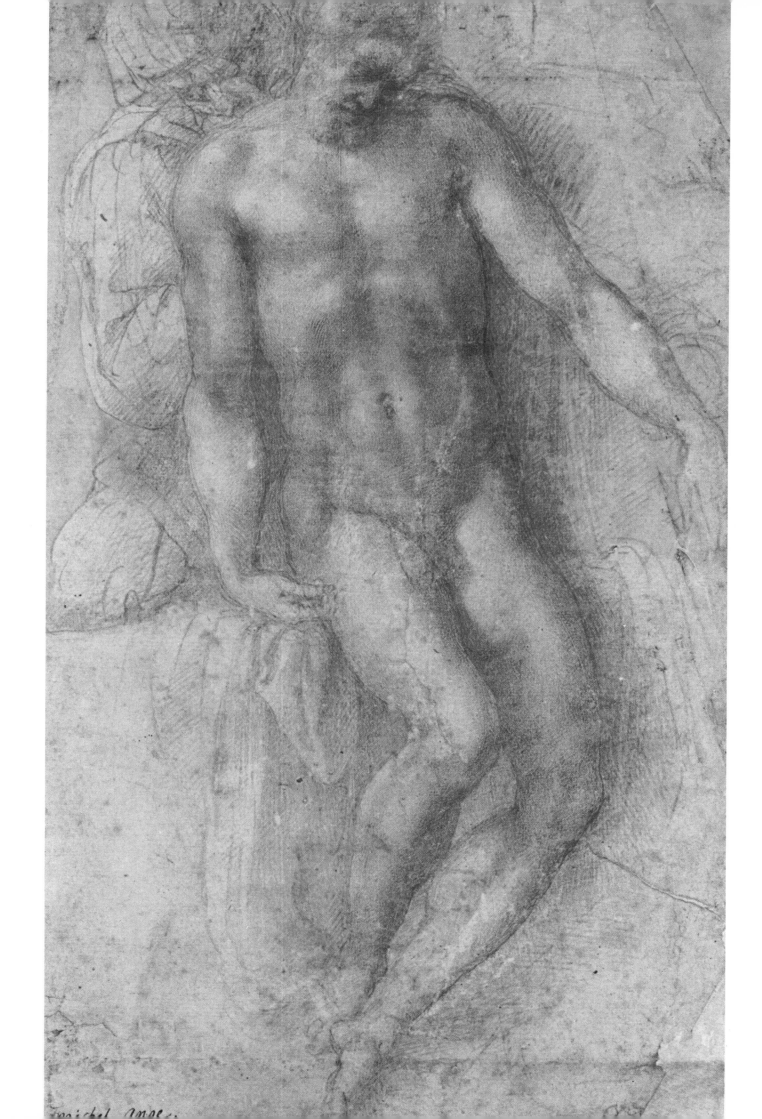

FRA BARTOLOMEO

Painter; real name Bartolomeo di Paolo del Fattorino, called Baccio della Porta; born in Florence, probably before March 28th, 1472, died October 6th, 1517, either in S. Marco in Florence or in Pian di Mugnone. After 1485 in the studio of Cosimo Rosselli, but also influenced by Domenico Ghirlandaio. Often collaborated with Mariotto Albertinelli. 1496 Bartolomeo, affected by the preaching of Savonarola, burned his pictures and ceased painting. 1500 entrance into monastery of San Domenico in Prato. 1504 persuaded to take up painting again by Sante Pagnini, prior of San Marco. From 1505, principal of the painters' workshop at San Marco. April to July 1508, journey to Venice. 1514, journey to Rome. Fra Bartolomeo assimilated the various tendencies of the late 15th century, and combined them with the achievements of Leonardo, if always on the basis of a calm and static compositional manner, and a concept of nature softened by a certain idealized stylization. From extreme delicateness of form slowly evolved to great monumentality and impressive rhetoric, in which his visits to Rome and Venice may have played a part. Certainly, apart from Andrea del Sarto, the most important of the local Florentine masters of the High Renaissance.

28 Rocky landscape with monastery

Pen and bistre, 260 x 209, Inv. 270, R. 150.

Orig.: *Albert von Saxe-Teschen, L. 174.*

Lit.: *S.R. 322; Schönbrunner-Meder, No. 1055; Knapp, pp. 312 and 92; Gabelentz, No. 860; Berenson, 511 A; Isolde Härth,* Zu Landschafts-Zeichnungen Fra Bartolomeos und seines Kreises, Mitteilungen des Kunsthistorischen Institutes, Florence *IX, 1959, p. 129; Benesch 1964, No. 19.*

In 1957 a volume of forty-one sheets from the collection of the Florentine 18th century connoisseur Cavaliere Gaburri was auctioned in London and soon scattered all over the world. Since then, we know more about Fra Bartolomeo's landscape drawings, although their chronological place within the body of his work is not yet clearly defined. Many of these sheets are drawings from nature, from actual landscapes, noted down by Fra Bartolomeo for later use in paintings. Isolde Härth showed that such drawings were copied and used by his pupils. One of these copies shows the monastery, in the center of our sheet, in the wide landscape where it belongs, while here, as Benesch correctly observed, it is placed within rocks studied in close-up, strangely contrasting with the distant perspective of the monastery. Rocks were not transformed into mountains by Fra Bartolomeo alone; it was an ancient tradition that died in the course of the 16th century, but still flourished in the first decades. Compared with the studies from nature, our drawing has an unusual graphic and formal density, a wealth of contrasts in space, and chiaroscuro which gives it special qualities. How far Fra Bartolomeo's impressions on the Venetian journey affected landscape compositions such as this must still be investigated, but Knapp suggests that this sheet dates from the subsequent period.

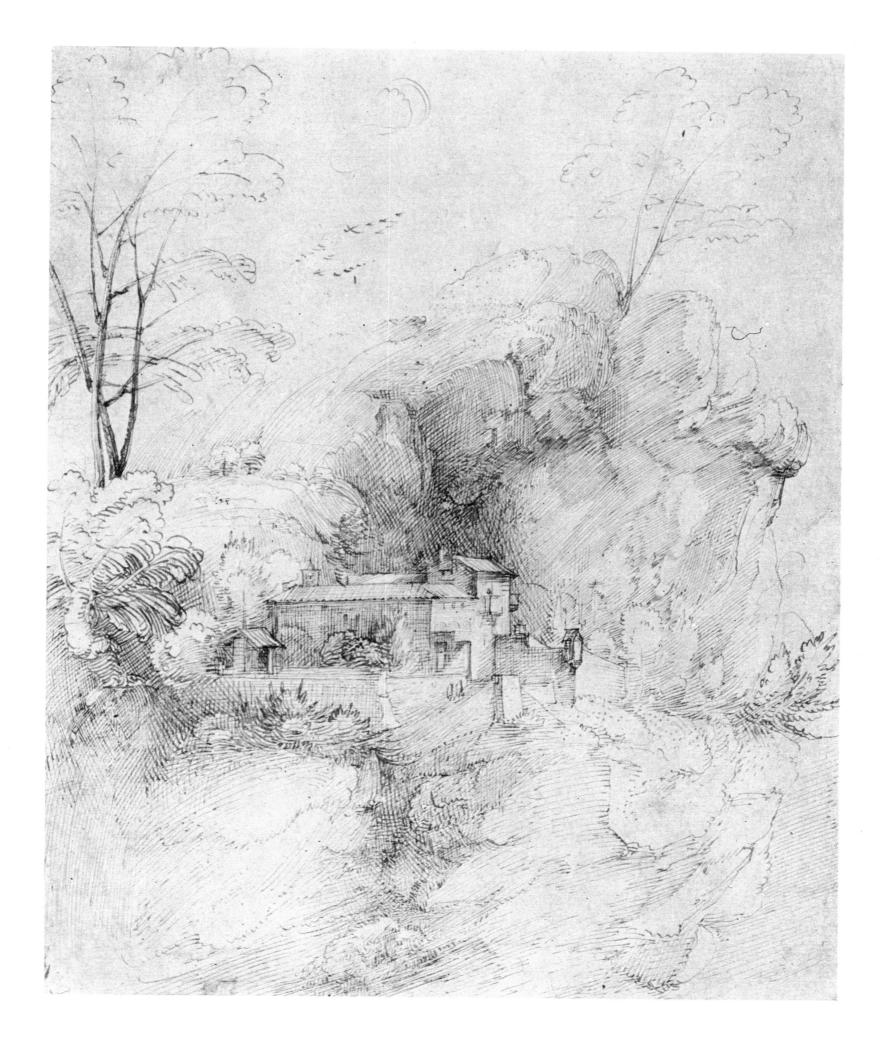

29 Madonna della Cintola

Black chalk, white highlights, reddish prepared paper, 215 x 160; Inv. 84; R. 155.

Orig.: *Albert von Saxe-Teschen, L. 174.*

Lit.: *S.R. 115; Schönbrunner-Meder No. 565; Knapp, p. 312; Gabelentz No. 859; R. 155; Berenson, No. 510.*

Knapp had already recognized the close relationship of this drawing to the *Assumption of the Virgin with two Saints* in the National Gallery in Naples, which was, however, to be completed by Fra Paolino. Closely related sheets, also from the Master's final years, are in Munich (Gabelentz No. 318 and 319). Of all of these, the Viennese drawing is without doubt the most tightly packed and monumental, and most like the painting, with no more than three main figures, and the rounded upper edge. Fra Bartolomeo's designs of this kind are always extraordinarily explosive in effect. The Madonna rises from the tomb with almost cosmic force. Accompanying fanfares from the angels' trumpets strengthen the richness and power of the event, while the Frate's clear, precise idiom in posture and gesture charges the whole with deep meaning. It is strange that in his pictures these positively baroque visions are invariably watered down. The trumpets become lutes and fiddles. The heavenly hosts are reduced to two almost symmetrical little angels and a few cherub-heads. The spatial power is diminished, the Madonna is now pushed into the background and the two Saints in the foreground dominate. He clearly did not have the courage to execute these relationships in the reversed perspective that in our drawing practically drives the Madonna towards us and out of the sheet. There, basically, lies his limitation, compared with Raphael and Michelangelo, who usually went the opposite way.

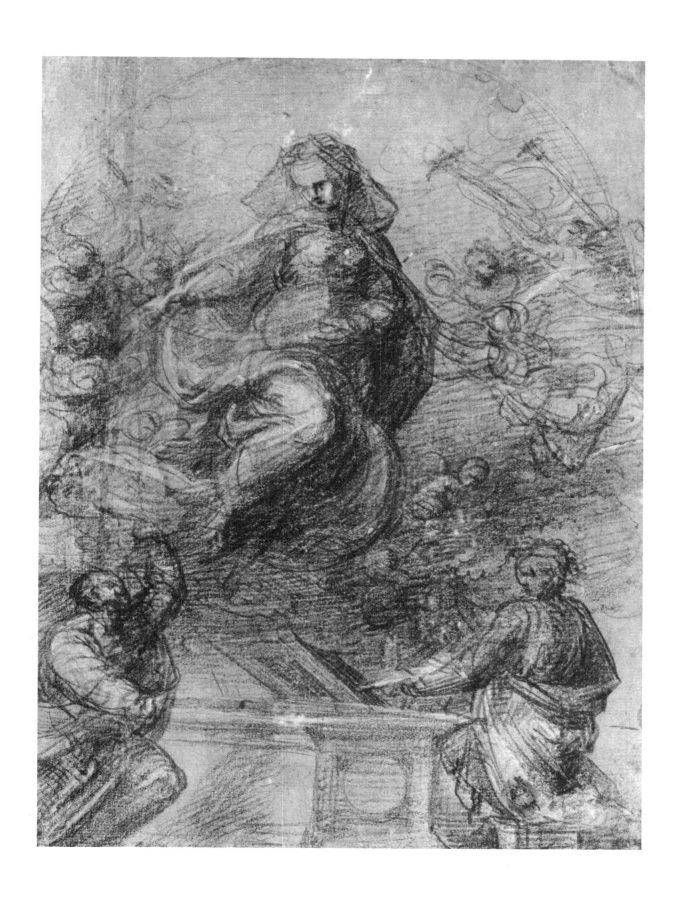

ANDREA DEL SARTO

Painter: proper name Andrea Lanfranchi (?); born in Florence July 16th, 1486, died there of the plague, September 28th, 1530. Son of a tailor, hence the name. According to Vasari, first pupil of a goldsmith, then of Piero di Cosimo. 1506, established a workshop with Franciabigio. 1511, workshop association with sculptor Jacopo Sansovino. Between May 25th, 1518, and October 17, 1519, court-painter to Francis I at Fontainebleau. 1520, perhaps in Rome. 1523, flight from plague to San Piero a Luco in the Mugello, where he remained for a year. After Fra Bartolomeo, Sarto is the greatest artistic force in the first third of the 16th century in Florence. His monumental, rich style was formed early, and reflects his sharp observation of life, his highly developed sense for simplicity, dignity of composition and drama of presentation, while he basically retained Giotto's and Masaccio's tradition of rhythmically structured, static massiveness. He had a decisive influence on the further development of Florentine art, not only on his pupils Rosso and Pontormo, but particularly on the masters of the late 16th and early 17th century. He was a virtuoso in painting and drawing techniques, and had a remarkable gift for the almost cubist translation of space and light into geometric elements of form.

30 Portrait of a woman

Black and red chalk, white paper, patched at top left corner, 16th century pen and ink inscription: Andrea del Sarto; *in pencil 22.; 389 x 243; Inv. 164; R. 220.*

Orig.: *Albert von Saxe-Teschen. L. 174.*

Lit.: *Waagen 1867, p. 136; S.R. 202; R. 220; Berenson 2368 C; Cox Rearick, A 367; Benesch 1964, No. 27.*

This drawing is executed like a picture, and hardly the study for a painted portrait but, as the coloring attests, probably a finished work in the nature of Michelangelo's gift-drawings. Sheets like this invariably give rise to doubt in our day and age, when the sketch often seems preferable to the finished version. Even Wickhoff regarded it as a copy after Sarto, Cox-Rearick thought it more likely to be after Bugiardini, while Waagen, closer to the old values, considered our sheet to be a mastepiece of the great Florentine. Berenson's attribution to Pontormo, adopted in the Albertina catalogue and by Benesch, is no longer tenable in the light of greater knowledge of this Sarto-pupil. Here we see nothing of his exaggerated, neurotic expression, or his tendency to roundness and the elegant elongation of shapes. The solid proportions entirely belong to the first decades of the 16th century, as do the calm pose and the clear, self-confident expression, which has, however, already some of that slight alienation later to be developed by artists like Bronzino. Clarity and plastic volume are not only evident in the finely modelled head, where all the lights are in exactly the right spots, but also in the gown that is clearly dissected into separate geometric facets which, together with the nicely calculated relationship between light and shadow, produce the effect of volume. The sheet's most sensitive and spontaneous areas are those showing the frills of the sleeves with their lively outline, and the hands, the shape of which is also strongly determined by geometric elements. Except for Andrea del Sarto, no Florentine artist of the early 16th century has this volumetric power, this capacity for translating visible images into geometric, abstract elements of form, and at the same time that human directness that speaks from the portrait. The old attribution should therefore be seriously reconsidered. The woman's costume, as the design, would best fit with the final years of Andrea del Sarto's life.

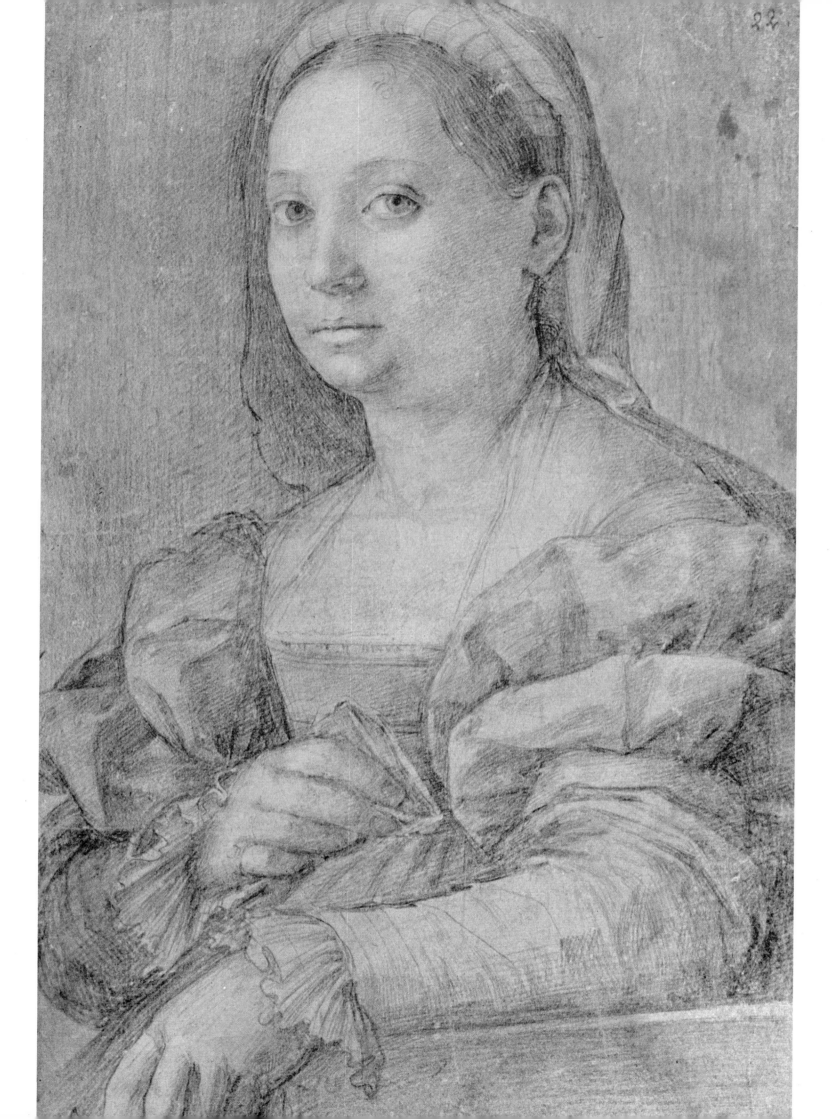

Painter; born Florence, March 1st, 1495; died, Florence, October 5th, 1557. Pupil of Perugino, later influenced by Andrea del Sarto, who was helpful to him. From the end of the thirties until his death, court-painter of the Medici. Admired by Vasari as master of small figures, grotesques, animals, rare plants and cartoons for tapestries. Only rarely transcended the crafts-aspect of art, following completely in the footsteps of the 15th-century cassone painters. Perugino infected him with his delight in landscapes, Sarto caused the enrichment and monumentalization of his figurative style, and, finally, his repertory was widened by the integration of the figure-repertoire of Florentine Mannerists like Vasari and Bronzino as well as of Michelangelo. He was an artist skilled in mixing at will his own basically decorative associations with the motifs of the most disparate artists, among them Lucas van Leyden and Dürer, and combining them in an agreeable and pleasing narrative style. His painting retains a certain enamelled glassiness from his Perugino training, in spite of sophisticated, subdued Florentine colors. His world is typical for that of the *studioli* — the collections of rarities and small-scale works of art — that are particularly characteristic for Florence.

31 Figure in period costume

Red chalk, 275 x 111; Inscr. 27; Inv. 152; R. 66.

Orig.: *Albert von Saxe-Teschen, L. 174.*

Lit.: *S.R. 190; Schönbrunner-Meder 1, 71; Berenson 189; R. 166; Forlani* Cinquecento, *No. 48; Gould 1962, No. 8; Lada Nikolenko,* Francesco Ubertini called Il Bacchiacca, *New York 1966, p. 37; Luisa Marcucci,* Contributo al Bacchiacca, *in:* Bollettino d'arte *43, 1958, p. 38 f, n. 6.*

In the period from 1517 to 1520, several of the most eminent artists in Florence — Andrea del Sarto, Jacopo Pontormo and Francesco Granacci, among others — were working on the appointment of a room with, apparently, painted panelling and decorated furniture (*cassone* and *spaliere*), for Pier Francesco Borgherini. Some of these extraordinarily charming little panels, depicting the story of Joseph, in which the taste for rich, contemporary costumes, landscapes, buildings and unconventional compositions could be gratified more easily than in the large-scale works, are preserved in the National Gallery, London, the Uffizi and Pitti in Florence, and in the Villa Borghese in Rome. Bacchiacca, too, contributed to these decorations that Vasari frequently mentioned. Our drawing is preliminary for one of his pictures: The scene where Benjamin is captured and taken back to Joseph after the beaker had been found, while the brothers beg for mercy. One of the brothers, shown weeping, wearing a large sun-hat that is part of his travelling costume, provides an important motif at the end of the right-hand episode of the picture. Bacchiacca's style is here already much influenced by Andrea del Sarto and his circle. All that remains of the training with Perugino is, at most, the delicacy of line. The old attribution to Andrea accurately marks the style. But Bacchiacca's work is more hesitant and less forceful in modelling and structural development. The contours are tentative and frequently modelled with softly smudged shadows. Interestingly, this, and the tendency to genre-like, immediate humanity in presentation, links a drawing like this with those of Polidoro da Caravaggio, although a relationship between the two artists would be hard to establish. Other drawings for this picture, the cartoon among them, are in the Louvre and in the Uffizi (Berenson 186, 187 and 188).

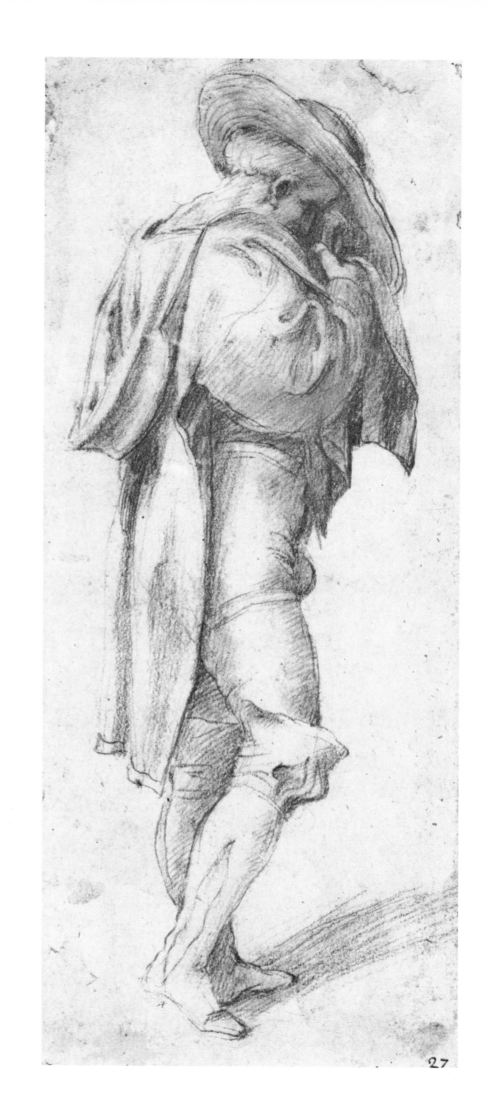

27

BALDASSARE PERUZZI

Architect and painter; baptized March 7th, 1481, in Siena; died in Rome, January 1st, 1536. Probably pupil of Francesco di Giorgio. Worked first in Siena and environs, then moved to Rome shortly before the death of Alexander VI (August 18th, 1503). Became part of the circle around Pinturicchio and Jacopo Ripanda with their antiquarian interests. Practiced architecture (Farnesina) and painting (frescoes in S. Onofrio, the Farnesina, S. Maria della Pace, the Cancelleria etc.). Designed tombs, triumphal arches, and theater-projects; also worked as façade-painter and in this capacity is important for the later activities of Polidoro da Caravaggio. After the death of Raphael, became architect of St. Peter in collaboration with Antonio da Sangallo. After 1525, contributed work to the Cathedral of Siena; 1527, after the sack, temporary architectural supervisor of works at the Cathedral. Short journeys to Rome; January 1st, final return to Rome as architect of St. Peter. Principal work of that period, the Palazzo Massimo. Peruzzi's artistic activities are at first closely linked with the Quattrocento antiquarian tradition which had been particularly stimulated by Pinturicchio and Filippino Lippi, and which spread over many parts of Italy, affecting such artists as Falconetto and Amico Aspertini. Probably influenced by Raphael, also by Michelangelo, from whom he borrowed some motifs, Peruzzi developed a more classical figurative style, but achieved neither Raphael's coherent and spatial compositional form, nor his scale, nor yet his dynamically animated expressiveness. His style remains unmonumental, graceful, and decoratively two-dimensional, while leaning on the models of classical antiquity. His antiquarian interests made him, together with Giovanni da Udine, one of the most important propagators of the newly revived antique style of decoration, the so-called grotesques. After Raphael's death, he established a close relationship with Raphael's pupils and collaborated with them in fresco decorations (Villa Madama). Probably more important as architect than as painter. His art was popularized, chiefly through books of Sebastiano Serlio, who was strongly influenced by him.

32 Design for an apse

Pen and brown ink, wash, preliminary stylus preparation, brownish paper, 161 x 204. Late 16th century inscription: Di Baldassare da Siena. *Peruzzi's inscription in the rectangles:* Judicii Solomonis istoria Judicii deniellis prophet (a)e Istoria. *Inv. 96, R. 125.*

Orig.: *Graf Moritz von Fries, L. 2903; Albert von Saxe-Teschen. L. 174.*

Lit.: *S.R. 129; R. 125; Frommel p. 140 ff.*

From July 10th, 1527, Peruzzi was architectural supervisor of the Cathedral of Siena, having executed various commissions for it over the two previous years. Our drawing shows a new design for the apse and the repositioning of the choir stalls. We see that the master was obliged to take some of the older accessories into account, such as Gothic-looking pews that were changed only in 1565, as well as the Quattrocentesque altarpiece. All the same, he tried to create an overall Renaissance impression by the arrangement of the pilasters and the strict geometrical division of the apse, and by the angels, which were probably meant to be sculpted and rather resemble classical figures of Victory on the spandrels of triumphal arches. Between the consoles, which have a Quattrocento look, Peruzzi placed a bust of Christ surrounded by portraits of Popes. In the hemispherical part of the apse is the transfiguration of Christ, and to the left and right of the old altarpiece with the Virgin and Saints, space is provided for two judgment scenes, one of Solomon and one of Daniel, evidently a reference to the legal function of the bishops, whose throne is below. Peruzzi seems to have left Siena while the building operations were still in progress. Beccafumi, who executed the painting in the apse between 1535 and 1544, was presented with this division of space, but tried to give uniformity to the design by painting Christ ascending between angels above, and below, to the right and left of the altarpiece (which he may have replaced), groups of Apostles within an architectural loggia. Peruzzi, on the other hand, had extended the pilasters by means of garlands that, following early Christian models, grew out of vases. Moses and Elijah, floating in the sky, are separated from Christ, who is enthroned on a bank of clouds. For the three Apostles, shown as lambs at his feet, he employs a rather typical formula from Early Christian art, a link which during the Renaissance was not infrequently made.

The smaller, stricter, partition of space suited Peruzzi's taste for decorative and graceful schemes, his predilection for the precise architectural organization of areas. In this he was a master, although he never quite overcame the Quattrocento, in spite of his antique-ish draperies and motifs. There is a nervous, decorative, fussy trait in the line, which covers the sheet with little hoops and flourishes, and joyfully traces every detail of the Gothic ornamentation of the pews. This is a typical Sienese feature, clearly expressed in this important document concerning a little-known stage in the building of the Cathedral.

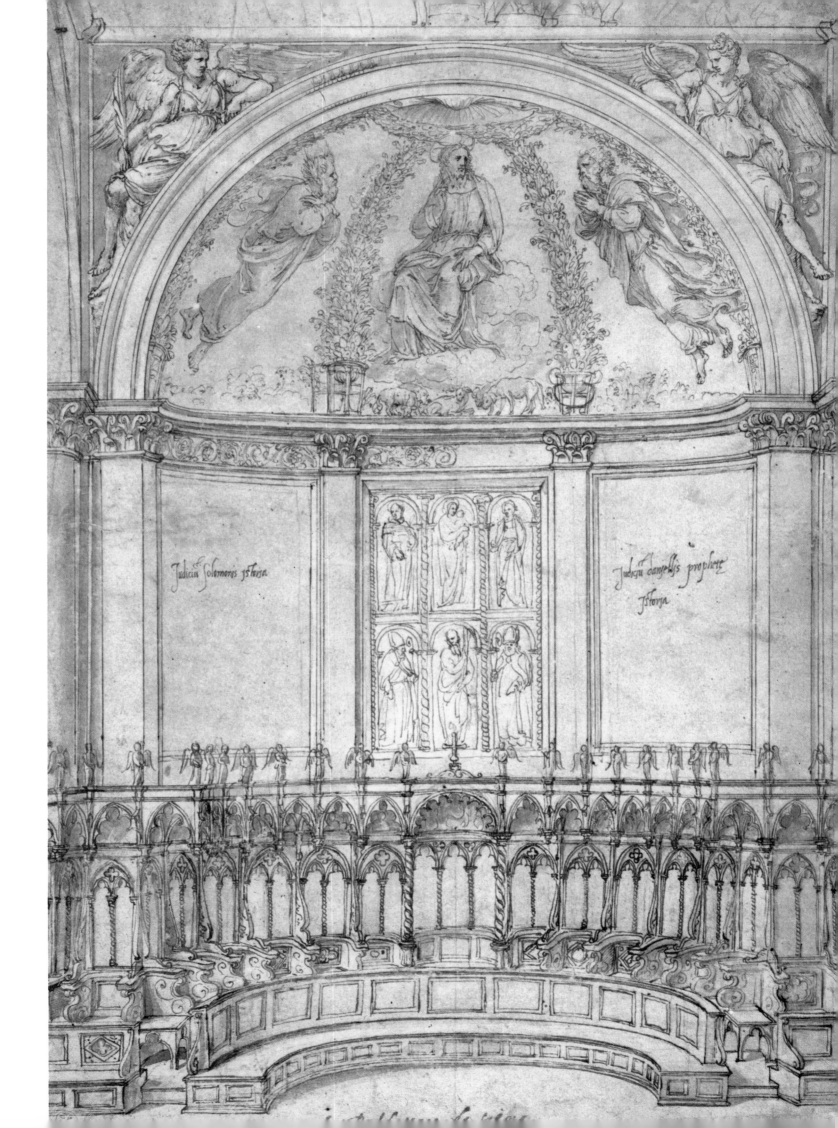

Iudiciū Solomonis jstoria

Iudiciū oangellis prophete
Istoria

DOMENICO BECCAFUMI

Painter, sculptor, woodcut artist; son of Giacomo di Pace, who worked on the land of Lorenzo Becca-fumi at the cortine in Valdibiena near Montaperti. Died in Siena before May 15, 1551, according to Vasari at the age of sixty-five. Supposed to have been in Rome for two years, studying Michel-angelo, Raphael and the Antique, before the end of 1512, when he must have returned to Siena. From that date, regular commissions for frescoes and painted altarpieces, for the mosaic floor and the bronze angels in Siena Cathedral. Principal work, frescoes for the Sala del Concistoro in the Palazzo Pubblico in Siena (1529-1535).

Earliest known works, documented from 1513 onwards, show a pronounced personal style, in which Tuscan, i.e. Florentine and Sienese traits, dominate Roman influences. His contemporaries admired his inventiveness, his individual manner of expression, his chiaroscuro — he used light and shade for effects in which bodies dematerialized, to become pure vehicles of expression — his daring foreshortening and his knowledge of perspective. His tendency to imaginative, individual, expressive work is similar to that of contemporary artists like Rosso and Pontormo in Florence, but he differs from them mainly in his audacious light effects and corresponding coloring.

33 Male Nude

Brush and bistre, black chalk, white highlights, incised with stylus for transfer, brown paper, 222 x 431; inscription: Domenico Beccafumi il Meccharino da Siena 1531. *Patched right bottom corner, Inv. 276, R. 205.*

Orig.: *Albert von Saxe-Teschen, L. 174.*

Lit.: *S.R. 337; R. 205; Kurz, p. 39; Sanminiatelli, p. 165, No. 122.*

The huge Michelangelesque figure of a man in the pose of a recumbent River God is closely connected with Beccafumi's cartoons for the floor of Siena Cathedral, like that of Moses on Sinai, where a very similar figure occurs. It is also re-lated to his chiaroscuro woodcuts, commonly thought to date from the fourth decade of the century, when Michelangelo's and other artists' figures were also growing more immense. The technique with the very broad brush-strokes, sim-ulating a pen technique which Bandinelli prob-ably introduced in Italy, and the even more broadly applied white highlights on the brown paper, are also closely connected with these works in the chiaroscuro manner. The profuse underlying chalk-drawing still shows an alterna-tive head-posture, and attests that we are dealing with an original sheet, as does the impasto-treat-ment of the white highlights on the man's head. Just here on the left, behind the shoulder and in the hair, the brush produces the darkest strokes for forceful contrast. The upper torso seems to strain towards us in powerful modelling, while legs and the less strongly drawn scenery recede into the background. The sheet makes its greatest effect when we look at it from a distance and take the opportunity to appreciate Beccafumi's virtuosity in handling foreshorten-ing in space.

A sheet in the Louvre, which used to belong to Vasari and Mariette, repeats our drawing (San-miniatelli, p. 155 No. 80, Ill.) with further sty-lization of line. It was certainly created later than our drawing, and the tracing marks on our drawing may possibly have been used for this repetition. Sanminiatelli suggests that it might have been the model for a chiaroscuro woodcut which is lost, but it would more likely have been a presentation drawing in its own right. This would also explain the fact that the replica got into the hands of Vasari. This figure was often adapted by Beccafumi, and one of the first ideas may be found in a drawing in the Uffizi (Forlani, Cinquecento Nr. 53).

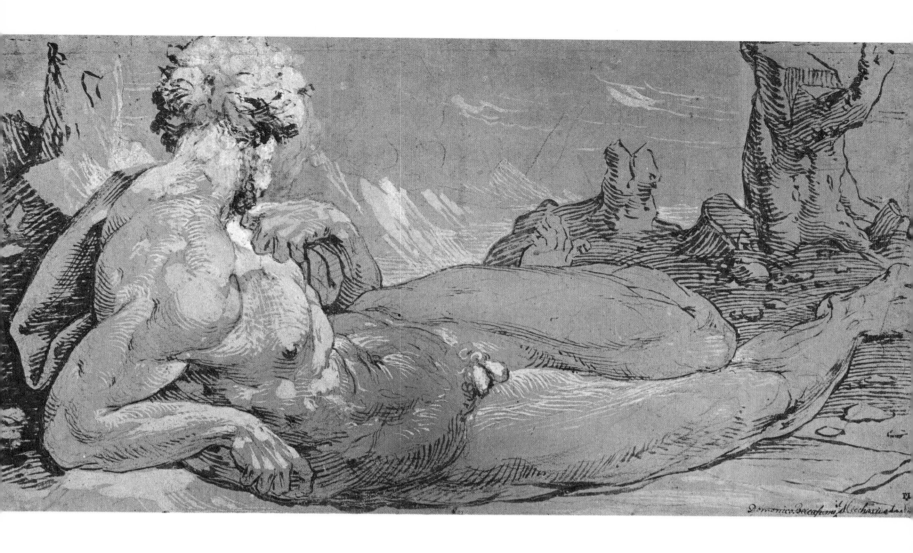

RAPHAEL

Raffaello Sanzio, painter and architect, born in Urbino, March 28th, 1483; died Rome, April 6th, 1520. First trained with his father, the painter Giovanni Santi, and after his early death in 1494, with Pietro Perugino in Perugia. Made mark by own work around 1500 in Umbria. 1503 seemed to have assisted Pinturicchio in design of frescoes for Biblioteca Piccolomini in Siena Cathedral. From 1504, in Florence, where he studied and absorbed chiefly works of Michelangelo and Leonardo, but also those of Fra Bartolomeo and the Florentine art of the 15th century. Painted chiefly Madonnas for his Florentine clients, while continuing to create large altarpieces and frescoes for Perugia. End of 1508, Julius II called him to Rome, where he soon afterwards entered the Papal service. From then on, worked almost exclusively for Julius II and Leo X and their court as painter and architect. Principal works, decorations for the Papal chambers, the Stanze and Loggie in the Vatican, cartoons for tapestries for the Sistine Chapel, and a group of important altar-paintings, such as the Sistine Madonna in Dresden, the St. Cecilia in Bologna, and the Transfiguration in the Vatican Gallery. Besides, he also worked for the greatest private patron of the High Renaissance, the rich banker Agostino Chigi, chiefly on his chapels in S. Maria della Pace and S. Maria del Popolo (whose architecture was also designed by Raphael and which was appointed with sculptures after his designs), and on the new Palazzo by the Tiber, the famous Farnesina with the celebrated Galatea and the Loggia di Psiche. Towards the end of his relatively short life, Raphael occupied himself chiefly with architecture: the building of St. Peter and the Villa Madama, summer-residence of the Cardinal — nephew of Leo X, Giulio de' Medici, the future Pope Clement VIII — and with archaeological research.
Raphael is described by his contemporaries as an extremely lovable man and as having a special appeal for animals. His elevated social ambitions, responsible for rumors that he was hoping for a Cardinal's hat, are expressed in the house he built for himself. Even his earliest works show his inborn sense for harmonious order and spatial articulation, with which he animated Perugino's more rigid compositions. With never-flagging energy he studied each modern trend, and monumentalized and widened the treasury of idealized figures he inherited from his master. Constant practice in drawing from life and the models of classical antiquity led both to greater human depths and animation in his figures. They are charged with individual life, and nonetheless conform to a classical canon in proportion, movement and expression of emotions. No master before or after him achieved such a fusion of classical antiquity and modern, personal, Christian feeling, and his creative work was for many centuries to become the pattern for all art striving for the classical.

34 The Virgin with the pomegranate

Black pencil, white paper, 411 x 295, Inv. 4879.
Orig.: *Julien de Parme; Prince de Ligne; Albert von Saxe-Teschen, L. 174.*

Lit.: *S.R. 238; Fischel 1913, I, No. 53; R. 49; Swoboda, p. 187; Benesch 1964, No. 22; Pope-Hennessy 1970, p. 182.*

Raphael's early Madonnas, such as the Madonna Solly in Berlin or the very similar one that recently appeared in private ownership in New York, to which our sheet is still closely related in construction, are all grave and severe, and wear the veil usually covering the head of a Mary in mourning. Here, both mother and child almost sorrowfully regard the opened pomegranate, the red flesh of which suggested Christ's sacrificial blood to the mystic eye of the time. As in the two other Madonnas, and their Perugino models that in turn go back to old tradition, the child is quite encompassed by the frontal body of the Virgin, but on the cushion and parapet in front of her, it already moves with some freedom in a complicated pose. The Virgin's delicate, flowerlike head with its slight inclination also turns with greater life and suppleness than in the early works. The features are more precisely and more strongly animated, and less stylized. Even the landscape has greater depth. Benesch accurately observed that these features reveal a close connection with the subsequently painted (approximately 1504) tender and sensitive Madonna Connestabile della Stafa in Leningrad, a connection that had been closer still when the child's left arm in an earlier stage of the design still visible was reaching across its tummy for the fruit. Now it has assumed the posture once shared by the Madonna Terranuova in an early stage (Fischel 1913, I, Ill. 62) before her gesture became Leonardesque. The Madonna Ansidei, completed in 1505 but designed perhaps even earlier, and considered by Fischel as related to our sheet, is also close in style. Thus, in our drawing we have the mature solution to the problem of the half-length Madonna at the end of Raphael's Umbrian period.

The sheet is so highly finished, so thoroughly executed in delicate lines in the light areas and strong cross-hatching in the dark, that we may take it to be a cartoon, i.e. the final preliminary drawing for a painting of the same size. The technique of the strangely stylized eyelet-depressions in the folds still clearly comes from Perugino, who used to work out his cartoons in an identical manner, but the delicate gradations in modelling are characteristic for Raphael.

Years ago there was a ruin of a picture intimately linked to our drawing on the Roman art market. Was it the damaged remainder or a copy of a lost original?

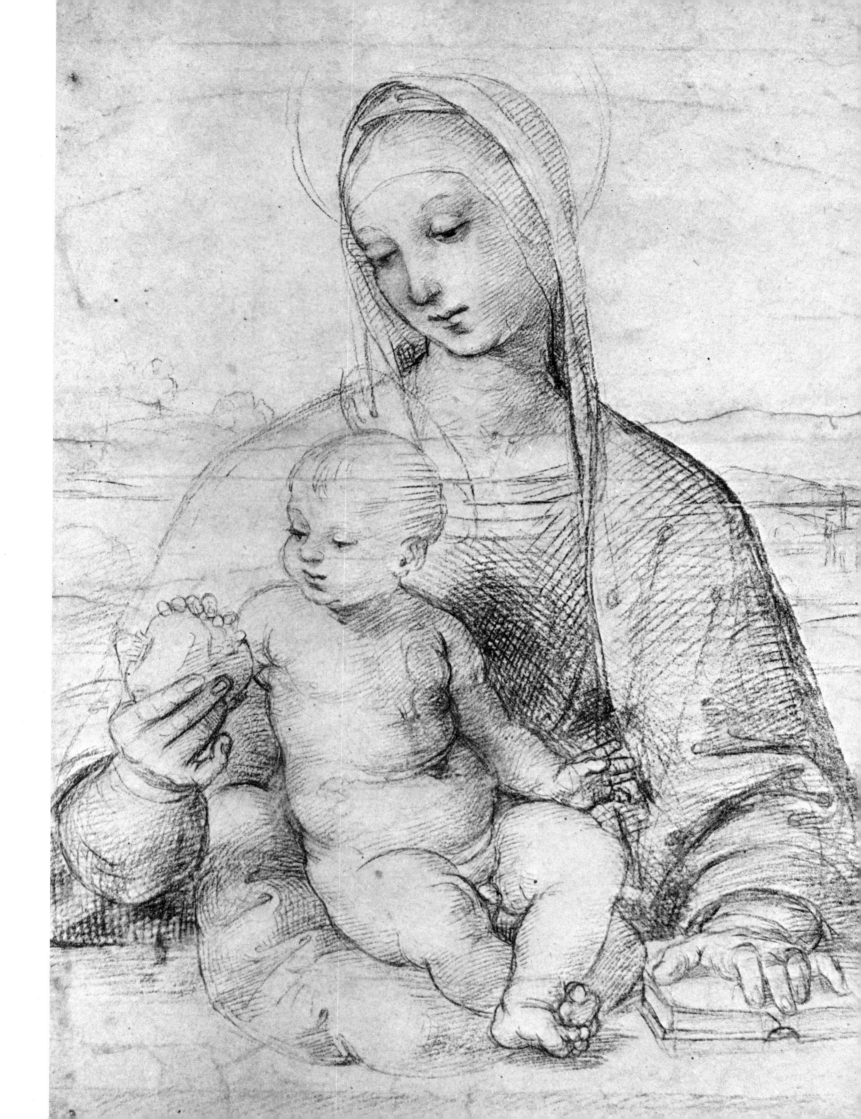

35 Studies for the Virgin

Red chalk, pen and bistre, white paper, patch at right bottom corner, 256x184, Inv. 209, R. 53 v.

Orig.: *Charles Prince de Ligne, Albert von Saxe-Teschen, L. 174.*

Lit.: *S.R. 250; Fischel 1913, III, No. 10; Pouncey and Gere, p. 16.*

In Florence, Raphael's Madonnas outgrew their Umbrian severity. No longer only frontal sitting or standing figures, they turn in space; the children become livelier and more mobile, break out of the mother's enfolding shape and play a part in determining the silhouette. The line, too, becomes richer, looser and freer; silverpoint, black chalk and pen are joined by red chalk, brush and bistre, probably suggested by Leonardo, that great master of movement and animation.

Our sheet, together with one in London (Pouncey and Gere No. 19), forms the core for the development of a whole group of half-length Madonnas. Raphael begins in the center by drawing in red chalk a seated Madonna. The child stands on her lap, its head pressed close to hers, following the model of a work by Donatello that in turn reaches far back to the ancient Byzantine tradition of the "sweet loving" Virgin. Above, he draws the same motif again, a little smaller, giving the heads a slightly different tilt. Then disregarding the first drawing, he quickly alters the child and places it in the Madonna's lap, head raised towards her, feet turned to the left — basically still the old prototype of the Madonna Solly, though different in function and position. Then, in red chalk, he rapidly draws a further child, half lying in its mother's arms and reaching out for her bosom-cloth. Then he takes up the pen. The two red-chalk sketches are first of all almost exactly copied in the London sheet and then varied further. The "sweet loving" Virgin may then have suggested the Madonna Tempi and the small Cowper Madonna; the Virgin with the lying child grows into the Madonna Colonna.

On our sheet, other motifs are developed. The sitting child of the red-chalk study is given greater mobility (bottom, right), first, with arms still reaching out for the mother, then turned forward, probably interested in the book that the Virgin is holding. The positions of the mother's arm are also varied like those of an articulated marionette, and the motif begins to suggest the Madonna with the Palm tree, in Edinburgh.

Top left, Raphael places the child in the Madonna's lap, a position at which he probably arrived by reversing the sketch discussed earlier. This was to become the starting point to the large Cowper Madonna of 1508 in the National Gallery in Washington. Finally, Raphael occupies himself with the subject of the Virgin suckling the baby; the *Madonna lactans:* top right, in a reversal of the Madonna just discussed; bottom left, a reversal of the red-chalk study above. A further variant of this motif produces the Madonna Orléans in Chantilly. On the recto is a drawing in silverpoint, pen and ink on a brown ground, which elaborates the central motif of the drawing in London: the child sprawled across the Virgin's lap, which Raphael took from Michelangelo's Tondo, (in the Royal Academy, London) and developed in the Bridgewater Madonna.

In these two sheets we meet Raphael on a truly productive day. Intensely occupied with the problem of Mother and Child, proceeding from traditional and new types, he finds motifs for the movements of almost all his Florentine half-length Madonnas. It took him years to work all this out in paintings.

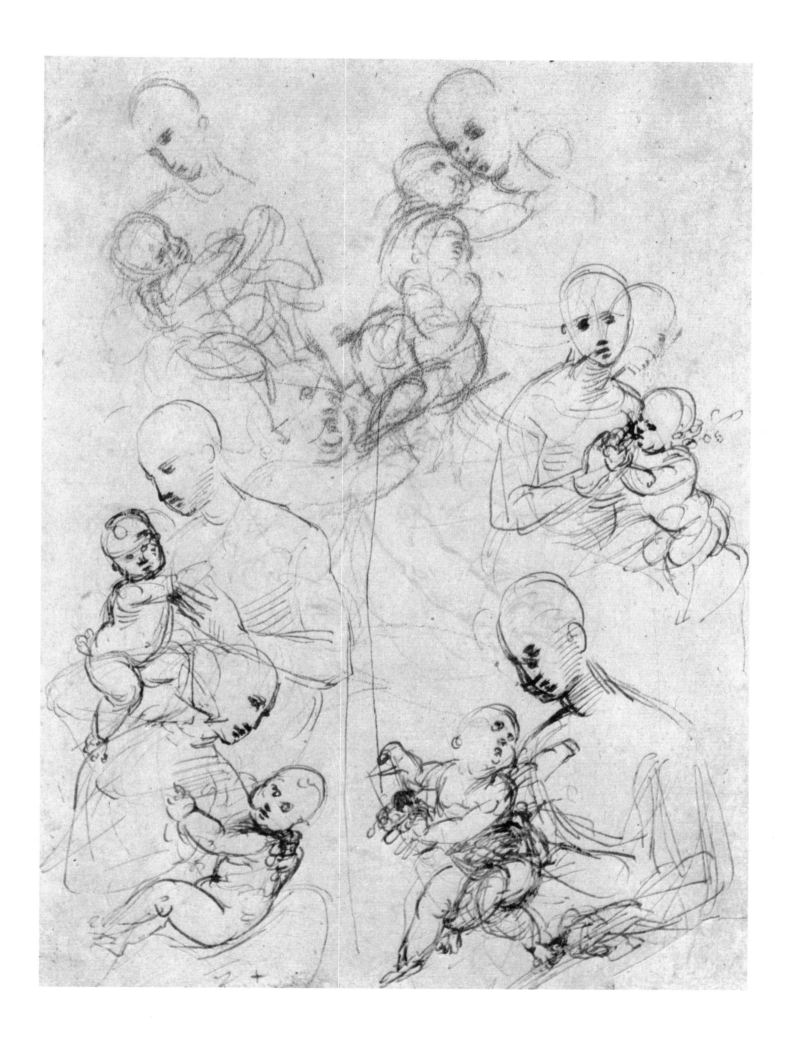

36 Madonna and child

Metalpoint, pen and ink, white paper, 186 x 146, Inv. 205, R. 56.

Orig.: *Coll. Viti Antaldi, L. 2245; Prince Charles de Ligne, Albert von Saxe-Teschen, L. 174.*

Lit.: *S.R. 245; Fischel 1913, VIII, No. 336; R. 56.*

On the verso of this enchanting sheet from the Collection of Timoteo Viti, a friend of Raphael's youth, are quick studies for three figures in his first large fresco, the Disputa, painted in 1509, and so enthusiastically admired by Pope Julius II that he dismissed all other painters and transferred the commission for the decoration of the Stanze to Raphael alone. Next to the drawings, Raphael had jotted down a few lines from a love-sonnet, which give a glimpse of a mysterious relationship to an apparently high-ranking woman.

Raphael's recent completion of his Florentine training is distinctly recognizable in our sheet. The Madonna, in the rhythmically turned pose on the ground, is derived from Michelangelo's Doni Tondo, the full roundness of form, and the expression that is filled with life comes from Leonardo, and the triangular construction, with the dynamic diagonal of the child stretching for the book in the Virgin's hand, is Florentine. Raphael's style of drawing blossoms out in this sketch in total calligraphic freedom, and suggests and elucidates with spare, sensitive lines. What matters to him is to present the movement: the child's body, the turn of the Virgin's head, the cherubs fluttering from the right and the left. This is accentuated in bold lines; the rest is delicately indicated, as is the powerful landscape silhouette in the background that unifies the whole.

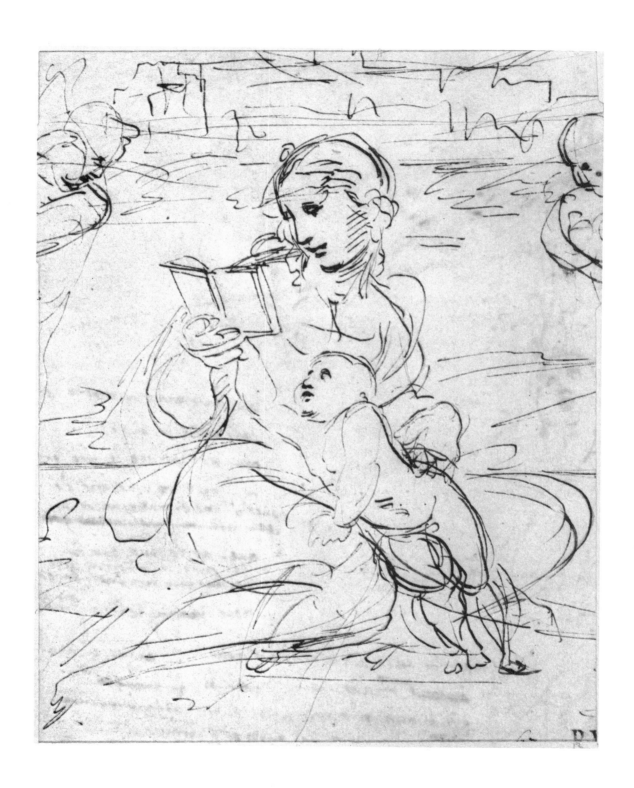

37 Study for the Massacre of the Innocents

Red chalk; brownish/white paper, 235 x 408.
Pen and ink inscription: Raffaelle. *Inv. 188,*
R. 63.

Orig.: *Cardinal Santa Croce; P. Crozat; P. J.*
Mariette, L. 2097; Julien de Parme; Albert von
Saxe-Teschen, L. 174.

Lit.: *S.R. 220; Fischel 1913, V, No. 236; R. 63;*
Popham and Wilde, p. 310 f. Pouncey and Gere,
p. 18 f.

When Raphael went to Rome at the end of 1508, he had only just studied and analyzed the dramatic battle-cartoons by Leonardo and Michelangelo, and also designed battle-scenes of his own, in which his interest in ancient sarcophagi is apparent.

However, the *Stanza della Segnatura* with its static elements offered little occasion for highly dramatic painting. In his designs for the ceiling-fresco of the Judgment of Solomon, Raphael originally attempted to use such a scene of classical action (Fischel 1913 V, No. 230-232), but finally had to adjust it to the more static demands of the subject and the confined space. The finest of the studies for an executioner, developed during the earlier stage, now becomes the starting point for the famous drawing for the engraving "The Massacre of the Innocents," wonderfully executed in two versions, by Marcantonio Raimondi. In a drawing now in London (Pouncey and Gere, No. 21, Fischel 1913, V, No. 233) Raphael worked out the nude figures of the central characters, and experimented with a group in the background, a soldier grabbing a woman by the hair, insofar as he tried to show it seen from two different points of view. In a further sheet at Windsor Castle, the composition has found its nearly definite form. (Fischel 1913, V, No. 234; Popham and Wilde, No. 793). However the space for the woman with the child fleeing from the executioner, adapted from the Judgment of Solomon, is still blank. She is minutely studied on our sheet. The whole motif is lightly sketched (the executioner, incidentally in a pose almost closer to the Judgment than in the drawing at Windsor), but then Raphael concentrates on the woman's legs and her arm, which he forcefully models in the light with soft red chalk to compact roundness of form. He did not use in the engraving a second study of the right leg, slightly differently posed. Light and shade are his main concern, and so is the contour at which he arrived by forceful repetition. All this was finally incorporated into a drawing now in Budapest (Loránd Zentai, Raffaello Emlékkiállítas, Szépmüvézeti Muzeum, Budapest 1970, No. 23) which already exactly corresponds to the print and which, if it is not by Raphael himself, must be based on his original drawing. The process of preparation attests to the fact that Raphael did as much work for a small engraving as he did for a large fresco.

On the verso is a study for a further ceiling-fresco in the Stanza. This chronologically places the sheet in the period 1509/10.

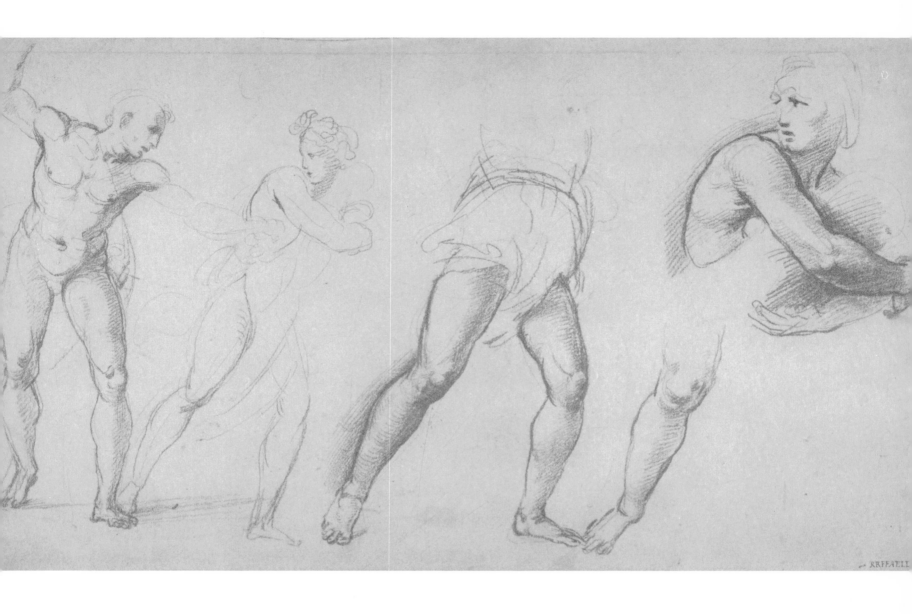

38 Sybil

Red chalk, preparatory drawing in stylus, traces of pen and ink. 279 x 172. R. 72; Inv. 181.

Orig.: *Albert von Saxe-Teschen, L. 174.*

Lit.: *S.R. 129; Fischel 1898, No. 282; R. 72; Dussler 1966, p. 103.*

Red chalk was the material that Raphael evidently preferred for single studies in his later Roman period. Besides the soft kind that he used in the study for the Massacre of the Innocents, he also used a harder sort for linear drawings, as this of the Sybil in S. Maria della Pace. From Autumn 1510 until the beginning of June 1511, Julius II was campaigning in Northern Italy, especially in Bologna. We know that Michelangelo could make no real progress with the Sistine Chapel for lack of money. This state of affairs may have provided the rich banker Agostino Chigi with an opportunity to obtain Raphael's services for the decoration of his chapel in S. Maria della Pace. At all events, the verso of a drawing for the School of Athens bears the first design for the frescoes. The drawing, with beautifully moving lines and accentuated hatching that follows the contour in free curves, resembles strongly the drawings for the Parnassus in the Stanza della Segnatura. Raphael did all he could to fit his figures as well as possible into the irregular spandrels above the apse, and to make the Sybils appear animated, active and interrelated. A group of drawings attests to his struggles with this problem (cf. Hirst, p. 168). In our sheet, the solution has already been found. The eldest Sybil supports her weight by grasping with both hands the block which is her seat, and gazes with interest across at a tablet held by an angel. Unlike Michelangelo's Sybils, whose inspiration comes through ecstasy or through profound brooding and inner struggles, here it is a case of listening for, and turning towards, the messages brought by angels. The book remains carelessly opened and threatens to slide down.

The stylus with which Raphael first indicated the movement had at first marked differently the complicated position of the crossed legs above the urn. The pose seen here was to be slightly changed as well, so that even in such a finished study, where the rich folds of the drapery were the main concern, the master is still creatively at work.

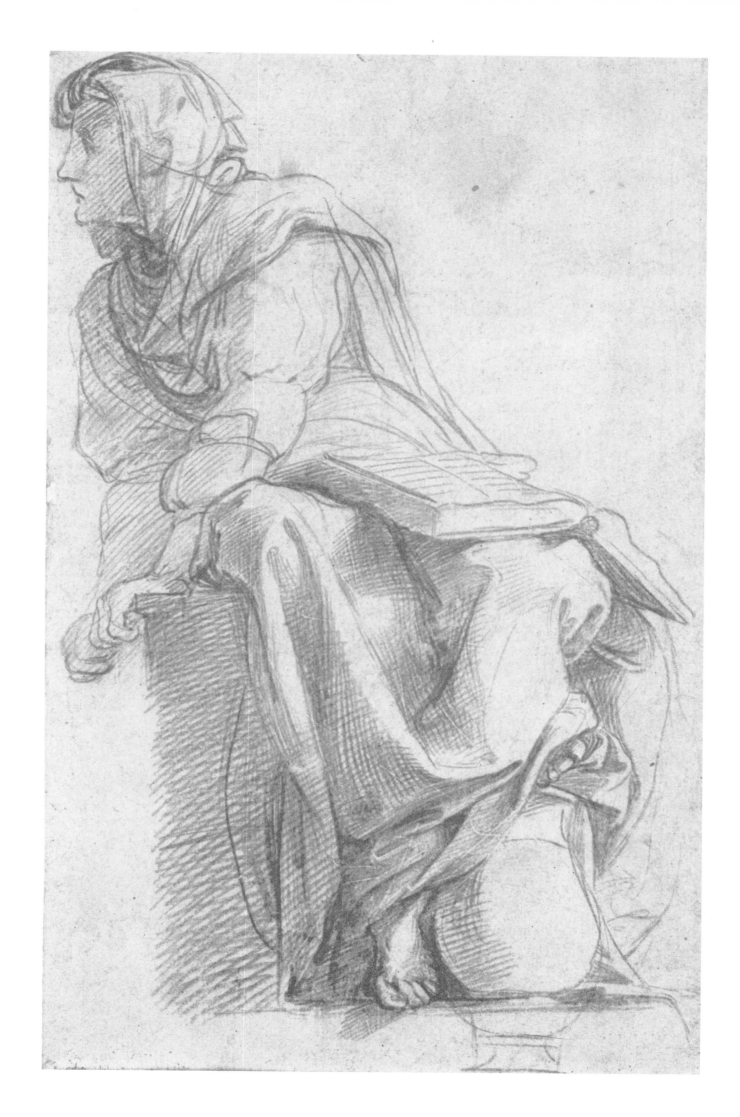

39 Nude studies

Red chalk, metalpoint, white paper, 410 x 281. Inscription in the hand of Albrecht Dürer: 1515 / Raffahell de Vrbin der so hoch peim / pobst geacht ist gewest hat der hat / dyse nackette bild gemacht Und hat / sy dem albrecht dürer gen nornberg geschickt Im seine hand zw weisen. Inv. 17575, R. 74.

Orig.: *Albrecht Dürer; Willibald Imhoff; Emperor Rudolf II; Imperial Treasury; Imperial Court Library; Albert von Saxe-Teschen, L. 174.*

Lit.: *S.R. 282; R. 74; Panofsky 1948, I, p. 284; Hartt 1958, p. 2 ff.; Shearman 1959, p. 458; Oberhuber 1962, p. 46; Dussler 1966, p. 94.*

This study-sheet of nudes is a unique document of the relationship between Raphael and Dürer, of which we also know from other sources, and which led to an exchange of presents between the two. The sheet comes from Dürer's estate, and he himself added the inscription: "1515 / Raffaello da Urbino, who was so high in the esteem of the Pope, made these naked pictures and sent them to Albrecht Dürer in Nuremberg to show him his hand." This is the only drawing of Raphael's to reach us with a contemporary inscription and date. Yet it is in the nature of research that doubts were nevertheless cast on the sheet: doubts because of the realistic presentation of the nudes, and such thorough exploration of the model's muscular body as we had not before encountered in Raphael. The delicate line-treatment that articulates the surfaces by minutely following each protuberance and indentation and allows a unifying light to play all over the body, has yielded its calligraphic independence to objective representation. Raphael knew very well why he sent this sheet to Dürer. Faithful representation of life was close to the heart of both artists. Yet, ideality is still there, and although the drawing is so faithful to the model, we sense the inspiration from classical Antiquity. 1515 is the time when Raphael comes closest to Antique sculpture and compositional form; this emerges particularly clearly in the cartoons for the tapestries of the Apostle series. The pointing figure in our drawing served for the concurrently created fresco of the Battle of Ostia, which was largely executed by members of the workshop, especially by Giulio Romano.

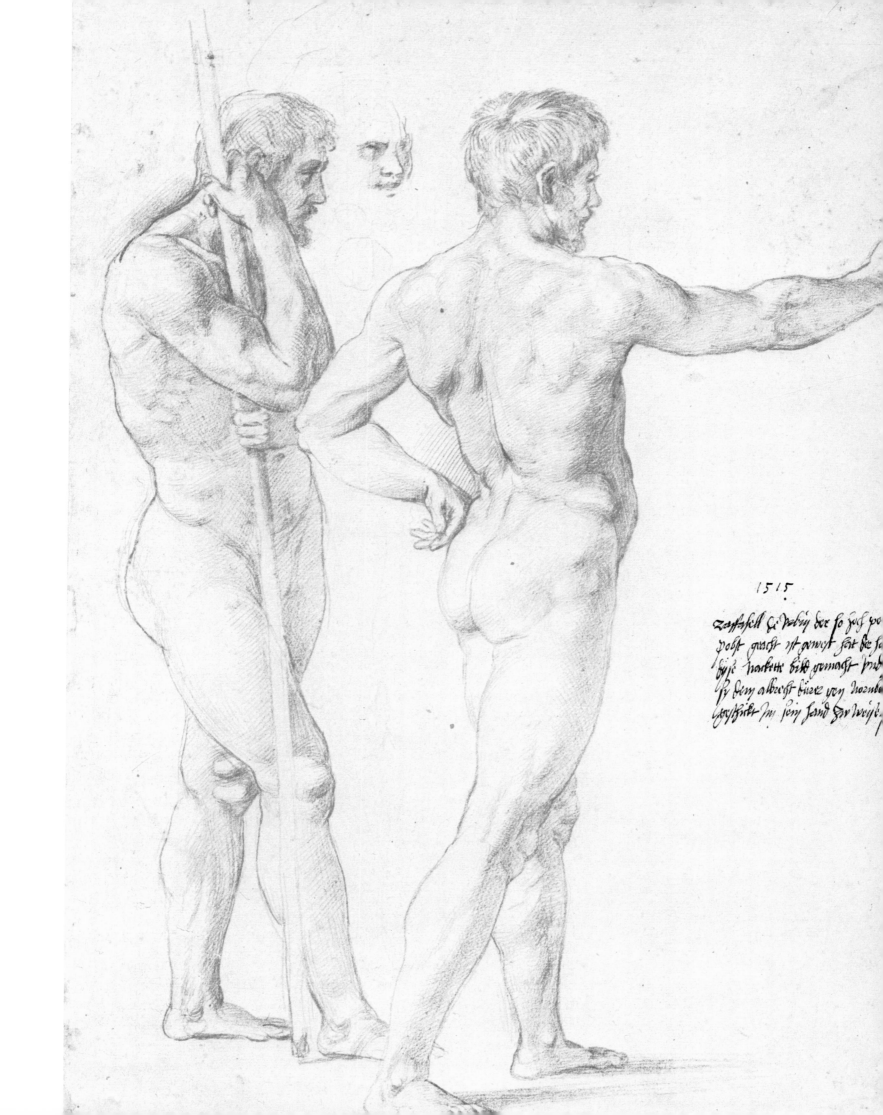

1515

Zaffasell Ce Debiy der so sich po
pobst gnacht ist gewest hat die sa
biff harkette bild gemacht vnd
zu dem albrecht durer gen nornbe
geschickt Jn sein sand hör weiß.

40 Two riders

Red chalk, preparatory drawing in white paper patched top and top left. Pen and ink inscription: Rafaelle, 286 x 203.

Lit.: *S.R. 284; Fischel 1898, No. 351; Schön-brunner-Meder (?), No. 782; Berenson, No. 161; R. 77.*

During the period of 1514/15, the nuns of Santa Maria dello Spasimo in Palermo must have commissioned an altarpiece from Raphael. He painted a Christ falling under the cross, but the picture takes its name "Lo spasimo," "the Swoon," after an incidental scene, the Virgin sinking to the ground at the sight of her suffering son, exchanging with him a grief-laden glance. At the time, Raphael was painting the tapestry-cartoons for the Sistine ceiling, and the rapidity and freedom of that work is reflected in the unusually free and summary treatment of the painting, for which, however, he already in many places enlisted the aid of his pupils. Vasari tells us that the picture became famous because the ship that carried it sank, but the picture, unharmed, was washed ashore near Genoa as by a miracle. It finally reached its destination in Sicily, was sent from there to Spain and is today in the Prado.

Our drawing is the Master's study for two equestrian figures, left and right in the middleground, and probably executed by Giulio Romano. Raphael's concern was only for the general form, the plastic articulation of space and the relationship of light and shade, and that is why the drawing is concentrated on a few, meaningful, geometrically clear contours and patches of hatching, that express all that is essential. The study, attributed once by many experts to the great master of red chalk drawings, Andrea del Sarto, probably because of the models' period costumes and the technique — is a positive masterpiece of graphic economy.

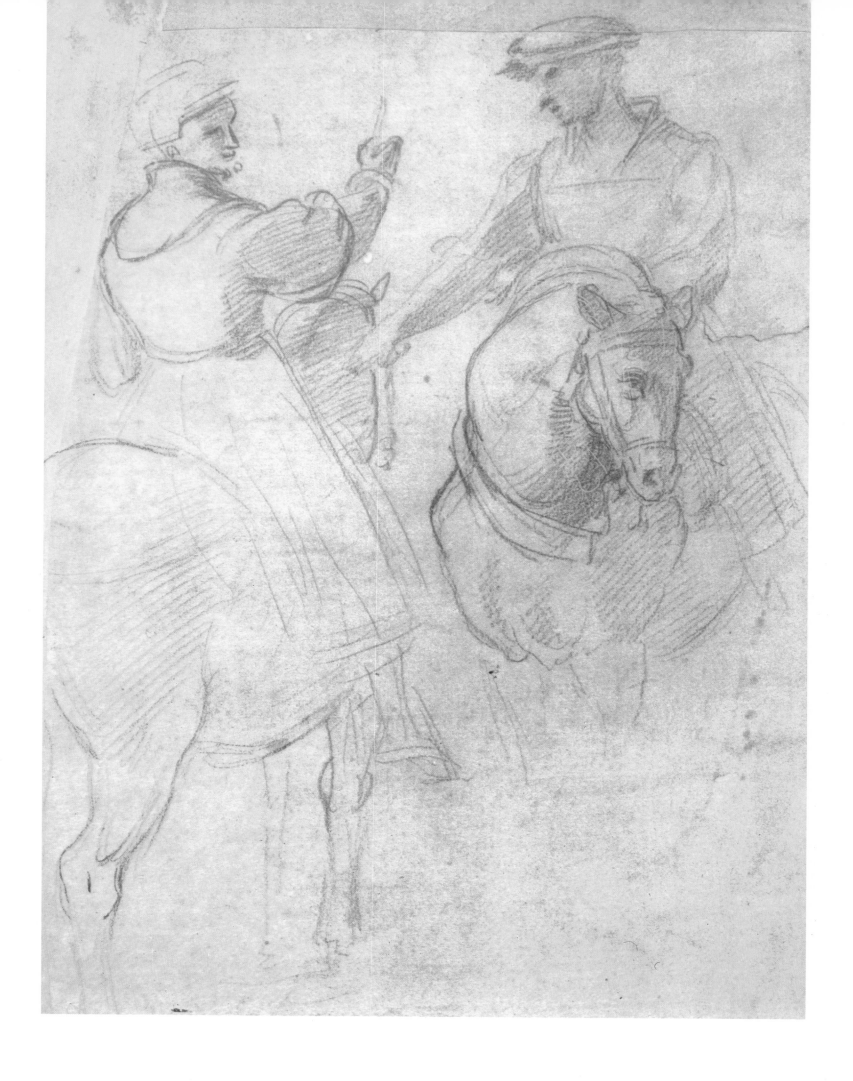

41 Apostle head

Stylus, black chalk, brown paper patched round edges, 240 x 182, old inscription in pen and ink: 31. Inv. No. 242, R. 79.

Orig.: *P. Crozat; P.J. Mariette, L. 1852; Albert von Saxe-Teschen, L. 174.*

Lit.: *S.R. 294; Fischel 1898, No. 346; R. 79; Pouncey & Gere, p. 34; Oberhuber,* Transfiguration, *p. 145; Dussler 1966, p. 69.*

The most important commission executed personally by Raphael at the end of his life was the Transfiguration for the High Altar in Cardinal Giulio de' Medici's church in Narbonne. However, after his sudden death, this last work remained in Rome, where it was placed in San Pietro in Montorio. A group of drawings shows the progressive development of the picture, that was the more important to Raphael as his declared rival, Sebastiano del Piombo — aided with drawings by Michelangelo, was commissioned with a second picture for the same church. The heavenly vision of Christ transfigured above an assembly of Apostles vainly trying to cure a possessed boy has always been much admired.

The figures below, thought to be painted by the workshop were less esteemed until Fischel some years ago drew attention to some magnificent heads. The expression of those heads caused Raphael special concern. After the cartoon had been finished, he traced them once more onto fresh paper and redrew them from the model. These belong to the most impressive studies preserved from his late period, even if some of them occasionally were subject to doubt. The sheet in the Albertina is a study for one of the figures in the background, who looks with a gaze full of emotion towards another Apostle. The humanity of this gaze has been caught, idealized, and heightened by the soft light that plays over the features, and the clear modelling of the head. The refinement in the use of the black chalk, the depth and differentiation in the shadows of the neck, the delicate and loose treatment of lines in hair and beard, and the decisiveness of the contour all bear the unmistakable marks of Raphael's own hand, who in this most mature of his works explores every possibility of deepening the content of life and emotion through lucidity of form.

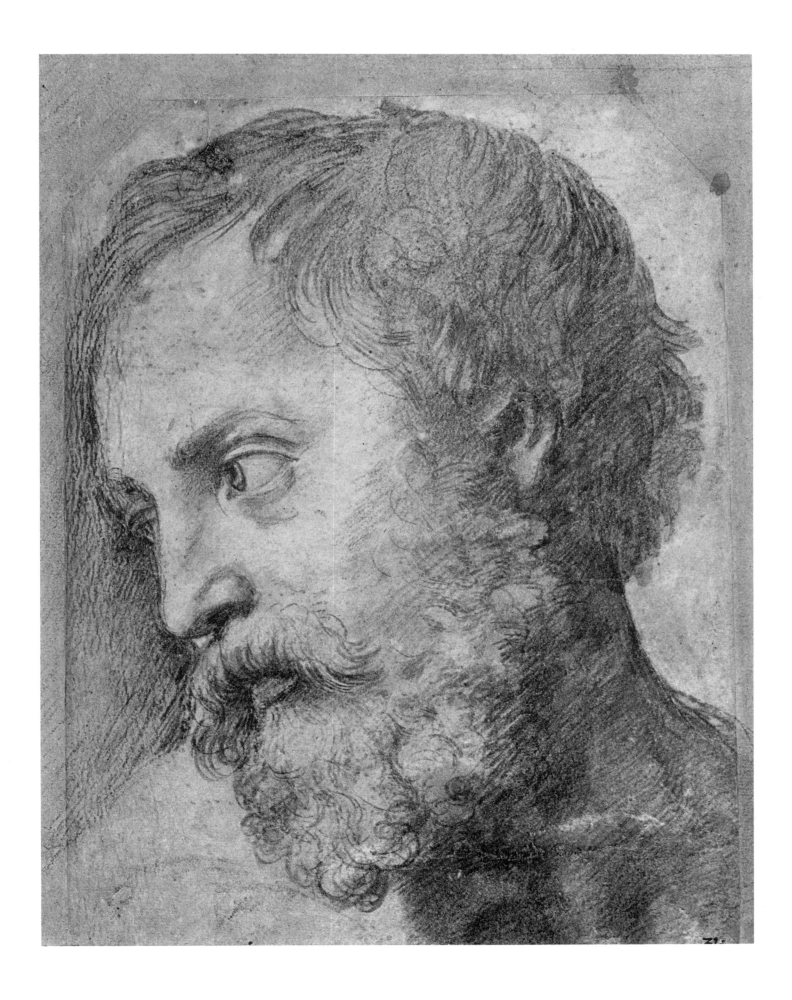

GIULIO PIPPI, CALLED GIULIO ROMANO

Painter and architect. Born in Rome, probably 1499; died in Mantua, November 1st, 1546. Came to Raphael when still a child, assisted with frescoes and pictures from 1515/16. After Raphael's death, first continued the master's works, in particular the decorations of the Sala di Costantino, then independently designed altarpieces and minor decorative works. On the recommendation of Baldassare Castiglione he went to Mantua in October 1524, and became court painter to Federigo Gonzaga and his successors. His activities as architect and painter transformed not only the entire city, but affected the art of Northern Italy as far as Venice and Verona.

He reached his maturity in Raphael's workshop at the time when the master was most concerned with the art of classical antiquity and especially with antique reliefs. This was the starting point for the art of Giulio Romano. He saw man not as an individual, but in terms of the reliefs of Antiquity: as a being driven by exterior and passionate interior forces; this becomes apparent in his painting. He soon renounced all control of nature, contenting himself with a highly flexible formal idiom — developed from the Antique — which he skilfully animated by his dynamic manner of composing in flowing planes, his handling of light and generally heightened expressiveness. Through his great inventiveness and decorative talent, he remained influential beyond his lifetime and still affected artists of the calibre of Rubens. His pupil Primaticcio and artists like Martin van Heemskerk spread his influence to France and the Netherlands. German artists also followed his example. Engravings by the Mantuan artist-family Scultori, Giorgio Ghisi, and many others spread his fame, so that he was the only Italian artist to be mentioned by Shakespeare.

42 Hunting scene with boar, stags, and hares

Pen and bistre, wash. Pen and ink inscription: traces of squaring in charcoal.
Buff paper, 256 x 409; Inv. 338; R. 95.

Orig.: *Charles Prince de Ligne, L. 592; Albert von Saxe-Teschen, L. 174.*

Lit.: *S.R. 419; R. 95; Hartt No. 149.*

The Palazzo del Te in Mantua, begun in 1526 and decorated with frescoes and *stucchi* over a period of years, is still one of the most interesting documentations of the classicist art that immediately followed the High Renaissance. Giulio worked there with a group of assistants, but designed each detail in person. The various rooms are decorated in a richly varied scheme, using a wealth of mythological and allegorical themes. In the small Sala dei Venti we find an extraordinarily complicated ceiling-design depicting planets, stars and constellations and their influence on the lives of men, due homage to Renaissance astrological notions. Our drawing is the model for a fresco-medallion showing the effect produced by the constellation of the two asses (Asellus borealis and aurealis) in the

Tropic of Cancer, in the house of Mars. According to a (late-antique) handbook by Firmicus Maternus, men born under this sign are destined to be great hunters (cf. E. Gombrich, the Sala dei Venti in the Palazzo del Te, Journal of the Warburg and Courtauld Institute, 13, 1950, p. 189 ff.).

Originally, these scenes were intended for rectangular areas instead of medallions. All the sketches are of the same format as ours, and had to be laboriously adapted. This pen drawing with bistre wash shows the mature work of Raphael's pupil at its most characteristic. Men and beasts are moving across the plane in a dynamic diagonal. The frenzied figures are seized by such passion of movement that divisions between them seem to disappear. Light flickers over the whole design, and only the darker shadows in the onrush of men and women on the left differentiate this group from the animals, less dark and heavy, on the right. Space, largely lacking here, was introduced in the course of execution in the different format. The relief-like composition is closely linked with antique models, particularly the two hunters on foot with their typically classical movements and drapery.

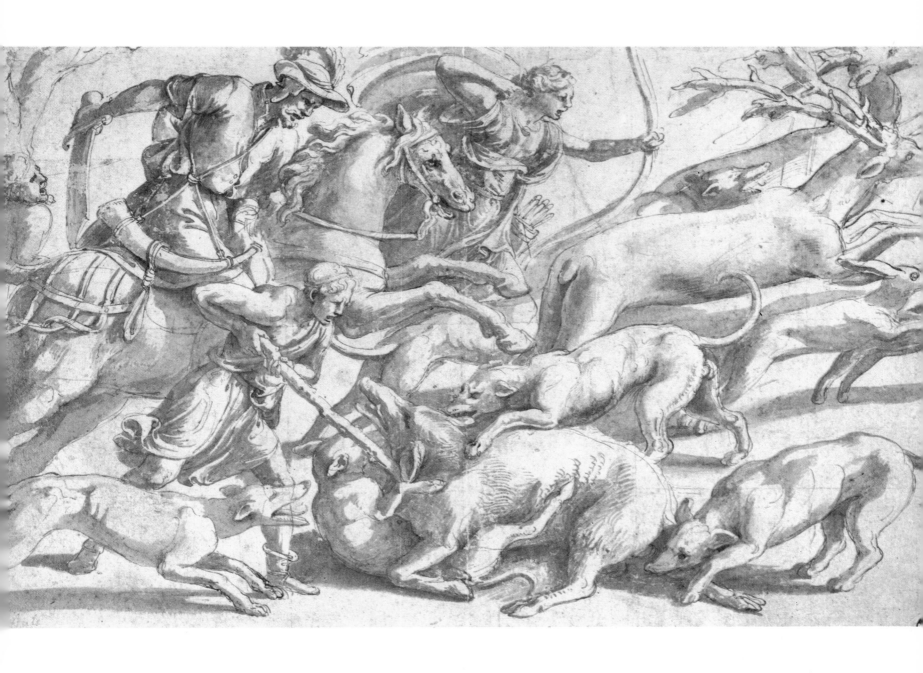

POLIDORO CALDARA, CALLED POLIDORO DA CARAVAGGIO

Painter, born approximately 1490/1500 in Caravaggio, Lombardy, died Messina 1543 (?). According to Vasari, he was discovered among the workmen at the Loggie when he was eighteen, and employed as a painter by Raphael. At all events, his first documentable works seem to have been painted in connection with pupils of Raphael, especially Perino del Vaga.

Collaborated with Maturino (a Florentine painter who is still undocumented today) above all on mythological and historical façade-decorations, with subjects in the antique manner, following the examples of Peruzzi. Polidoro's fresh interpretation of the antique relief-style inspired all travellers to Rome, including illustrious masters like Rubens. After the Sack of Rome, Polidoro went first to Naples and then to Messina, where he was influenced by the realistic Netherlandish trends dominant there, and formed a school.

Polidoro is one of the most individual of Raphael's pupils. Even his early works show such distinct character that one may be certain that his artistic development was largely complete when he arrived in Rome. His predilection for classicist landscapes and genre-motifs was evidently brought from the North. The connections with Florentine masters like Rosso, and the circle around Andrea de Sarto in general, which clearly emerges in the style of his red-chalk drawings, may be explained by his close associations with the Florentine Maturino. Polidoro is a master of mood, movement and life, and most of all a virtuoso in the handling of light, who succeeds in presenting his subjects and figures in strong contrasting masses of floating chiaroscuro.

43 Group of people in a landscape

Red chalk, white paper, two pieces pasted together, 211 x 187. Inv. 398, R. 173.

Orig.: *Conte Malvasia; Crozat; Julien de Parme; Mariette, L. 1852; Prince Charles de Ligne; Albert von Saxe-Teschen, L. 174.*

Lit.: *S.R. 474; R. 173; Marabottini, p. 314, No. 68, T. LXXXVII, 9.*

From the de Ligne Collection, the Albertina acquired a particularly fine group of Polidoro's red chalk drawings, which can be traced back to the collection of Mariette, and perhaps even further to Crozat and to the collector and writer on the arts, Count Malvasia. Soft red chalk — in which lines fuse in great dark color masses with soft, grainy contours, the white paper in soft contrast — was the material in which Polidoro created his most beautiful drawings. Marabottini acutely observed that the scene may have originally shown an Adoration of the Shepherds. Under the tree, there are recognizable traces of a standing figure, bending forwards; under the hill on the left kneels another, possibly proffering a gift of an animal. In the foreground, the woman bears a strong resemblance to the Madonna in a drawing at the Uffizi (Marabottini No. 66), and is also related to a study of a sewing woman in the same collection. Later Polidoro, evidently dissatisfied, covered up the adoring figures and transformed the sheet into a pure genre-scene with wanderers and figures, suggesting Gypsies resting by the wayside. Possibly this sheet was created in Naples, where the classicist tendency that Polidoro had displayed in Rome increasingly receded, and this Italian from the North began to indulge in the highly popularized religious imagery appropriate to the impulsive, direct religious concept of the Southern Italians. None of his contemporaries had such strong connections with the day-to-day life of the people, and no one was in a position to express precisely and with such force the ambience of hardship, as well as the primitive spontaneity in the life of the lower classes.

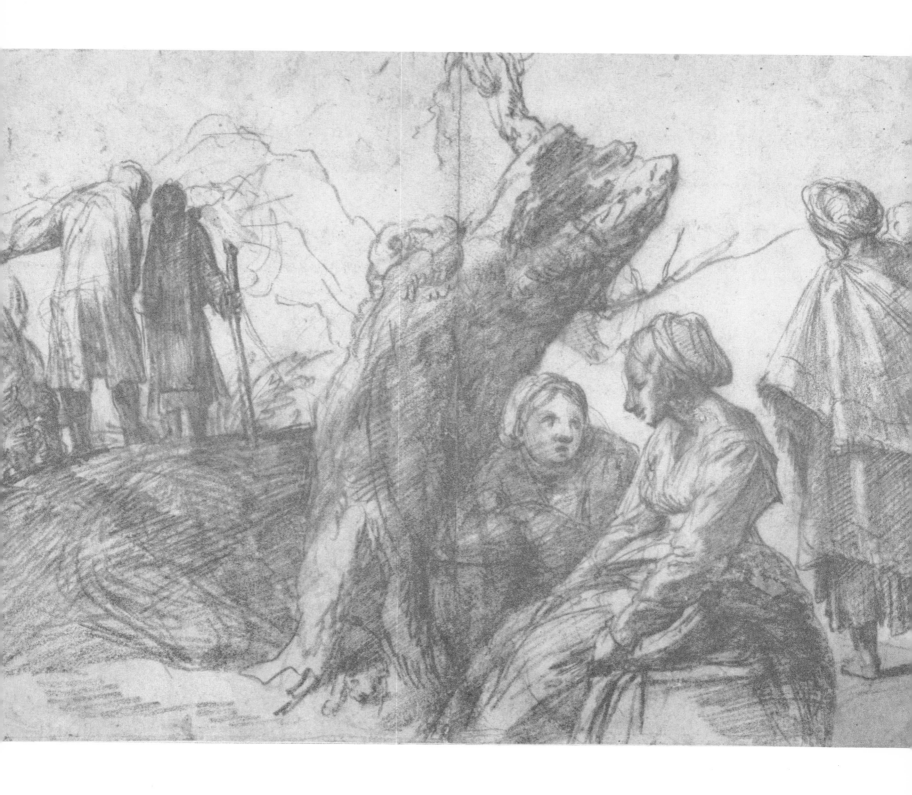

PERINO BONACCORSI, CALLED DEL VAGA

Painter. Born in Florence 1501, died in Rome, October 1547. First pupil of the little-known Andrea de' Ceri, then of Ridolfo del Ghirlandaio. Collaborated on a triumphal arch for Leo X's entry into Florence in 1515. A little-known painter called Vaga then took him first to Toscanella and then to Rome. Entered Raphael's workshop and worked on the paintings in the Loggie at the Vatican; worked in Rome, partly still in collaboration with Giovanni da Udine, with a short interruption in Florence, 1522. After the Sack of Rome, during which he greatly suffered, he went to Genoa in 1528, became court-painter to Prince Andrea Doria, and created his first important work, the decoration of the Palazzo Doria. Attempted to settle temporarily in Pisa, but returned to Genoa and, in 1539, to Rome. After a difficult start he became the busiest decorator in Rome, working for Popes, Cardinals and Princes. Vasari, who knew him personally, says that he spent his last years rushing from one workshop to another to supervise a host of collaborators, always surrounded by "sculptors, stucco-workers, wood-carvers, tailors, joiners, painters, gilders and other artisans." He was a man of delicate constitution and a life of debauchery is thought to have hastened his death.
Vasari found him "very handsome, courteous, modest and kind and as having all the parts of his body corresponding to the virtues of his soul," but even so, he describes him as a jealous artist, grasping every possible commission and often accepting more than he could actually execute. So, towards the end of his life he became a proper impresario, rather like Vasari himself, whose creative activity mainly consisted in designing, drawing and supervising assistants. His great gift for decorative design and sense of graceful movement quite early made him a valuable member of Raphael's workshop, equally good at grotesques and historical scenes. Perino is at his best in such decorative small works, because he would always translate even large-scale works into decorative terms.

44 Two seated warriors in antique costume

Red chalk, squared with stylus, patched at right edge. 295 x 251; Inv. 574; S.R. 672.

Orig.: *Conte Gelosi, L. 574; Prince de Ligne; Albert von Saxe-Teschen, L. 174.*

Lit.: *S.R. 672; Davidson 1966, No. 19.*

In the Palazzo Doria in Genoa, at the top of the main staircase on the Piano Nobile, in the Loggia that faces the sea, a shock is in store: an assembly of gigantic heroic warrior-figures is seated on a raised pediment. The figures represent the ancestors of the family made great through exploits at sea. Dressed partly in rich, partly in fantastic, costume, they sit in affected poses holding marshals "and admirals" batons, lances and staffs, and shields with the family coat-of-arms. Gestures, leading from one figure to the other, make for a complicated network of arms and legs, a huge interwoven frieze from which the impressive heads, that are partly portraits, stare out in strangely alien manner. Our drawing, as attested by a knee on the right, may once have been part of the finished drawing for the whole wall to the right of the stairs that Perino used to visualise the entire fresco before execution. We are at the beginning of the series, which starts, unsurprisingly for a race of warriors, with Hercules, dressed, however, in Roman armor. From his training period with Raphael the artist retained in these figures only the link with the classical antiquity, and perhaps the careful observation, modelling and rounding of the bodies. The figures, artificial and affected for all their monumentality, no longer follow any law of nature. Down to the tips of their toes, the bodies are tense and move in poses that are a strange mixture of aimless vital energy and deliberate elegance. The Florentine emerges here, who in the years following Raphael's death was capable of following the example of Rosso's expressive willfulness, Parmigianino's artificial elegance, Bandinelli's vain gestures, but most of all, Michelangelo's beautiful nudes, in which that artist had through his own interpretation given nature a new, more expressive realism.

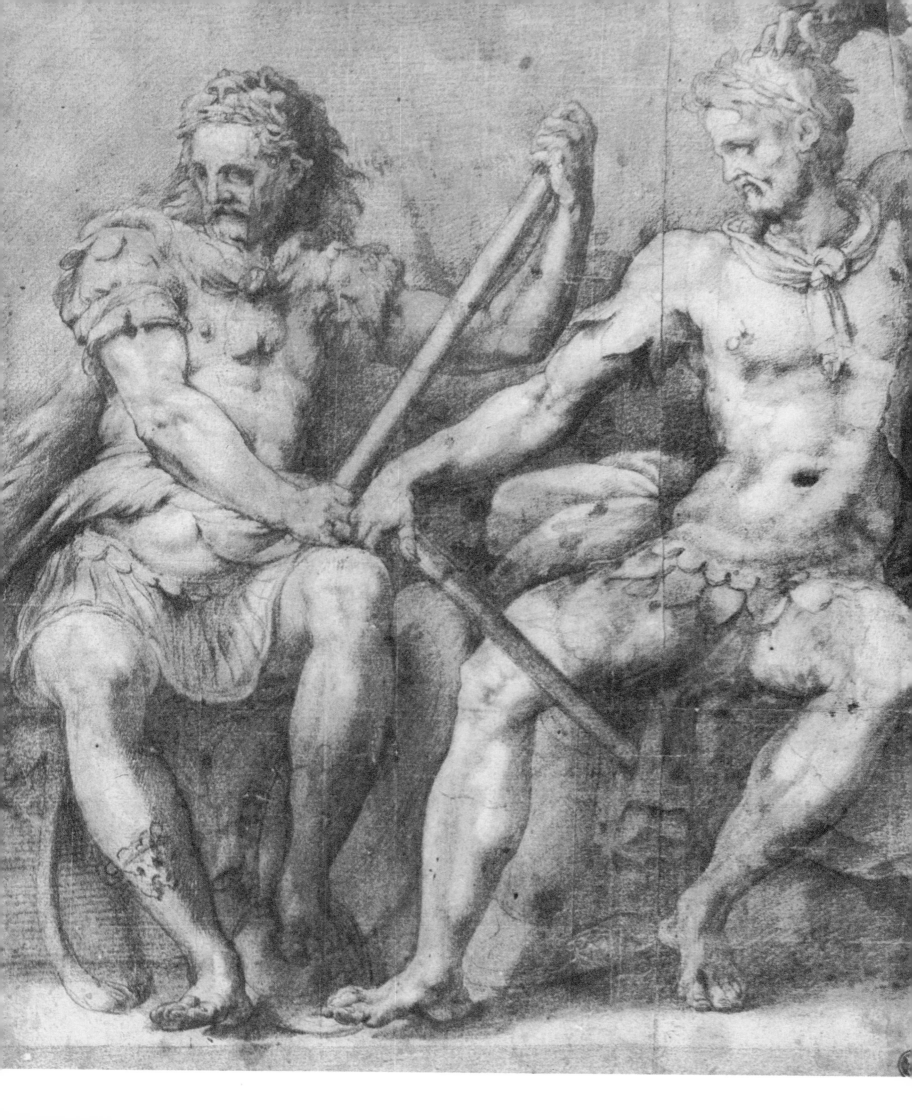

GIORGIO VASARI

Painter, architect, writer on the arts. Born July 30, 1511, in Arezzo; died June 27, 1574, in Florence. First trained with the glass and fresco-painter Guillaume de Marcillat in Arezzo, then in Florence together with Francesco Salviati, Bandinelli, Andrea del Sarto and others. Influenced by Rosso Fiorentino in Arezzo, 1528. Practiced chiefly in Florence, Rome and Arezzo, but also in many other Italian cities — Pisa, Bologna, Venice, Naples etc. Principal works: Sala dei Cento Giorni in the Cancelleria, Rome; the frescoes of the Sala Regia in the Vatican; the decorations in the Palazzo Vecchio, Florence; and the architecture of the corridors of the Uffizi. Probable starting-point for his artistic development was contemporary Florentine art, but he adopted many Roman trends through his own studies in Rome and as transmitted by Giulio Romano and Parmigianino, either directly or through Salviati. Like Perino and Giulio, he became a great decorator and impresario, able to organize and decorate enormous wall areas with tremendous facility and speed. His intellectual capacities, which also make him the most important writer on the arts of his day, and his manners uniquely qualified him as a court artist. He spent his later years chiefly in the service of the Medicis and the Popes and their courtiers. Vasari's talents as a decorator chiefly lie in his sense for even, uncontrasting arrangements of planes, and a network of oblique lines into which flat, geometrically handled figures are easily fitted. His dense figure arrangements are consequently dominated by a positively abstract, intellectual quality, which is heightened by his taste for complicated allegories. Subdued coloring, always tied in with the general tone, also simplifies the speedy organization of the color areas. He is at his best when his native sense for dignified rhetoric is allowed to come to the fore in compositions where the number of figures is kept to a minimum.

45 Crucifixion with Mary, John and the Magdalen

Pen and black ink, brown wash, over preliminary metalpoint drawing on ochre-prepared paper, white highlights partly oxydized, 456 x 337; Inv. 13146.

Orig.: *Albert von Saxe-Teschen.*

Lit.: *S.D. 158.*

This drawing was until recently regarded as the work of an unknown artist. Someone had proposed Pompeo Aquilano, but it in fact is an early sketch for a picture that Vasari painted in 1560 for the Chiesa del Carmine in Florence, which he describes in his memoirs, "Ricordo come in questo anno si fece una tavola: drentovi Cristo Crocifisso con angeli atorno che racoglievano il sangue, et a piedi la Madalena con San Giovanni e la Nostra Dama. Fu questa tavola alta braccia sei 1/2 larga 4 1/2, e fu posta nel Carmino insiemi con una predella, drentovi la natività di Cristo, e 'l dossale: che valevano ogni cosa cento settanta scudi." (Barocchi, p. 121, Pl. XXI.)
The predella is lost, but the painting, which Bocchi called in 1591 "colmo di divozione e di gravità" (ibid) still exists in the original place. According to Barocchi (p. 50), Vasari,

probably influenced by his northern collaborator Stradanus, made his figures more slender and placed them into a landscape; altogether, the panel is more upright in proportion. St. John's expressive gesture and his draperies, with slight alteration, are transferred to the Virgin, the disciple is turned into sharper profile and the Magdalen is more raised. The upper portions, the design of the cross under the tablet, sun and moon in discs to the right and left with weeping angels, and the angels that recall Vasari's great colleague Salviati are transferred to the picture largely as they are here. The design's effect is even broader, more monumental and at the same time flatter, closer to the secular works in the Palazzo Vecchio, which Vasari concurrently created. Also, as Wickhoff observed, the resemblance to the Crucifixion by Albertinelli in the Certosa becomes more distinct. The beauty of this sketch lies in the still monumentality, the denseness of the structure with the connecting glances and gestures, the gravitas and simplicity, in the clear sureness of the line that evenly describes the form, and in the delicate modelling and gentle light. It becomes a true masterpiece of Counter-Reformation art in Italy.

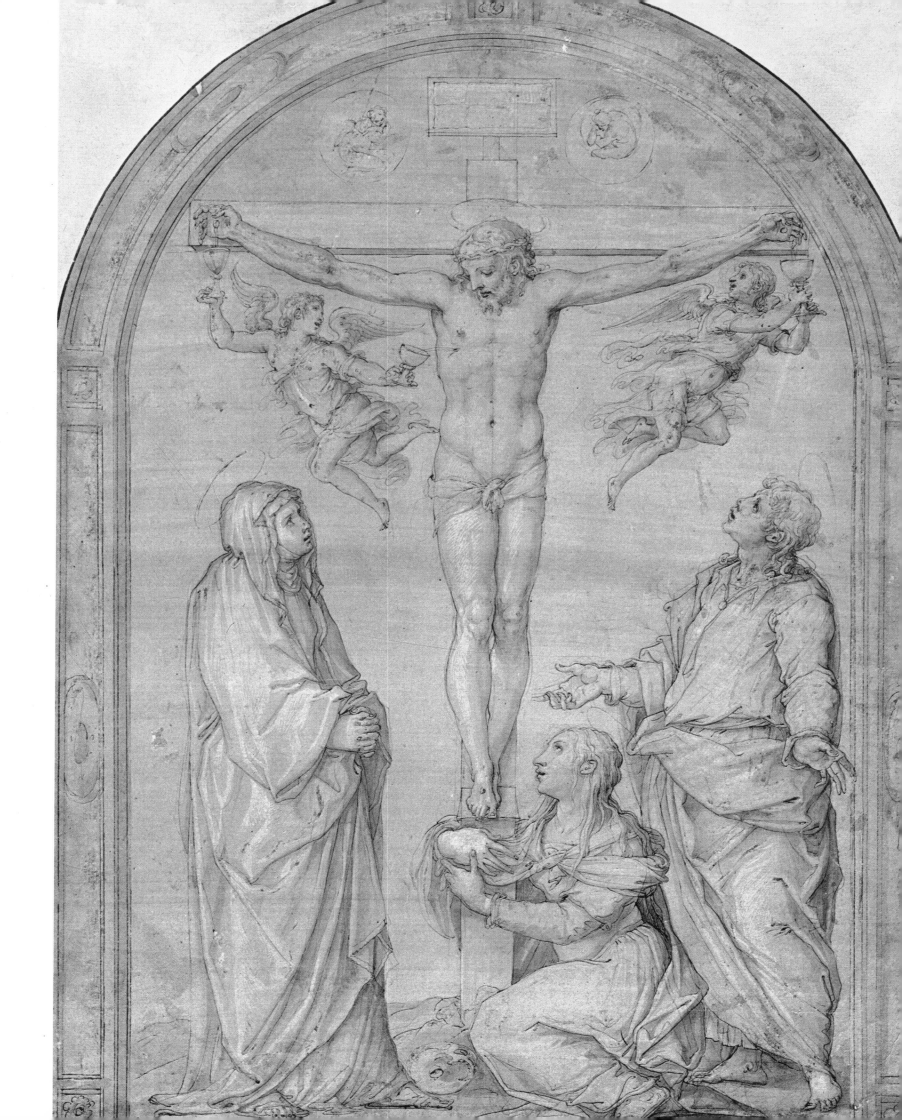

FEDERICO ZUCCARI

Painter, architect and art-theorician; born approximately 1540/4, in Sant'Angelo in Vado in the Marches, died in Ancona, July 20, 1609. Sent by his parents to become apprentice of his brother Taddeo in Rome. Worked in close collaboration with Taddeo, who died in 1566, and afterwards continued his brother's projects. 1564 to 1565 in Venice, impressed by Veronese, 1565 in Florence. 1574 journey to France, the Netherlands and England, 1575 to 1579 in Florence, then in Rome. Constant travels, including Spain 1585 to 1588, where he worked in the Escorial. 1593 founded Accademia di San Luca in Rome, becoming its Principal 1598. His work is found in many parts of Italy. Zuccari's style has its starting-point in that of his brother Taddeo, which had been formed in the Roman *ambience* and on the work of Correggio. Taddeo, together with Federigo Barocci, had been one of the leading artists who attempted to overcome the decorative petrification in Roman painting in the period of Giorgio Vasari and Salviati, and who formulated a more mobile, spatial, plastic and colorful style.

Federico was more intellectual than his brother, but without his vital energy. Like Vasari, he subordinated his figures and compositions to abstract schemes, and achieved great facility of figure-invention, which made him the ideal decorator and painter of large suites of frescoes. His largest, and also his most controversial, work was the painting in the dome of the Duomo at Florence. There he continued the tradition of Vasari, although in an entirely different spirit. His style is more realistic, his figures more compact, but he lacked the sense for the monumental that would have been appropriate to the occasion. As a theoretician, he placed himself in the van of the group that looked to *Disegno* as the intellectual fountainhead of art and all human creativeness. Among his drawings, his intimate studies from life, where he records what he sees for his own reference and without academic consideration, have a special charm. His technique *à deux crayons* in black and red had a great following.

46 Federico Zuccari drawing in the woods of Vallombrosa

Black and red chalk, inscribed: 1576 adi... agosto... 271 x 395. Folded in center. Inv. 13329.

Orig.: *Albert von Saxe-Teschen, L. 174.*

Lit.: *Schönbrunner-Meder XII, No. 1383; Heikamp, p. 60.*

This sheet used to be stored with works of anonymous Flemish artists and attributed to L. Van Valkenborgh, as one would hardly suspect an Italian hand in so realistic a woodland scene. The technique, with a mixture of black and red chalk, however, is typical for Zuccari, as is the slightly dry but precise and mobile line that catches images clearly and objectively without too much concern for light and atmosphere. As Detlef Heikamp established, the sheet belongs to one of the sketchbooks, many sheets of which once entered the Crozat Collection from that of Jabach, and later were dispersed. Several drawings, including one other in the Albertina, relate to Zuccari's visits to Vallombrosa in August 1576 and 1577, during which he recorded the monks, the monastery, Andrea del Sarto's painting in the church, the surroundings, and his friends. Here we meet him in the famous pine forest, his sword by his side, and about to start drawing, while his friend is already enjoying his picnic. The verso of the sheet, that was once the centerspread of a sketchbook, shows two other drawings of the same forest. The complete realism with which Zuccari caught here all he noticed remains, however, confined to such intimate jottings; incidentally, this sheet, too, makes one recognize the great decorator's compositional talent.

FEDERIGO BAROCCI

Painter and etcher; born approximately 1535, died 30 September, 1612, in Urbino. Pupil of his father Ambrogio, and of Battista Franco; 1556 temporarily in Rome; 1560 again in Rome where he works with his compatriots Taddeo and Federico Zuccari at the Vatican. On returning home he supplied practically the whole of Italy, but also Rudolf II in Prague, with pictures. The most important formative influence on his style was, on the one hand, the art of Venice, as transmitted to him by Franco, and on the other the work of Correggio in particular. From it he took the ecstatic emotional expression, the extreme individuality of form, and the vivid lighting. But all is translated into irrational, visionary and ethereal terms, so that he became influential to the late Mannerists like Vanni, Salimbeni, and even Bellange in France, with their ascetic, unsensual, exaggeratedly elegant style. But owing to his individual feeling for human nature, his color sense, and his full proportions and forms, his work also became an important factor in the Baroque revival of the arts around 1600 in the art of the Carracci. In Central Italy, he certainly is the most important pioneer of 17th century religious art.

47 Girl's head

Chalk, red chalk, heightened with white, buff paper, 340 x 248; Inv. 24359; R. 386.

Orig.: *Sir Peter Lely, L. 2092; Jonathan Richardson, L. 2170; Sir Joshua Reynolds, L. 2364; Oscar Kutschera-Woborsky.*

Lit.: *R. 386; Olsen, No. 34, p. 175.*

This charming head served as a preliminary study for the child crouching in the foreground of the former altar panel at San Vitale in Ravenna, with the martyrdom of the church's Patron Saint, today in the Brera at Milan. Barocci painted it between June 20, 1580 and April 1583. A small sketch below, recognizable when the sheet is turned to the right, shows the pose of this figure in general outline. Above is yet another sketch for a seated figure, with a tablet or book, evidently planned to be seen from below and probably depicting a prophet. Its purpose has not yet been established. Unusually large numbers of Barocci drawings are fortunately preserved, as his legacy of drawings was evidently very carefully looked after in Urbino, and enjoyed an early high esteem. He used to prepare his work with the greatest care by making free sketches and finished comprehensive designs and also drew beautiful detail studies from life, usually, like this one, in several chalks. Apart from his ability to enter into human nature, this drawing shows his delicate color sense and his magical handling of light, which flows over his subject, dissolving its substance into facets, facets of light which then have an important place in the highly mobile, rich, shimmering whole of the picture.

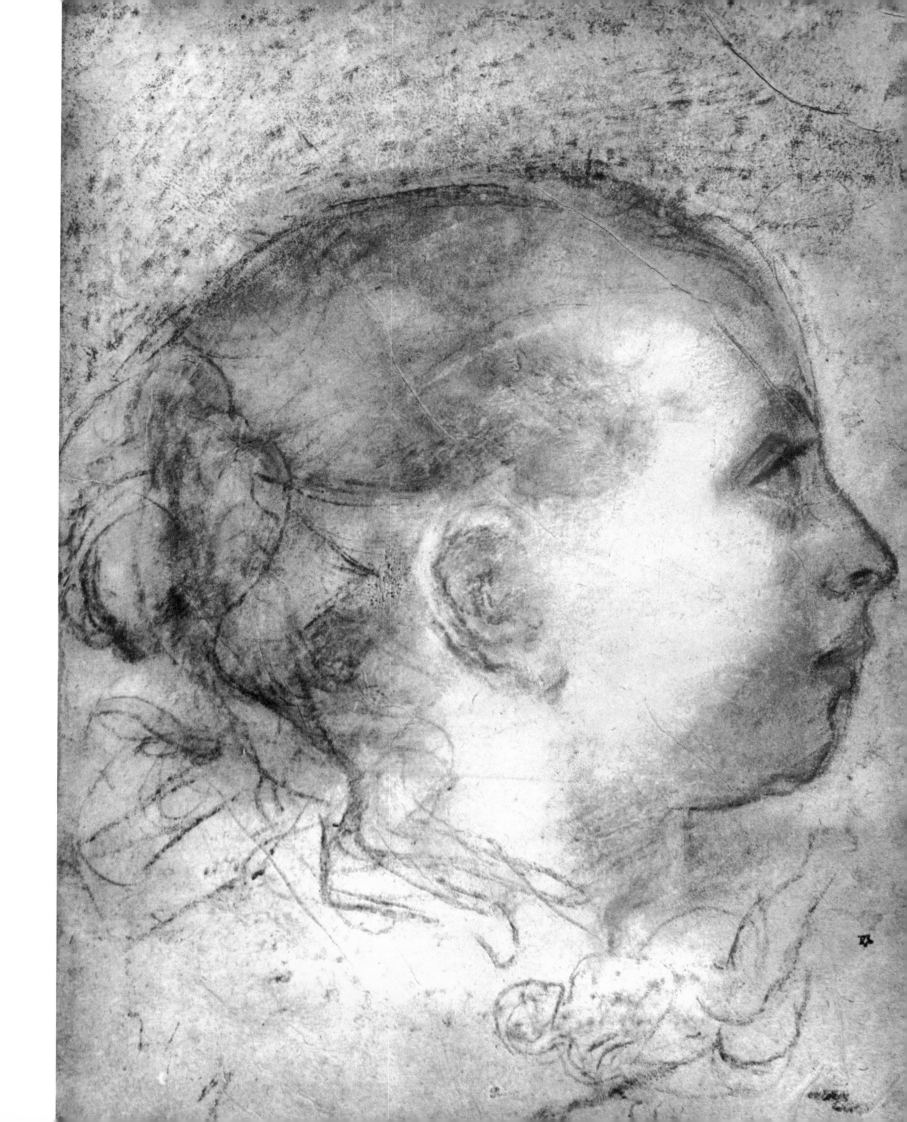

48 The Madonna della Cintola

Chalk, pen and ink, brown wash heightened with white, on blue paper, squared, 506 x 351. Old pen and ink inscription: Fed. Baroccio. *Inv. 545; R. 392.*

Orig.: *Graf Moritz von Fries, L. 2903; Albert von Saxe-Teschen, L. 174.*

Lit.: *S.R. 640; Schmarsow, p. 53; Olsen, No. 68, p. 214; Pl. 106 a; Knab, Callot, No. 731.*

The picture for which this highly finished sketch was the preliminary drawing is not known, but further drawings for it are in existence. The monumental approach, the wealth of clearly articulated drapery and the power of spatial conviction place this sheet in Barocci's final period, near the Ascension in the collection of the Principe Cesare di Castelbarco Albani in Milan (Olsen, T. 111). The motif is essentially a reversal and further elaboration of the 1589/93 Madonna del Rosario at the Palazzo Vescovile in Senigallia (Olsen, T. 79). The landscape with sea and distant mountains, however, has now changed to a view of Urbino, leading one to assume that the commission came from that city. In this drawing secondary figures, angels, and perhaps a further group of people, indicated in a rich, lively chalk drawing at bottom left, are largely pushed back, and only the main characters — Mary, presumably handing her belt to the doubting Apostle Thomas, who would not believe in her physical Ascension — are worked out in brush and pen, as are a few essential elements in the landscape and aureole, which lend atmosphere to the whole. Barocci appears here not only as a first-rank virtuoso of light but as a master of great, passionate composition, reminiscent of other great Urbinians like Melozzo da Forlì. The rhythmic harmony between the Madonna — an apparition of light — and the ecstatic backwards-arching Saint, heralds the great religious altarpieces of the Baroque and is typical of the religious art that developed out of the mounting trends of the Counter-Reformation.

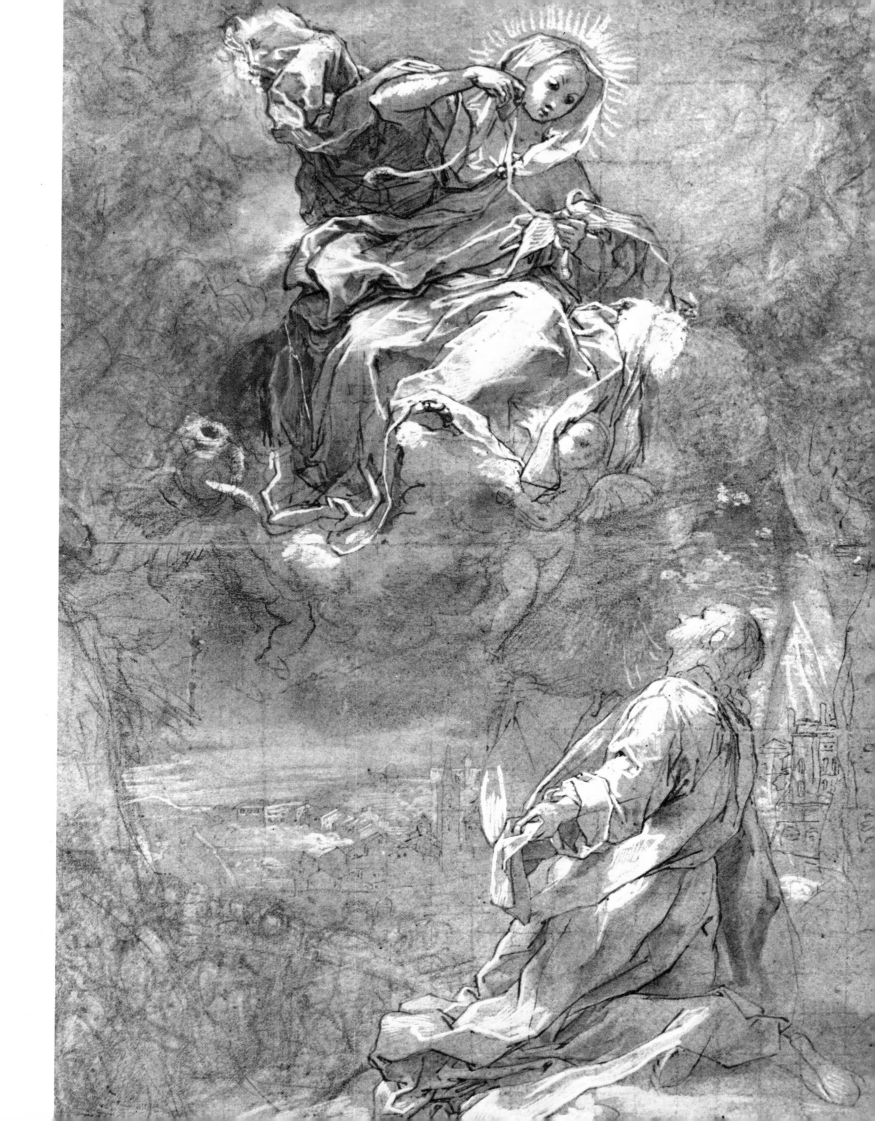

JACOPO LIGOZZI

Painter, miniaturist, engraver and designer of woodcuts; born Verona 1547, died Florence 1627. Probably pupil of his father, the painter Giovanni Ermanno Ligozzi. Certainly first trained in miniature painting in surroundings connected with Northern and especially German art. (Mina Bacci, p. 50 ff.)

From 1575, court-painter in Florence; also produced designs for embroideries, works in semi-precious stones (pietre dure); arranger of fêtes, and also miniature painter for clients like that great man of natural science, Ulisse Aldovrandi (Bacci-Forlani). As a painter, he belonged to the antimannerist movement released by the Counter-Reformation, which prepared the way for the Baroque in the final quarter of the 16th century. Ligozzi's drawings are invariably very highly finished, often heightened with gold, and as delicate as miniatures.

49 Cartouche with macabre symbols

Pen and brown ink, brown and grey wash, traces of charcoal, white paper; Inscription, SIC ET EGO; *265 x 168; Inv. 2720, V. 217.*

Orig.: *Albert von Saxe-Teschen, L. 174.*

Lit.: *S.L. 154; V. 217; Forlani, Cinquecento, p. 256, Pl. 103; Bacou 1968, No. 70.*

Hermann Voss (1920, p. 422) was the first to recognize and describe Ligozzi's taste for the macabre that depended on German early 16th century art, Baldung Grien among others. Our sheet comes from a series of similar cartouches (V. 217-20) that may have been patterns for miniatures on the title page of a funeral oration, as Forlani suggests, or may have been intended for some decoration occasioned by a State funeral. Besides the German motifs, one of which is the contrast between the succulent young woman and the macabre skeleton, these cartouches are also informed by the fantastic imagery of Italian mannerism, nourished by antique grotesque decoration, where the transition of human bodies into plants, the festoons, and especially the abstract ornaments have their roots. Lelio Orsi produced similar designs in Reggio Emilia, and Buontalenti, the great decorator, often collaborated with Ligozzi. Jacques Callot in Florence was later to produce similarly fantastic designs. Thus, these most highly finished drawings are typical for the court art of Florence, and of the later 16th century in general, with its great taste for this mixture of bizarre invention, high craftsmanship, intellectual games involving allegory and sensual excitement, for the art of the Scherzo and Capriccio, which even on purely formal occasions had great significance and was to point the way for similar phenomena in the court-oriented art of the 18th century.

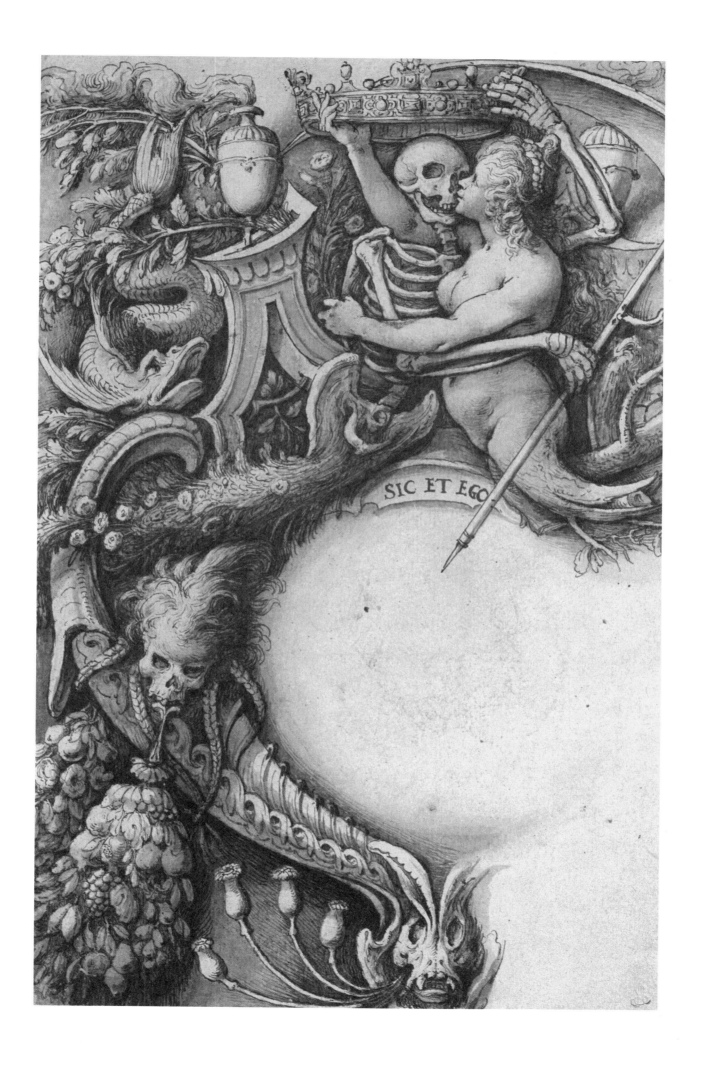

IL BAMBAIA

Sculptor and engraver, named Agostino Busti; born 1483, died in Milan, June 22, 1548. From 1512 worked on sculptures for Milan Cathedral. His principal work was the tomb of Gaston de Foix, on which he worked from approximately 1515 until 1521, but of which only fragments have been preserved. Virtuoso sculptor of small-scale figures, remained all his life within the decorative style of the 15th century, but intensively analyzed and observed the Antique, approaching the linear, dematerialized concept of Bramantino. A series of copper engravings and drypoint etchings were attributed to him in recent years, which together with a sketchbook, in Berlin, attest his interest in classical antiquity and in classical subject matter (cf. Dreyer-Winner 1964).

50　Design for a Fireplace

Pen and bistre, brown wash, brush and grey ink, over incisions with stylus (for architecture); top corners diagonally cut, right bottom corner patched. 424 x 280; Inv. 49, B. 409.

Orig.: *Albert von Saxe-Teschen, L. 174.*

Lit.: *Schönbrunner-Meder VII, No. 745; Venturi XI p. 673, Fig. 530.*

Lombardy is well-known for remarkably rich and decorative sculpture and architectural decoration. The main facade of the Certosa in Pavia is the best-known example. Lombard artists spread this taste all over Northern Italy. Best known are the Lombardi in Venice, who, however, already incorporate something of the new classicist trend that was formulated by Donatello in Padua, and of which Riccio was one of the main representatives. Related to the classicizing art of the Lombardi is that of Bambaia in Milan, but it is transformed and even more typically Lombard in elegance, refinement of execution, and in particular in the deep cavities and sharp edges of his sculptures, differentiations that dissolve the figures into apparitions of light. Most closely related to our sheet is a tomb design in the Victoria and Albert Museum in London (Dreyer-Winner, Ill. 42), commonly regarded as the preliminary drawing for Bambaia's principal work, the tomb of Gaston de Foix. Preserved fragments show the sophisticated decorative style in its full beauty. Fireplaces always presented great opportunities for the display of sculptural splendor in interiors, to the glorification of the residents. Here, gods of antiquity, mythological scenes, and finally, at the top, the goddess of fame, are mustered for the purpose. The drawing's special charm lies in the use of two very contrasting inks that, simulating the effect otherwise achieved by the artist in sculptural materials, give it an appearance of airiness and splendor.

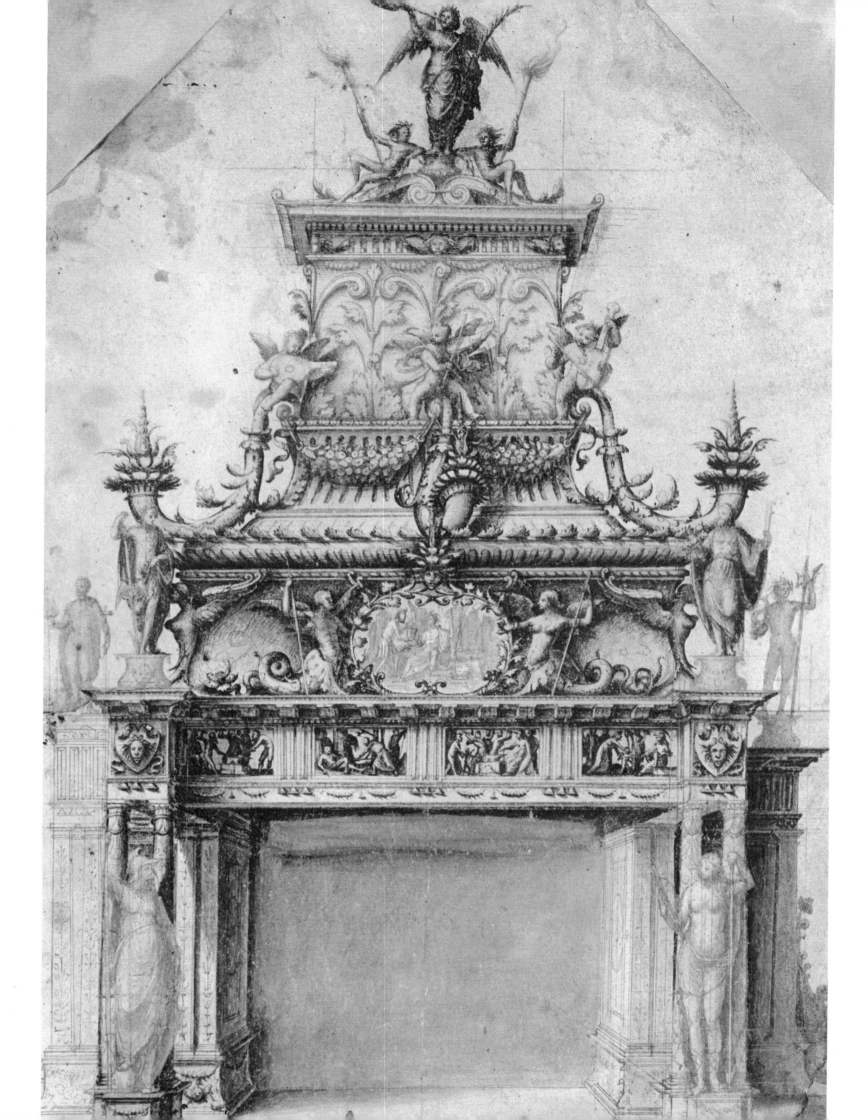

ANDREA SOLARIO

Painter, born in Milan (?) 1470/1474, died in Milan, 1524. Traveled with his brother Christoforo Solario to Venice in 1490. Schooled there, chiefly in Alvise Vivarini's circle, in the traditions of Antonello da Messina. Netherlandish art was also formative for him. On his return to Milan, came under the influence of Leonardo, whose figurative motives, compositional ideas and 'sfumato' he used. Between 1507 and 1510 in France, in the service of Cardinal Georges d'Amboise, working on fresco-decorations, now lost.

Andrea's is principally an art of the relatively small painted panel, worked in finest craftsmanship. His compositions are usually static; his figures are clearly realized volumes in space; his colors, deep and strong. His main significance lies in linking Venetian atmosphere and Antonello's clarity with Netherlandish sensuality and realism of surface and landscape design. In spite of his basic idealism and the gentle loveliness of his images, he created a foundation on which Savoldo could build his realism.

51 Study for a half-length Christ carrying the Cross

Black chalk, brush and light brown bistre, pen and dark brown bistre, squared in black chalk, 204 x 168, Inv. 18817, B. 395.

Orig.: *Conte Gelosi, L. 545; Albert von Saxe-Teschen, L. 174.*

Lit.: *J. Meder,* Andrea Solario's Handzeichnungen, Mitteilungen der Gesellschaft fur Vervielfältigende Kunst, *Graphische Künste, XXXVI, 1913, p. 35 ff.; Kurt Badt,* Andrea Solario, *Leipzig 1914, p. 88 f. Wilhelm Suida,* Leonardo da Vinci und seine Schule in Mailand, Monatshefte für Kunstwissenschaft, *1920, pp. 30 and 34, Ill. 395; Della Pergola I, No. 150; Luisa Cogliati Arani,* Andrea Solario, *Milan 1966, p. 101, No. 10.*

This drawing is a preliminary study for the picture in the Galleria Borghese in Rome, dated 1511. It was therefore created after Solario had been to France and this is borne out in the very realistic treatment of the henchmen, which shows distinct Netherland influences. These trends, however, are indiscernible in the drawing. Solario first mapped it out in chalk, extending the motif of Christ beyond the previously defined area. He goes over this motif with a few lines of the brush, but then entirely concentrates on modelling and surface design, especially on Christ's torso and head, within the outlined frame, and in the facial expression of the single Roman soldier. Solario proves typically Milanese in the strangely elegant sweetness of the faces, and in the modulation of light, achieved with subtle oblique hatching that models and dematerializes the body while fully displaying the charm of the surface. The figures are more strongly worked in relief than Luini's. In devotional pictures such as these, the point was to engage the viewer with few direct and effective motifs; this concentration on expression led Solario to the Netherlandish elements of the final picture.

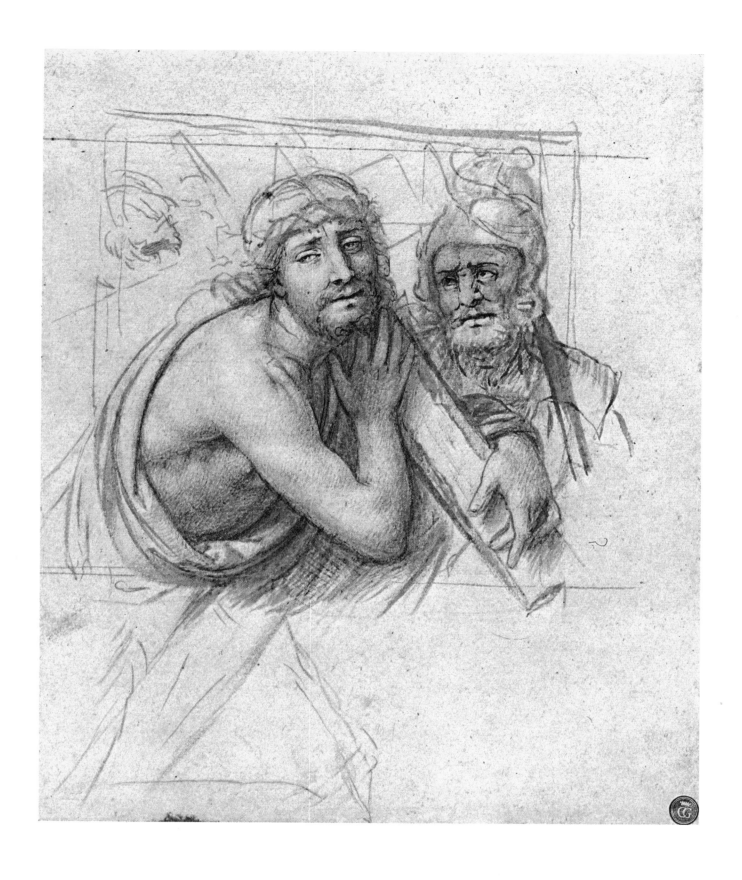

BERNARDINO LUINI

Painter, born probably in Milan approximately 1480, died probably at the beginning of 1532. No documented evidence exists for his activities in the early years of the 16th century. (First dated, but not reliably attributed work, 1507). Recognizably influenced by Borgognone, Bramantino and, in a wider sense, Foppa. Also influenced by Leonardo, whose pupil he was long thought to have been. Ottino della Chiesa assumes a journey to Rome about 1508, but it is hard to find any evidence of it in the artist's work. Relatively limited in invention, but extremely sensitive in the design of surfaces. Typically Lombard in broad display of body and clothes, in light, color and volume; in the effort to achieve subtlety and beauty of expression, and the balanced, undramatic compositions, in the feeling for the sensual quality of surfaces, which, however, dissolve in the light, achieving an ideal, airy quality. The Milanese representative of the classical stage of the art of the early 16th century, and equivalent to Florentines like Fra Bartolomeo.

52 Portrait of a young lady with fan

Black, red, brown, yellow and white chalk, white paper, 414 x 284, Inv. 59, B. 405.

Orig.: *Albert von Saxe-Teschen, L. 174.*

Lit.: *S.R. 71; Schönbrunner-Meder 352; E. Schäffer,* Un disegno del Luini nell'Albertina di Vienna, Rassegna d'arte *II, 1911, p. 144; L. Beltrami,* Bernardino Luini, *Milan 1911, p. 360; A. Ottino della Chiesa,* Bernardino Luini, *Novara 1956, p. 148, No. 41; Benesch 1964, T. II, p. 322.*

It is not surprising that this portrait with its gentle sfumato, especially in the face that is caressed by light, and in the delicate hand, was once attributed to Leonardo. According to a notice in the records of the Albertina, Frizzoni was the first to recognize the authorship of Luini, and the sheet fits in well with his attractive work in its seemingly innocent mixture of sensual charm and gentleness of mood. Beltrami and Schäffer suggest that the sitter was Ippolita Sforza Bentivoglio, wife of Alessandro Bentivoglio, and the sheet a preliminary study for the frescoes in San Maurizio in Milan, painted between 1522 and 1524. Benesch was probably right in rejecting this suggestion. The delicate, narrow-faced girl has little in common with the robust Ippolita except for the posture. More closely related in subtlety and mood is the famous portrait of a woman in the Washington National Gallery, with its enchanting smile (Ottino della Chiesa, fig. 162), but still it is too early to say whether we are dealing with the same person. It is amazing, at all events, how Luini, by means of smudged lines and few subtle colors conjures up the bloom of life in face and decolletage, and brings an almost coquettish expression into the smile. Benesch accurately observes that in such colored chalk portraits, first produced in this manner in Leonardo's circle, lies the basis for Holbein's famous portrait drawings.

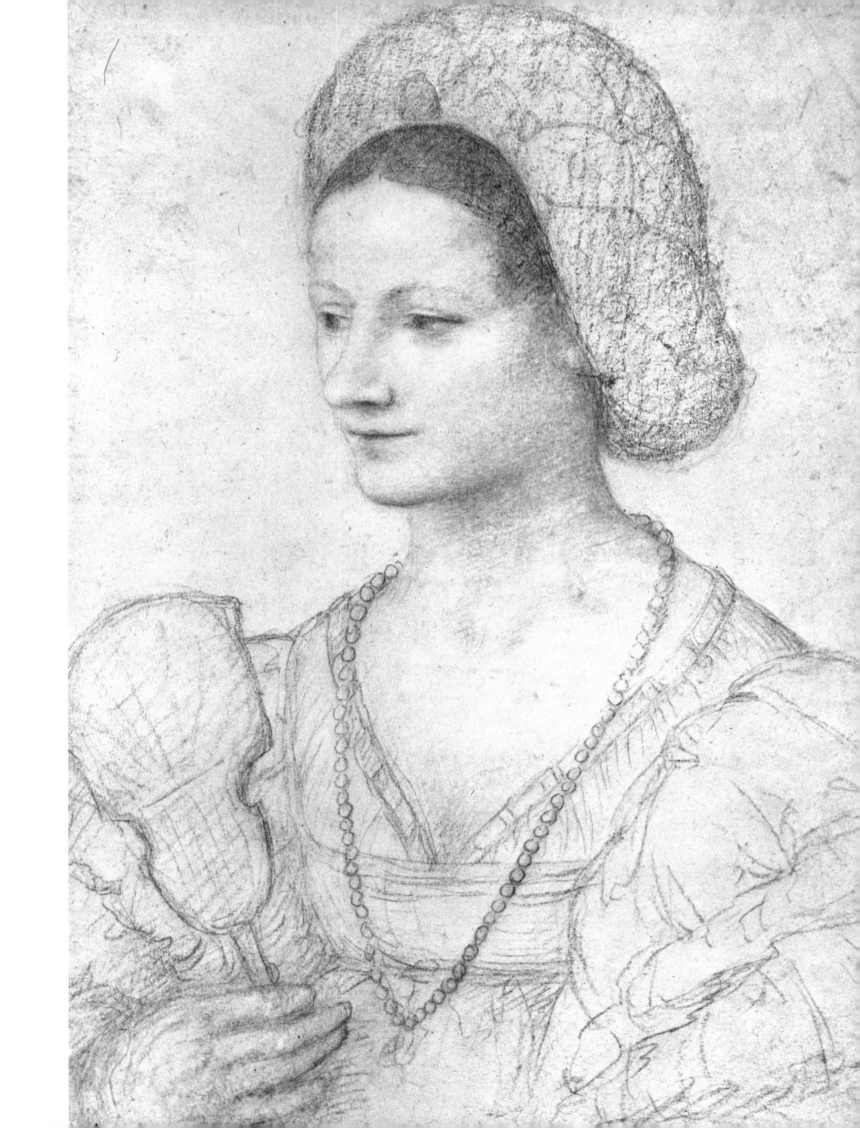

FRANCESCO MARIA MAZZOLA, CALLED IL PARMIGIANINO

Painter and etcher, born in Parma, November 1503; died in Casalmaggiore in 1540. His teachers are unknown, but the influence of Correggio and Anselmi on his early works is recognizable. 1521, he created his first important altarpiece, in Viadana, whither he had fled from the French not long before. Commissions for frescoes (at the side of Correggio) in San Giovanni Evangelista in Parma soon followed. Late in 1523 he went to Rome and remained until the Sack surprised him at work on the large altarpiece of the Vision of St. Jerome, now in the National Gallery, London. He first went to Bologna, and then, in 1531, to Parma. His interest in alchemy (possibly aroused by his chemical experiments in connection with his etching) caused him to neglect his painting in the Steccata in Parma, and in 1539, to avoid a lawsuit, he fled to Casalmaggiore, where he died in neglect. Parmigianino's contemporaries admired the grace, sweetness, and ease of his invention. He links the northern Italian world of emotion and its feeling for the romantic with the clear, formal style of Tuscany and Rome, which he acquired during his training in the Eternal City. A draughtsman *par excellence,* he had a love for flowing, sweeping lines that indicate vitality and motion, and the precise clarity of line and hatching, which he gave full expression in his etchings as well. His sense for lively distribution of light and shade is expressed in the numerous chiaroscuro woodcuts that were created after his drawings. His animated compositions and elegant figures influenced not only his contemporaries in the North, but artists in France and the Netherlands, as well as artists of later centuries who were striving for gracefulness and courtly sophistication.

53 Self-portrait in ornamental frame

Portrait: pen and bistre, white paper; 103 x 117; the frame: red chalk, 265 x 180, inscription: Multaque cum Forma, Gratia mista fuit. Ovidius. *Bottom:* Ritratto di Francesco Mazzuoli, Parmigiano, fatto di suo mano. Vasari, Vite de Pittori, etc. I volume of the 3rd part, p. 230; edition de' Quinti. Florence *1568. Inv. 2623.*

Orig.: *Vasari (?); Earl of Arundel; Albert von Saxe-Teschen, L. 174.*

Lit.: *S.L. 54; Freedberg, p. 256 (Addenda); Popham p. 46; Oberhuber 1963, No. 7; Quintavalle p. 58.*

Vasari made his woodcut-portrait for Parmigianino's Vita after this sheet; Popham thinks that he might also have owned it. When in the Earl of Arundel's collection, it was etched by Hendrick van der Borcht II. The red chalk frame, on the other hand, comes neither from Vasari nor the Arundel Collection, but certainly from the 16th century, and probably from Vasari's circle. The extremely subtle drawing shows Parmigianino's precise style in the clarity of his line and the application of hatching, in which fine lines are arranged in dense groups, creating nicely judged contrasts of light and shade that play over the surface. Some lines are so subtle that they quite dissolve in the light, especially the contour of the hair at the top of the head, and the lower part of the gown. Occasionally slightly stronger lines are placed for emphasis in beard, ear, nose, neck and eye, giving life to the portrait. The well-groomed elegance of hair and beard and the delicate shape of the head correspond to the master's image in his paintings, and to a self-portrait sketch for the Steccata, now in Chatsworth (Popham Pl. l; Quintaville, Fig. 38). This drawing, which corresponds with Parmigianino's mature style in controlled sophistication, can consequently be dated to his final years in Parma.

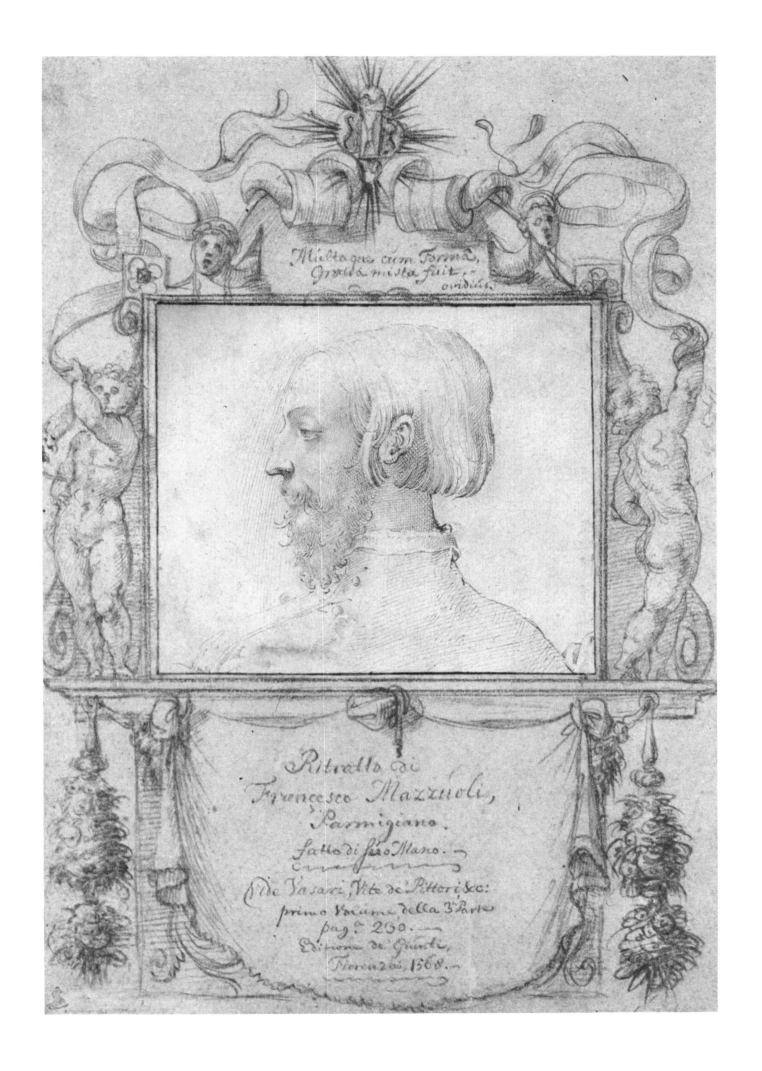

54 Sacra Conversazione, the Virgin and Child with St. John the Baptist, a Franciscan Saint, and perhaps a patron

Red chalk, white paper, 295 x 206, Inv. 2642.

Orig.: *Albert von Saxe-Teschen.*

Lit.: *S.L. 72; Oberhuber 1963, No. 8.*

This sheet is typical for the artist's early work, and is closely connected with the painting in S. Maria in Bardi that Parmigianino probably created during his stay at Viadana in 1521, and with the frescoes in San Giovanni Evangelista that he painted shortly afterwards. The young master still derives some of his motifs from those of Francesco Francia, but the figure-style, in the naive lack of constraint in movement and the modelling of essential body-forms, is extremely close to Correggio; the elongation of the bodies and a peculiarly abstract tendency connect also with Beccafumi via the Sienese Anselmi. The sweeping line, describing the figures in long curves, is already characteristic of Parmigianino. Flow of form and line was the artist's main concern: bodies are entirely subjugated to this linear tendency. Through this, and through the all-embracing stream of light and the figures' subtle movements, he achieves a romantic, fairy-tale mood that gives this work great charm in spite of youthful failings.

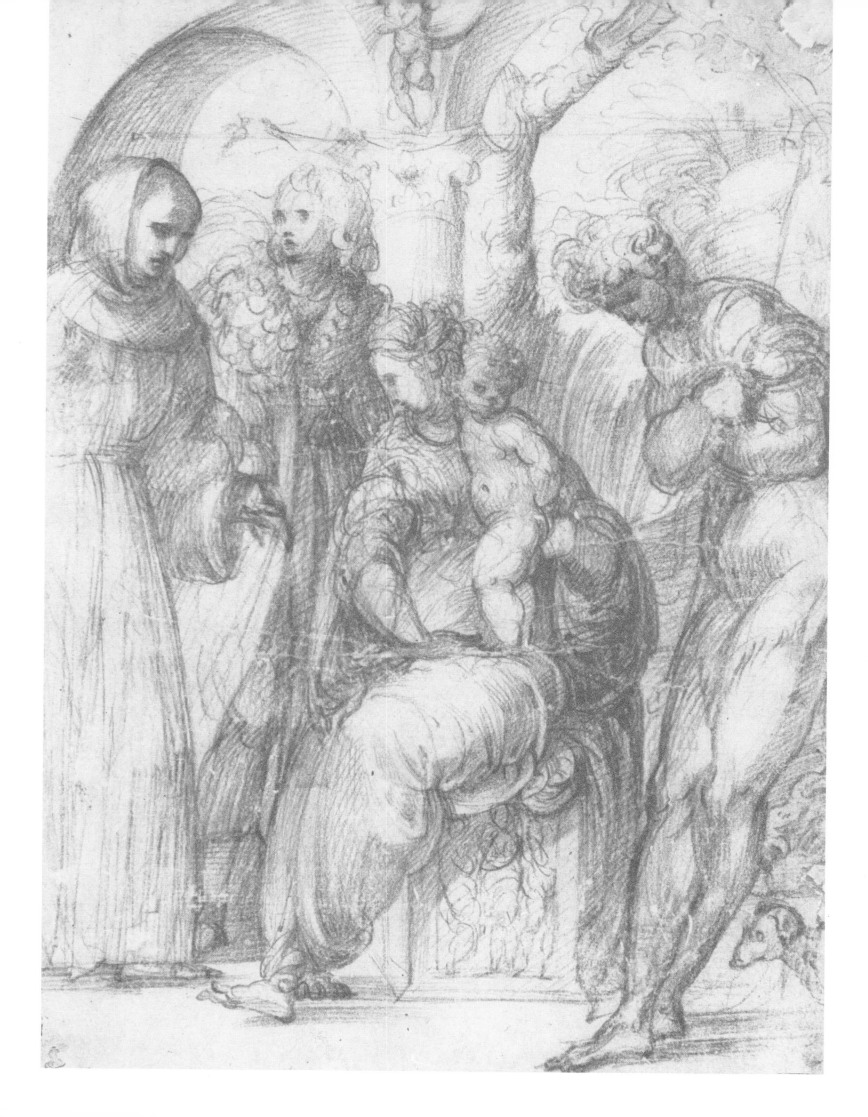

55 Boy's head

Black and red chalk, white paper, cut out irregularly, mounted on slightly toned paper, 236 x 198. Inv. 2615. B. 35.

Orig.: *Marquis de Lagoy, L. 1710; Albert von Saxe-Teschen, L. 174.*

Lit.: *S.L. 45, B. 335; Oberhuber 1963, No. 7.*

Vasari describes how Parmigianino would not allow himself to be disturbed in the work on his large altar-panel of St. Jerome (today in the National Gallery, London) when the Sacco broke upon in Rome. The Germans entering his studio so admired his work that they allowed him to continue painting and preserved him from harm. Our drawing is probably a fragment from some cartoon for the head of the boy Jesus who is held between the knees of the Virgin in the manner of the Bruges Madonna by Michelangelo. The little head, combining gravity with a certain roguishness of tilt, has special charm in the delicate modulation of light, the easy drawing of the curls, and in particular in the combination of the two chalks. We feel how thoroughly Parmigianino had studied Raphael in Rome and so obtained his clarity of form; but the way in which, for instance, the patch of light sits on the nose, the eyes are shaped, and especially the softly flowing shadows, show the effects of Correggio, to whom this drawing was once attributed.

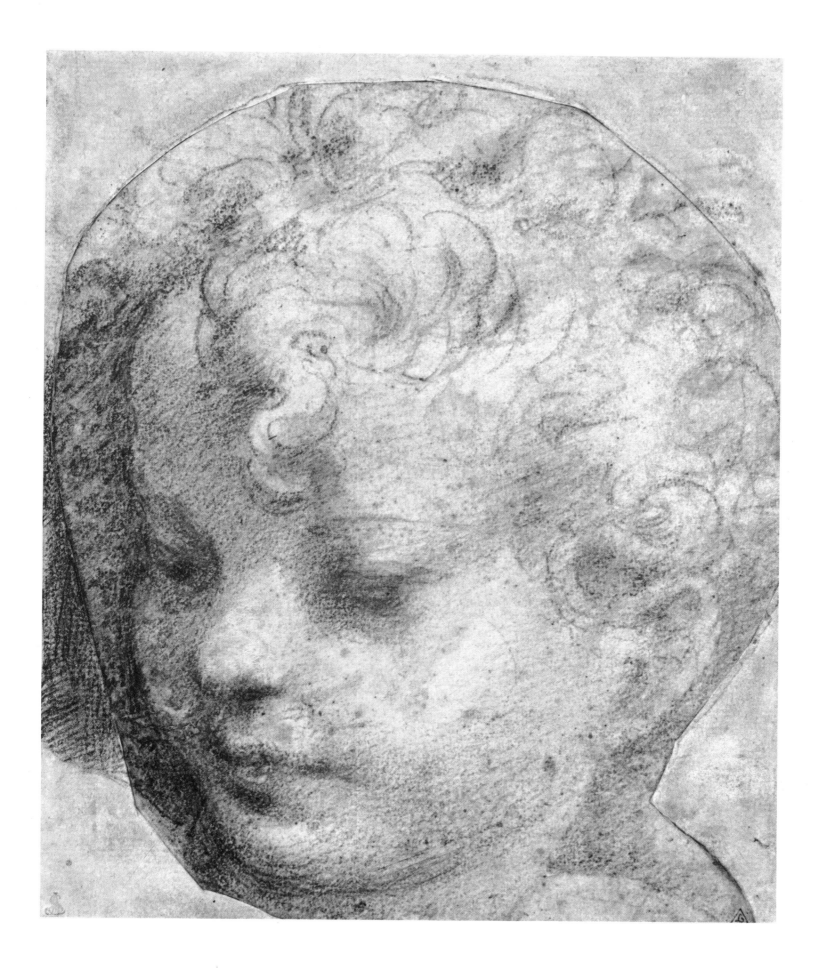

56 Caryatid

*Red chalk, preliminary drawing in stylus, height-
ened in white, buff paper, patched top right
corner, 229 x 111. Inscribed, verso: Del Parmi-
gianino D. 50. Top left, inscribed. 69. Inv. 17.
661.*

Orig.: *Albert von Saxe-Teschen, L. 174.*

Lit.: *S.L. 117, Oberhuber 1963, No. 25.*

Otto Benesch first established this as an early
preliminary study for the center maiden carrying
a vase in the vault preceding the east apse of S.
Maria della Steccata, Parmigianino's principal
large-scale work after his return to Parma in
1531. The Albertina owns another study of this
figure at an even earlier stage (Oberhuber 1963,
No. 24). This drawing, as few others, shows the
ease, elegance and grace with which Parmigia-
nino impressed his contemporaries. The figure
seems to float, positively dissolved in light. Lines
of extreme subtleness and precision form it into
an apparition that combines abstract, geometric
beauty with finely pulsing life and a tender,
idealized emotional expression. To be a living
decoration was, incidentally, the figure's function
in the fresco, and its significance as one of the
wise virgins of the biblical parable was only of
secondary interest.

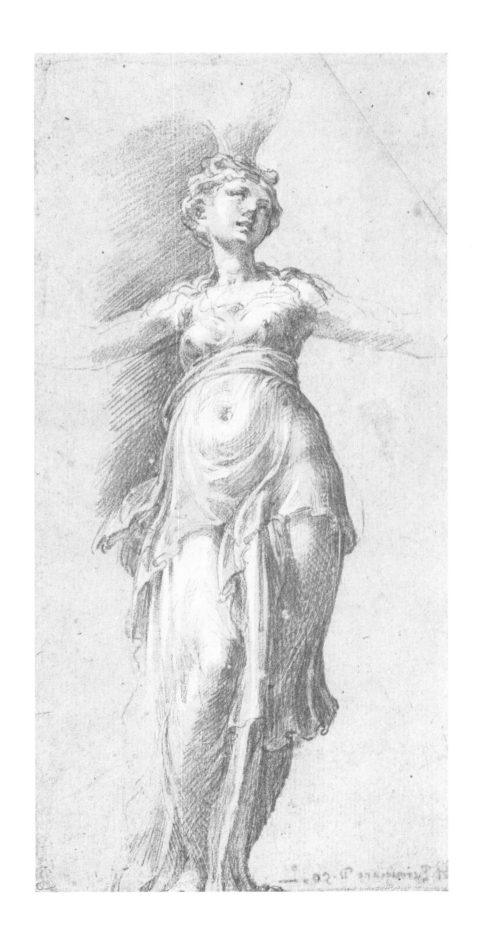

FRANCESCO PRIMATICCIO

Painter, sculptor and architect; born approximately 1504 in Bologna, died in Paris 1570. Probably first trained at Fracuzzi's and Bagnacavallo's, then 1525-26 at Giulio Romano's in Mantua. 1532 summoned by François I to Fontainebleau where, together with Rosso who also arrived in 1531 (but died in 1540), he became the spiritual head of the school that formed there. Spent 1540/2 and 1546 in Rome in the service of the French king, and there studied and absorbed the new trends. His large decorative cycles are partly destroyed, like those in the *Galerie d'Ulysse* 1541-1570, partly badly preserved, like those in the *Salle du bal,* 1552-1556, both in the Palace of Fontainebleau. From 1552, Primaticcio had at his disposal the services of Nicolò dell'Abate, who painted after his drawings.

His creative work can today best be seen in his wonderful light-filled red chalk drawings that show a master who achieved a combination of Giulio Romano's classicizing expressive ideal, and the spirited, decorative court style of artists like Rosso Fiorentino, and the elegance and grace of the mature Parmigianino. Primaticcio's rich, gently animated, compositionally sophisticated, graceful, yet forceful style had long-lasting effects in France and the Netherlands. By way of prints, it travelled back to Italy.

57 Ceres

Red-chalk, heightened with white, white paper, patched top, and bottom right, inscription, illegible today, on right below Ceres' arm, 194x 284. Inv. 17658, B. 28.

Orig.: *Mariette, L. 2097; Albert von Saxe-Teschen, L. 174.*

Lit.: *S.B. 13; L. Dimier,* Le Primatice, *Paris 1900, p. 451, No. 146; B. 28.*

As we know from Vasari, Primaticcio supplied the drawings for the frescoes of the large audience-chamber at Fontainebleau, the *Salle du Bal,* while Nicolò dell'Abate was partly responsible for the execution. A whole group of these designs is preserved, some of them at the Albertina. Our Ceres, and her counterpart Proserpina with Cerberus (B. 29), both surprisingly referred to as "Diana" by Dimier, are preliminary drawings for the frescoes on the right and left of the large fireplace at the farther end wall. Primaticcio's inspiration for his motif of the Goddess came from Michelangelo's famous picture of Leda that was in France at the time, and the related "Notte" from the Medici tomb, which Primaticcio must have seen on his trip to Rome. The alteration in the figure's right leg, which first resembles the position of the Notte and then follows that of the Leda, is characteristic. Nevertheless the style, with slightly flat yet dynamic groupings of figures and limbs, comes closer to the ideals of Giulio Romano, and the delicate observation of the light approaches Parmigianino. The ease of the movement, neither driven like Giulio's, nor inhibited by tension like Parmigianino's, and the apparent inevitability in which sensuality, transfigured by light, taste, and purity of form, is displayed, is Primaticcio's very own in this rapidly drawn, yet infinitely sure sketch, that betrays a master of the most sophisticated contour and the subtlest modulation.

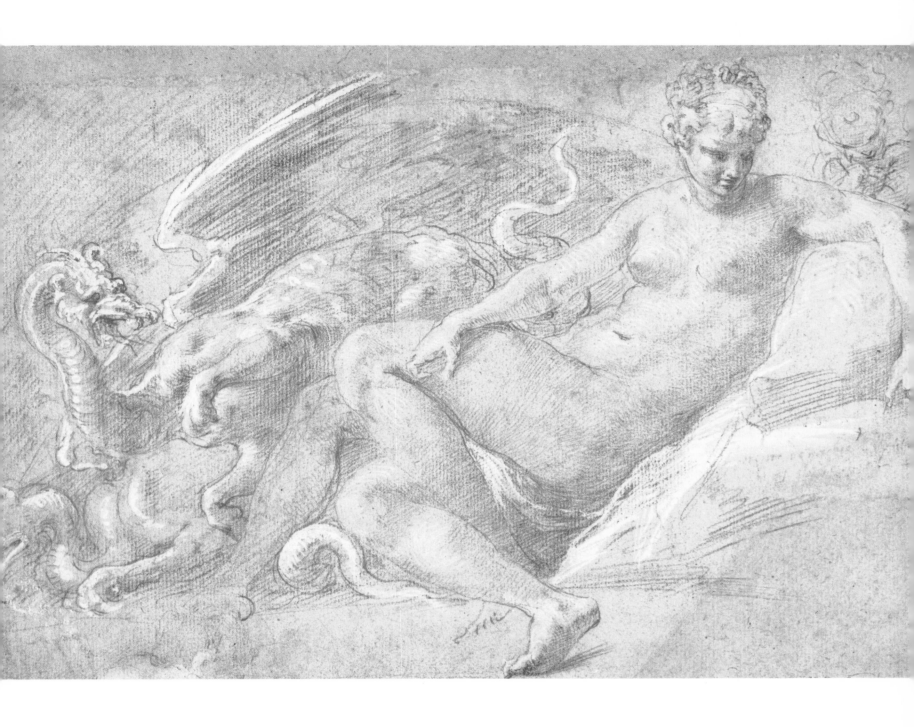

58 Rest on the Flight into Egypt

*Black chalk, brown wash, heightened with white,
buff paper. 350 x 285, Inv. 2001, B. 38.*

Orig.: *Albert von Saxe-Teschen, L. 174.*

Lit.: *S.B. 44; B. 38; Adhémar 1954, No. 63;
Sylvie Béguin* Le "Maître de Flore" de l'Ecole
de Fontainebleau, Art de France *I, 1961, p. 304;
W. MacAllister Johnson,* Prolegomena to the *Images où tableaux de Platte Peinture,* with an
excursus on two drawings of the School of Fontainebleau, Gazette des Beaux Arts, *6me pér.,
Pl. 73, p. 287.*

Rosso, Primaticcio and Nicolò dell'Abate, who
only came to France in 1552, were the principal
masters of the first School of Fontainebleau.
There were also numbers of less famous, but
interesting Italian painters living in their
shadow. Because of less powerful personality,
they were more subject to the influences
of the *ambience* and the taste of the French
court, and formed the link between the Italian
Masters and their subsequent French successors.
Sylvie Béguin, for instance, points out that Giulio Camillo, Nicolò dell'Abate's son, forms a link
between his father's style and that of Antoine Caron. It was of Camillo she thought in connection
with our drawing, traditionally attributed to the
father. It was still reproduced by Adhémar as
a typical work of that artist, and rightly praised
as the quintessence of the School of Fontainebleau under Italian influence. Indeed, relationship of all the motifs and the style with that
of Nicolò is very pronounced: the strangely
nervous delineation of limbs, the broadened
bodies, those characteristic attitudes of the putti
gazing over their own shoulders, the landscape
studded with Antique motifs.
One is almost tempted to think of it as a mature
work by the master himself. But everything is
smoothed out, more rounded than Nicolò's

known drawings aiming at fuller volume: for example, the body of the Virgin, in spite of subtly
flowing and transparent drapery, has something
of a block-like character. The composition lacks
the dynamic force that otherwise is typical for
Nicolò's work and is radically constructed in
horizontals and verticals, extremely strict in symmetry, stressed by the central position of the
Virgin and the tree. With all subtlety and loveliness, a certain cool detachment is discernibly affecting the relationship between the figures who
function in almost isolated, separated groups.
This conjures up the work of Antoine Caron,
although that artist's paintings and drawings are
cooler still, and his figures more slender in proportion. The ideal of courtly humanism expressed
in this drawing was recently pointed out by MacAllister Johnson. The theme can be traced back
to Northern prototypes like Cranach's woodcut
with the "Rest on the Flight" of 1509. There,
too, a plethora of cherubs on the ground and in
the tree surround the Holy family, and in the
peculiarly separated Joseph it, in turn, probably
follows another Northern model. The apple-throwing cherubs in the tree, and two others
playing with a hare by the Madonna's feet —
another hare is indicated in charcoal — as well
as the garland-carrying putti come from Philostrates' description of a classical picture. Raphael
and his school, especially Giovanni da Udine and
Giulio Romano, had already attempted to reconstruct this very subject. The Madonna thus becomes the new Venus, aided by the fact that the
hare used to be one of Venus's own early attributes, and angels traditionally offered fruit
from the tree to the Infant Jesus on the flight. It
is interesting to note, as MacAllister Johnson has
pointed out also, that the group of putti was
used again with few deviations in the drawing
of a Flora attributed to the young Caron.

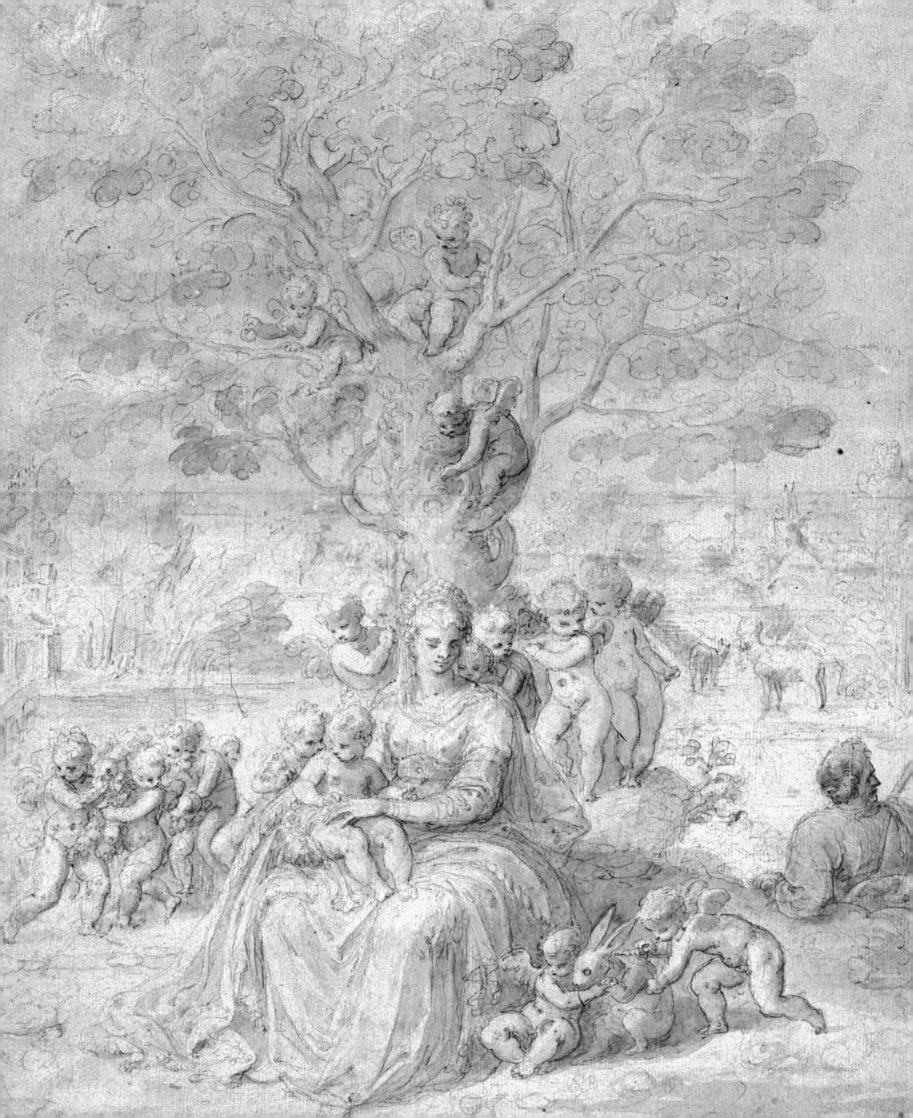

GIULIO CAMPI

Painter and architect, born probably in Cremona approximately 1500, died in Cremona 1571. Son and pupil of the painter Galeazzo Campi, pupil also of Bernardino Gatti called il Soiaro. His work, principally created for churches in Cremona and surroundings, is at first linked with the early Romanino, but is then influenced by Pordenone who worked in Cremona at the time. Probably the most important of the artist family Campi, whose creative activities stretched over the entire 16th century and whose works still largely determine the artistic character of Cremona.

59 King David playing a psalm on the viola da gamba

Pen, brush and bistre, preliminary drawing in charcoal, white highlights, buff paper, 419 x 271, inv. 1661, B. 421.

Orig.: *Albert von Saxe-Teschen.*

Lit.: *S.V. 27, B. 421; Oberhuber 1963, No. 186.*

San Sigismondo in Cremona is a positive jewel of North Italian church decoration, with purely 16th century frescoes and paintings by Giulio, Antonio and Bernardino Campi, Bernardino Gatti and Camillo Boccaccino. The light, fresh colors, the frequently bizarre inventions, the stunning effects of foreshortening, and especially the decorative sense of their frescoes make a visit to this church a most exciting experience. In 1540, Giulio Campi painted the altarpiece for this church, of which the Albertina also has a prelim-

inary sketch. In 1570, he decorated the vault before the apse with paintings of the Descent of the Holy Ghost and various Old and New Testament themes. Among the most impressive are the large figures for the lunettes, for which the Albertina posseses two drawings: A prophet for the left choir-wall, and the King David for the right. While the turbaned, elongated figure, worked in sweeping curves into the sumptuous niche, is clearly derived from Pordenone, the most inventive master of the Veneto, the precious elegant line of the king's posture, and especially the bodies of the cherubs, show that the artist carefully studied the work of Parmigianino. The interesting musical instruments are a pleasing sight in the violin-city of Cremona, and together with the richly decorated hymn book contribute to the general opulence.

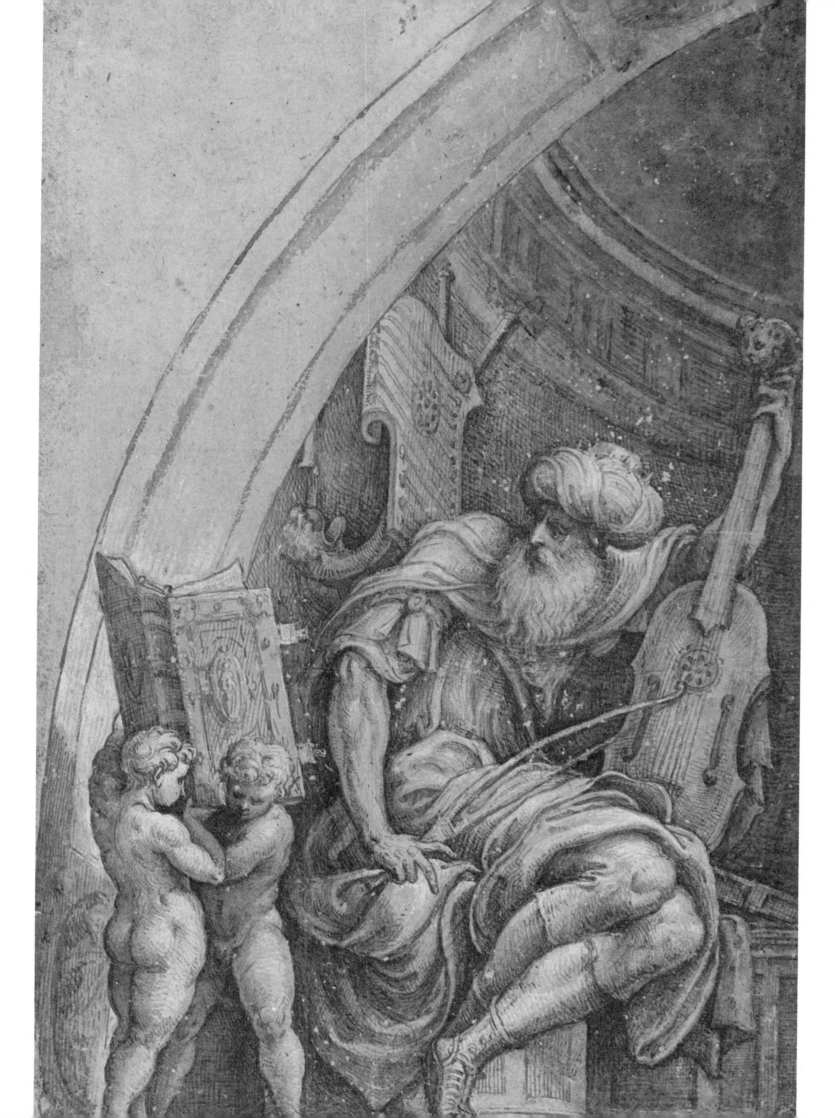

TITIAN

Tiziano Vecellio, painter; born in Pieve di Cadore about 1490; died in August 1576. Arrived in Venice at the age of nine and trained with the Zuccati, then with Gentile and Giovanni Bellini. Finally came to Giorgione. In 1511, he painted the frescoes in the Scuola del Santo in Padua, and then became a painter of panel pictures to the exclusion of murals. Around 1518, through his Assunta in S. Maria dei Frari, became known as the foremost painter of Venice, which he remained to his death. 1533, he was ennobled by Emperor Charles V, and went to Augsburg in 1547 to paint his portrait. Charles's successor to the Spanish throne, Philip II, becomes his most important client. In 1545/46 Titian was in Rome painting portraits of Pope Paul III. From Venice, he supplied the entire area with important pictures. Titian is still regarded as *the* painter, the color-virtuoso, *par excellence*. To this sense for organization of large color-areas, in which he differed from his chief teacher, Giorgione, comes his monumentality, his dignity, his convincing drama and the depth of his spiritual expression, coupled with an eye for the sensual surface beauty of objects, closely linked with his sense for color. Titian exudes great warmth, tempered only by the dignity of the elevated social tone that, along with his color sense — derived from traditional Byzantine mosaics and from maritime lighting — is a typically Venetian feature, a reflection of Byzantine spiritual nobility in worldly terms. The influence of Titian's painting and the artistic principles that govern it has endured uninterruptedly, and can be traced through all European art.

6o Adoration of the Child

Brush and bistre, preliminary drawing in charcoal, 259 x 216. Inv. 1649, V. 36.

Orig.: *Charles Prince de Ligne; Albert von Saxe-Teschen, L. 174.*

Lit.: *S.V. 235; Schönbrunner-Meder VII, 1953; V. 36; Tietze 1944; Morassi, 1942, p. 176, Pl. 139; Benesch 1961, No. 8. Maria Luisa Ferrari, No. 718; A. Venturi, L'Arte 25, 1922, p. 114; Ferrari, Il Romanino, Milan 1961, Pl. 18; F. Kossoff, A new book on Romanino, The Burlington Magazine 105, p. 73; Benesch 1964, No. 16, Mostra di Girolamo Romanino, Catalogo a cura di Gaetano Panazza, Brescia 1965, No. 130.*

This sheet belongs to the most disputed of the Albertina. Charles de Ligne called it Palma Vecchio; Wickhoff proposed the circle of Giovanni Bellini; Schönbrunner-Meder, Brescian, and because of a reference by Frizzoni, Romanino; this attribution was held up by Roberto Longhi and supported by Maria Luisa Ferrari. Stix and Fröhlich-Bum tentatively suggested Giorgione, an idea emphatically supported by Benesch, while Morassi, the Tietzes and Kossoff considered the drawing to be from the circle of Giorgione. The attribution to Brescian artists must be rejected as wayward, and that to Giorgione, whose Allendale Madonna in the Washington National Gallery was the most likely pattern, especially in the drapery, is also untenable. Every comparison, mainly one with a related drawing in Windsor Castle, strikingly shows the difference in the principles on which this drawing was created. Each of Giorgione's figures is solidly connected with the ground, and volume and space in Leonardo terms are achieved by modelling and subtly graduated shadows — with *sfumato*. The spatial relationship of the figures is of primary importance. In our drawing, the area is first organized into clear horizontals and verticals. The figures are conceived in broad masses of light and shade, so differentiated as to conjure up the immediate sensation of glowing color, and produce a spatiality that is pure color and light. As soon as this purely pictorial principle and the creation of space through color-values is recognized, the drawing reveals itself as a positive stroke of genius in every detail. It then becomes interesting to note its very close affinity with a small picture in the Kress Foundation, formerly in Washington but now in Raleigh, North Carolina (K. 1874), which Wilhelm Suida (Spigolature Giorgionesche, Arte Veneta VIII, 1954, p. 155) first attributed to the very young Titian, and which is now recognized as such by most scholars including Pallucchini (1969, p. 232, Ill. 9). Indeed, the closest parallels to this picture exist precisely in those works which, just because of the style-characteristics observed in our drawing, are now attributed to Titian and not Giorgione: The Fête Champêtre in the Louvre, and the Orpheus and Eurydice in the Accademia Carrara in Bergamo. Both show the stratified landscape with the absolutely straight horizon from which the buildings jut; they compare in this and in the brushwork with Titian's frescoes in the Scuola del Santo.

Handling of space and figures, in our drawing, on the other hand, is mainly related to The Woman taken in Adultery, in Glasgow. There we see the same systems of motion, the same great glowing areas of light, and, most importantly, the same high horizon line and the same manner of ensconcement of figures into the picture-area. There, as here, the figures are almost entirely organized in dense rows, touching one another. The young Titian's drawing-style has not yet been definitively elucidated, and to show how this sheet fits into the body of his documented drawings would be a subject for a special project. But no matter what the final attribution may be, this sheet transmits the magic of a mysterious mood, created by figures concentrated within themselves in a landscape filled with light that is typical for all that was created in the Giorgione circle.

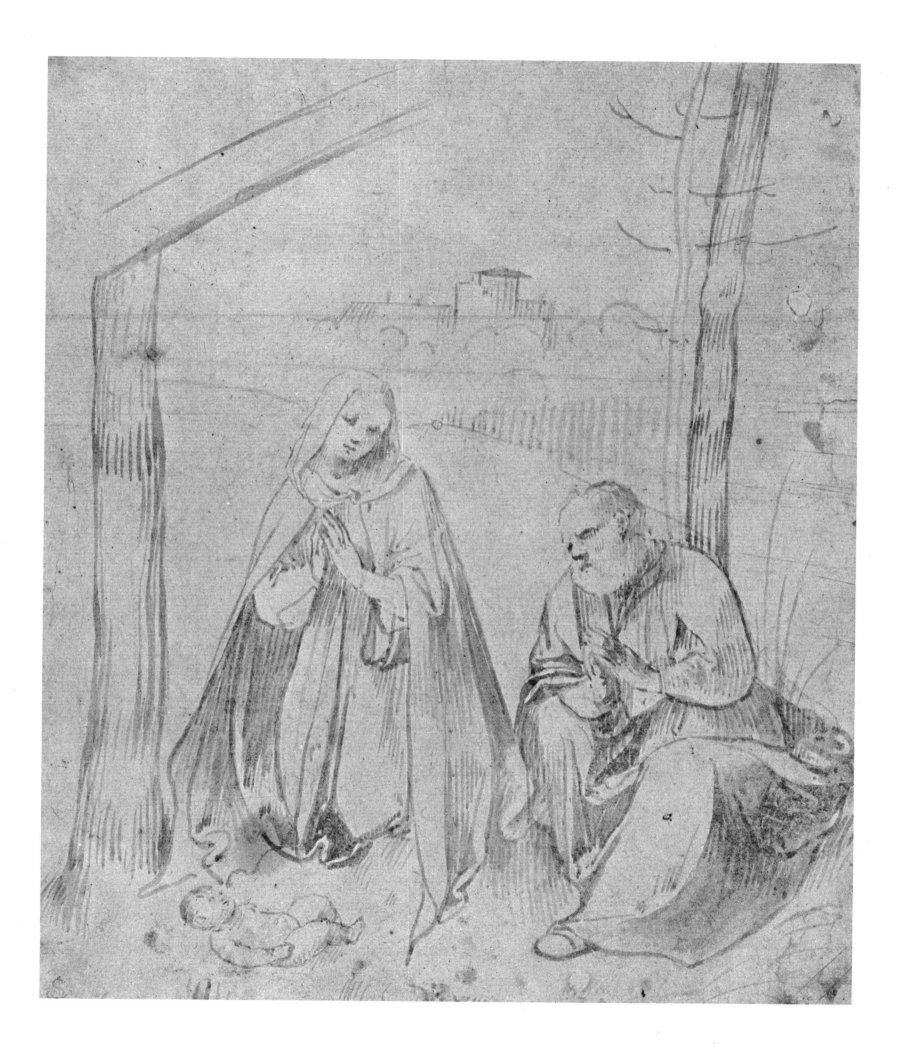

DOMENICO CAMPAGNOLA

Painter, copper-engraver and designer of woodcuts. Born 1500, the son of a German father, died December 10, 1564. Adopted son of Giulio Campagnola, probably in Titian's workshop for a time. Little is known of his creative activity in Padua, where he largely worked. His practice as engraver, during which he formulated a highly individual style that closely matches his manner of drawing, was confined to the years 1517/18. His woodcuts probably originate also from that date. These landscape woodcuts and drawings, in which he translates Titian's style in a linear, calligraphic and more easily comprehensible idiom, were of great significance for the art of the landscape throughout Europe, inspiring even masters like Bruegel. A certain relationship to the landscapes of the Danube school has as yet no established link.

61 Two kneeling boys in a landscape

Pen and bistre, white paper, old patch bottom right, 236 x 213, inv. 24364, V. 38.

Orig.: *P.J. Mariette, L. 1852; W. Esdaile, L. 2617; Sir Thomas Lawrence, L. 2445; Benjamin West, L. 419, Thomas Agnew; acquired 1923.*

Lit.: *V. 38; W. Constable, A drawing by Titian, The Burlington Magazine XLII, 1923, p. 192; Hadeln 1924, No. 7; Tietze 1944, No. 1970; Morassi 1954, fig. 203; Benesch 1961, No. 9; Benesch 1964, No. 17; Pallucchini 1969, p. 330, fig. 553.*

From the time that this drawing had been published by Constable, all experts unanimously agreed on its attribution to Titian. Only Constable himself, uncertain whether the landscape background originated from the same hand as the boys in the foreground, pointed to closely related landscape-drawings by Campagnola. But it was accurately observed that figures and landscape certainly originated from the same master, even though the foreground, with a treetrunk that does not extend to the full depth, may have been drawn earlier and independently, and the landscape added a little later and joined on at an undulation of the ground. The attribution to Titian is chiefly based on the close stylistic relationship to a drawing in the École des Beaux-Arts in Paris (Pallucchini 1959, p. 330, Tietze, No. 1961) that is largely regarded as a preliminary sketch for Titian's fresco of the jealous husband killing his wife. W.R. Rearick, whose work on Titian's drawings is unfortunately not yet published, suggested to the writer that the Tietzes were probably justified in their doubts about that drawing, which decisively differs from the fresco. They had recognized the extremely close connection between it and sheets which they had been obliged to attribute to Titian's gifted imitator, Domenico Campagnola: the youth in the mythological scene, formerly in the Mather Collection, now in Princeton (Inv. 46-81, Tietze 568); the group of Monks, in Berlin (Tietze 423); and the closely related Judgment of Paris, in the Louvre (Tietze 537). The connection between these and the drawings in London that take up the theme of the two boys in a landscape (Tietze 1932 as Titian, and Tietze 487 as Campagnola), of which the second one seems to be authentically signed "Domenicus Campagnola," appears quite unshakable to this writer. The elimination of these drawings, including the Apostle Group, in the Louvre (Tietze 1952), would clear the way for more accurate knowledge of Titian's early drawings. The point of departure would then be such documented works as the Group of Trees, in the Metropolitan Museum in New York (Tietze 1943), and figure studies such as the ones for *The Duke of Urbino,* in the Uffizi and for the *St. Sebastian* in Brescia, in the Staedel in Frankfurt (Tietze 1911 and 1915). In the light of these pen and ink drawings, sheets like the *Two Satyrs in a landscape,* in the Curtis Baer Collection (Tietze 1948), may reveal themselves with certainty as early works, and other lesser known drawings might then be linked with them.

All documented Titian drawings show that he tried to achieve the final visual appearance by working out precise contours, and forcefully distributing light and shade with cubic clarity. The artist of our sheet on the other hand had an abstract conception of body and movement operating in free curves and dynamic thrusts. Titian's lighting is only subsequently added. An example of Titian's sense for cubic clarity appears, incidentally, in the construction of the landscape in the drawing owned by Curtis Baer, while ours shows a much more detailed and decorative conception, clearly based on the art of Domenico's adoptive father, Giulio Campagnola. It is from him that Domenico also takes his linear style with clear parallel hatching that gives the background engraved precision. Even as his work, the sheet remains one of the most beautiful products of that romantic Giorgionesque school of landscape design, with the ruined cottages that may have been suggested by Dürer, and the free-figure style that gives Venetian art in the first quarter of the 16th century its wonderful charm. While this sheet was in France, Watteau apparently copied it, together with a group of further Campagnola drawings in red chalk (K.T. Parker and J. Mathey, Antoine Watteau, Paris 1957, No. 43).

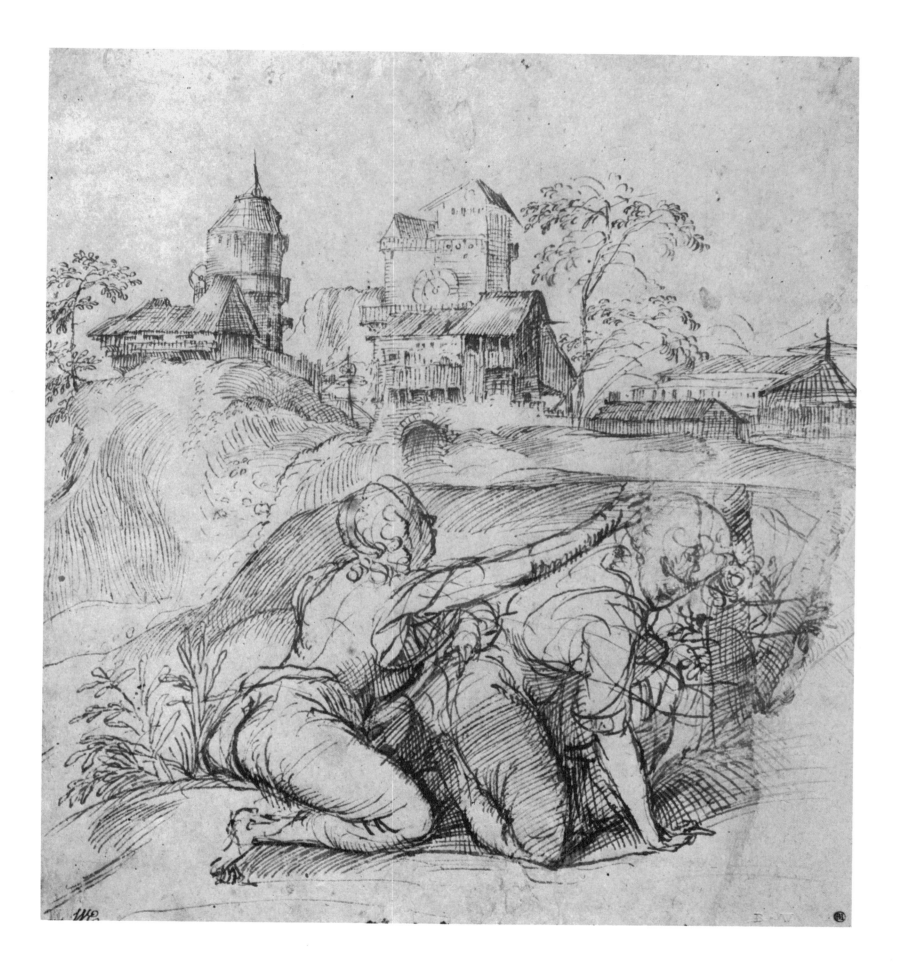

GIOVANNI ANTONIO PORDENONE

Painter, named Giovanni Antonio de' Sacchi, but called after his native place, Pordenone, Friuli. Married 1504, died 1539 in Ferrara. His father, Angelo de Lodesanis, came from the area of Brescia, where Pordenone frequently worked — in 1520/21 in the cathedral of Cremona, and 1529/31 in S. Maria di Campagna at Piacenza. His early work shows the influence of Gianfrancesco da Tolmezzo and Bartolommeo Montagna. Then he came in contact with the work of the young Titian, and through a journey south about 1516, in which he can be traced as far as Alviano, Val Tiberina, probably with the art of Rome. Pordenone chiefly practiced as a fresco-painter all over the Friuli, elsewhere in Northern Italian cities, and in Venice. Formulated a highly dramatic style, based chiefly on Titian's art of the second decade of the century; it is distinguished by large gestures, monumental, dramatic drapery and rich invention. His influence on art in Northern Italy was highly important.

62 Head and shoulders of a horseman

Red chalk, white paper, 156 x 118; Inv. 2408; V. 53.

Orig.: *Albert von Saxe-Teschen, L. 174.*

Lit.: *S.B. 149; V. 53; E. Tietze-Conrat,* Zwei Venezianische Zeichnungen in der Albertina, *in* Die Graphischen Künste, *N.F. II, p. 87; Fiocco 1943, p. 126, Pl. 95; Tietze 1944, No. 1358; Benesch 1961, No. 22.*

Traditionally regarded as a Guercino, described on the mount as Venetian by Morelli, and as a Romanino by Wickhoff. Erica Tietze-Conrat finally recognized the drawing as a preliminary study for the most important equestrian figure in the foreground of the large crucifixion by Pordenone, in the Cathedral of Cremona. A study for the entire fresco is in the Pierpont Morgan Library in New York (Fiocco, Pl. 94). It shows our rider playing a relatively neutral part to the right of the cross. In a further red-chalk study, in the Louvre (Fiocco, Pl. 95), of the rider and his horse, the dramatic pose of the final figure is developed. He excitedly regards the converted Longinus in the center of the fresco who directs the spectator in a large gesture towards Christ. In our sheet, Pordenone chiefly studied the expression of the face, but also the clothes and the sumptuous plumed hat. The clear constructional form is overlaid by profuse groups of lines, producing a subtly graduated *sfumato* and diffusing the figure in light. This spontaneous study belongs to the most vivid products of Venetian graphic art. In the fresco itself, Pordenone subsequently altered details in the shoulderline, especially in the opulent sleeve and the placing of the arm, to achieve a pose of even greater significance.

ANDREA SCHIAVONE

Real name Andrea Meldolla; painter and etcher, born in Zara, Dalmatia, hence his surname Schia-vone (Slovene). Worked in Venice from approximately 1540, and was paid there 1556 to 1560 for his paintings in the *Libreria*, died in Venice 1563. As Vasari observed, Schiavone obtained few official commissions, so that his work mainly consists of smaller pictures for private clients; he was also a very productive etcher. Schiavone is a typical representative of Venetian art at the moment when the influences from Florence, Rome and Parma, particularly the effects of Parmigianino and Salviati, but also of Giulio Romano, are strongly noticeable. Schiavone was extremely dependent on Parmi-gianino, and was thought to be his pupil by Lomazzo. Noticeable also is the influence of Titian, and a close connection with the early Tintoretto and Giuseppe Porta. His drawings, frequently colored, have great charm in their free and loose handling.

63 Lamentation of Christ

Pen and brown ink over abundant preliminary drawing in stylus, brown and green watercolor, white highlights, buff paper, inscribed bottom left Andrea Schiavone, F. 1550; 200 x 272; Inv. 1579; V. 60.

Orig.: *Albert von Saxe-Teschen, L. 174.*

Lit.: *S.V. 263; Fröhlich-Bum 1913/14, p. 161; W. 60; Tietze 1944, No. 1455; Benesch 1961, No. 32; Oberhuber 1963, No. 196; Müller-Hof-stede 1964, p. 141.*

The color scheme of this charming sheet may be an imitation of the chiaroscuro woodcut, with its various tints, popular in the 16th century. Raphael and Parmigianino often made drawings for such woodcuts, and Andrea Vicentino, who did much cutting for these prints, liked to use green. One of his prints, of which documented green pulls exist (B. XIII, 64, 23), was actually produced from a very Parmigianinesque original by Schiavone. As Müller-Hofstede pointed out, the composition of this sheet is based, however, on a design by Raphael or his workshop, known through an engraving by Enea Vico of 1548. It also influenced Jacopo Bassano and had a great impact on Netherlandish artists. Schiavone trans-formed his model in the spirit of Parmigianino by giving it greater fluency of movement and by adding a row of standing figures behind the kneeling group. These recall the master of Parma's etching of the Lamentation, both in the grouping of the heads and the interesting phys-iognomies. Venetian, however, is the broad dis-play of form, and the loose and painterly han-dling that characterizes all of Schiavone's work, releasing the drama of Raphael's gestures into freely flowing emotion.

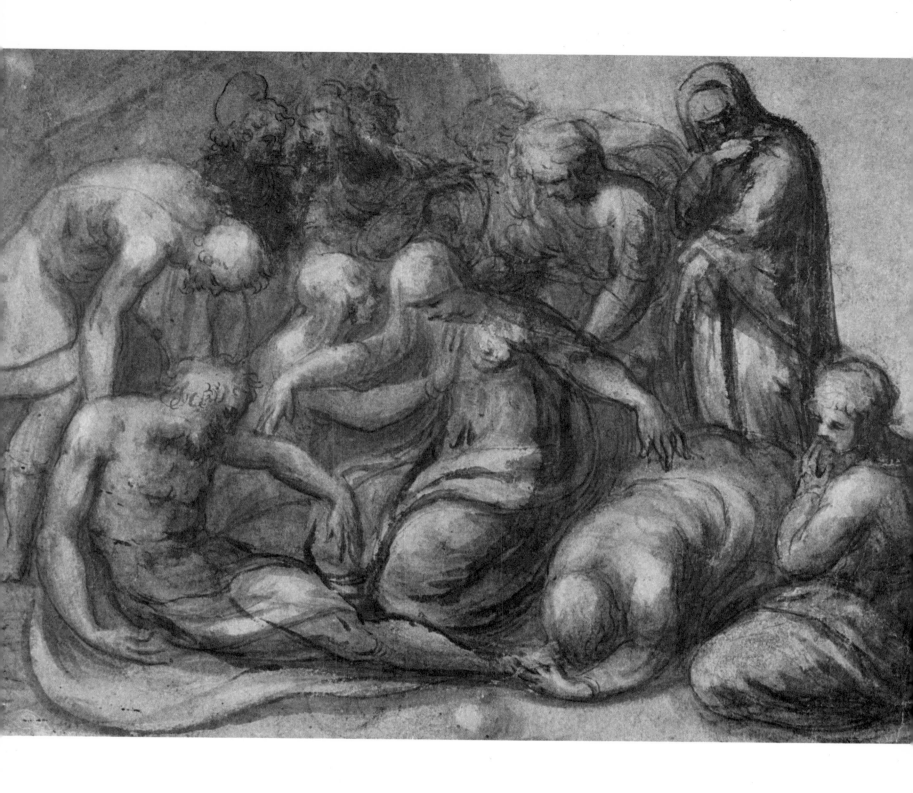

JACOPO BASSANO

Painter, real name Jacopo da Ponte; born in Bassano approximately 1515; died in Bassano, February 13, 1592. Son of a painter, Francesco, and probably his pupil. Approximately 1530 in Venice; taught by Bonifacio de' Pitati, but also influenced by Titian. Obtained a privilege from the Venetian Senate, in January 1535, but already in 1535/36 painted pictures for the Audience-Chambers of the Palazzo Pretorio in Bassano. 1541, exempted from paying taxes because of his skill; 1549, became Counsellor and envoy of Bassano; assisted his son Francesco in the painting of the Palazzo Ducale in Venice; and in 1581 a letter reveals that he was then aged and could no longer do much work. Master of great originality, who in his youth joined with the most modern trends that came from Parma, Florence, Rome and Venice, but who then overcame this "mannerist" phase, arriving at broad, monumental shapes and very glowing colors, made even more brilliant through forceful chiaroscuro, and more substantial through loose but thick application of paint. His great sense for reality emerges from his figures as well as from his excellent animal pictures and genre pieces. A large workshop, staffed in particular by his sons Francesco and Leandro, and also Giovanni Battista and Girolamo, multiplied or further developed his inventions. Bassano's style greatly influenced European artists, especially those of the 16th and 17th century.

64 Apostle head

Charcoal, red chalk, pastel on blue paper, 132 x 132, inscr. Bassano, *Inv. 1553; V. 72.*

Orig.: *Albert von Saxe-Teschen, L. 174.*

Lit.: *S.V. 138; Hadeln 1926, Pl. 76; Lili Fröhlich-Bum, Zeichnungen des Jacopo Bassano, Zeitschrift für bildende Kunst 65, 1931/32, p. 125; Tietze 1944, No. 200; Mostra Jacopo Bassano, Catalogo a cura Pietro Zampetti, Venice 1957, No. 17; E. Arslan, I Bassano, Milan 1960, p. 178; Benesch 1961, No. 40; Pignatti 1970, Pl. XIV.*

Preliminary drawings, as Fröhlich-Bum was the first to recognize, for the Apostle in the foreground, left, of the 1570 "Descent of the Holy Spirit," in the Museum of Bassano. The tilt of this powerful head, and the light that shines on it, is of the greatest importance for the composition as a whole. It is the point of this study, drawn on typical Venetian light blue paper. Bassano uses his pastels almost like paints, with broad color applications and accentuating lines that place the emphasis in telling spots, so that the head, although diffused by light, retains its plastic force and obtains its own color substance replacing the substance of the head depicted. Bassano liked to work in such colored chalks, and thus continued a tradition which in Italy had first gained importance in Lombardy and reached another high-point in the 16th century in the work of Barocci.

JACOPO TINTORETTO (?)

Painter; real name Jacopo Robusti; born approximately 1518, died May 1594 in Venice. His teachers are unknown; Titian, Bonifazio dei Pitati, Schiavone and Paris Bordone are quoted. Raffaello Borghini's statement that "Tintoretto has his drawing from Michelangelo and his color from Titian," has to be taken as a literary commonplace, even through drawings after Michelangelo's sculpture clearly show Tintoretto's interest in this master's work. As Pallucchini showed, Tintoretto grew out of the Venetian cultural climate of the forties so strongly under the spell of Florence, Rome and Parma, which also played such an important part in the formation of Giuseppe Porta, Jacopo Bassano and Andrea Schiavone. Tintoretto is the most important large-scale painter of the second half of the 16th century in Venice. The dynamic richness and geometric clarity, cosmic in effect, of his compositions, their spatial depth, the speaking gestures and movements of his figures, their noble expression, the powerful modelling, and his concentration on the essential elements of plastic form make him a counterpart of the great Roman and Tuscan fresco-painters, in the Venetian idiom of oil on canvas. Dramatist and painter of atmosphere, psychologist and painter of social status, "Convenienza," Tintoretto is one of the most important and richest masters of the Cinquecento. His portraits are also of the greatest importance.

65 Portrait of an old lady

Brush and oils in brown, grey, red and white on buff paper, 353 x 249; 17th century inscription: La Matre di M(esser) Galasso Galassi fu lasciato Nella Re(dita) / di d(et)to galeasso et Anibal fratelli et figli di d(e)tta Madona. *64; Inv. 17656; V. 71.*

Orig.: *Charles Prince de Ligne; Albert von Saxe-Teschen, L. 174.*

Lit.: *S.V. 71; Schönbrunner-Meder VI, No. 651; Tietze 1944, No. A 199;* Mostra Jacopo Bassano, *Venice 1957, p. 254, No. 26; R. Pallucchini,* Commento alla Mostra di Jacopo Bassano, Arte Veneta 1957, *p. 118, ill. 116; W. Arslan,* I Bassano, *Milano 1960, p. 380; Benesch 1961, No. 139; Fiocco 1961, p. 319, fig. 374; Benesch 1964, No. 57.*

The extreme expressiveness of this face, reflecting worry and responsibility for the family and its future, as well as great self-confidence, was admired by most people who had dealt with this sheet, and especially by Otto Benesch, who regards it as "one of the most magnificent, forward-looking achievements of Cinquecento Venetian draughtsmanship." This classification led him to support the old attribution — traditional from the days of de Ligne and Wickhoff — to Jacopo Bassano, that psychologist among Venetian portraitists. But Jacopo used to dissolve visible substance in color, and placed human before social values, while this face expresses conscious dignity, is plastically modelled and strongly outlined, and altogether at odds with his work. Other scholars even considered it as belonging to the Seicento, more open to free psychological expression. The Tietzes suggested Domenico Fetti; Arslan went so far as to propose an Emilian, and Fiocco suggested Domenico Tintoretto. Indeed, we often find Domenico using an oil-on-paper technique, but his portraits are usually more stylized, and without such density of structure, also lacking in his drawings.

Jacopo Tintoretto, on the other hand, occasionally uses this oil-technique. He is the modeller, the sculptor among Venetian painters, as well as one of the most expressive portrait-artists conscious, as a true Venetian, also of the sitter's social rank. The high-collared fashion is frequently encountered in Venice between 1550 and 1570. In Jacopo's paintings of the sixties, as for instance in the background of the great Crucifixion in the Scuola di San Rocco, many of the heads resemble our portrait in modelling, accentuation and brushstrokes (cf. H. Tietze, Tintoretto, London 1948, Ill. 131, 132). In consequence it seems possible to this writer that this deep and expressive portrait may be revealing a new facet of Jacopo as a draughtsman. Of course, caution is called for, particularly in the case of such isolated sheets; it remains an open question whether one of his gifted collaborators and successors may not have achieved an exceptional stroke of genius.

la Mater di m̃ e alvaʒō ej fu lasidto ballo
di S. galeaʒo et aníbal fuelli et sfti li di suo medsia

PAOLO VERONESE

Painter, real name Paolo Caliari; born in Verona probably in 1530; died April 19, 1588, in Venice. Taught by the Veronese painter Antonio Badile, who refers to him as his pupil on May 2, 1541. First known works date from 1548; frescoes in the Villa Soranzo dated 1551. A little later, perhaps already in 1553, he apparently settled in Venice, where he executed oil paintings in the Palace of the Doges and in San Sebastiano; from there he went to paint frescoes in Murano and the villas in the Veneto. 1556/7 he was named the best of the painters taking part in the decorations of the *Libreria,* and from then on was counted among the leading Venetian painters. A trip to Rome is documented, in the company of Girolamo Grimani, who stayed there in 1555, 1560, and 1566. He adopted the light coloring of the art of Badile, and intensively studied the trends of the "maniera" arriving from Rome, Florence, and Parma, the work of Giulio Romano, Parmigianino, Nicolò dell'Abate, Salviati, Giuseppe Porta, and others. Compared to Zelotti, who started from similar premises, he was, however, far more affected by Venetian painting and the work of Titian. His powers of observation and his sense for light and its play in landscapes or over fine fabrics, his subtle color sense and imagination, his grace, and his controlled, yet deep psychological penetration place him far above the level of other decorators in the Veneto. In him, idealism and realism, appearance and substance, are harmoniously balanced. This makes him the very artist to cater to Venetian tastes, especially in secular decoration and the renderings of mythological and allegorical subjects. His religious paintings frequently have profane overtones in the splendor of their material effects and the elements of social grandeur, which brought him before the tribunal of the Inquisition in 1573. They also caused Veronese to become one of the important forerunners of society-orientated art of the 18th century.

66 Allegory of Victory

Pen and brown ink, heightened in white on blue-grey prepared paper, 386 x 276; Inv. 1636; VII 2.

Orig.: *Sir Joshua Reynolds, L. 2364; Count Moritz von Fries, L. 2903; Albert von Saxe-Teschen, L. 174.*

Lit.: *S.V. 223; Fiocco 1928, p. 210; Tietze 1944, No. 2187; Benesch 1961, No. 44; Bacou 1968, No. 64.*

The inventory of drawings by Paolo Veronese that were still in the possession of his family in 1682 lists ninety-four chiaroscuri. Earlier, Ridolfo had already mentioned such finished drawings in Venetian collections furnished on the versi by Veronese with exact descriptions. They were without doubt the drawings that his contemporaries most admired. Veronese himself probably regarded them as more than "modelli," i.e. as visualizations of ideas that, according to his remarks on the versi, he would like to execute one day if only he had the time, but as finished sheets that would make good presents. Our sheet, of which another version exists at the Louvre, is closely related in style to two others in the same collection; they must have been part of Francesco Muselli's collection, which Ridolfi had seen in Verona (Tietze 2131 and 2135; Bacou No. 63/64). One of these also represents an Allegory: such themes were much to Veronese's taste, as he liked to depict grave feminine beauty in a picturesque *ambience.* In our drawing, the dignified figure with the flag is standing among Roman ruins in the sort of landscape that forms the background of so many of Paolo's works, and which is structured with great liveliness in planes and volumes. The light that touches the leaves of the tree, the capitals and reliefs is quite magical, particularly where it suggests the sheen on the silken draperies, and the full roundness of the figure. Sensual splendor and moral depth — because Victory is here attributed to higher powers by unmistakable expression and gesture — combine in a picture of mature beauty. How all authorities to date have attributed this sheet to the workshop remains a mystery. Philip Pouncey also poses this question in surprise on the back of the mount, and is convinced that this drawing is by the master.

67 Pastoral landscape with flock and shepherdess, town in the background

Pen and brown ink, paper lightly prepared with red chalk, 280 x 427; Inv. 24365; V. 12.

Orig.: *Earl Spencer, L. 1530; F. Abbot, L. 970; acquired 1923.*

Lit.: *Stix, Albertina N.F. II, No. 17; V. 42;* Hadeln, Besprechung von Stix, Zeitschrift für bildende Kunst, Kunstchronik 60, *1926/27, p. 112; Lili Fröhlich-Bum,* Die Landschaftszeichnungen Tizians, Belvedere *VIII, 1929, p. 75; Tietze A. 1973; Benesch 1961, No. 16.*

Both Stix and Fröhlich-Bum regarded this monumental, rich landscape as the work of Titian. Hadeln and the Tietzes rightly rejected this attribution, and the latter proposed a Northern Italian under Venetian influence. Otto Benesch recognized the connection between the figure at bottom right with Veronese's drawings. Indeed, the relationship to the art of Veronese's landscape is very close. The construction, with diagonal layers of ground, strongly emphasized at the edges by hatching, is still following Titian's landscape style, while aiming towards a denser, decorative structure, where separate elements emerge with plastic emphasis. Details like the thin, highly flexible tree trunk in the foreground, the rocks in shell-formation on the left, and in particular, the picturesque arrangement of the building-group in the background, are extraordinarily reminiscent of fresco-landscapes in the Villa Maser. For all their greater breadth and more classic style, they also recall the landscape backgrounds of Veronese's paintings, which contain many related details, like the hill-embedded group of buildings (background, left), or the hut behind the tree in the foreground. We know of no other finished pen and ink drawings of this kind by Veronese, but the line, and the way in which light and shadow run in substantial, living channels, are closely related to his style of painting. Even if the attribution to Paolo Veronese must remain hypothetical, this sheet is a splendid example of this fresh approach to nature, real and filled with light, which characterizes his landscapes, even when bound by traditional formulae, and raises them far above the work commonly produced in this area in the third quarter of the 16th century. The combination of idealized decorative form and sensually rich detail, both translated into terms of painting and drawing, are typical of the master's whole creative work.

BATTISTA ANGOLO, CALLED BATTISTA DEL MORO (?)

Painter, miniaturist and etcher; born approximately 1515, probably in Verona; made his will in 1573 and was shortly afterwards referred to as dead. According to Vasari, he was taught by the Veronese painter Francesco Torbido del Moro, whose surname he took. Worked in Verona, in Murano with his son Marco about 1557, probably also in the Sacristy of San Sebastiano, Venice, and in various villas in the Veneto. Enjoyed a certain renown as painter of *grisailles* on facades. Much of work has been lost or not yet researched. Formative influences probably included the frescoes by Giulio Romano in the Cathedral of Verona, and the work of Salviati and his circle. Later, his style grew freer and lighter, probably under the influence of Zelotti, with whom he collaborated. His attractive etchings, especially the landscapes, were influenced by the Netherlands.

68 The triumph of Marcus Furius Camillus

Black chalk, brush and mauve wash, traces of pen drawing, 231 x 355; Inv. 24574; B. 432.

Orig.: *Acquired 1925; collector's stamp illegible.*

This drawing enchants by lightness of movement and spaciousness, and in particular by the subtle mauve brushwork that delicately models the figures in light and shade, right up to the more solid group of spectators in the right corner. The graceful female figure standing there recognizably embodies the figure-ideal of Paolo Veronese, and possibly of Andrea Schiavone. She reappears below in a different pose, in an area left blank for a door, surrounded by more figures and architectural motifs merely indicated with a few touches of the brush. On the other hand, a sitting female figure, foreground left, remains unfinished. This drawing used to be attributed to Bernardino Campi, but it is in fact the preliminary sketch for a fresco in the South Room in the right wing of the Villa Giusti-Giacomini in Magnadola di Cessalto near Treviso, where Campi never worked (Crosato, T. 124 and 125). The master is not known, but forms of movement and facial types point most clearly to Verona, the circle of Domenico Brusasocci and the family of Angolo del Moro. Indeed, our drawing also closely relates to two sheets in the British Museum that Hadeln (1926, Pl. 16, 17) published as the work of Battista Angolo del Moro, and of which one bears an old inscription with his name. Much in the figurework, in the lighting, and especially in the technique — chalk and mauve brush — are closely related. The Villa is, however, supposed to have been built in 1575, after the death of Battista. Our drawing is more advanced in style than the London sheets, and caution must be exercised regarding a firm attribution until more is known about late 16th century Veronese painting.

JACOPO NIGRETTI, CALLED PALMA IL GIOVANE

Venice 1544-1628, son of Antonio Palma, who first taught him to draw. Second coucin of Palma Vecchio. Discovered by Guido Ubaldo, Duke of Urbino, while copying a painting by Titian; taken to Pesaro and Urbino for his studies, and sent from there to Rome, where he remained for eight years, *"disegnando le più pregiate statue di Roma, in particolare ritrasse il Cartone di Michel'Angelo Buonarotti, e le pitture di Polidoro, piacendogli molto quella maniera, perchè si approssimava (diceve egli) allo stile Veneziano..."* (Ridolfi II, p. 174).

Returned to Venice 1568, to be decisively influenced by the works of Tintoretto, whom, like Titian, he especially revered. Also influenced by Veronese and by the Bassani's realism and chiaroscuro, which he could, of course, study as well in the Tintorettos. After the older master's death, he was deluged with commissions; quality of work was impaired. Nevertheless, without apparent effort and without denying his artistic origins, he achieved a near-realist restlessness of style appropriate to the beginnings of the Baroque, for which the way was being prepared in Venice through the creative activities of Domenico Feti and Jan Liss. In this, he may be compared to Lodovico Carracci. Palma was a prolific and excellent draughtsman; there is a large body of drawings in the Graphische Sammlung in Munich (over four hundred sheets), in the Uffizi, in Bergamo, and about forty drawings in the Albertina. His graphic talents, admired already by his own contemporaries, also emerge in the vitality of his etchings and especially in his handbook on drawing, *"De excellentia et nobilitate delineationis,"* published 1611 by Jacopo Franco (Bartsch 2-27); his graphism reveals a decidedly Baroque temperament. His open, pictorial — in this respect typically Venetian — style of drawing was to be adopted not only in his home territory, but also in the Roman and Florentine High Baroque by Cortona, Mola, Franceschini and other *"macchiettisti."* Ivan Fenyö drew attention to Parmigianino's influence on Palma's graphic style.

Two lines from Boschini's *"Carta del navegar pitoresco"* are typical for Palma's work: *"E in tal modo patron de la Pitura, | Che in quatro colpi el fava una figura."*

69 Massacre of the Innocents

Leadpoint, pen and ink, bistre *wash; 316 x 264; Inv. 1665, V. 189.*

Lit.: *Wickhoff, S.V. 251; V. 189; Tietze, p. 223, No. 1199.*

Composition and figure-style, the diagonal and circular movements ("serpentinate"), link with Tintoretto, as does the abruptly vanishing plane of the perspective, which heightens the suspenseful horror of the events. The turbulent mountain scenery in the background also occurs in Tintoretto, as for instance in the Scuola di San Rocco. The loose, pictorial style of drawing and wash, reminiscent of Veronese, is nevertheless Palma's very own. Hans and Erika Tietze date the sheet within the first years of the 17th century, but

it may already have been produced around 1590; because of its stylistic affinity with Tintoretto and, in particular, with a preliminary drawing, now at the Uffizi, for the "Brazen Snake" in the sacristy of the Jesuit church in Venice, which Palma was painting at the time (see Forlani 1958, No. 37, fig. 9). Also, most drawings created around and after 1600 show more bodily plasticity (cf. Heil, fig. 4, 5; Forlani, fig. 24). The Albertina owns another sketch, related in style, *The Martyrdom of St. Sebastian,* which shows buildings similarly "classicist" in effect (V. 201, EC Venice 1961, No. 67).

Lit. on the drawing: *Baglione; Ridolfi; Boschini, La carta del navegar pitoresco, Venice 1660; Hadeln; Heil; Tietze; Forlani; Bergamo; Fenyö.*

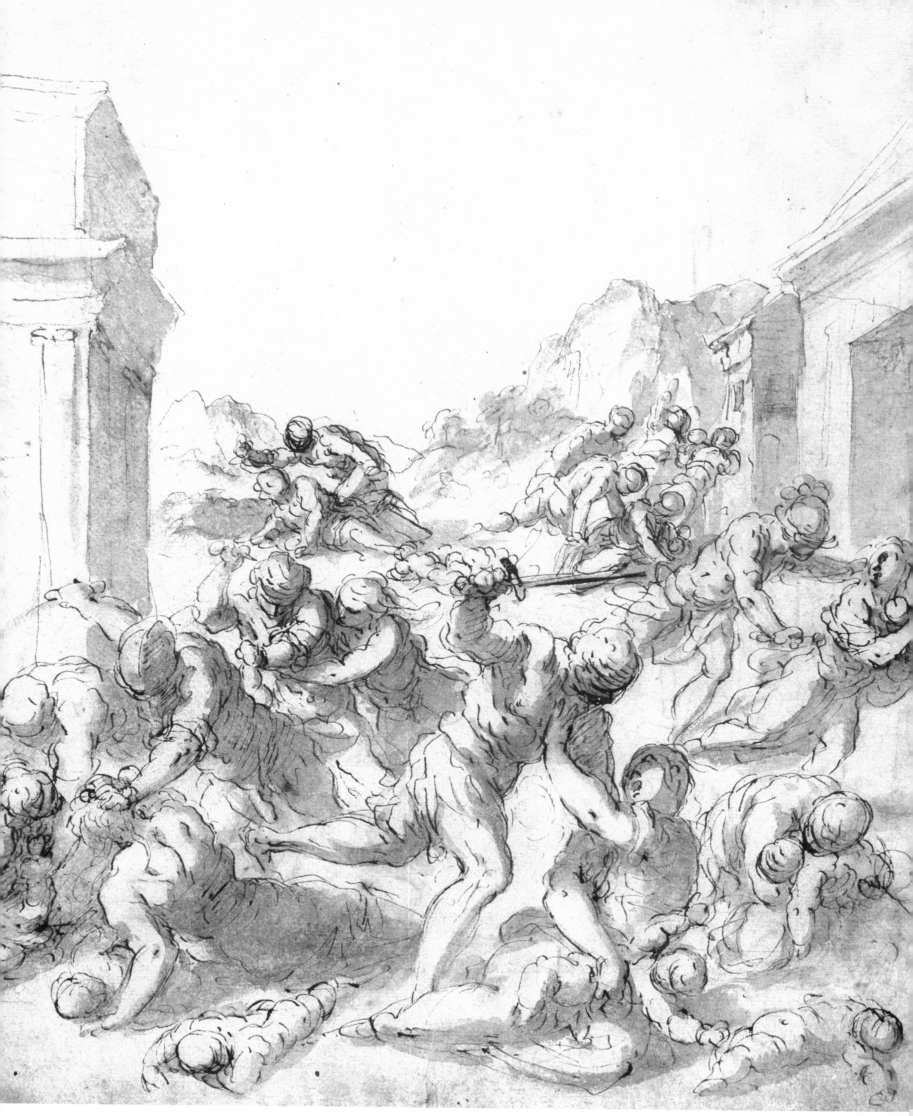

GIULIO CESARE PROCACCINI

Born approximately 1570 in Bologna, son and pupil of Ercole Procaccini the Elder; moved to Milan after 1585, together with his father and elder brother, Camillo. Giulio Cesare first worked as a sculptor in the Cathedral of Milan, and began to practice as a painter soon after 1600. His style was formed under the influence of his brother who was also an engraver of some importance, and then by the early activities of the Carracci, particularly Lodovico, and not least, the work of Correggio and Parmigianino. Was also called "il Correggio insubre." Worked in Milan, died there in 1625; also worked in various other places in Lombardy, and around 1618 in Genoa.

70 Boy's head with curls

Charcoal, heightened in white body color, green/blue paper, octagonally cut. 265 x 229; Inv. 24985; B. 448.

Orig.: *Legat Oswald Kutschera Woborsky. On left, strip of paper added by artist. Bottom left corner patched.*

Lit.: *Malvasia; Carlo Torre,* Il Ritratto di Milano, *Milan 1674; N. Pevsner,* Giulio Cesare Procaccini, *Rivista d'Arte, XI, Florence 1929, p. 321 ff.; N. Ivanoff,* Disegni dei Procaccini, *La Critica d'Arte, V. 1958, p. 222 ff., 328; E.C. Milan 1959, p. 34 ff., 60 ff., No. 25-42; Fenyö, p. 100.*
Lit. (on drawing): *B. 448.*

"*Quel pittore delineava queste divine fattezze, perche i suoi pensieri erano angelici*" wrote Carlo in 1674 in his *Ritratto di Milano,* and Malvasio reports "*Dissegnò questo pittore con gratiosa maniera a tanto di lapis, come di penna, e gustava d'istradar alla perfettione del buon dissegno i giovani principiant.*" The head is similar in conception to the heads of angels in the paintings of the Liberation of St. Peter now in the Museo Civico in Turin (see Luigi Mallé, Museo Civico di Torino, I Dipinti del Museo d'Arte Antica, Turin 1963, Pl. 112-113), the Madonna with Saints in Santa Maria di Carignano in Genoa (Pevsner, fig. II), and others.

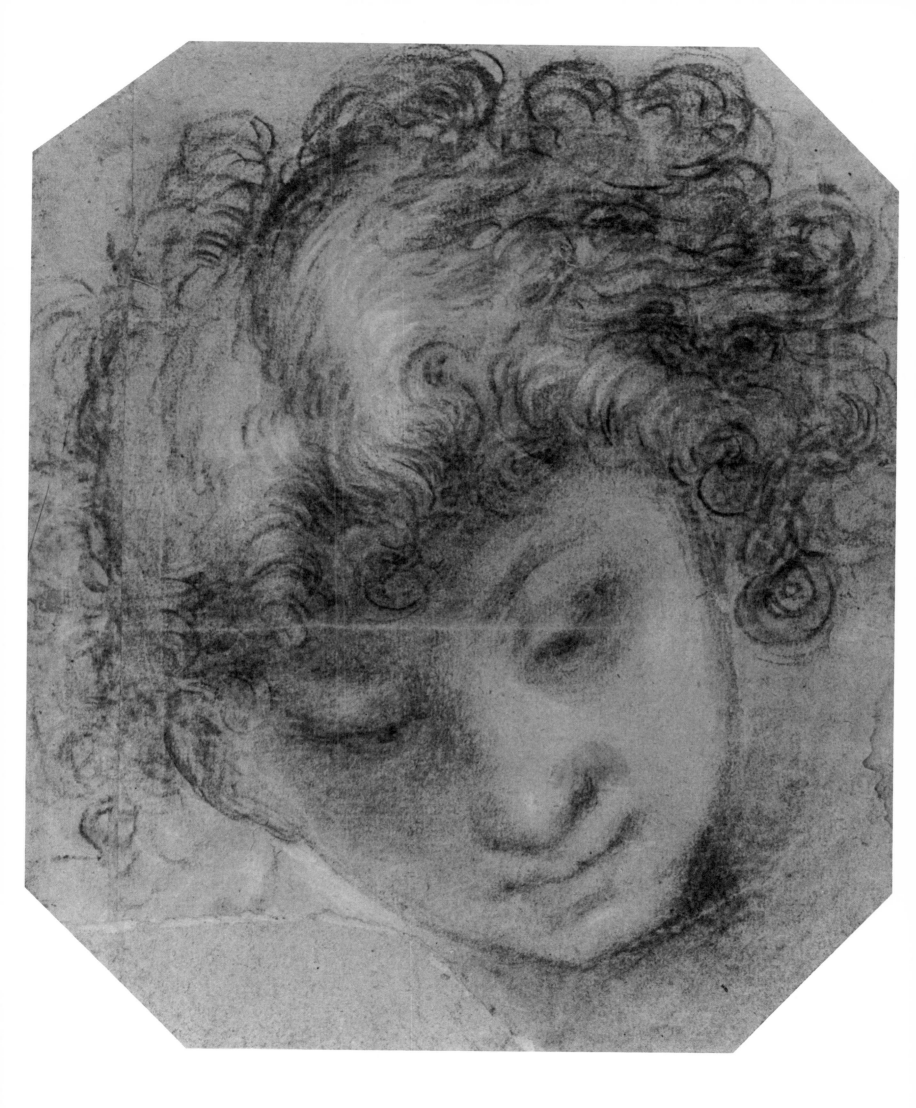

Born 1560 in Bologna, taught together with his brother Agostino by his cousin Lodovico Carracci, who together with both founded 1585-86 the famous *"Accademia degli Incamminati."* In deliberate contrast to the Mannerists, this school turned to a new, unprejudiced study of life, the masters of the High Renaissance and the classical Antique, and became the model for subsequent academies. Shortly before, Annibale and Agostino had visited Parma and Venice, and studied the work of Correggio, Parmigianino, Nicolò dell'Abate, Titian, Tintoretto and the Bassani. 1595, Cardinal Odoardo Farnese summoned Annibale to Rome. There he created his principal work, the "Galleria Farnese" in the Palazzo Farnese. His brother Agostino collaborated with him from 1597 to 1600.

Annibale was the most versatile and talented of the Carracci. His *repertoire* stretched from the realistic genre pictures in which he specialized in his early years in Bologna (cf. *"Arte per via"* resp. *"Arti di Bologna"*), to the dramatic, idealized paintings that he developed later, especially in Rome, freely and confidently leaning on the Antique, Raphael, Michelangelo and Titian. This so-called "academic" side of his creative activity was soon recognized as the counterpoint to the relentless realism of Caravaggio and his followers. Annibale also set new trends in his true-to-life portraits, and his heroic and idealized landscapes. He created many of his drawings "nell'hore di recreatione," as we learn from his "Arti di Bologna," engraved by Simon Guillain and published in Rome, 1646. It became the model for the *"Cris du peuple"* published much later. Pierre Jean Mariette, the great 18th century connoisseur and scholar ("érudit"), who saw the Carracci not as eclectics, as did later critics, but as the revivalists of the classical art of the Antique, of Michelangelo, Raphael and Titian, wrote, *"Annibale Carrache est sans contredit, un des plus fiers dessinateurs qui ait jamais été. Il s'étoit exercé toute sa vie à dessiner d'après nature, où a jetter sur le papier les différentes pensées que son imagination lui suggèroit. Le fréquent usage de dessiner, qui lui avoit été inspiré par Louis Carrache, comme l'unique moyen de se rendre supérieur dans son art, lui avoit rendu la pratique du dessin extrêmement facile; insensiblement elle étoit devenue pour lui un objet de délassement"* (Cat. Crozat, p. 48).

Mariette himself owned one of the most important collections of Carracci-drawings of his time, which can be traced back through Crozat and the painter Pierre Mignard, to Annibale's immediate circle of friends (Angeloni, Agucchi). Many of the Albertina's sheets also come from this source. When Annibale died in Rome in 1609 after a long illness that had partly psychosomatic causes, his pupils, with tears in their eyes *"baciando morta quella mano, che era solita dar spirito, e vita dell'ombre"* (Bellori, p. 77). These words applied both literally and metaphorically, particularly to his drawings that link in their breadth and freedom largely with the Venetian tradition, wherein Guercino, though not himself Annibale's actual pupil, was to become his successor.

71　The Lutist Mascheroni

Portrait study, en face. *Red chalk, heightened with white chalk, pink/grey paper. 411 x 284; Inv. 25606; B. 109.*

Orig.: *Lempereur (Lugt 1740); Friedrich Amerling; Archduke Friedrich (acquired 1916 through Joseph Meder from the estate of the painter Amerling; 1929 reacquired by the Albertina). Old Collector's designation "Annibal Carracci del" (in pencil, presumably by Lempereur).*

Lit.: *Malvasia; Bellori; Mariette; Mahon; Wittkower; E.C. Bologna 1956; Bacou, Louvre 1961; Fenyö, Carracci; E.C. Mariette; E.C. New York 1967; Roli.*

Study for the half-length portrait in the Dresden Gemäldegalerie showing the musician with lute, pen and sheet-music, known as "Giovanni Gabrielli" or "il Mascherone." Malvasia had still seen the painting, which Annibale created shortly before his summons to Rome (1595), in the Duke of Modena's collection and wrote, *"quello del sonatore Mascheroni tanto suo famigliare & amico"* (Felsina Pittrice I, 1678, p. 502). A pen and ink study in Windsor Castle, presumably the *"primo pensiero,"* also shows only the musician's head and shoulders, although the sector is larger (Wittkower, p. 133, fig. 27), A further red chalk study, however without the vitality of the

sheet in the Albertina, is in the Uffizi (Inv. 12405), and a copy, in the Louvre (Inv. 7625, formerly in the Collection Jabach). A certain but not compelling resemblance between the sitter and the Agostino Carracci's portrait-engraving of the actor Giovanni Gabrielli, known as "il Silvello" (Bartsch 153), another friend of the Carracci, led to the 19th century equation of Gabrielli and Mascheroni. The Albertina drawing rivals the pen and ink sketch in Windsor in the immediate vital impact of expression, in which Annibale anticipates portrait drawings by Rubens and Van Dyck, as well as Bernini. The soft, highly animated fluidum of his chalk technique, which he handles in a painter's manner, points to Flemish Masters and Bernini. Annibale, who during his youth in Bologna had made no less thorough and unprejudiced a study of the realities than the contemporary Caravaggio, became one of the most significant founders of Baroque portraiture, and the red-chalk head in the Albertina is an important milestone.

Lit. on the drawing: *B. 109; Ludwig von Baldass,* Graph. Künste *XLI, 1918, p. 1 ff.; Wittkower, p. 133, fig. 27 (Zeichnung in Windsor); E.C. Bologna 1956, Disegni, No. 103, Pl. 35; Benesch, Meisterzeichnungen, No. 46. On the painting in Dresden: Voss,* Barock, *p. 161 (ill.), 490; Mahon,* Studies, *p. 266 f. No. 50.*

72 Nude study of a young man

Half-length figure facing right; head in profile, left arm extended, jug held in lowered right hand. Charcoal on blue paper. 336 x 397; Inv. 2174; B. 95.

Orig.: *Crozat (Lugt 1952, effaced); Mariette (Lugt 1852), Prince de Ligne (Bartsch p. 94, No. 22).*

Lit.: *Mariette; Crozat; Bartsch, Ligne, p. 94, No. 22; Wickhoff, S.B. 220; B. 95 (Agostino Carracci).*

This half-length nude, and another, also at the Albertina, drawn from the same model (B. 96, head *en face*, right arm raised, bending at right angles) was probably created in connection with the frescoes in the Palazzo Farnese without finding immediate application. It is in stylistic connection with several studies for these cycles. (Wittkower, Pl. 56, 57, 65-70 a.o.; E.C. Bologna 1956, Pl. 45, 46, 51, 53, 54, a.o.; Fenyö, Carracci, fig. 30, 32-34; E.C. Louvre 1961, Pl. XVIII-XXI). Both studies were attributed to Annibale in the older collections and catalogues, including that of Wickhoff. Only Stix and Spitzmüller assign them to Annibale's elder brother Agostino Carracci (1557-1602), who worked with Annibale for the Galleria Farnese 1597-1600 before going to Parma, where he died. However, the reference to two Tritons, similar in movement, in an engraving by Mauro Oddi (Parma 1639-1703) after a painting of Europa and the Bull, now lost (Bartsch XXI, p. 213, No. 2), that Agostino presumably created during his final years in Parma, is insufficient evidence for attributing these forceful, realistic studies to Agostino, who, for all family-resemblance in style, drew in the more reserved, mannerist way of Lodovico Carracci (Bologna 1555-1619), the Procaccinis and others. The collaboration of the "Incamminati" was often very close indeed. Mutual stimulation and borrowing was quite usual, and it was especially Annibale's wealth of invention and unceasing creativity that fired the elder two artists' enthusiasm (cf. E.C. Bologna 1961, Pl. 15-26). Both Bodmer and Otto Benesch again attributed this and the other sheet to Annibale (observation on mount).

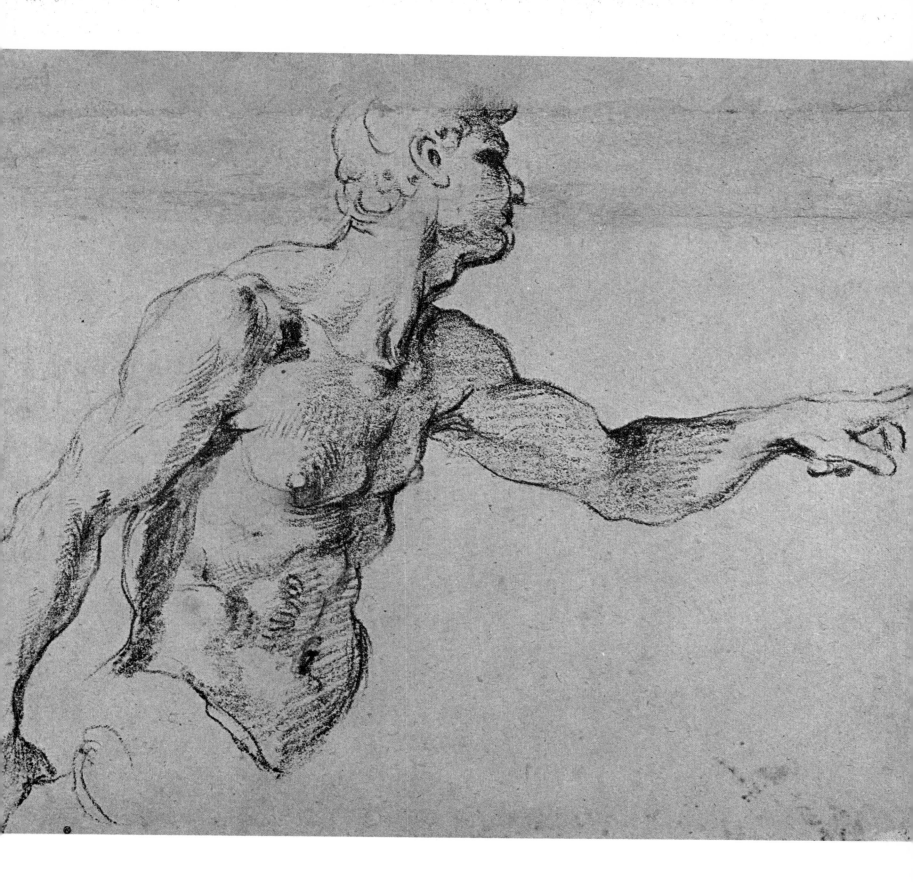

Bologna 1575-1642. Son of a musician, first studied with the Flemish Denys Calvaert, together with Domenichino and Albani. Calvaert directed his pupils' attention chiefly to Albrecht Dürer and also to Raphael. About 1595 Guido Reni, attracted by the academy of the Carracci and their free study of the Antique and of life, enrolled as Lodovico's student. At the beginning of the new century, he went to Rome and joined the circle of Annibale's pupils. Simultaneously, he made studies after Caravaggio, but informed that master's realism and chiaroscuro with his own firm belief in beauty (*"indistruttibile sogno di bellizza,"* Gnudi), in a sense, transforming it in his own spirit. He was increasingly, and more deeply than the Carracci and their other pupils, attracted by the example of Raphael. Like Andrea del Sarto and Correggio, Reni the draughtsman was searching for him "with his soul," *"Vorrei aver auto penello angelico e forme di Paradiso, per formare l'Arcangelo e vederlo in Cielo,"* he later wrote to Monsgr. Massani, when he had been commissioned to paint an Archangel Michael for Sta Maria della Concezione in Rome (Bellori, Idea del perfetto Pittore). 1600-05 he was again in Bologna; from 1607-14 he worked in Rome for Pope Paul V and Cardinal Scipione Borghese, with short interruptions in 1611-12 (Bologna, again). After completing "Aurora" he returned for good to his native city, *"a godere la sua quiete e la sua liberta"* (Malvasia).

Guido Reni became the guiding light for all artists searching for classical harmony, both of his own period and after, within Italy and elsewhere and especially in France (Vouet, La Hire, Le Sueur). Reni's presentation of his inherent concept of beauty was to inspire the theory of art from Bellori to Winckelmann. He succeeded in combining the lucid form and harmony of the classical Antique with the achievements, and the feeling for realism in the arts of his own time. Even Bernini was his sincere admirer.

73 Allegory of the Dawn – the "Aurora"

Aurora, followed by Apollo in the chariot of the sun, accompanied by Horae, floats above the earth. Red chalk, pen and ink. 126 x 255. Inv. 24 550. B. 151. Wash, on left, probably unintentional. Gallnut-ink erosion in several spots of the paper. Collector's number "110" (in a later ink).

Lit.: *Bellori; Malvasia; Chantelou; Hermann Voss*, Der Spiegel II, *Berlin 1923; Kurz; Hess (Thieme-Becker);* Cavalli and Gnudi, EC Reni, *Bologna 1954 (incl. Bibl.).*

Design for the ceiling fresco in the Casino dell'Aurora of the former Palazzo Borghese — now the Rospigliosi-Pallavicini — in Rome, which Reni painted for Cardinal Scipio Borghese. There is a further, more detailed sketch in the same technique in the Louvre: a fragment in which Aurora is missing and only the sun carriage and part of the team are visible, but which shows Eolus, god of winds — or is it Chronos? — who is left out of the fresco (G. Rouchès, Musée du Louvre, Dessins italiens du XVIIᵉ siècle, Paris, Pl. 8). The Albertina sheet may be taken as Reni's "primo pensiero" for the painting that assured his fame for centuries, and where, in the encaustic effect of his paint, he competed with the Antique and with Raphael's frescoes in the Villa Farnesina (Gnudi, E.C. Reni, 1954, p. 36). His own lines around the sketch indicate that he thought of it as final, although the grandiose coastline beneath the dawn-goddess is still missing. In the definite "disegno," and the rhythmically relaxed style "filled with inner musicality" (Voss), Reni approaches Raphael of Urbino's example more closely than the Carracci or their other successors ever did, and indeed more closely than in most of his own drawings. Reni's Aurora, engraved by Pasqualini, in reverse, found a Baroque antithesis in Guercino's "Aurora Ludovisi" ten years later.

Guercino, like Reni once a student at the Carracci Academy, presented an arrangement in perspective to be seen from below (sotto in su) with great spatial effects and heightened light and shade values (see also No. 75). Reni's Aurora also inspired Francesco Albani's painting "The Allegory of the Air," part of the "Four Elements" cycle in the Galleria Sabauda in Turin. Probably concurrently with Reni, but possibly already influenced by his first designs, the famous historiographer Giovanni Baglione produced the sketch that is now in the Lambert Krahe Collection in the Kunstmuseum, Düsseldorf. There, the Chronus whom Reni had indicated behind Apollo in the sketch is flying before the sun-carriage, while Aurora is barely suggested. Walter Vitzthum suspects that Baglione was also trying to obtain the commission to decorate the Casino Aurora.

Lit. on the drawing: *Josef Meder*, Die Vorzeichnung zu Guido Renis Aurora, Graph. Kunste *XLVIII, 1925, p. 40 f.; Kurz, p. 200; B. 151; E.C. Reni, 1954, p. 316, No. 16; Benesch,* Meister Zeichnungen, *No. 48;* Walter Vitzthum, Burlington Magazine *CVI, 1964, p. 180;* E.C. Düsseldorf *1970, No. 33, Baglione.*

FRANCESCO BARBIERI, CALLED IL GUERCINO

Born 1591 in Cento near Ferrara, largely self-taught under the formative influence of the Carracci, especially Lodovico, without being his actual pupil. 1607, assistant to the local painter Benedetto Gennari in Cento. At first worked on commissions in Cento, Ferrara, Bologna and Mantua; visited Venice in 1618 where he met Palma Giovane. Summoned to Rome in 1621 by Gregory XV Ludovisi, he created in the Villa of that name on Monte Pincio his principal fresco, the "Aurora Ludovisi." End of 1623, returned to Cento, where he worked with some interruptions (1626 in Piacenza) until 1642. Moved to Bologna after Guido Reni's death, where he displayed great activity until he died in 1666. Of all the Bolognese, Guercino was most affected by the work of Caravaggio and his successors with their realistic chiaroscuro, although he of course idealized these influences, especially in his mature works, under the impact of his counterpart, Guido Reni. Like the Carracci, he was versatile and was also active as a painter of landscapes and genre. ("Et in Arcadia.") In his drawing, he is linked directly with the Carracci, especially Lodovico, who admired him, and Annibale, from whom he differs in his particularly varied, Caravaggesque chiaroscuro. He has always been highly esteemed by collectors, especially in England.

74 St. Domenic kneeling before the Madonna and child

Red chalk, pen and ink, bistre wash. 272 x 207; Inv. 2345; B. 215. Old signature, "Guarchino" (by another hand).

Orig.: *Mariette; Burduge; Prince de Ligne (Bartsch, p. 107, No. 23).*

Lit.: *Bartsch; Ligne, p. 107; Wickhoff, S.B. 403; B. 215.*

Sketch for an altarpiece, not yet identified, from the early period, comparable to studies for the Madonna del Carmine in the Pinacoteca of Cento (cf. Mahon, Guercino, Disegni 8-10); the sketches of 1617, for the "Return of the prodigal son," in the Pinacoteca at Turin, are also related in style (Mahon 23-25). The nobility of features and movement are striking, recalling Correggio, and Lodovico Carracci, who sometimes used a similar sensitive wash and line (cf. Bodmer, Pl. 119, 120).

75 Allegory of the Night

Red chalk, 265 x 229; Inv. 2298; B. 224. Bottom right, the figure "16" (ink, in a different hand, at later date).

Lit.: *Wickhoff, S.B. 357; B. 224; Steffano Bottari, Guercino, Disegni, Bologna 1966, Pl. XXVII; Mahon, Guercino, Disegni, No. 85.*

Study for a part of the "Aurora Ludovisi," counterpart to Guido Reni's Aurora, which Guercino was commissioned to paint by Pope Gregory XV for his villa (palazzino or casino) on Monte Pincio — a masterpiece of illusionist ceiling-painting (sotto in su) which came to have great influence and was also engraved by Pasqualini. The architectural perspective was painted by Agostino Tasso, and partly altered by Guercino. The "Allegory of the Night" was painted, opposite "The Dawn," at the narrow end of a rectangular ceiling-field beneath a painted, ruined arch. The allegorical figure is shown asleep over a book. This also is the pose in the Albertina drawing, while another, earlier red-chalk study in Windsor shows her still in the process of reading (Mahon, Guercino, Disegni, 84, 85). The Albertina drawing also contains indications of some ruins — scenery which Guercino introduced into Tassi's architecture. The sleeping Putto was altered for the fresco, and joined by a second one. Further sketches and studies for the Aurora Ludovisi are known (Mahon 78-85). The picturesque chiaroscuro that seems soft — in the spirit of Correggio and the Carracci — in the drawing, and more contrasting in the painting, and the faces show the influence of Caravaggio. Guercino studied and absorbed this artist's work more intensively than any of the other masters of the Carracci school, although his type of chiaroscuro was also found in works by Dosso Dossi, Tintoretto, Palma Giovane and the Bassani.

GIOVANNI LANFRANCO

Born 1582 in Parma; first studied with Agostino Carracci in Rome, where he collaborated on the frescoes in the Palazzo Farnese, and also did some independent work (Camerino degli Eremiti). 1610-11 again in his native city, until 1634 in Rome. From 1634-1646, Naples, and then in Rome until his death in 1647. Apart from Guercino and his Aurora Ludovisi, it was Lanfranco who actually pioneered the illusionist, turbulent wall- and ceiling-painting in Rome and Naples. He was a forerunner of Cortona and other High Baroque artists, and in diametric opposition to his former fellow-student at Annibale's, Domenichino. Correggio's frescoes in Parma made a lifelong impression on him, and continuously influenced his work, determining his version of Baroque painting, also in religious subjects. His talented pupil Beinaschi took over these tendencies. Correggio's "morbidezza" and soft fluidum also affected Lanfranco's drawings, which have only lately received much attention: masterpieces of pictorial/luminarist expression, in which the line entirely dissolves in light, often anticipating the age of Tiepolo.

76 St. Peter walking on the waters towards Christ

At the back, fishing boat with Apostles. Graphite/slate, red chalk, pen and ink, bistre wash. Grid in red and black chalk. 309 x 266; Inv. 2798; S.L. 235. B. 8.

Bottom left, wide strip, patch; further patches at top edge. Old graphite inscription "Lanfranco" and number "H. 148" (ink). On the back of the mount, Bellori's relevant text-reference.

Orig.: *J. Richardson (Lugt 2169, recto).*

Lit.: *Passeri; Hess; Bellori; Voss, Barock; Bean; Vitzthum; Roli.*

Sketch for an altar picture for St. Peter in Rome, commissioned from Lanfranco by Urban VIII in 1626, paid for in 1631, and replaced by a mosaic in 1726. Only a torso is preserved from the original painting, now in the Vatican Gallery. Gerard Audran and Pietro Aquila created engravings, reversed left to right, after this composition, which was highly esteemed in its time. It forms a Baroque link with Giotto's famous mosaic in St. Peter, "the Navicella," which itself was restored and changed in the 17th century. Giotto had presented a frontal Christ, and shown a fisherman outside the Apostles' boat on the bank. Lanfranco's rendering is both more human and more passionate; the Apostles themselves are engaged in fishing, although this is not reported in the gospel (Matthew XIV). The Louvre possesses a further design in the same technique, only sketchier and with stronger wash (Inv. 6312, formerly Coll. Crozat). This drawing is earlier than the sheet in the Albertina, which was occasionally disputed; on the suggestion of this writer it is now again regarded as the work of Lanfranco.

Lit. on the drawing: *Wickhoff, S.L. 235 ("autograph"); Bean, E.C. Louvre 1959, No. 14; Bean Vitzthum, p. 106 ff., fig. 2, 3 (Louvre); Benesch, Meister Zeichnungen, No. 47; Roli, No. 38. For Giotto, a.o., Wilhelm Hausenstein, Berlin, s.a., p. 195 ff. (with ill. of mosaic, and copies as well as the new version by Andrea da Firenze in Santa Maria Novella, showing Chirst walking towards St Peter, as later Lanfranco).*

PIETRO BERRETTINI, CALLED PIETRO DA CORTONA

Born 1596 in Cortona, in a family of long established builders and masons. Pupil of Andrea Commodi, whom he followed to Rome in 1612. 1614 at Baccio Ciarpi's. Studied works of Raphael, Michelangelo, the Carracci and Caravaggio, and especially Borgianni and Rubens. Through the Marchese Sacchetti, his first client, and the poet Marino Marini, he gained entrance to the circle of Urban VIII, under whose patronage he became one of the leading painters and architects in Rome. Also worked in Florence where he was in 1637, 1640-42; from 1644 to 1648 worked on the decorations at the Palazzo Pitti. Cortona, together with Bernini and Borromini, was in the very center of Roman creative life, and instrumental in shaping its High Baroque phase. He consorted with members of Cassiano del Pozzo's circle, Poussin, Testa and Mola, and was the principal of the Accademia di San Luca from 1634 to 1638, both during the quarrel with the Netherlandish "Schilderbent" (1635) and the argument with Andrea Sacchi and representatives of the classical movement. In 1669 he died in Rome, where the ceiling-frescos in the Palazzo Barberini (1633-39) and the Chiesa Nuova (Santa Maria in Vallicella, 1648-65) number among his best-known works and mark the apogee of the High Baroque in Rome. As a landscape painter, Cortona attracted attention in particular with his early work (frescos in the Villa Sacchetti in Castelfusano, 1626-29), in which he perpetuated the Carracci's and Domenichino's artistic heritage (and sometimes also Paul Bril's).

From the beginning he pioneered a large-scale, patchy, spontaneous, open way of painting, "quella immediatezza e freschezza di scrittura" (Briganti) with which he formed a school and became the leader of the *macchiettisti*. His graphic style underwent an analogous development, and increasingly departed from the Florentine tradition of "*disegno.*" Only his pen and ink drawings, which he occasionally created as parallels to studies in chalk or brush, carry at times echoes of this tradition, insofar as it is not hidden under light-and-shade hatching.

77 Christ and the Samaritan woman at the well

Chalk, pen and ink, bistre wash and heightened in white body color, buff paper. 249 x 333; Inv. 885. R. 706.

Lit.: *Passeri-Hess; Baldinucci; Wibiral; Briganti; E.C. Bologna 1962; Roli.*

Fresco design for the chapel of the Villa Sacchetti in Castelfusano, about 1628 (Briganti). In the painting, Cortona altered the movement of the figures and considerably enlarged the landscape; the background contains motifs of the coastline near Castelfusano. The composition is still orientated towards the Carracci, particularly in the drawing and the pathos, which is restrained in comparison with the master's later work, such as the ceiling fresco of the Palazzo Barberini of the following decade. It especially recalls the paintings of the same subject by Annibale, in the Brera at Milan, and in the Vienna Kunsthistorisches Museum (E.C. Bologna 1956, Pl. 87 and 101. See also Fenyö, Pl. 83, Lodovico C.)

The loosened manner of drawing, where line, wash and blank space are considered of equal importance, is in keeping with the leader of the "macchiettisti." Cortona worked at the country house of the Marchese Marcello Sacchetti from 1626-1630.

Lit. on the drawing: *Wickhoff, S.R. 989; R. 706; Briganti, p. 325; No. 885, ill. 88 (see also 67); E.C. Claude 1964, No. 219.*

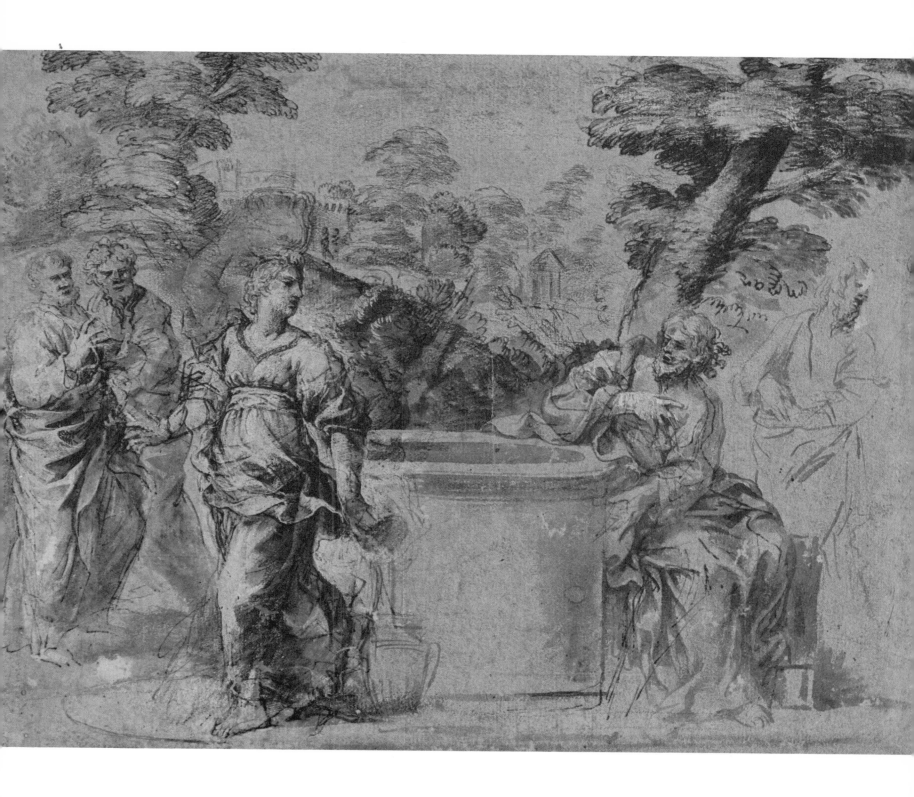

78 Young woman's head

*Head and shoulders, half-profile, seen diagonally
from above.*

*Chalk, red chalk, white heightening, blue/grey
paper. 285 x 210; Inv. 24, 554.*

Orig.: *Luigi Grassi (Lugt 1171). Old inscription,
"Di Pietro da C." (ink).*

Study for the young woman holding the garland,
in the right corner of the mural "The Golden
Age" in the *Sala della Stufa* at the Pitti Palace,
Florence, created in 1637. An almost identical
but less vivid study is in the Louvre (Inv. 579).
A further study in the Uffizi, after the same
model but worked out only in the main features,
is probably the first version (Inv. II. 758). The
Louvre has most of the studies for the other
figures of the "Golden" and "Silver Age"; these
correspond also in graphic technique to the
sheet in the Albertina. In these studies, in which
sensuality and life are emphasized no less than
in the frescoes, Cortona is evidently competing
with Rubens.

Lit. on the drawing: *A. Stix, Belvedere 1930, II,
Pl. 1221; R. 704; Briganti, p. 326, fig. 170 (see
also Pl. 159, 162, 287/42, 52).*

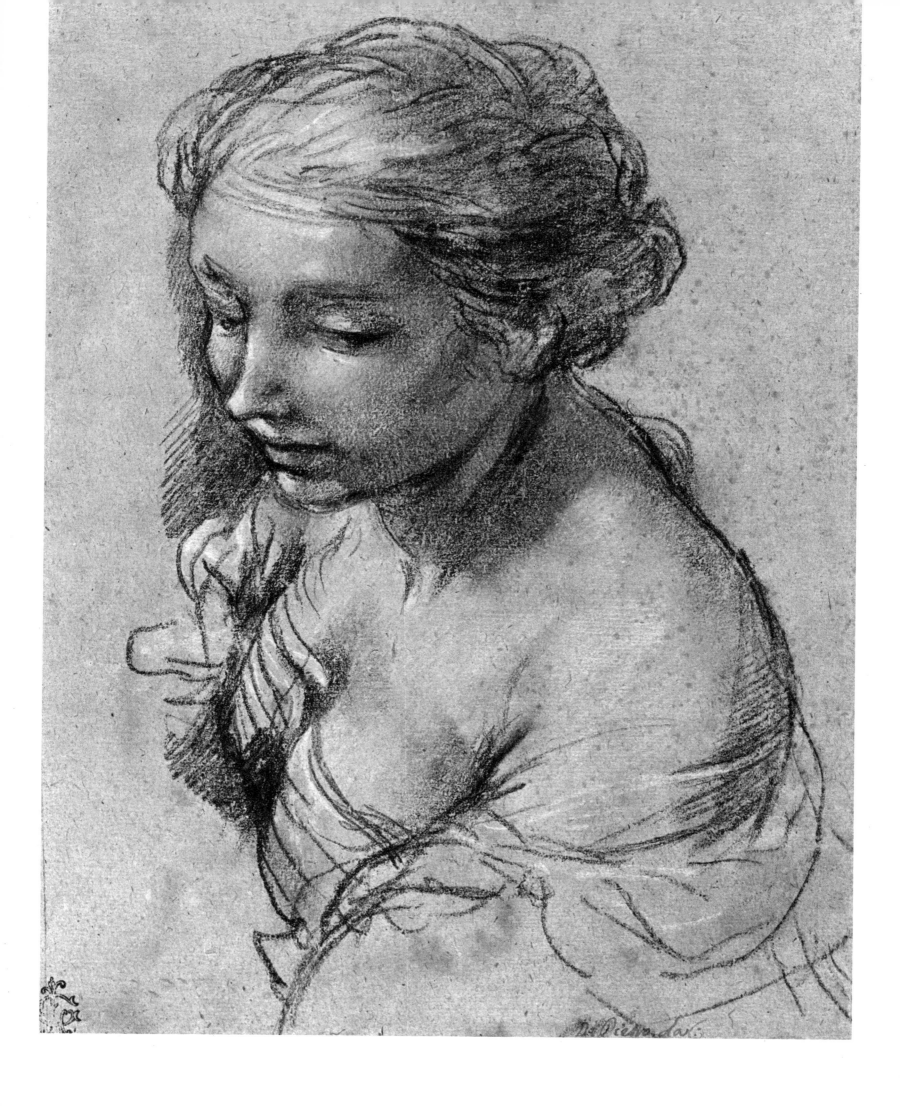

79 San Carlo Borromeo visiting the sick

Chalk, pen and ink, bistre wash. 381 x 216; Inv. 23176. Acquired 1923 as a Giuseppe M. Crespi. The ink has in some places eaten through the paper. Top, some pink brush marks probably unintended.

Sketch and first idea ("primo pensiero") for the painting on a panel for the High Altar in San Carlo ai Catinari in Rome, put up in 1667. The Albertina has another, later sketch for it, showing, as does the painting, San Carlo in procession with the relic of the Cross under a canopy, accompanied by choristers carrying burning torches. (R. 714: Charcoal, pen and ink. Briganti: Pl. 283, 284. "San Carlo porta in processione il Sacro Chiodo fra gli appestati.") The sheet shown was once attributed to Francesco Maffei from Vicenza and also, tentatively, to Morazzone. It leans on an even earlier composition painted by Pierre Mignard in 1657 for the same High Altar before his return to France, and which is today in the Museum of Narbonne. It was engraved by François Poilly (later also by Audran) and a sketch in oils is in the collection of the Marchese Tupputi di Schinosa in Naples. Mignard depicted the Saint visiting a plague hospital and giving Holy Communion; in this composition, with loggia-like architecture and a view to the outside, the artist followed Domenichino's Communion of St. Jerome, now in the Vatican Pinacoteca (Voss 196). Mignard enlarged the architectural scenery in order to include scenes from hospital life, on the right and the left, in his narrative. Of these only rudiments remain in Cortona's sketch, like the colonnade indicated in temperamental brush strokes and the barely recognizable sickbed in the background. The putti that flutter beneath the arch were also borrowed from Mignard, and thus from Domenichino, although Cortona transferred them from their original position on the other side. For the rest, he considerably simplified and dramatized Mignard's composition. There is a pentimento visible in the chalk sketch of the Saint's head. Many elements in this highly turbulent sketch, which because of its light and shade effects indeed recalls Northern Italian masters like Guercino and Mola, as well as Gaulli, were used in the finished painting: The figure of the Saint, his positioning among the throng of the sick, and the woman turning towards him, left, front. She is missing in the second Albertina sketch, which otherwise more closely approaches the composition of the painting (R. 714, Briganti, fig. 283). The sketches "St. Margaret of Cortona's vision of Christ" in the Uffizi (Inv. 3003 S) and "Mary in the Temple" in the Louvre (Inv. 479) are executed in a similar dramatic chiaroscuro manner and probably also date from the master's final creative period (Briganti, Pl. 287/38 and 288/73).

Lit. on the drawing: B. 741 (Appendix, Maffei); E.C. Venice 1959, Disegni, No. 61 (Maffei). For the painting, Briganti, p. 268, No. 143. For Mignard, Ferdinando Bologna, La Revue des Arts VIII, Paris 1958, p. 107 ff.

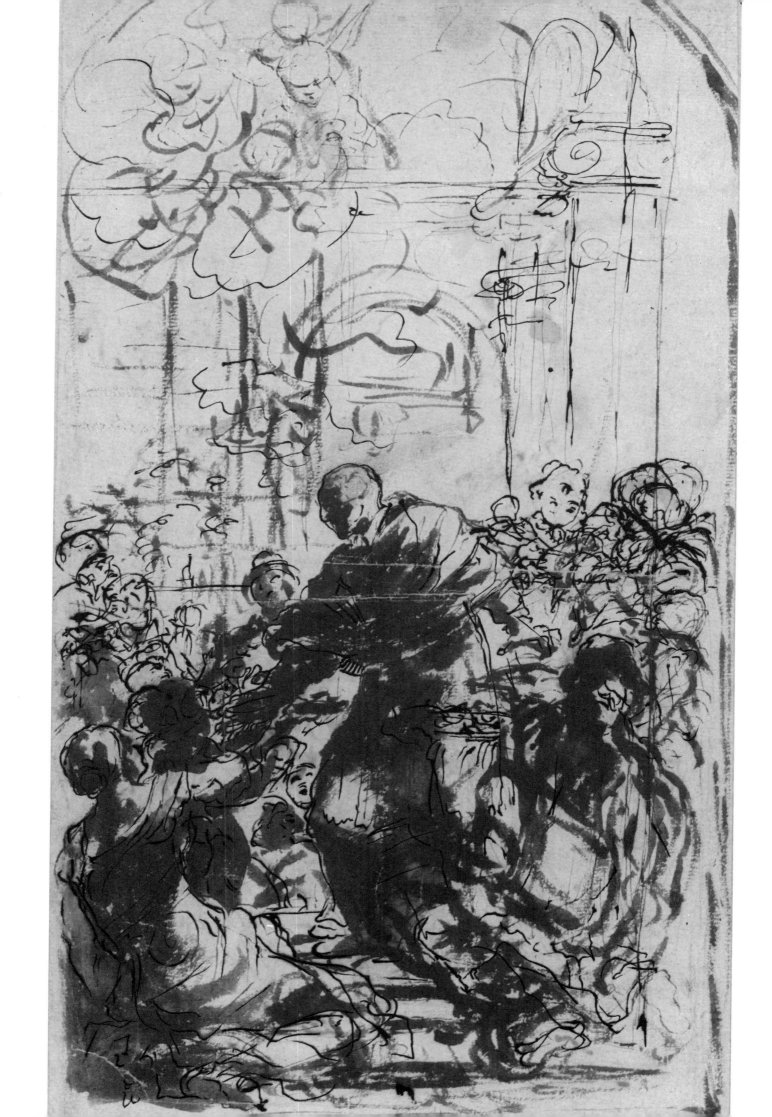

PIER FRANCESCO MOLA

Born 1612 in Coldrerio near Como. Son of the architect Giovanni B. Mola, who already took him to Rome in 1616 and apprenticed him first to Prospero Orsi and then to Giuseppe Cesari (Cavaliere d'Arpino). Formatively trained further by Francesco Albani in Bologna, by Guercino, and then pursued his studies extensively in Venice. In Rome, Mola consorted with Cortona, Poussin and Pietro Testa, a friend whose portrait he painted in 1637 in Lucca (drawing now in Montpellier) and with whom he shared a taste for atmospheric landscapes. 1641, in Coldrerio, then until his death, 1666, continuously active in Rome. Principal of the Accademia di San Lucca 1662/63. Guercino's influence stimulated the drawings of Mola, who heightened that artist's atmospheric, loose style in Baroque intensity. Like Guercino and the Carracci, Mola also produced caricatures, — approaching those of Bernini. He altogether differed as a draughtsman from his friend Testa who, as a native Tuscan, kept greater faith with the expressive force of the line, the "disegno."

80 Rachel by the well

Pen and ink, bistre wash, heightened in white body-color, blue paper, 233 x 274; Inv. 24 980; B. 281.

Orig.: *Legat Oswald Kutschera-Woborsky.*

Lit.: *Passeri; Hess; Voss; Barock (also Thieme-Becker); W. Arslan, Bollettino d'arte, Rome 1925; Marabottini (Testa), Eckhard Schaar, Jnl. f. Kunstgeschichte, 24, 1961, p. 154 ff.; Ann B. Sutherland, Burlington Mag. CVI, 1964, p. 663 ff.; John Rowlands, Master Drawings 11/3, 1964, p. 217 ff.; Roli E.C. Düsseldorf 1969.*

A masterpiece of luminarist drawing in pen and brush, expressing the spirit of the "macchiettisti," Lanfranco and Cortona, from whom Mola otherwise differed in choice of subject. He preferred, like his friend Testa, intimate atmospheric scenes, even for historical paintings and landscapes, and was less of a fresco painter. This sheet is a spirited High Baroque counterpart to the calmer, more enclosed landscape-studies and scenes of a Claude, Poussin or Testa: artists nearer to Mola, both personally and conceptually. Like Claude, Poussin, Gaspard Dughet or the Bolognese Grimaldi, Mola succeeded in exploiting the blue tone of the paper, popular in Venice since the days of Bellini, as a mood-evoking link between landscape and action.

Lit. on the drawing: *B. 281. E.C. Claude, 1964, No. 236.*

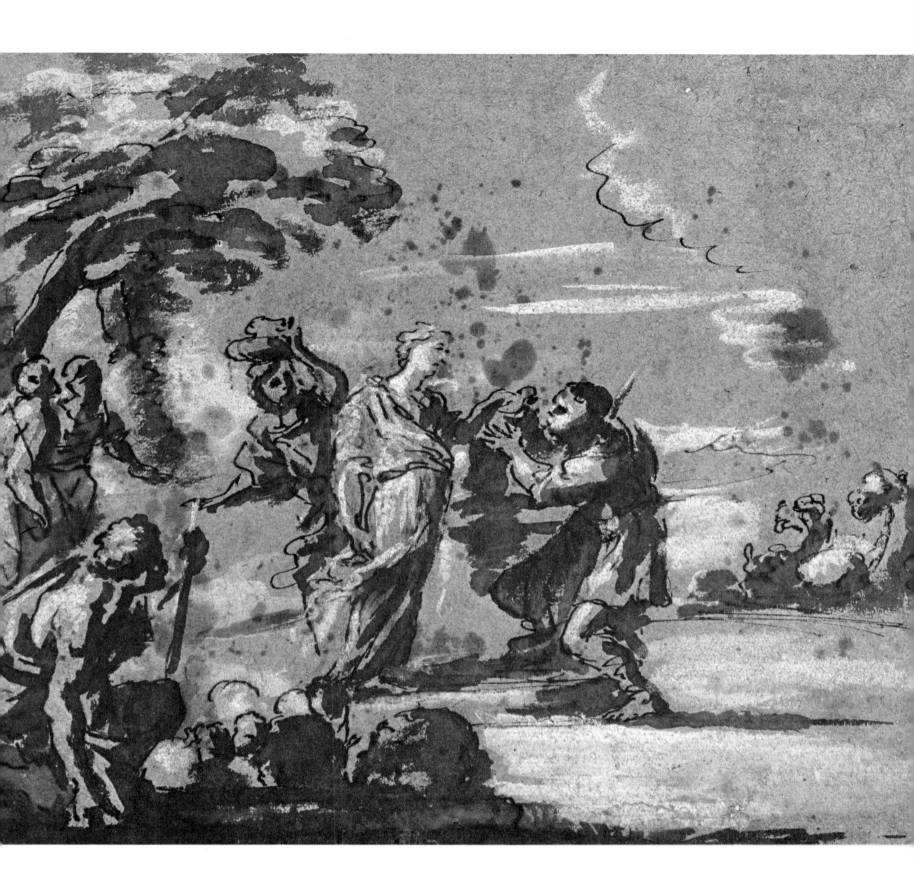

STEFANO DELLA BELLA

Florence 1616-1664, son of the sculptor Francesco della Bella (collaborator of Giovanni da Bologna), taught by the goldsmiths Gasparo Mola and Orazio Vanni, and soon made drawings after the engravings of Callot, who inspired him all his life. Further training from the painter and etcher G.B. Vanni, himself a pupil of Giulio Parigi's, "con qualche assistenza di Remigio Cantagallina" (Baldinucci) and Cesare Dandini. "... posta da parte la pittura, si diede tutto all'intaglio" (Baldinucci). Was successor to Callot, whose patron Don Lorenzo, brother of Cosimo II, became his own and sent him to work and study in Rome from 1633-1636 (Baldinucci speaks of three years). He produced his first important work, "The entrance of the Polish ambassador," in Rome in 1633. 1639 he went to Paris where he worked, with some interruptions, until 1650. Important commissions, such as the "Siege of Arras" from Cardinal Richelieu, collaboration with Israel Silvestre, an old friend from Rome, the publishers Israel Henriet (a friend of Callot's), Langlois (Ciartres) and Pierre Mariette filled these creatively most productive years. A journey to Belgium and Holland in 1647 took him to Amsterdam, where he made etchings of the port and probably also met Rembrandt, whose drawings and etchings influenced his own. The troubles of the Fronde in 1648/49, and a longing for Italy, especially Rome of which "tanto amati sassi, antichità e rovine" confirmed his determination to return in spite of being high in Cardinal Mazarin's favor. 1650-52 in Rome, and from then on, except for further short visits to Rome, chiefly in Florence under the patronage of Prince Mattia de' Medici — where he died in 1664. Stefano was the most gifted and independent of Callot's followers. While he did not equal him in memorable sharpness of expression "non ebbe una taglia così pulita, quanto quella del Callot" (Baldinucci), he excelled him especially in his more mature work, in the melting, poetical quality of his engraving, which he achieved by change to a softer, more atmospheric needle-technique. This change is also noticeable in his drawings. Baldinucci mentions "un certo gusto più pittoresco di quello di Callot." In his landscapes "birds are singing, waters are rushing and leaves are trembling" writes Cornelius de Bie (1661). Jombert (1772) already compares him to Claude Lorraine, whose work he may have known. Versatile as he was without giving up his own individuality, he also approached the art of the Castiglione and the High Baroque of Cortona and Bernini.

Bella's contemporaries (Baldinucci) thought him equal to Callot and esteemed him accordingly; Pierre Jean Mariette, the great 18th century connoisseur, preferred him; in the following century he was largely ignored and his work mistaken for Callot's.

81 Death rides in triumph over the battlefield

Top right, study for horse and drapery.

Graphite, red chalk, pen and ink, watercolor wash. 194 x 219; Inv. 961; R. 538.

Orig.: *Fries (Lugt 2903).*

Lit.: *Baldinucci; Cornelius de Bie; Jombert; Vesme; E.C. Callot 1968.*

Design for the etching of the same title (reversed right to left), of the year 1663, with the verse "Ici la Mort triomphe entre les Funerailles; se plus beaux promenoirs sont les lieux des batailles... ." Stefano della Bella, in this devastating allegory of the victor of all battles, translated the message of Jacques Callot's "Misères de la guerre" into the allegorical idiom of the High Baroque, which finds similar expression in Bernini's tombs where death, in a different context, is nevertheless personified. The root of such renderings, of course, lies in the dances of death of the late middle ages and the German Renaissance (Baldung, Holbein etc.) with which della Bella was familiar.

He repeatedly returned to this subject before his death.

The etching (Jombert 227, Vesme 93) is more comprehensive and detailed, with a large battlefield and many turbulent scenes, minutely etched in the manner of Callot, in the background.

The pictorial arrangement of the drawing, and the free, energetically placed lines are characteristic for della Bella's mature work, and reminiscent of such masters of the High Baroque as Bernini, Cortona, and Baldassare Franceschini (Il Volterrano) who had worked in Florence and — similar to della Bella, except as a painter — grew up in the Florentine tradition of the "disegno" that had its last high-point in the work of Callot. The partial studies, top right, are drawn in that older style, strongly leaning on that of Callot, and suggest that della Bella already made use of the sheet in the thirties.

Lit. on the drawing: *Wickhoff, S.R. 1071, Pl. X; R. 538; Benesch, Meisterzeichnungen, No. 52; E.C. Callot 1968, No. 580 and 807, Pl. 37 and 52.*

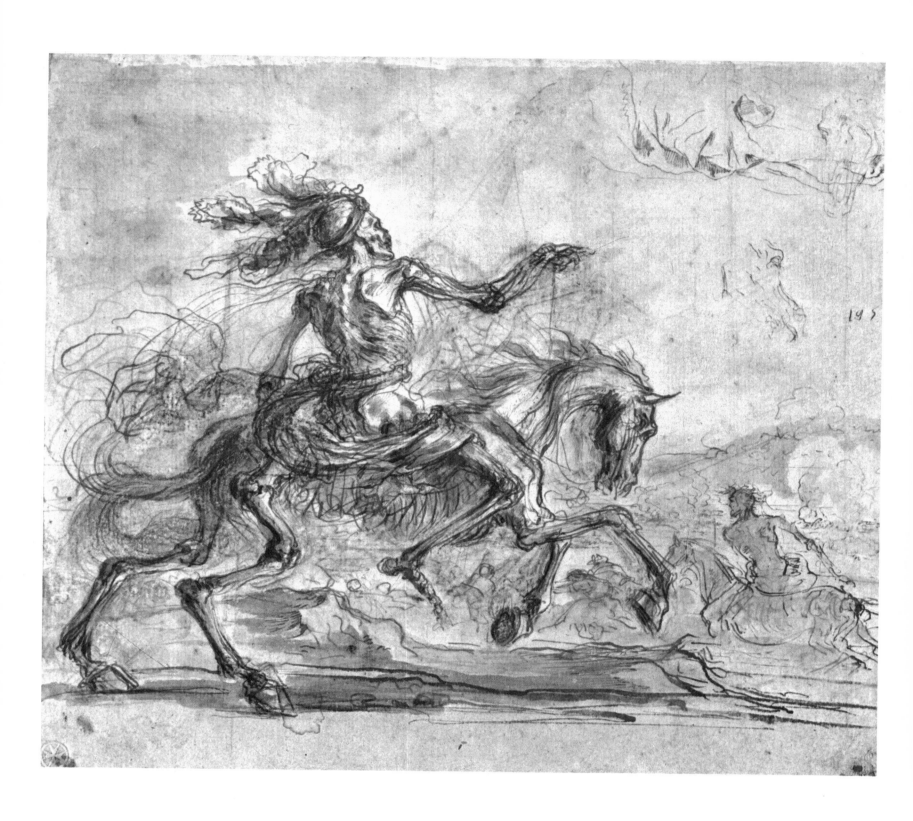

BALDASSARE FRANCESCHINI, CALLED IL VOLTERRANO

Born in Volterra; first, pupil of his father, the sculptor Gasparo Franceschini, who sent him in 1628 to Matteo Rosselli in Florence, where he was trained as a painter until 1630. After temporary activity in Volterra during 1630 and '31, he settled in Florence, where he died in 1689. In 1635, he collaborated with Giovanni da San Giovanni on the frescoes of the Palazzo Pitti, and in 1636 was employed as independent fresco painter in the Medici's Villa Petraia. 1640 and 1652 Don Lorenzo de' Medici (patron of Callot and Stefano della Bella) and Filippo Niccolini sent him on educational journeys to Bologna, Ferrara, Venice and Parma, in 1652 also to Rome. In the course of his travels, he exchanged the impulsive naturalism of the Florentine kind, as seen in the painting "Burla del piovano Arlotto," in the Uffizi — long attributed to Manozzi — for a picturesque High Baroque style. In this, he was formatively influenced by Correggio and Cortona, whose Florentine activities (Palazzo Pitti, 1637, 1640-42, 1644-48) much stimulated Franceschini. His style grew increasingly expressive and dramatic, and excelled that of Cortona and his pupil Ciro Ferri, over whom he was victorious in the competition for the commission of the Annunziata-ceiling in 1664. In this work, his spontaneous realism repeatedly breaks through. Apart from the ceiling-paintings in oil, and the Tribuna frescoes of the Church of the Annunziata in Florence (1664-70, 1676-83), the most important work in his High Baroque phase consisted of the dome-frescoes of the Capella Niccolini in Santa Croce, (1652-60) — a much admired masterpiece of *sotto in su* painting. His change of style is apparent also in his drawings, of which the Uffizi own the lion's share of three hundred sheets, followed by the Albertina with sixty-seven sheets from almost every period of his creative activity (R.634-99 a.o.). Thus the sure, controlled line of his early sheets — which rivalled Rosselli's and Manozzi's (i.e. R. 653, 675, 676, 685-688) — makes way for an open, nervous manner of drawing, searching for passionate expression that sometimes causes Franceschini to be mistaken for Cortona or Ciro Ferri, German artists, or Austrians like Daniel Gran. In this aspect, he may also be considered with Bernini and Gaulli. Mariette already reported "J'ai des dessins de lui, qui sont tellement dans la manière de Pietro da Cortona, qu'on le croisait disciple de ce grand peintre." Like Cortona, Franceschini also had architectural talents, which he expressed in numerous designs.

82 Sketch for the Road to Calvary

St. Veronica offers the cloak to Christ stumbling under the cross. Front right, Mary in a faint, with two female figures. Graphite, red chalk, on yellowish paper. 281 x 220. Patch at right bottom corner. Inv. 23932; R. 649. Acquired 1924.

Lit.: *Baldinucci; Bocchi-Cinelli*, Le bellezze di Firenze, *1677; Mariette; Benesch*, Meisterzeichnungen; *Roli.*

Design for the picture in the Gallery Corsini in Florence, painted for the Marchese Carlo Gerini as a counterpart to a "Rest on the flight into Egypt" (cf. Baldinucci, XVIII, p. 116 f.). Both pictures were engraved by Lorenzo Lorenzi about 1750. Created after 1662, while Franceschini was working on the Assunta-ceiling of the Annunziata church in Florence. The line moves more nervously than that of Cortona and Ciro Ferri, his fellow-competitor for the Annunziata-ceiling, while the Tuscan sense for "disegno," the defining line, reappears and renews its impact among the effects typical for the High Baroque and incidental effects of the "macchiettisti." The tonal contrasts of color are also in keeping with this feeling.

Lit. on the drawing: *R. 649 (general).*

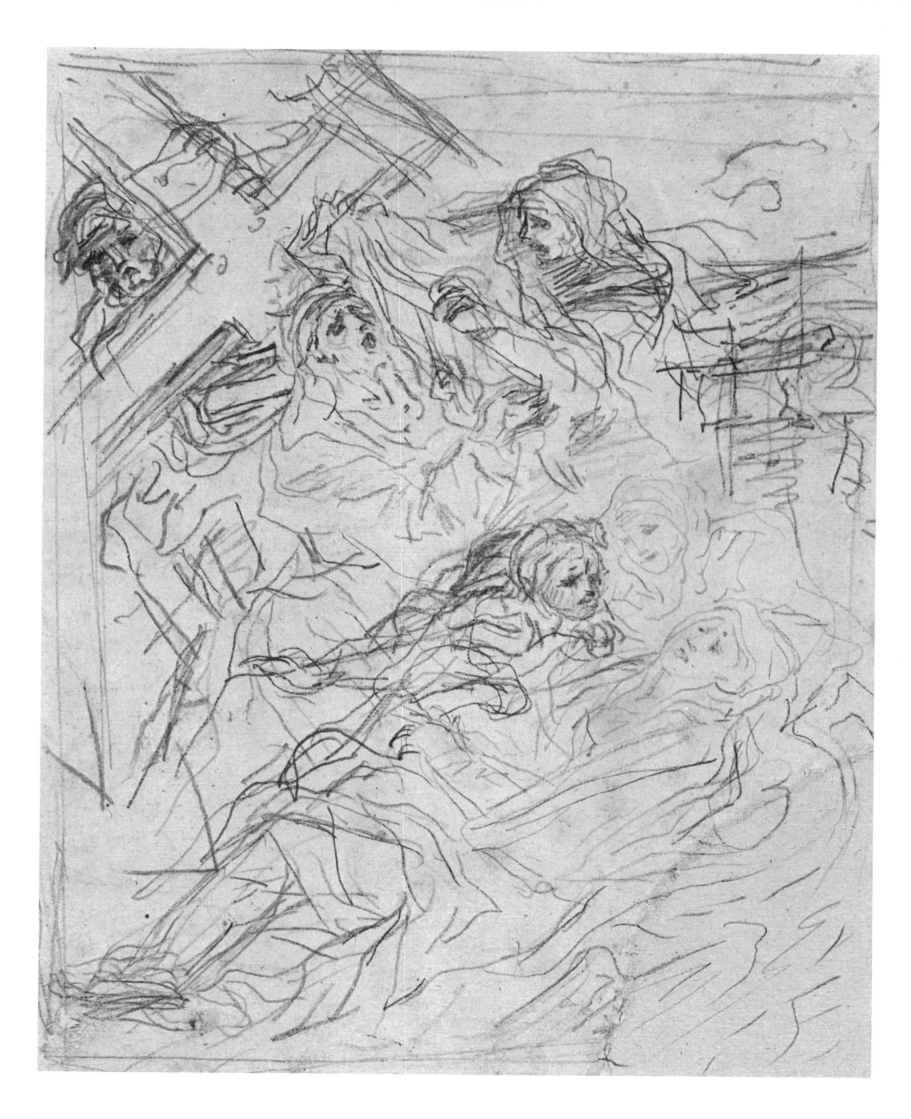

Born 1613 in Taverna, came to Rome in 1630, trained under the influence of Ribera, the Roman followers of Caravaggio, Guercino, Lanfranco and Pietro da Cortona, under whose direction he was to paint the huge frescoes in San Andrea della Valle in 1650/51. 1641 he entered the Order of the Knights of Malta in Rome. 1653/56 in Modena (frescoes in San Bigo), also in Bologna, where he met Guercino; then in Venice and Genoa; 1656-61 he stayed in Naples and Rome (1660), then until his death in 1699 in La Valetta in Malta. 1672, he once more visited his native city of Taverna.

Preti was after Ribera one of the most important and at the same time most individual of Caravaggio's followers, whose realism he endowed with new High Baroque and colorist emphasis. The latter may also have been stimulated by his studies of the Venetians, especially of Veronese, the Bassani, Liss and Feti. The young Luca Giordano was his student.

As a draughtsman Preti was also one of the greatest talents of the Neapolitan school, and skilled in every technique: chalk, red chalk, pen and brush. He was a particular master of spontaneous expression of movement, the sparest possible pictorial indication, chiaroscuro, as well as plastic effects. In this area, too, Luca Giordano and later artists learned much from him. Characteristic for him, as for other painters of similar temperament, is the description of Preti's working methods by Dominici, who had met the old Master himself, "dopo che il cavaliere si avea col pensiero formato l'idea del soggetto, lo abbozzava in più maniere sopra la carta e di quel che più gli piaceva, fermava poscia il disegno, e dal disegno le figure sul naturale... Disegnavalo poi con semplice chiaroscuro trattizato con signi grossi" (quoted by Ivanoff, p. 131).

83 St. John the Baptist

Seen from below. Red chalk, red wash, 286 x 231; Inv. 981. B. 584.

Orig.: *Mariette (Lugt 1852) old note "Mattias Preti" (Pencil).*

Lit.: *Pascoli; De Dominici, B. Chimirri; A. Frangipane,* Mattia Preti, *Milano 1941; Valerio Mariani,* Mattia Preti a Malta, *Rome, 1929; Raffaello Causa,* Emporium *CXVI, Bergamo 1952; Ivanoff; Vitzthum, Oeil; Vitzthum,* E.C. Naples *1966;* Florence 1967; E.C. Paris *1967; Rome 1969.*

Classified by Walter Vitzthum as a preliminary study to the fresco of the Baptism of Christ in the fourth *campata* in San Giovanni in La Valetta. There is a further study in the Ecole des Beaux-Arts in Paris (Inv. 295). The painting, created between 1663 and 1666, shows the figure much changed and in profile (Mariani, fig. 22, 23). Preti, at all events, also used these studies for the figure of Christ, in similar frontal view, in "Ecce Homo", a ceiling painting on canvas in the Oratory of S. Giovanni (Mariani, fig. 54) and in the 1677 painting of St. John for the Altar in the Dominican church at Taverna, where the Master also included a self-portrait (Chimirri-Frangipane, Pl. XXXIII).

One of the most powerful drawings from the height of his creative life. The realism of Ribera and Guercino — highly congenial to Preti, who drew much inspiration from him — appears charged with High Baroque drama, in the spirit of Lanfranco and Cortona. The forceful foreshortening and expressive "incorrect" drawing — explained by the angle from which the painting was to be seen — misled Wickhoff to interpret the figure as the risen Christ. The effect of the modelling, developed from the pictorial fluidum, are also typical for this period of Preti's work.

Lit. on the drawing: *Wickhoff, S.R. 1092; B. 584; Vitzthum; E.C. Florence 1967, p. 51 (under No. 79), 54 (No. 81).*

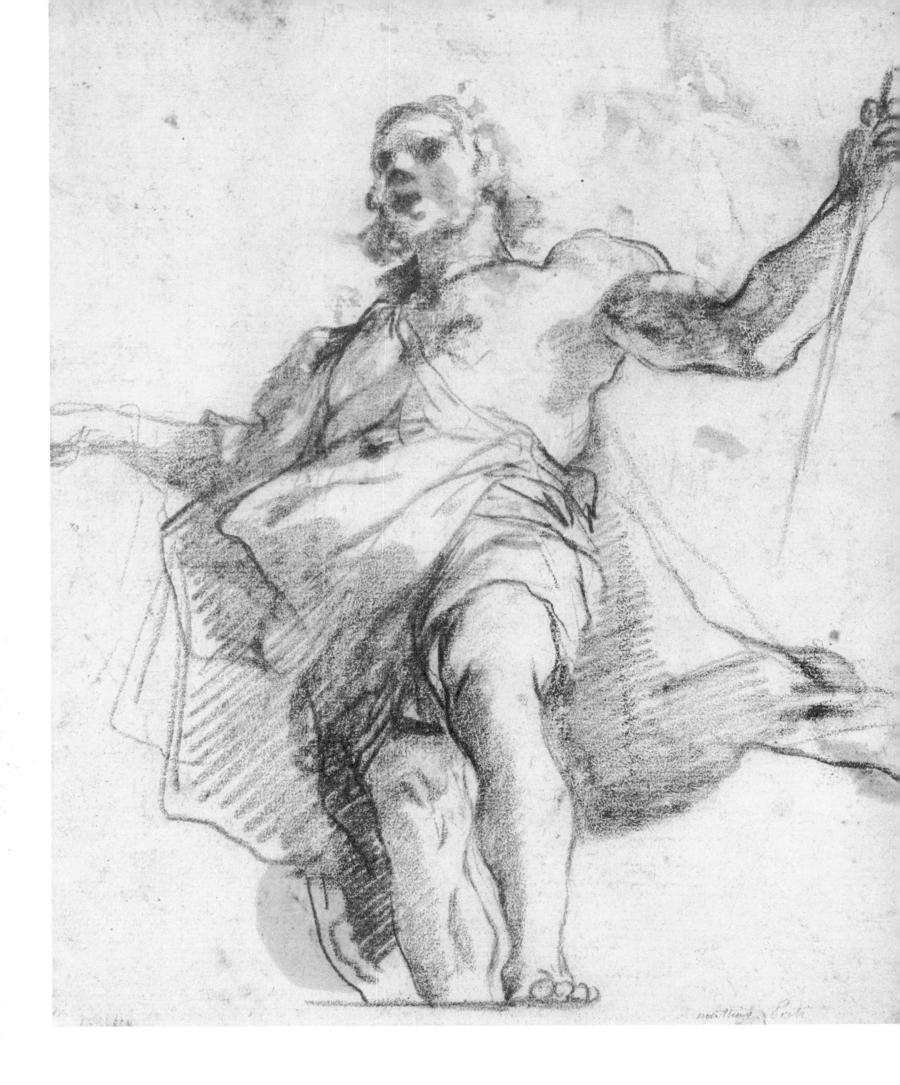

BENEDETTO CASTIGLIONE, CALLED IL GRECHETTO

Born Genoa approximately 1600 (Blunt), taught by Giovanni Batt. Paggi, Gio. Andrea de Ferrari, Van Dyck (1621-1627 in Genoa) and Sinibaldo Scorza, a painter of animals and pastorales, mythological and biblical scenes, whose impact on Castiglione was the most lasting. He was also influenced by Jan Roos, an animal painter working in Genoa who had been a pupil of Snyders, and from as early as 1630 by the etchings of Rembrandt, which he was one of the first to copy, and to which he was constantly to return even in his mature work. His Rembrandt interpretation was to be influential — mainly in the 18th century in Italy, France and in Germany to the days of Goethe (Munz). From 1634 to 1648 in Rome, where he was a member of Poussin's and Claude's circle, which attracted "il Grechetto" because of his taste for Arcadian subjects. But in Rome, he also approached the High Baroque of Cortona, Bernini and even Rubens, to whom he had not paid much attention nearer home, during his youth in Genoa. In Rome and Naples, where he was in 1635, he influenced Salvator Rosa. 1645, he stayed in Genoa. In the last two decades of his life, Castiglione worked chiefly for the Mantuan court, staying in turn in Genoa, Parma, Venice and Mantua, where he died in 1670.

Draughtsman, etcher and master of monotype printing, which he had invented in 1645, and which was made to measure for his picturesque and expressive idiom, Castiglione was one of the most important artists to pave the way for 18th century art, especially for Tiepolo, whose "scherzi" and "capricci" he anticipated, and Fragonard. After the Castiglione collection at Windsor, the largest of its kind, comes that of the Albertina: one of the most important, also, in engravings and monotypes.

84 Adoration of the Shepherds

Brush, and red/brown oil and turpentine paint. 422 x 567; Inv. 14 421; B. 519. Old notice "Benedetto Castiglioni de la collection du Prince de Liechtenstein".

Orig.: *Prince de Ligne (Bartsch, p. 135, No. 7); Liechtenstein. Engraved by Bartolozzi (A.W. Tuer, Bartolozzi, London 1881, 11, p. 146, No. 2045).*

Lit.: *Soprani-Ratti; Delogu; Munz; Goethe; Blunt, Castiglione.*

The Christmas theme "il Presepio" suited Castiglione particularly well, as it gave him an opportunity of depicting the life of the shepherds in all its poetry, rather as Hugo van der Goes had done two centuries earlier in his famous Portinari Altar panel at the Uffizi in Florence. The Albertina owns two further Presepio-drawings in related technique and similar format (B. 518, 520). All are related to etchings, monotype prints and paintings by the Master, and were probably created during his greatest creative period, about and after 1650, when he was already working for the Gonzagas. Three sheets in Windsor have special affinities with this sheet, both in subject and style — a *Presepio* with God the Father and angels (Blunt 131, Pl. 23), another Adoration of the Shepherds (Blunt 102, Pl. 11) and an Adoration of the Magi (Blunt, 178, Pl. 37).

Lit. on the drawing: *Wickhoff, S.L. 285, No. 519; Fenyö, p. 120 ff.*

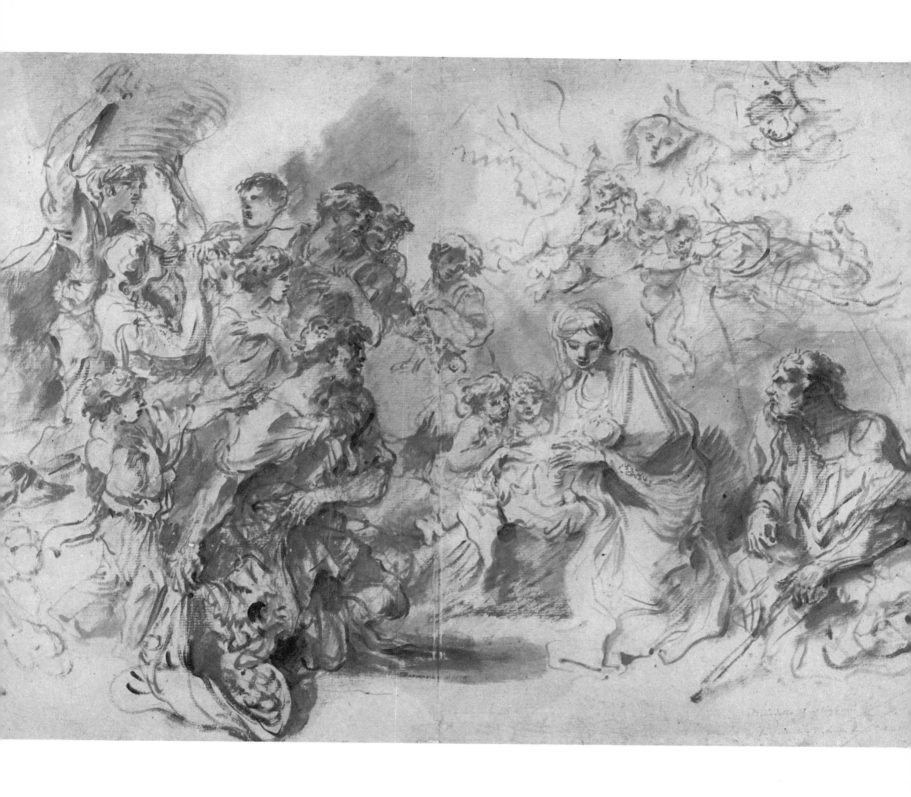

SALVATOR ROSA

Painter, engraver, poet, musician. Born 1615 in Arenella near Naples; he studied painting on his parents' suggestion, and trained with Domenico Antonio Greco, Francesco Fracanzano, Francesco Ribera and Aniello Falcone. During this time he became familiar with the art of the Caravaggio-followers and the "Bamboccianti," masters of genre-pictures with small figures in the circle of Pieter van Laer, called "Bamboccio." Rosa first became notable as a painter of battle-scenes, a subject to which he remained faithful. Came to Rome in 1635, and soon became famous. Forced to return home by an illness in 1637; back in Rome in 1639, where he occupied himself also with acting and poetry. In 1640 to 1648 at the Medici Court in Florence; there until his death in 1673.

Salvator considered himself, as did his contemporaries, as a Universal Genius, and open to every sort of stimulus, which he succeeded in fusing with his own independent personality. About 1640, he turned away from the realism of the Bamboccianti — his satire on this art-movement is well-known — and turned toward Claude's and Dughet's conception of nature; related to Dughet in his style of painting "macchietti," he emulated him (Sutton) and also occasionally the Classical style of Poussin. There is a relationship between his style and that of Pietro Testa (Ozzola) with whom he shared a liking for deserted landscapes and pastoral life, which he treated in his pictures, poems and arias — in the spirit of Sannazarro's "Arcadia." In this respect he found significance in the work of Benedetto Castiglione, who himself stayed in Rome and Naples during the thirties, and whose bucolic mythological fantasies sometimes touch on those of Rosa's, although the latter's work is charged with greater classical gravity. His loose, almost staccato, figure-style often follows Ribera; the freedom of his wash excels that of his teacher; and was to be especially admired in the 18th century. "On ne peut voir rien de plus léger ne de plus spirituel que la touche de ce maître; elle seule le peut distinguer des autres peintres," writes d'Argenville. The bravura-style of his landscapes and historical drawings points forward to Marco Ricci, Alessio de Marchis and the Guardis, and his influence on Magnasco and English landscape artists was considerable.

85 Contest between Apollo and Marsyas

Apollo with viola, Marsyas with the pipes of Pan, between them, King Midas. Nymphs and Satyrs. Chalk, pen and bistre wash, blue paper, 248 x 308; Inv. 13 176; B. 578.

Lit.: *Passeri-Hess; Baldinucci; d'Argenville; Leandro Ozzola, Salvator Rosa, Strasbourg 1908; Ozzolo, Cicerone I, Leipzig 1909, p. 601 ff.; Artoro Pettorelli, Salvator Rosa, Turin 1924; Voss; E.C. Rome 1950; p. 21 ff.; Luigi Salerno, Salvator Rosa, Florence/Milan 1963; Blunt, Castiglione; Ivanoff.*

One of the most poetic Italian drawings of the Albertina, attributed by Wickhoff to an anonymous 18th century master; by Stix and Spitzmüller, tentatively, to Andrea Vaccaro with reference to his painting "Orpheus and the Bacchantes" in the Palazzo Reale in Naples (Rinaldi, Pl. 29). Vaccaro (Naples 1609-1670) of whom hardly any drawings are known, could hardly be the creator of this sheet, considering his style of painting formed on Caravaggio's, his plastic chiaroscuro, and his rather Classic figure-ideal.

The open atmosphere in this sheet, and the loosely sketched figures, the expressions indicated with such economy of line, point strongly to Salvator Rosa. Rosa has adopted Ribera's rapid pen and ink technique, and enriched it with the lively wash that is so characteristic for him. A musician himself, he sensitively expresses in this sheet subtle gradations of musical feeling.

Lit. on the drawing: *B. 578; Wickhoff, S.D. 191; cf. Ivanoff, Pl. 90-93; E.C. Rome, 1969, Pl. 19-21.*

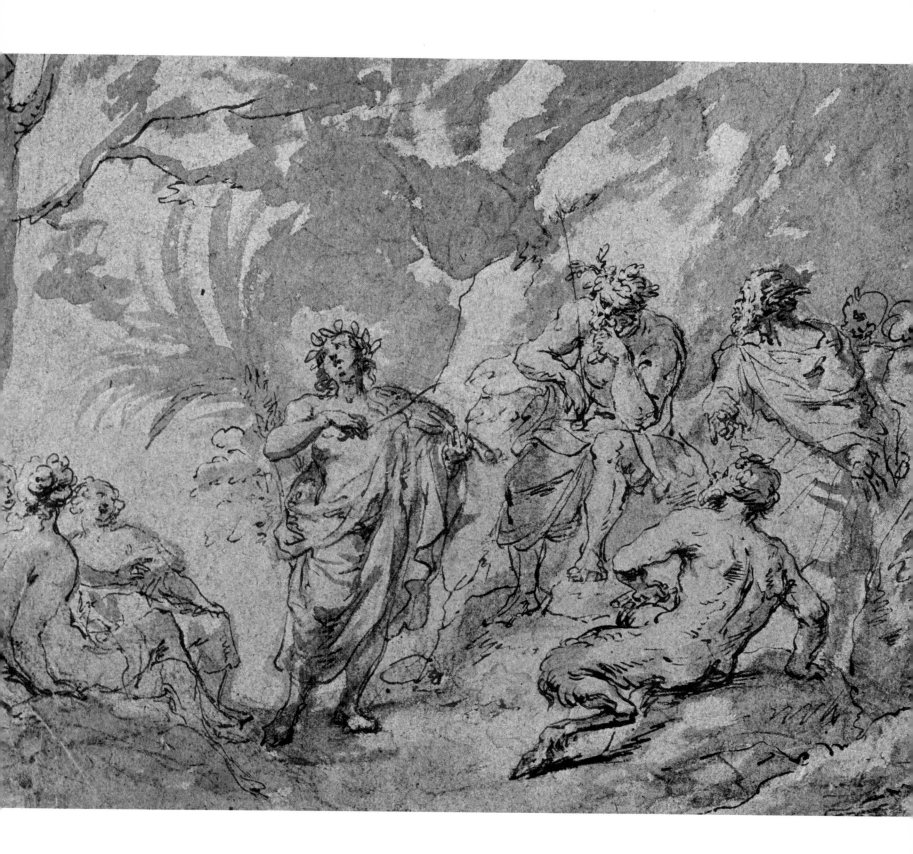

CARLO MARATTA

Born 1625 at Camerano in the Marches, came to Rome 1636 and in 1637 began his studies with Andrea Sacchi, with whom according to Bellori he is supposed to have worked for nineteen years, and who referred him mainly to Raphael's example. His fame is founded on the presepio picture in S. Giuseppe dei Falignami (Voss 335), partly inspired by Correggio's Holy Night, for which the Albertina owns a small sketch (R. 767). His frescoes of the same subject (S. Isidore, sketch 766 in the Albertina, Quirinale Palace), also creations of great, solemn and balanced composition, increased his reputation, which he enjoyed until his death in Rome in 1713. Maratta, lauded in his epitaph as "Restitutor Bonarum Artium," stood like Sacchi in opposition to the tempestuous passion and exaggerated joy in decorative effects that fired the High Baroque painting of artists like Cortona. His special preference, and strength, lay in the altarpiece, to which, like his teacher Sacchi, Raphael, and the Carracci, he gave new artistic meaning. Bernini admired him on this account. Also appreciated were his representative but vivid portraits, which he began painting in the sixties. He was less successful, though not uninfluential, in his ceiling-paintings, where he deliberately avoided illusionist tricks such as Cortona or Gaulli might have employed. (Palazzo Albieri). The particular effectiveness of his paintings lies in the broad, singing line, peculiar to him, and "the rhythmical harmony that seems predestined to ring out in grand environments" (Voss). All the same, in his late work, he comes close to the high pathos of the High Baroque, which is also expressed in the flowing lines in many of his drawings of the period, in which his pupil Giuseppe Passeri followed him. Maratta was all his life a prolific draughtsman, attested by his graphic bequest, shared mainly by the Kunstmuseum in Düsseldorf — a collection of several hundred sheets — Windsor Castle and the Academy of San Fernando and the National Library in Madrid. The Albertina's share of some twenty-five drawings may appear modest in comparison, but it is, as so often in this Collection, especially choice and varied.

86 Self-portrait

Head and shoulders, face turned slightly to right. Graphite, chalk in black and red. 506 x 363; Inv. 1042; R. 705.

Lit.: *Bellori; Passeri; Voss; Muzzetti; Blunt 1960; Schaar*, Maratta; *Dreyer.*

A late work, similar in line to the 1706 sketch (in Düsseldorf) for the double portrait of Maratta and his last patron, Marchese Niccolò Maria Pallavicini, in Stourhead. (Schaar, No. 407-411 particularly 410, 411, Pl. 104, 105). Also comparable is the self-portrait, engraved by J.J. Frey, in the Royal Gallery in Bruxelles, where the Master features as a Cavaliere, with the Order he had received from Pope Clemens XI in 1704, holding sketchbook and slate, as in the other engraving by J.H. Riedel, probably after a further drawing. The Albertina sheet, executed like an engraving, with some of the weakness in the cross-hatched interior modelling that was to occur in sheets of Maratta's last decade, when his hands trembled and would not always obey him, was presumably intended for a further portrait engraving that never materialized. The weaknesses referred to, however, do nothing to diminish the liveliness of the expression.

Lit. on the drawing: *Wickhoff, S.R. 1154; R. 765.*

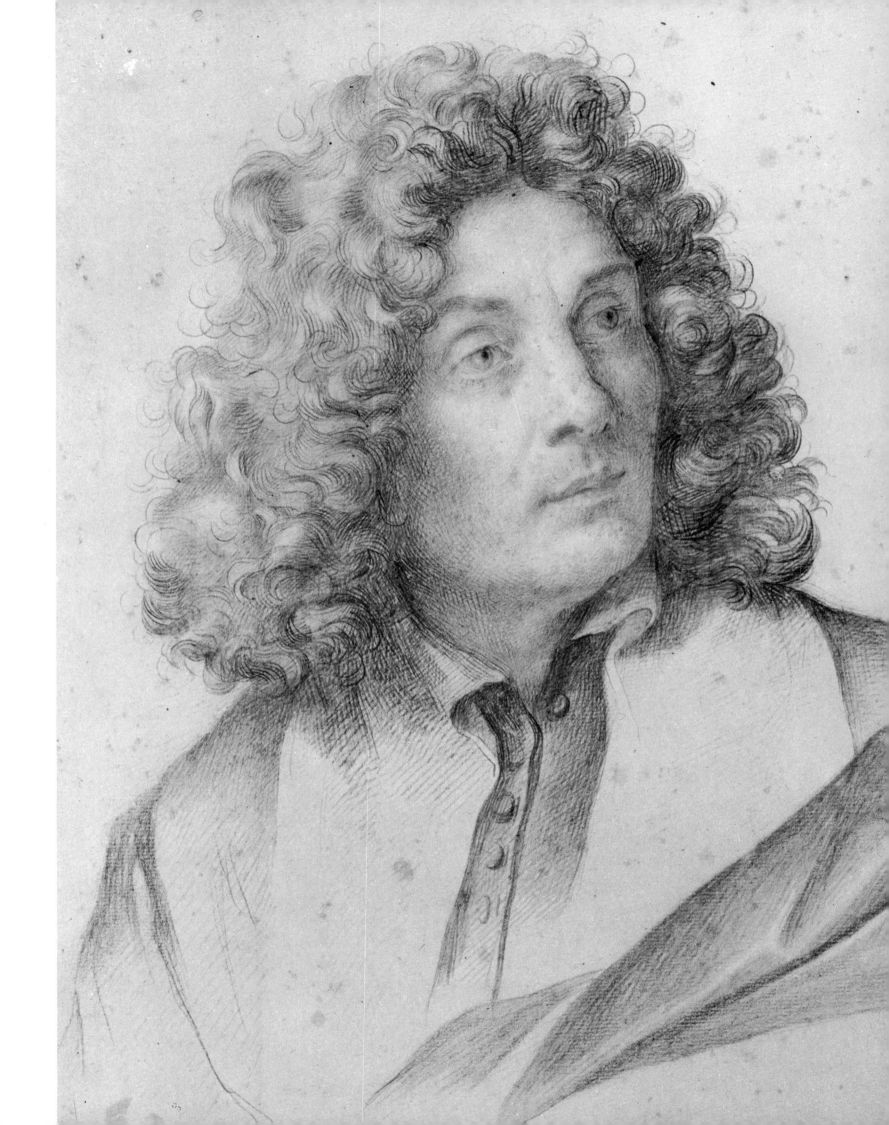

GIOVANNI BATTISTA GAULLI, CALLED BACICCIO

Born 1639 in Genoa, where he was first trained as a painter. In 1657, when his entire family was wiped out by the plague, he went to Rome and met Lorenzo Bernini, who furthered his career and lastingly influenced his creative work. Gaulli became the "interpreter in paint" of the great sculptor's mature and later work. His drawings are often taken for those of Bernini, and also of Cortona, whom he excelled in tense dynamic quality and sensual, brilliant color — a possible heritage from his Genoese home. Gaulli became a leading master of Late Baroque fresco and oil painting (also portraiture) in Rome, counterpart to Maratta and the Classical movement. A visit to Parma enriched his style with elements from the art of Correggio and his graceful, pictorial illusionism. Gaulli died in Rome in 1709.

87 Triumph of Faith

Lit. (selected): Pascali; Soprani; Ratti; Voss; M. V. Bragnoli, Paragone VII, 1950, p. 21 ff.; Enggas; Blunt 1960; Schaar; Redi; Dreyer.

Ecclesia triumphans on the "Cathedra," surrounded by Evangelists' symbols, among them the fall of vice. Text-band: "Certamen forte dedit ille ut vincere (t)." Chalk, pen and ink, wash in ink, heightened in white body-color, buff paper. 324 x 182; Inv. 2878; B. 552.

Design for a ceiling painting. The tempestuous drama, the ecstatic movements and the accented, broad lines, simulating Bernini's sculptural effects — as for instance in his Cathedra Petri in St. Peter's, of which the throne seems a conscious copy — resemble the frescoes that Bacciccio painted between 1675 and 1685, his principal work, in the church of the Gesù. The preliminary drawings are in the Kunstmuseum in Düsseldorf (see Schaar, Ill. 14; Enggas, fig. 98, 99).

88 Armida steals the sleeping Rinaldo

Red chalk, pen and ink, and grey wash. On the back: *a fountain supported by nereids and dolphins, by the side of this a small palm tree and some obelisks (for a fountain); in red chalk. Old writing on the back:* 155 — one hundred and fifty five. *Watemark: six-pointed star (Briquet 6087). 186 x 232. Inv. 24012. R. 705.*

Orig.: *M. Hévesy. Bought in 1924.*

Lit.: *R. 705 (Cortona, Diana and Endymion):* Claude Exhibition 1964, *No. 221 (Cortona); Enggas,* p. 28 ff., 133 ff., fig. 41 *(painting). For the theme: Renssalaer W. Lee, Ut Pictura Poesis, in* The Art Bulletin *XXII, New York 1940, p. 242 ff. (Fig. 9 reproduces a composition similar to a painting now to be seen in the National Museum in Stockholm, where it is attributed to Cortona, but is much more likely to be the work of Gaulli.)*

This is one of Gaulli's most poetical drawings, thanks also to its execution, which in graphic picturesque effect corresponds exactly to his paintings. The subject is taken from Canto XIV of Tasso's "Gerusalemme Liberata." The work has so far been attributed to Pietro da Cortona, and doubtlessly, especially on first sight, it is very like the light, open work of Cortona. The numbering of an old collector is the same as we find in numerous folios by Pietro da Cortona (for example R. 713). However, the connection with one of Gaulli's paintings, now in the Suida-Manning collection in New York, acknowledged by Enggas (p. 133 foll., fig. 41), and the forms, which in the quivering drapery with wide folds and caves, imitate Bernini, seem to be a proof of Gaulli's hand. On the other hand, it is linked in the same way with other paintings by Pietro da Cortona and by Gaspard Dughet (see Enggas, fig. 18-20, 36-40). The etchings on the back are directly inspired by Bernini.

SEBASTIANO RICCI

Was born in Belluno in 1659 and died in Venice in 1734. Arriving in Venice as a twelve-year-old, he studied under Federigo Cervelli and Sebastiano Mazzoni, and later, in 1678, he went to Bologna, where he studied at Giovanni Giuseppe dal Sole's school. From 1685 to 1687 he worked in Parma for Duke Ranuccio II Farnese, who invited him to go to Rome. Ricci stayed in the Farnese Palace until 1694, where he was able to study the Carracci Gallery and the works of famous painters such as Raphael, Pietro da Cortona, and Gaulli, to name just a few. When his protector died, Ricci passed through Florence, went to Pavia and then to Milan (where he did frescos in the church of Saint Bernardino dei Morti, 1695-98), and then later he went back to Venice. He was active in Vienna from 1701 to 1703 (frescos in Schönbrunn Palace); he then came back to Italy, working in Venice, Bergamo, Parma and Florence (in the Marucelli and Pitti Palaces, 1706-07). From 1712 to 1716 he was in London with his nephew Marco Ricci and there he received various important commissions (among others to paint the frescos in the Chelsea Hospital). On his way back to Italy he went to Paris, where he met Watteau. In Venice he died, after living one of the most fertile and fortunate lives an artist could hope for. Sebastiano Ricci is to be considered the true predecessor of eighteenth century Venetian art; starting out from the gloomy seventeenth century painting of his masters and predecessors (Loth, Zanchi, Langetti and others), he attained free movement of light, and his course was to be followed in the works of Tiepolo, Pellegrini, Diziani, Guardi and many others. With the exception of Tiepolo, no other artist was such a master of the currents of his time, which starting with Titian and Veronese had passed through Carracci, Reni, Pietro da Cortona, Gaulli to reach Crespi, Magnasco and Rembrandt. Rembrandt's graphic style, for example, seems revived in the light of the eighteenth century as seen in the later works of Ricci. He was an authentic virtuoso, capable of designing in the style of Callot and Watteau; he knew how to keep his originality and his own imaginativeness. The most important group of his folios is divided between Windsor (211) and the Venice Academy (133): they came from the collection of the British Consul in Venice, Joseph Smith, one of the last friends and patron of the two Riccis, of Canaletto and other Venetian masters.

89 Achilles gives Hector's dead body to Priam

In pen and ink, bistre wash, with highlights in white lead on brownish paper. 224 x 311 mm. Inv. 1753. V. 241.

Orig.: *Count Gelosi (the collector's mark differs from Lugt 513 and 545); Albert von Saxe-Teschen (L. 174).*

Lit.: *Pascoli; Orlandi; d'Argenville; Mariette; Zanetti; Lanzi; Derschau; A. Morassi in* Cronache d'Arte *1926, p. 256 ff.; Ojetti; Pallucchini I; Ornella Osti in* Commentari II, *1951, p. 119 ff.;* Blunt 1957; Pignatti; The Venice Exhibition *1969 (with Bibl.). For the folio: Wickhoff, S.V. 344; Ugo Ojetti, tab. 265; Venice Exhibition 1971, No. 81.*

From his beginnings in Parma to his later years, scenes from Greek and Roman history are frequently the subjects of Ricci's work. Among the paintings in the great hall of the Parma University, "The Rape of Helena" may be compared to our folio in its Homeric theme; it belongs to the first decade of the eightened century, when the artist already possessed his luminous style. To this period also belongs the cycle of frescos in the Florentine Marucelli Palace (1706-1707), the most important cycle of Ricci articulated in rich multiplicity of historical and mythological themes. In the composition, which is intensely dramatic and dissolved in the atmospheric luminosity of this folio, Ricci proposed a new interpretation of this classical subject, which was to reveal itself as an example, not only for Tiepolo but also for Pellegrini and Diziani. This lies in the intended contrast between the lively figures, constructed from agitated lines, from the rich-toned water color and the vibrating touches of white lead, plus the classical size of the composition, the activity taking place, above all, in the foreground, as in Veronese. Not only the subject, but also its representation, as in the harmonious slim bodies, has that Greek taste that sometimes turns up again to illuminate Venetian art. Light, in its moderate, yet moving tilt and its vibration, the tones — light colors over other light colors — are characteristic of this phase and successive phases in Ricci's work. One thinks, as a comparison, of "The Continence of Scipio" (Correr Museum, Pignatti I) and of the "Sacrifice of Polyxena" (Windsor, Blunt 270, tab. 26; a study in the Albertina Gallery gives a variation with the king on the right, V. 244); both are sketches for paintings and frescos datable to the years around 1705-1706.

MARCO RICCI

Marco Ricci was born in 1676 in Belluno and died in Venice in 1730. He was the nephew and student of Sebastiano Ricci, and worked with him on landscape painting in Florence between 1706 and 1707, and later, on numerous occasions. He probably went to Rome and to Milan where his particularly important meeting with Magnasco took place. From 1708 to 1710 he worked in England as a scenographer with Pellegrini, and later from 1712 to 1716 with Sebastiano Ricci: his return journey to Venice took him to Paris, through Flanders and the Netherlands.

Marco Ricci introduced landscape painting to Venetian art, just as Sebastiano had introduced historical painting. Titian's example was essential to his work, sharing with Titian the communal experience of Cadore scenery; we must not forget the influence he received from the works of Salvator Rosa, Dughet, Pieter Mulier, Tempesta, and the Venetian-Roman paintings of views and ruins by Luca Carlevaris. With his romantic landscapes he preceded Piranesi. From 1723 onwards he made etchings, but there are many more works done by others, taken from his works, than by Ricci. Giuseppe Zais (1709-1784) was one of his pupils and a direct follower; Zuccarelli, Canaletto, and Guardi were all subject to his influence. Most of his drawings, about three hundred, are to be found at Windsor, and came — as did the works of Sebastiano Ricci — from the collection of the British Consul, Joseph Smith.

90 Riverside scene with large tree and mountains

In lead point and pen and ink. 459 x 323 mm. Inv. 1770. V. 245.

Lit.: *Bottari; Zanetti; Temanza; d'Argenville; Delogu 1931; Pallucchini II; Blunt 1957;* Bassano Exhibition *1963; Pignatti;* Venice Exhibition *1967; For the folio: Wickhoff, S.V. 362; V. 245;* Bassano Exhibition *1963, p. 136, No. 110.*

The broad, mobile conception of the motive, derived from the foothills of the Alps of the Venetian district where the artist was born, and the mighty trunk announce Titian and his group of engravers, Campagnola, Boldrini and others. The folio would belong to Ricci's later period: it was probably destined for etching, and to this end a counterproof was undoubtedly made (with a damp sheet). As a result, the drawing has taken on a very odd, atmospheric fading. Similar folios are conserved at Windsor and in other collections (Blunt, 83, 89, 157; Pignatti, 78-80).

GIOVANNI BATTISTA PIAZZETTA

Piazzetta was born in 1683 in Venice and died there in 1754. He was the son of a sculptor and engraver, Giacomo Piazzetta. After an early period of instruction under his father, he perfected his painting in Antonio Molinari's workshop. Towards 1703 he went to Giuseppe Maria Crespi in Bologna; Crespi was very impressed with Piazzetta's talent. In Bologna he studied Carracci and even more, Guercino, feeling that in Guercino's use of light and shade, there was a lively likeness to his own work (Albrizzi). He went back to Venice in 1711, and was to remain there for the rest of his life; in 1754 he was called upon to preside over the Painters Academy. Poor in facts and external events, Piazzetta's artistic life is rich in internal messages and tensions, all in harmony with his conception of art as a mission. His biographer Albrizzi describes him as a "lover of solitude, and therefore a little melancholic" and regrets, in agreement with d'Argenville, the slowness of his work: "et jamais content de ce qu'il faisait, au point de recommencer quatre a cinq fois le même tableau, ce qui désespérait ses meilleurs amis." This is the reason why there are so few of his works. His preference for chiaroscuro, which he shared with his masters in Venice and, on the whole, with the art of the late seventeenth century, following the spirit of Caravaggio, and the expressive personal research, animated by heightened reality, as seen in his drawings, makes Piazzetta the artistic antithesis of Sebastiano Ricci. He never did fresco painting, as Ricci did, only oil paintings on canvas, even in his great compositions for ceilings — for example "the Glory of Saint Domenic", in the church of Saints John and Paul in Venice. In his drawings he usually preferred charcoal and pencils, following light and shade effects of plastic sensuality and strong pictorial quality. While the painter was still alive, his studies from life were already famous, most of them engraved by Cattini and collected under the title of "Icones ad vivum Expressae" (1754). Among his pupils, Maggiotto, Cappella and Franz Xaver Palcko were all influenced by his picturesqueness. Piazzetta did many designs for engravers — Marco Pitteri being the best of them — and illustrations for books: here we would like to cite Tasso's "Gerusalemme Liberata," Milton's "Paradise Lost" and Bossuet's "Œuvres." If his influence was great on the young Tiepolo, his teaching was also valuable to Austrian, Bohemian and Tyrolese artists, among them Paul Troger.

91 Self-portrait

In charcoal, stumped with white highlights, on greyish-blue paper. Signed and dated in pen and ink: Io Giò: Battà. Piazzetta disegnai di propa mano / in etta d'Anni 52 / A di 10 Dece / 1735. *350 x 241 mm. Inv. 1771. V. 253.*

Lit.: *G.B. Abrizzi,* Memories of the life of G. Piazzetta, *in* Studies of pictures drawn by Giambattista Piazzetta... *Venice 1760; d'Argenville; Orlandi; Zanetti; Lanzi; Aldo Ravà,* G.B. Piazzetta, *Florence 1921; Pallucchini 1956; Blunt 1957; Pignatti;* Venice Exhibition *1969. For the folio: Wickhoff, S.V. 365; Aldo Ravà, frontispiece; Pallucchini 1956, p. 53, tav. 133;* Venice Exhibition *1961, No. 88; Benesch, Meisterzeichnungen, No. 55;* Budapest Exhibition *1966, No. 32.*

A very forceful masterpiece of late baroque portraiture, in which the master, an expert in the study of physiognomy and portrait technique, displays all his mastery. The pose, self-conscious and serious, takes on an atmospheric quality — the artists had often tried to do this in similar studies, using the same technique — the capture of that characteristic instant in which the personality of the subject seems to be transported to the observer in its living essence. A self-portrait, drawn in his early years, is in Windsor Castle (Blunt 1957, no. 29, tab. 9). D'Argenville states: "Dans la vigueur de son âge il étoit d'un tempérament trés vif et fort jaloux de sa réputation."

ALESSIO DE MARCHIS

De Marchis was born in 1684 in Naples and died in Perugia in 1752. He was a painter of land-scapes and architecture who based his own work on the works of Salvator Rosa, Gaspard Dughet and Roman-Dutch landscape painters such as du Jardin, Jan Hackaert, Bisschop and van Bloemen. He worked in Rome during the pontificate of Clement XI (who died in 1721), painting the Albani and Ruspoli families: Agostino Masucci drew his portrait for Nicola Pio's "Vite" and De Marchis inserted a landscape of ruins. To study a fire "from real life" (Lanzi), he set a haystack on fire, for which he was arrested and obliged to leave Rome. Later he went to work for the Albanis in Urbino, and did most of his work in the Marches and Umbria, especially in Perugia (1730), where he died. As a landscape painter, he was, without doubt, the most interesting of Salvator Rosa's followers, especially in following Rosa's fanciful, mottled brush strokes. His fusion of red pencil with bistre wash is characteristic and allows him to produce a magnificent effect of depth. Many of his works have been attributed to Dughet.

92 Riverside scene with a herd of cows

Done in red pencil, with green and yellow water colors. 256 x 417 mm. Inv. 596. B. 672.

Lit.: *Lanzi; A.M. Clark; Marco Chiarini in Master Drawings 1967, p. 289 foll. For the folio: Wickhoff, S.R. 696; B. 672.*

The motive gives one the idea of the Tiber Valley to the north of Rome: the immediacy of nature's impression anticipates the English watercolor landscapes.

CARLO INNOCENZO CARLONE

Carlone was born in 1686 and died in 1775 at Scaria d'Intelvi in the province of Como. He was the son of the sculptor and architect Giovanni Battista Carlone, and brother of the sculptor and stucco decorator Diego Carlone; he was the pupil of Giulio Quaglio, his fellow countryman, and with him worked in Venice, in the Venetian district and in Ljubljana during the years between 1703 and 1706. He then went to Rome for a period of study under Francesco Trevisani. Carlone was a painter with a varied cultural store: besides assimilating the art of his direct masters, he also assimilated the work of great Venetian painters (Ricci, Pittoni and Bencovich), Roman and Genoese painters (Piola, Ferrari and Baciccio). He attained a style of notable originality, vibrating with sensitivity but which, at the same time, is pleasingly decorative. The same can be said for his drawings, which are delicate but at the same time, lively, emitting a singular graphic fascination. He was a highly productive artist, whose works are found outside Italy, in Southern Germany (Passau, Ansbach, Mannheim, Brühl) and in Austria (Vienna, Linz, Stadl Paurat near Lambach, Breslau and in various other places) where his presence is documented from 1712 and where he was one of the most loved and popular Italian artists of the time. The note of expressive-mannerism in his art, in fact, is compatible with the concept of German sensitivity.

93 The Apotheosis of Bartolomeo Colleoni

Pen and ink, bistre wash and traces of lead point; the squaring is done in lead point. 346 x 207 mm. Inv. 23731.

Orig.: *Lubojatzky, bought in 1924.*

Lit.: *Füssli; Voss; Barigozzi Brini and Garas. For the folio: B. 653 (Neapolitan, first half of the 18th century); Barigozzi Brini and Garas,* Carlone, *p. 42 ff., 70 ff., 131, tav. 5, fig. 46 (painting; A. Barigozzi Brini in* Art Bulletin *XLVI, 1964, p. 231; H. Voss in* Arte Lombarda *VI, Milan 1961, p. 238 ff.; K. Woisetschlager,* Meisterwerke der Österreichischen und Deutschen Barockmalerei im Joanneum zu Graz, *Vienna 1961, p. 34.*

The famous condottieri, immortalized by Verrocchio in front of the Venetian church of Saints John and Paul, is here crowned by Fame, and surrounded on the left by Justice, Truth and Strength; on the right, by Hercules and the allegory of Abbundance; his beaten enemies lie at his feet. This is the sketch for the ceiling of the Colleoni villa at Calusco d'Adda (now in the Poldi Pezzoli Museum in Milan) (Bushart). In the same collection is the oil sketch, done in the same bold oval form. The framing of the fresco curves inwards at the center: the rest of the oil sketch is nearer to the fresco than the drawings. Another oil sketch — kept in the Museum Joanneum in Graz — frames the composition in a wide smooth oval. The comparison must be extended to the fresco painted previously (1722) on the ceiling of the Marmorea Hall in the Belvedere Superiore in Vienna: this fresco represents The Apotheosis of Eugene of Savoy (the preparatory design is in the British Museum, and an oil sketch is in the Comolli collection at Cagno near Como). Carlone fused into his atmospheric drawings, which are generally very well finished, Venetian elements (Ricci, Bencovich, Diziani, Pittoni) and sometimes Genoese ones. These latter elements are, above all, revealed in the sensually rounded forms, forms which the wash underlines (in the same way that blushing does in paintings), helped by the line, which creates the profile, delicately outlines the mottling of the wash and makes one think of Piola, Ferrari, and Gaulli, whose work Carlone may have seen in Rome, and which may have deeply influenced him.

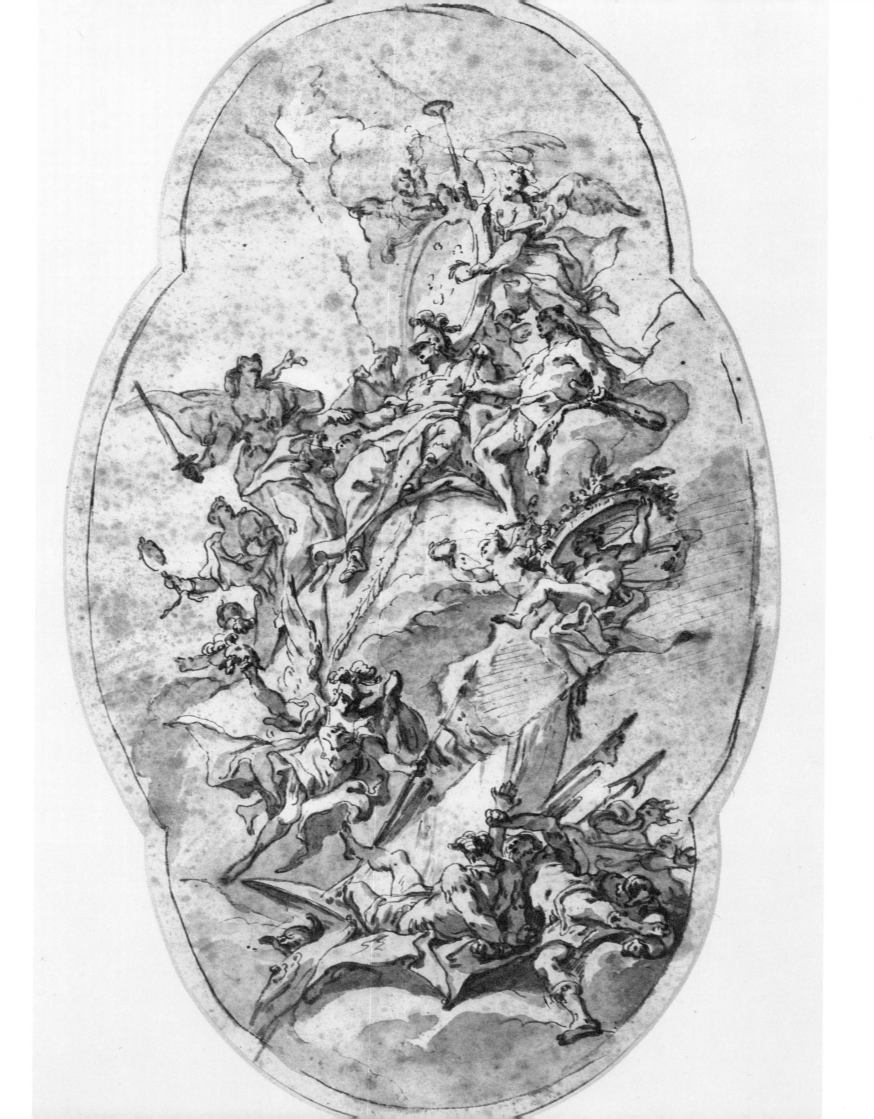

Panini was born in Piacenza in 1691 and died in Rome in 1765. His artistic formation is based on the influence of Ferdinando Galli Bibbiena, Giuseppe Natale and Giovanni Ghisolfi. As a painter of architecture, prospects, ruins and views, Panini went to Rome in 1711, and there he followed the school of Benedetto Luti, a painter of historical subjects "to distinguish himself and excel in the art of figure painting, too" (Pascoli). In Rome he was also interested in realistic costume painting, the genre of Pier Leone Ghezzi, the landscape painting of painters such as Locatelli and Vanvitelli (Gaspar van Wittel) and other masters belonging to the later Roman-Dutch school, such as Franz and Pieter van Bloemen. In order to enrich his style he added the romantic-arcadian elements found in Salvator Rosa's compositions, which during that same period left their mark on the work of De Marchis, and which emerge in his views and in his ruins. Through this kind of painting in which he ingeniously fused poetry and truth, he established himself as one of the most interesting interpreters of this type of art. Notable echoes of his manner can be found in Piranesi, Canaletto, Natoire, Hubert Robert, Fragonard and in many other painters from all over Europe. The lively delightful little figures which he inserts like a gentle breeze of contemporary reality into the fantasy of classical ruins created a school on their own, and were to animate his own religious figurations. In his first Roman period, Panini also did fresco paintings on walls and ceilings. He was 'princeps' of the Academy of Saint Luke in 1754, and a member and teacher at the French Academy in Villa Medici.

94 Portico with double Ionic columns and crumbling transept

Done in lead point, pen and ink with added watercolor. Monogram J.P.P. *357 x 252 mm. Inv. 2940. R. 932.*

Lit.: *Pascoli (under* Luti *and* Ghezzi); *Mariette; Voss; Wickhoff, S.L. 392; Ozzola, p. 23; R. 932; Arisi, p. 210, p. 372.*

A fantasy of classical ruins, brought back to life by the realism of the figures. The urn with a maenad in front, the statue of Hercules and the Hydra and the fountain of lions inspired by the Capitoline steps are to be found also in other folios (Albertina Gallery R. 935, 937) and are painted with or without variations. At the Print Cabinet in Berlin are to be found the studies for the women at the fountain (Inv. 17539 and 17543).

Because of its majestic architecture, the composition — a drawing with ruins of the Colosseum — is similar to this, with the statue of Hercules and the water trough on the steps of the fountain; this drawing, now in the Ashmolean Museum in Oxford, Arisi dates around 1745 (fig. 235, No. 180). The park and the nymphaeum, the reclining god in the background, recall the typical elements of Roman villas and gardens. Viviano Codazzi (1633-1672) and Ghisolfi had already started a similar grand fantasy, where classical and baroque motives meet, as can be seen in Bibbiena's scenography. However, the colorful, vibrating technique of watercolor is new, to be taken up by French painters of ruins and views, and even more so, by English ones. A large number of these rare Panini watercolors are in the Albertina.

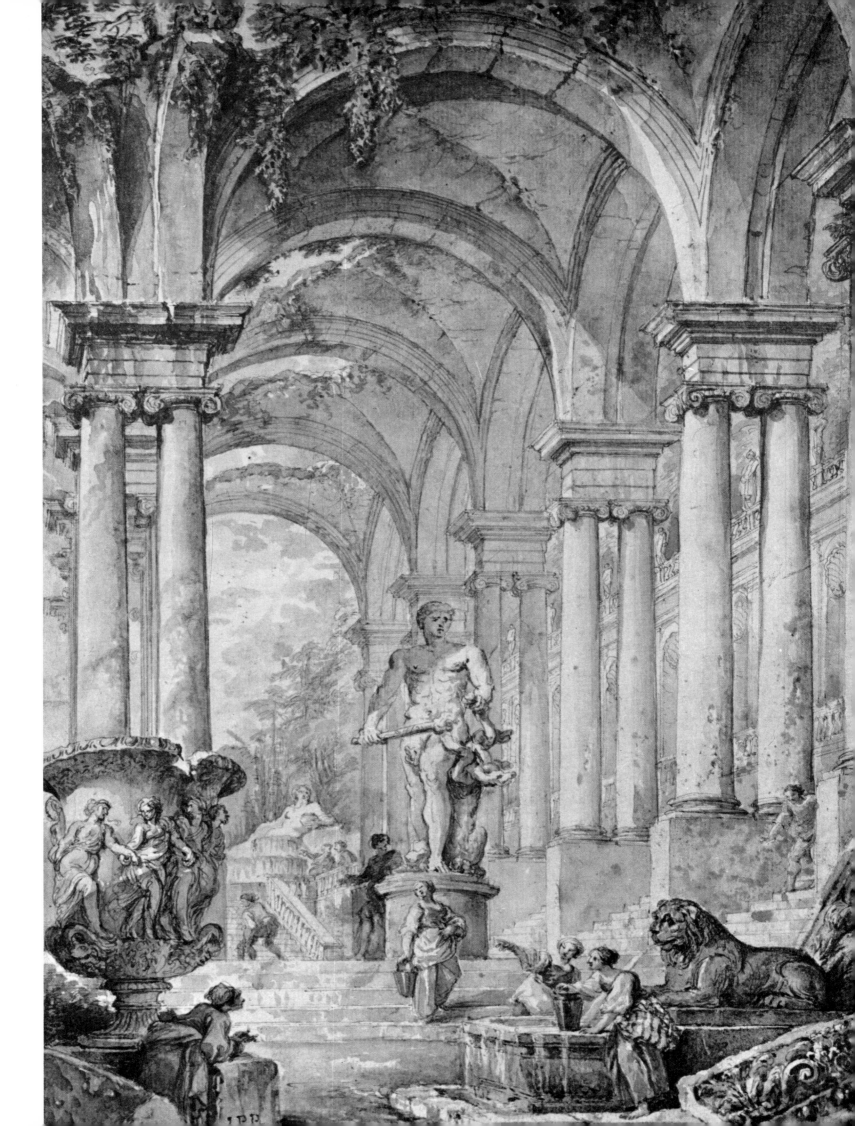

GIOVANNI BATTISTA TIEPOLO

Tiepolo was born in Venice in 1696, and died in Madrid in 1770. As a young pupil under Gregorio Lazzarini, Tiepolo was subject in his early years to the influence of the light-and-shade expressive realism of Piazzetta and Bencovich, and this was to reappear even in his later works; but he adopted the luminous manner of Ricci and Pellegrini, light being more congenial to Tiepolo's solar sensitivity. As he moves towards a more secure boldness than the fantasy and pleasant ease of Ricci, Tiepolo also submits to the fascination of Veronese's art, to that decorative richness and that magnificent solemnity. "The greatest painter that Venice possesses, Paolo Veronese's emulator" — this is how Count Algarotti spoke of him, and Zanetti said: "His style was original from the very beginning, and if as a young man he imitated the order of light and shade used by Piazzetta, it was because that was the fashion at that time; he made it more cheerful later and he added that vagueness which he saw was missing; thus giving pleasure to everyone. There is no painter of our time, who, more than he, has revived the dormant, happy, very lovely ideas of Paolo Caliari" (Molmenti page 330).

In 1719 Tiepolo married the sister of Gian Antonio and Francesco Guardi, Cecilia. This very active painter left paintings and frescos in Venice and Udine (1726), in Milan (1731 and again later), in Bergamo, Vicenza and numerous other towns in the Venetian region. In the years between 1750 and 1753 he was in Würzburg, where he did fresco paintings in the bishop's palace; in 1762 Charles III called him to Madrid: the old painter was still able to create paintings and frescos, but with difficulty, in the halls of the Royal Palace (the Throne Room), and there, in Madrid, he died (1770).

Tiepolo's multiform work is at its best in his frescos and sketches, which are unsurpassable in their expressive vigor, radiating with luminous energy, fantasies of history and allegory. He was an unexhaustable, very ingenious inventor and narrator, even in the ironic, smiling range which is manifest in his designs and etchings — "Jokes" and "Whims" — in which he comes closer to the manner of Castiglioni. In his scenes of genre, animals and landscapes, Tiepolo's son Gian Domenico was his by no means inferior follower.

95 Saint Fidelis of Sigmaringen and Saint Giuseppe di Leonessa crushing heresy

In lead point, lead pencil, pen and brush in bistre and water-color with white highlights on yellowish paper. 504 x 353 mm. Inv. 1813. V. 304.

Lit.: *Orlandi; Vincenzo da Canal, Life of Gregorio Lazzarini, Vinegia 1809; Zanetti; Longhi; Mariette; Algarotti; Moschini; Lanzi; Molmenti; Sack; Hadeln; Morassi; Vigni; Benesch 1947;* Venice Exhibition 1951; *Knox;* Udine Exhibition 1965; *Pignatti;* Venice Exhibition 1969. *For the folio: Wickhoff, S.V. 408; V. 304; Molmenti, p. 237, note II, No. 6; Sack, p. 270, No. 978; Knox, p. II, 38 (19); Knab in Zs.f. Kunst-und Denkmalpflege XIV, Vienna 1960, p. 142; Benesch,* Meisterzeichnungen, *No. 56.*

The Albertina Gallery possesses another version "after the exorcism" (Molmenti) of this scene; this second version has a different composition, but in size and style is exactly the same (V. 303). The first idea is to be seen in a drawing in the Correr Museum in Venice (Knox).

Fidelis of Sigmaringen, a martyr of the Counter-Reformation, was beatified in 1729 and sanctified in 1746. In the years between 1752 and 1758 Tiepolo painted the same subject for an altarpiece in the Capuchin church in Parma; in 1810 it entered the Parma museum, while the oil sketch is in the Picture Gallery in Turin (Molmenti, p. 154; Sack, p. 131; Morassi, pages 44, 51): for both of these pictures, the two drawings cited were used, though with great liberty, particularly the one reproduced here. In fact, we can see, vaguely drawn in the background, the gable of the church, toned down by white lead, which, in the painting, continues to the left. However, if we consider stylistic motives, the two folios could be substantially anterior to the painting, as George Knox maintains, and go back to the year in which Fidelis was beatified (1729) and before 1739, when Pietro Monaco engraved and published in his "Collection of 112 prints of Sacred Historical Paintings" a series of Tiepolo's subjects which are similar in style and cover similar scenes of hermits (Knox, in Master Drawings III, p. 389 ff.). They are compositions, notwithstanding the picturesquely atmospheric rendering, which are more finished and compact in their form than later drawings. Tiepolo, whose work can be considered today to consist of more than one thousand five hundred studies and sketches, drew a great deal in every period of his activity, not only for preparations for paintings and etchings, but also for drawing's sake, collecting his sheets in notebooks according to subject and their eventual use.

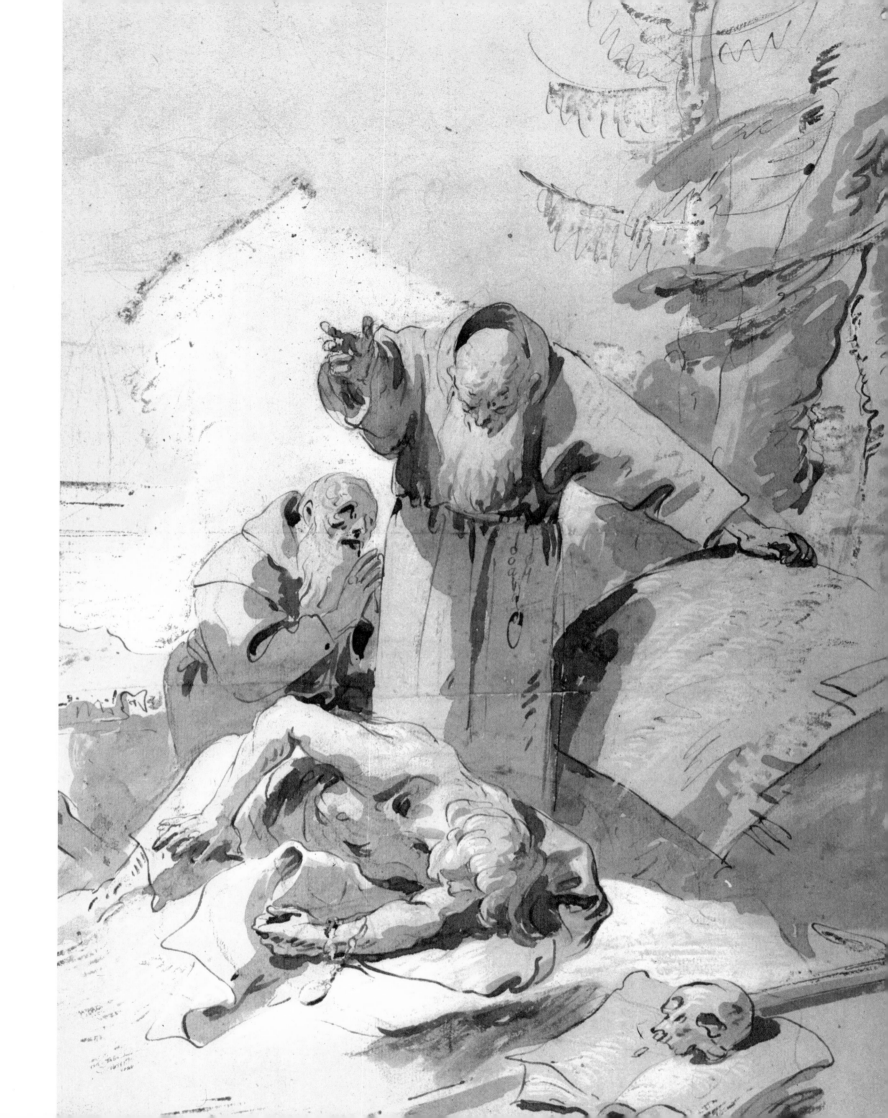

96 Reclining female figure

In lead point, pen and ink and wash. 210 x 159 mm. Inv. 23760. V. 299.

Orig.: *Sir Edward Cheney; bought in 1924.*

Lit.: *V. 299; Knox, p. 5, 7, 37 (7); Knab, p. 141; Venice Exhibition 1961, No. 101 foll.*

The design belongs to the notebook "Figures for Ceilings," of which the Albertina Gallery possesses other sheets with figures strongly foreshortened from below (V. 289-295, 298). Together with eight others, all documentable from Tiepolo's studio collection, the drawings passed through the hands of several owners, and then entered the English collection of Sir Edward Cheney, from about 1842 to 1884; about fifty years ago the group was divided up and sold separately. Other studies similar to this one are to be found in other notebooks, for example in the one belonging to the Sartorio collection in the museum of Trieste, which contains a sheet dated 17th Feb. 1744 (Vigni, p. 87 foll.). To the same period can be attributed the design reproduced here and those cited.

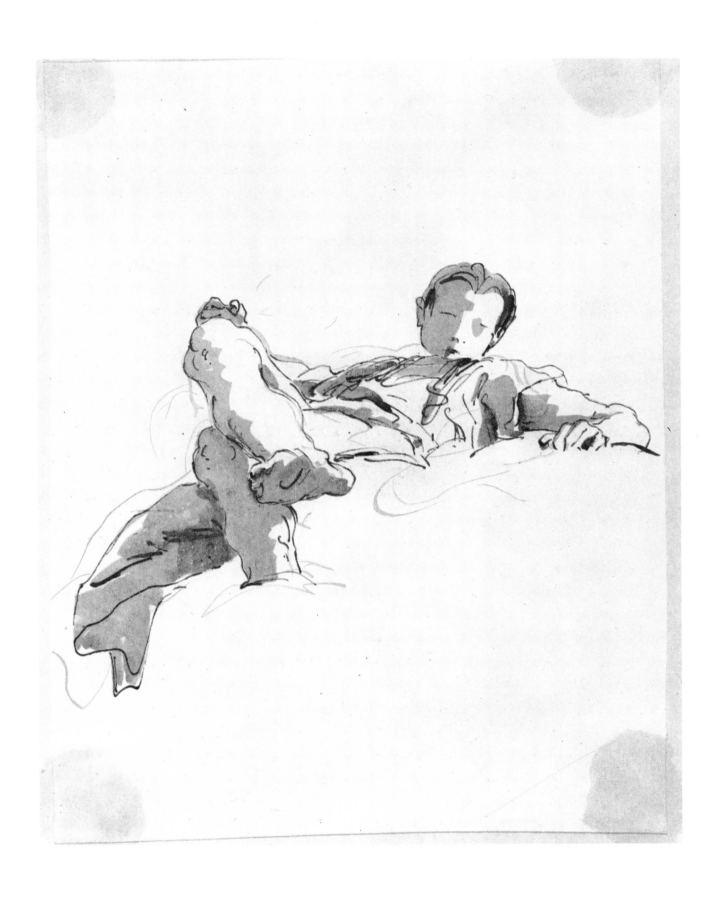

GIOVANNI DOMENICO TIEPOLO

G.D. Tiepolo was born in 1727 in Venice, the son and pupil of G.B. Tiepolo and the elder brother of Lorenzo. He followed his father and brother to Würzburg in the years between 1750 and 1753, and then to Madrid in 1762. After the death of his father he went back to Venice, where he worked for the rest of his life except for a period spent in Genoa in the years between 1783 and 1785. Gian Domenico Tiepolo found his expression and personal style in painting costumes, animals, pastoral-mythological subjects and landscapes, and in particular in the technique of design and etching. His line, more contained and over-elaborated, is easily adapted to caricatures (his series on Punchinello are famous), a genre which was singularly congenial to him. He was able to assimilate, on the other hand, inspiration from Callot, Rembrandt, Magnasco and Marco Ricci with such a revived and personal interpretation as to make them appear to be the fruit of his own artistic intuition.

97 Horse at a trough

Lead point, pen and ink and bistre wash. Signed: Tiepolo F. *(in ink). 184 x 250 mm. Inv. 24340. V. 308.*

Orig.: *Prince Waldburg-Wolfegg; Robert Scholtz, Budapest; bound O. Kutschera-Woborsky.*

Lit.: *Zanetti; Molmenti; Sack; O. Kutschera-Wobosky in* Jhb. der Preussischen Kunstsamm-lungen, *Berlin 1920, p. 173; V. 308; J. Byam Shaw,* The Drawings of Domenico Tiepolo, *London 1962; Pignatti;* Venice Exhibition *1969.*

The sheet — a horse drinking from the trough of a fountain decorated with a mascaron of a faun — is damaged in some parts of the margin; the gall-ink has run here and there over the paper. Our sheet recalls the Dutch masters who worked in Rome, Bamboccio, Berchem, du Jardin and van Bloemen, and transposes into the transfiguring Venetian atmosphere their poetical naturalism. These same models could have inspired the drawing with two donkeys and a goat in the Roman mountains, which is in the Fitzwilliam Museum in Cambridge (Byam Shaw, fig. 52).

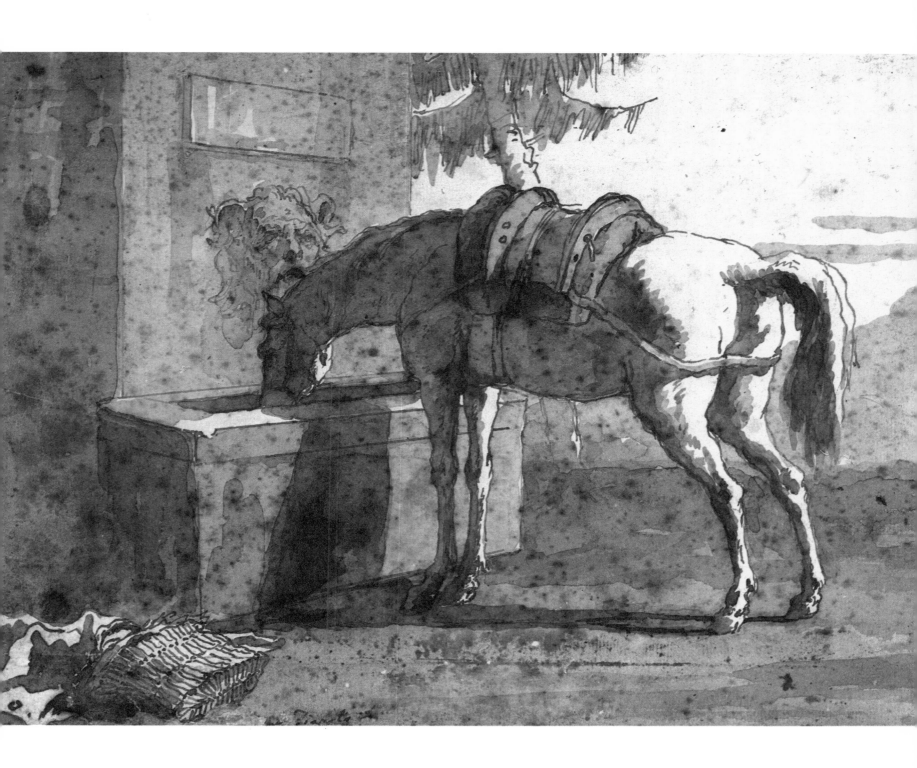

FRANCESCO ZUCCARELLI

Zuccarelli was born in 1702 in Pitigliano (Grosseto) and died in Florence in 1778. In Rome he became the disciple of the Arcadian landscape painter Paolo Anesi, and of Pietro Nelli, one of Morandi's pupils, who taught him, above all, how to draw figures. In 1730 he went to live in Venice and there followed in the footsteps of the recently deceased Marco Ricci. As he had done for Ricci, the British Consul Joseph Smith protected Zuccarelli; he took him to England, where he remained from 1752 to 1762 and later from 1765 to 1771, obtaining success there and also exerting a notable influence. In Venice Zuccarelli had met Richard Wilson and Sir Joshua Reynolds; this meeting was useful to all on an artistic plane. After having been one of the founders of the Royal Academy, in 1772 he was elected princeps of the Venetian Academy. He lived the last years of his life in Florence. Count Tasso, for whom Zuccarelli had worked during different periods between the years 1737 and 1751, described his work in this way — "... landscapes with the insertion of pretty figures, in such a way as in this genre he has surpassed not only modern painters, but is also competing with the most famous of ancient painters, as there has not, so far, existed anyone who has known how to add the vague sweet harmony of the countryside to more graciously affected figures, and with so much natural coloring." As was the fashion, Zuccarelli animated with his figures views and architectural scenes, for example of Visentini or Bellotto; his later pictures and designs often recall the work of Claude Lorrain.

98 Landscape with shepherd and woman on horseback

In charcoal and lead pencil, stumped, and with highlights on pale blue paper. Signed: Fran. Zuccarelli f. *348 x 287 mm. Inv. 1305. V. 374.*

Lit.: *Orlandi; Algarotti; F.M. Tassi;* "Lives of Painters, Sculptors and Architects from Bergamo," *Bergamo 1793; Ojetti; S.R. 1441; V. 374; Levey; Morassi in* Emporium *CXXX, Bergamo 1960, p. 7 foll.; Pignatti;* Venice Exhibition *1969.*

The sheet, one of the more densely poetical creations of the master and of his century, represents a hillock with a farm hidden among the pine trees, and towards the bottom two yoked oxen. The echoes of Claude Lorrain's last manner are interpreted with a lightness and a typically Venetian atmosphere.

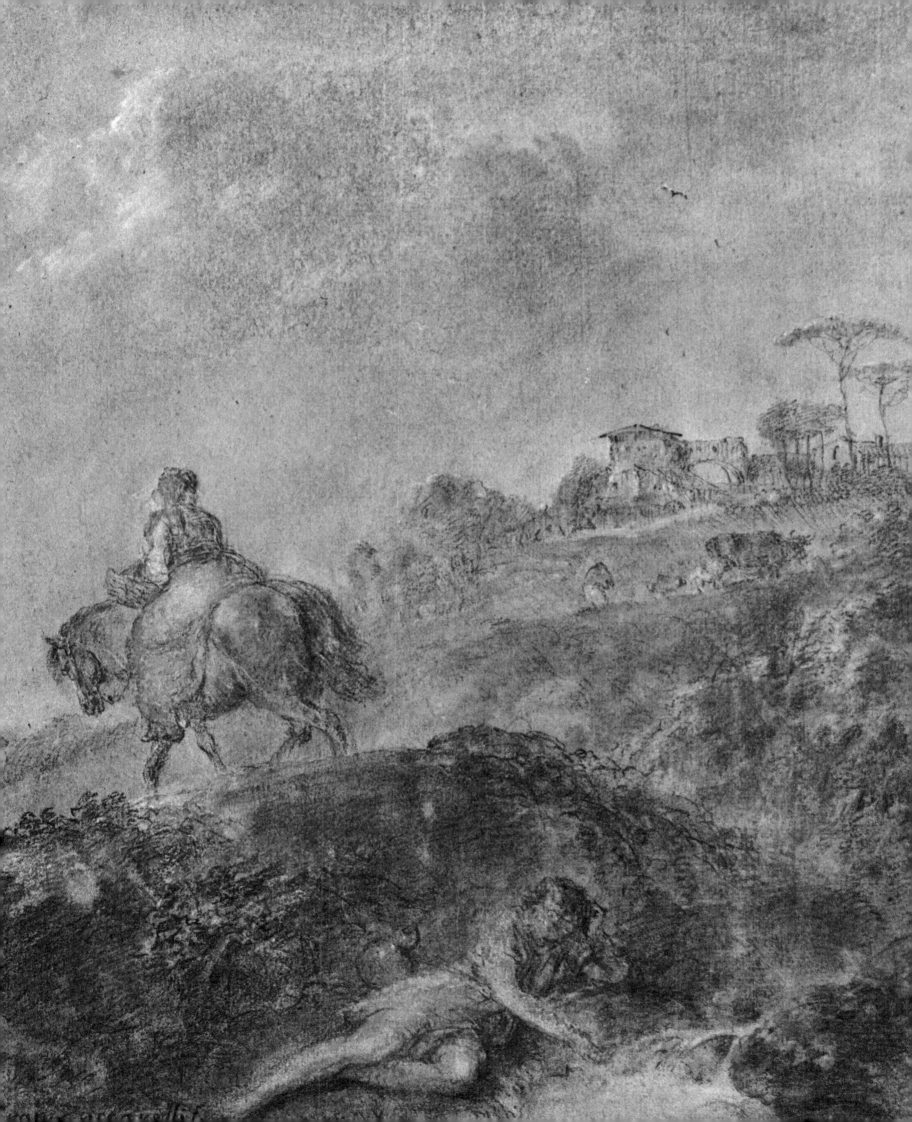

FRANCESCO GUARDI

Guardi was born in 1712 and died in 1793 in Venice. He was the pupil and helper of his brother Gian Antonio Guardi (1699-1760), a history painter. He directed the paternal workshop after the premature death of his father Domenico in 1716. When Gian Antonio died, Francesco took over the complete direction of the shop, which was comparable to that of Tiepolo from the point of view of family collaboration. If his early period of production consists of historical subjects and altarpieces, the Venetian landscape and views of the Lagoon become later, together with costume painting, his admirable and exclusive domain. Guardi's formation came from Marco Ricci and Canaletto, whom at the beginning he more or less freely copied, from Marieschi, from whom he assimilated graphic brushwork, and from Carlevaris. Also Magnasco was to impress him and influence him a great deal, in figure painting and drawing, and — more frequently in his later work — Guardi comes closer to his fantastic realism and his capricious stylistic transfiguration. The rendering of figures with short, but realistically expressed lines seems to bring Guardi closer to the manner of Callot, whose world often coincides with his own. However, the strong feeling of reality (which differentiates the work of Francesco from that of his brother), born of the Lagoon city, from its pictorial tradition and that intense picturesqueness that reaches extreme heights in Francesco, leads to fields very different from those of Callot. Not only this, but in the graphic and picturesque abbreviations, in the mottling and expressive deformation, Guardi went far beyond his predecessor from Nancy, who was educated on Florentine design. "Witty in invention, open to architecture, in mimicking grounds, in the expression of the air and of the horizon" — this is how one of his contemporary collectors, Don Giovanni Vianelli, defined him. We also have some views of the mainland by Guardi: in 1778 and in 1782 while travelling in the Valsugana and to Mastellina, his family's native town, he drew some splendid mountain landscapes. Most of his drawings still in existence are in the Correr Museum in Venice, which possesses two hundred and eighty-five of them.

99 The Grand Canal beyond the Rialto with the Ca' Pesaro in the distance on the left

In lead point, pen and ink, sepia and wash on brownish paper. On some of the buildings are notes for colors. 273 x 258 mm. Inv. 24333. V. 376.

Orig.: *Bought in 1924.*

Lit.: *C. Vianelli,* "Catalogue of the pictures existing in the house of Sig. Don Giovanni dr. Vianelli, *Venice 1790; Lanzi; Moschini; Missaglia; Simonson; Fiocco 1923; Goering; Pallucchini 1942; Benesch 1947; Vittorio Moschini,* "Francesco Guardi" *Milan 1952; Byam Shaw; Muraro 1948, 1949, 1958, 1967; Pignatti 1967;* The Guardi Exhibition *1965;* Venice Exhibition *1962; For the folio: V. 376; Byam Shaw, p. 20 foll. 59, No. 11;* Venice Exhibition *1961, No. 116.*

As Byam Shaw has proved, this is the preparatory drawing for the right half of the painting in the Brera Art Gallery in Milan (Goering 47), a folio in which is rendered the most genuine Venetian atmosphere, truly vibrating with life. In the Metropolitan Museum in New York there is another similar drawing with a complete view of the shore, taken, as was our folio, from the "Fabbriche Nuove" onwards (Byam Shaw, fig. 10). In the Albertina drawing the painter has managed to more completely interpret the atmosphere of the city, and to characterize the gondoliers, who seem to come alive through the slim outlines of their gondolas, thanks to a graphic abbreviation which is so intense as to by far surpass Canaletto's model and to awaken in us echoes of Callot, even if only for his acute observation of reality. Our drawing is to be dated around 1760, as is the painting in the Brera Gallery and a series of views of the Grand Canal which are stylistically similar (Byam Shaw, figs. 12-13); it was thus born in the fullness of Guardi's art and activity, because at that time he had found his unmistakable view and figurative style, that liveliness which not even the nineteenth century critics, defiers of Classicism, were able to deny (we need only think of Lanzi) and which in his later works was to reach even greater heights in picturesque and expressive renderings.

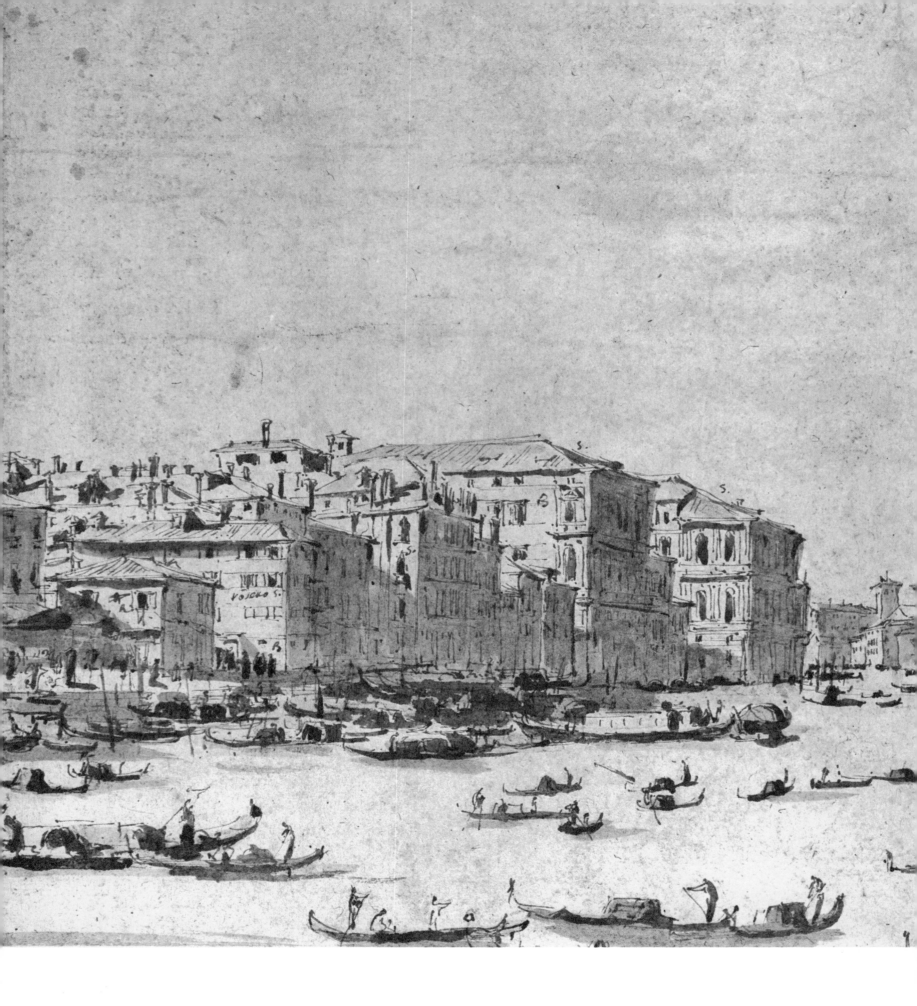

UBALDO GANDOLFI

Gandolfi was born in 1728 in San Matteo della Decima near Bologna and died in Ravenna in 1781. Together with his younger brother Gaetano he studied under Felice Torelli, Ercole Graziani and Ercole Lelli at the Clementina Academy in Bologna. In 1760 he was in Venice with his brother; he died while working on the frescos on the dome of Saint Vitale in Ravenna. Unlike his brother, Ubaldo Gandolfi was also a sculptor. The works of the two artists are so similar in character as to confuse, both giving living echoes of Venetian art (Piazzetta, Tiepolo and Diziani). Sometimes, Gaetano (1734-1802), who was also an etcher, presents elements characteristic of the classicists.

100 A boy's head

In pastels. 291 x 204 mm. Inv. 1871. B. 333.

Orig.: *Albert von Saxe-Teschen (L. 174).*

Lit.: *Lidia Bianchi "The Gandolfis," Bologna 1937; U. Ojetti; Wickhoff, S.V. 467 (Gaetano Gandolfi); B. 333.*

Gandolfi's contemporaries already appreciated studies of this kind, often done as oil sketches or as true paintings. In them can be clearly seen the influence of Piazzetta, Tiepolo and Pietro Longhi, and even echoes of Rosalba Carriera; however, in the delicate portrait of this young boy, in the pastel and pencil technique, Gandolfi can be put on the same level as French masters such as Boucher, Greuze, Guérin, Portail and Liotard.

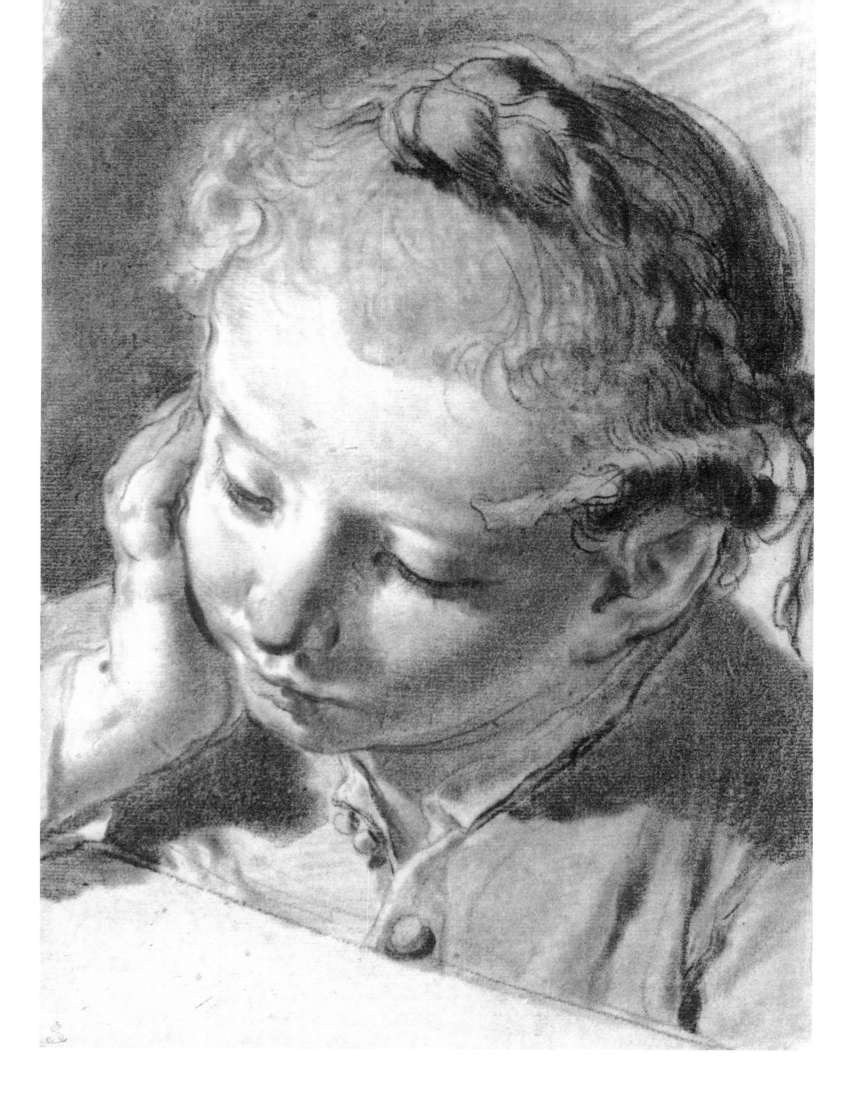

Black and white illustrations

1. Jean-Baptiste Isabey. *Duke Albert von Saxe-Teschen* (1817).

2. Alexander Roslin. *Archduchess Maria Cristina.* (Private collection Stockholm).

3. Jacob Schmutzer. *Count Giacomo Durazzo* (1765).

4. Friedrich Heinrich Füger. *Albert von Saxe-Teschen and Maria Cristina presenting the collection bought in Italy to the Empress Maria Teresa.* (Österreichische Gallery, Vienna).

5. Sebastian Warmut. *The old Silva-Taronca Palace, present site of the Albertina Gallery.*

6. *The ballroom in Duke Albert von Saxe-Teschen's palace, now transformed into a study room.*

7. C. Muller. *The nineteenth century disposition of the Albertina collection.*

8. Michelino da Besozzo. *Stag's head.* Silverpoint and pen.

9. Michele Giambono. *St. Christopher.* Pen. 199 x 134 mm.

10. Domenico Ghirlandaio. *The Angel's appearance to Zachariah in the temple.* Pen and wash. 256 x 374 mm.

11. Pietro Vannucci called Perugino. *Christ mourned by the Madonna and Saints.* Metal point and pen. 220 x 197 mm.

12. Marco Basaiti (?). *Christ talking to three Apostles.* Pen. 257 x 192 mm.

13. Andrea del Sarto. *Head of the Infant Jesus.* Red pencil. 122 x 106 mm.

14. Il Rosso Fiorentino. *The Annunciation.* Pen, wash with white highlights. 256 x 442 mm.

15. Baccio Bandinelli. *Five Male Nudes.* Pen. 422 x 279 mm.

16. Taddeo Zuccari. *Two Women with a Child.* Red pencil, pen and wash. 304 x 233 mm.

17. Antonio Allegri called Il Correggio. *Seated figure on clouds.* Red pencil. 136 x 162 mm.

18. Luca Cambiaso. *God the Father among Angels and clouds.* Pen and wash. 270 x 250 mm.

19. Giovanni Girolamo Savoldo. *Resting Pilgrim.* Black pencil and white chalk. 273 x 168 mm.

20. Girolamo da Treviso. *The Archangel Gabriel.* Pen, wash, and white highlights. 279 x 231 mm.

21. Jacopo Tintoretto. *Study of a male nude.* Charcoal. 328 x 227 mm.

22. Lodovico Carracci. *Alexander and Thaïs setting fire to Persepolis.* Lead point, pen and wash. 200 x 144 mm.

23. Annibale Carracci. *Madonna with Child and Angels over the city of Bologna.* Pen and wash. 305 x 225 mm.

24. Domenico Zampieri called Il Domenichino. *Landscape and building.* Pen. 217 x 315 mm.

25. Bartolomeo Manfredi. *Soldiers playing cards and drinking*. Pencil, pen and wash. 204 x 304 mm.

26. Giuseppe Ribera called Lo Spagnoletto. *Crucifixion of Saint Peter*. Pen and wash. 329 x 226 mm.

27. Giuseppe Cesari called Il Cavaliere d'Arpino. *Perseus and Andromeda*. Lead point, pen and wash. 167 x 270 mm.

28. Agostino Tassi. *Shipwreck*. Pen and wash. 325 x 268 mm.

29. Francesco Furini. *Moses saved from the water*. Pencil. 250 x 376 mm.

30. Giov. Batt. Beinaschi. *Coronation of the Virgin*. Pencil. 423 x 315 mm.

31. Pietro Berrettini called Pietro da Cortona. *Celestial Vision*. Pencil and charcoal. 384 x 730 mm.

32. Francesco Borromini. *Study for the façade of Saint Filippo Neri's Oratory in Rome*. Pencil. 433 x 303 mm.

33. Ciro Ferri. *Assumption of the Virgin*. Pencil. 356 x 246 mm.

34. Baldassare Franceschini called Il Volterrano. *Assumption of the Virgin*.

35. Baldassare Franceschini called Il Volterrano. *Angel Musician*. Pencil with white highlights. 397 x 258 mm.

36. Baldassare Franceschini called Il Volterrano. *Allegorical vision of Golgotha*. Red pencil and pencil. 287 x 206 mm.

37. Andrea Sacchi. *The Casa Santa with the Virgin transported by Angels*.

38. Pietro Testa. *Study of a Tree*. Pen. 204 x 188 mm.

39. Pier Francesco Mola. *Pastoral scene*. Red pencil, pen and wash. 190 x 185 mm.

40. Carlo Maratta. *Kneeling Woman*. Red chalk with white highlights.

41. Carlo Maratta. *Study of a Nun*. Red chalk with white highlights. 265 x 321 mm.

42. Carlo Maratta. *Coronation of Virtue*. Red chalk, pen and wash with white highlights. 341 x 263 mm.

43. Giuseppe Passeri. *The Ecstasy of the Beata Giacinta Marescotti*. Pen and wash. 324 x 223 mm.

44. Bernardo Strozzi. *Study of heads, helmets etc*. Red chalk, chalk. 265 x 407 mm.

45. Donato Creti. *Little Concert*. Pencil with white highlights. 235 x 270 mm.

46. Salvator Rosa. *Riverside scene with swimmers*. Pen. 122 x 226 mm.

47. Luca Giordano. *Celestial Vision*. Pencil, charcoal and wash. 278 x 405 mm.

48. Francesco Solimena. *The Apotheosis of Louis XIV*. Pencil, charcoal and wash. 352 x 252 mm.

49. Pietro Leone Ghezzi. *The Painter portraying a group of friends*. Pen. 270 x 395 mm.

50. Domenico Ferretti. *Coronation of Flora*. Pencil, bistre wash and white lead. 285 x 448 mm.

51. Sebastiano Ricci. *Allegory with Apollo*. Pencil. 311 x 234 mm.

52. Gaspare Diziani. *Annunciation*. Pen and wash. 442 x 291 mm.

53. Giov. Piazzetta. *Pastoral figure*. Charcoal with white highlights. 280 x 282 mm.

54. Giov. Batt. Tiepolo. *Landscape with a group of houses*. Pen and water color. 100 x 142 mm.

55. Antonio Canal called Il Canaletto. *The Brenta Canal near Padua*. Pen and water color. 334 x 530

56. Francesco Guardi. *The hall of a baroque palace*. Pen and water color. 394 x 273 mm.

Plates

1. Anonymous Florentine, around 1350. *Christ taken Prisoner.* Pen on parchment. 131 x 273 **mm.**

2. North Italian, middle 14th century. *Study.* Pen on parchment. 225 x 173 mm.

3. Michelino Molinari da Besozzo. *Study sheet, Adoration of the Magi and other subjects.* Silverpoint. 273 x 204 mm.

4. Stefano da Verona (Stefano da Zevio). *Flying angel.* Pen. 234 x 172 mm.

5. Pisanello (Antonio Pisano). *Allegory of Luxuria.* Pen. 129 x 152 mm.

6. Pisanello. *Sheet of Studies.* Pen and silverpoint on parchment. 211 x 160 mm.

7. Tuscan, first half of 15th Century. *Four portrait heads.* Pen. 111 x 88 and 135 x 101 mm.

8. Tuscan, first half 15th Century. *Animal studies.* Pen. 230 x 172 mm.

9. Lorenzo Ghiberti. *Five figure studies for a Flagellation of Christ.* Pen. 216 x 166 mm.

10. Fra Angelico, called Beato Angelico (Fra Giovanni da Fiesole). *Christ on the Cross.* Pen and watercolor. 239 x 190 mm.

11. Florence, third quarter 15th century. *Portrait of a Monk.* Black and red chalk, pen. 298 x 197 mm.

12. Leonardo da Vinci. *Apostle.* Silverpoint and pen. 146 x 113 mm.

13. Lorenzo di Credi. *Boy's head.* Silverpoint and ink with white highlights. 194 x 166 mm.

14. Raffaellino del Garbo. *Hand studies.* Silverpoint with white highlights. 320 x 244 mm.

15. Giuliano da Sangallo. *Judith with the head of Holofernes.* Chalk, brush, pen, bistre. 377 x 270 mm.

16. Andrea Mantegna. *Sheet of studies after a Trajanic relief on the Arch of Costantine in Rome.* Chalk and pen. 272 x 198 mm.

17. Bartolomeo Montagna. *The Drunkenness of Noah.* Pen. 253 x 374 mm.

18. Francesco Bonsignori. *Portrait of a man.* Chalk. 360 x 262 mm.

19. Venetian, last quarter 15th century. *Portrait of a youth.* Chalk. 330 x 269 mm.

20. Ercole de' Roberti. *St. John the Baptist.* Pen. 245 x 155 mm.

21. Lorenzo Costa. *Portrait of a man.* Chalk. 307 x 210 mm.

22. Francesco Francia. *Three figures making music.* Pen. 228 x 227 mm.

23. Il Bramantino. *Christ standing by the cross.* Pen and bistre heightened with white. 253 x 154 mm.

24. Michelangelo Buonarroti. *Three standing figures.* Pen. 290 x 197 mm.

25. Michelangelo Buonarroti. *Male nude, back view.* Chalk. 188 x 262 mm.

26. Michelangelo Buonarroti. *Nude, Young Man.* Red chalk. 268 x 188 mm.

27. Michelangelo Buonarroti. *Pietà.* Black chalk, red chalk. 404 x 233 mm.

28. Fra Bartolomeo. *Rocky landscape with monastery.* Pen. 260 x 209 mm.

29. Fra Bartolomeo. *Madonna della Cintola.* Black chalk with highlights. 215 x 160 mm.

30. Andrea del Sarto. *Portrait of a woman.* Black and red chalk. 289 x 243 mm.

31. Bacchiacca. *Figure in period costume.* Red chalk. 275 x 111 mm.

32. Baldassare Peruzzi. *Design for an Apse.* Pen. 161 x 204 mm.

33. Domenico Beccafumi. *Male nude.* Brush and chalk. 222 x 431 mm.

34. Raffaello Sanzio. *The Virgin with the pomegranate.* Pen. 411 x 295 mm.

35. Raffaello Sanzio. *Studies for the Virgin.* Red chalk and pen. 256 x 184 mm.

36. Raffaello Sanzio. *Madonna and child.* Pen. 186 x 146 mm.

37. Raffaello Sanzio. *Study for the Massacre of the Innocents.* Red chalk. 235 x 408 mm.

38. Raffaello Sanzio. *Sybil.* Red chalk. 279 x 172 mm.

39. Raffaello Sanzio. *Nude studies.* Red chalk. 410 x 281 mm.

40. Raffaello Sanzio. *Two Riders.* Red chalk. 286 x 203 mm.

41. Raffaello Sanzio. *Apostle head.* Chalk. 240 x 182 mm.

42. Giulio Romano. *Hunting scene with boar, stags and hares.* Pen. 256 x 409 mm.

43. Polidoro da Caravaggio. *Group of people in a landscape.* Red chalk. 211 x 187 mm.

44. Perino del Vaga. *Two seated warriors in antique costume.* Red chalk. 295 x 251 mm.

45. Giorgio Vasari. *Crucifixion with Mary, John and the Magdalen.* Pen and brown wash. 456 x 337 mm.

46. Federico Zuccari. *Federico Zuccari drawing in the woods of Vallombrosa.* Black and red chalk. 271 x 395 mm.

47. Federico Barocci. *Girl's head.* Black and red chalk. 340 x 248 mm.

48. Federico Barocci. *The Madonna della Cintola.* Black chalk and pen. 506 x 351 mm.

49. Jacopo Ligozzi. *Cartouche with macabre symbols.* Pen and wash. 265 x 168 mm.

50. Bambaia. *Design for a Fireplace.* Pen and brown wash. 424 x 280 mm.

51. Andrea Solario. *Study for a half-length Christ carrying the Cross.* Chalk, brush, and pen. 204 x 168 mm.

52. Bernardino Luini. *Portrait of a young lady with fan.* Chalks. 414 x 284 mm.

53. Parmigianino. *Self-portrait in ornamental frame.* Pen and red chalk. 103 x 117 and 265 x 180 mm.

54. Parmigianino. *Sacra conversazione, The Virgin and Child with St. John the Baptist, a Franciscan Saint and perhaps a patron.* Red chalk. 295 x 206 mm.

55. Parmigianino. *Boy's head.* Black and red chalk. 236 x 198 mm.

56. Parmigianino. *Caryatid.* Red chalk, heightened in white. 229 x 111 mm.

57. Francesco Primaticcio. *Ceres.* Red chalk, heightened with white. 194 x 284 mm.

58. School of Fontainebleau. *Rest on the Flight into Egypt.* Black chalk, brown wash heightened with white. 350 x 285 mm.

59. Giulio Campi. *King David playing a psalm on the Viola da Gamba.* Pen, brush and white highlights. 419 x 271 mm.

60. Titian. *Adoration of the Child.* Brush and bistre. 259 x 216 mm.

61. Domenico Campagnola. *Two kneeling boys in a landscape.* Pen. 263 x 213 mm.

62. Pordenone. *Head and shoulders of a horseman.* Red chalk. 156 x 118 mm.

63. Andrea Schiavone. *Lamentation of Christ.* Pen and watercolor, white highlights. 200 x 272 mm.

64. Jacopo Bassano. *Apostle head.* Charcoal and red chalk, pastels. 132 x 132 mm.

65. Jacopo Tintoretto (?). *Portrait of an old lady.* Brush and oils. 353 x 249 mm.

66. Paolo Veronese. *Allegory of Victory.* Pen heightened in white. 386 x 276 mm.

67. Paolo Veronese. *Pastoral landscape with flock and shepherdess,* town in the background. Pen. 280 x 427 mm.

68. Battista del Moro (?). *The triumph of Marcus Furius Camillus.* Black chalk. 231 x 355 mm.

69. Palma il Giovane. *Massacre of the Innocents.* Pen and bistre wash. 316 x 264 mm.

70. Giulio Cesare Procaccini. *Boy's head with curls.* Charcoal, heightened in white. 265 x 229 mm.

71. Annibale Carracci. *The Lutist Mascheroni.* Red chalk heightened with white chalk. 411 x 284 mm.

72. Annibale Carracci. *Nude study of a young man.* Charcoal. 336 x 397 mm.

73. Guido Reni. *Allegory of the Dawn.* Red chalk and pen. 126 x 255 mm.

74. Il Guercino. *St. Domenic kneeling before Madonna and child.* Red chalk, pen and bistre wash. 272 x 207 mm.

75. Il Guercino. *Allegory of the night.* Red chalk. 265 x 229 mm.

76. Giovanni Lanfranco. *St. Peter walking on the waters towards Christ.* Red chalk, pen and bistre wash. 309 x 266 mm.

77. Pietro da Cortona. *Christ and the Samaritan woman at the well.* Black chalk, pen and bistre wash. 249 x 333 mm.

78. Pietro da Cortona. *Young woman's head.* Black and red chalk heightened with white. 285 x 210 mm.

79. Pietro da Cortona. *San Carlo Borromeo visiting the sick.* Black chalk, pen and bistre wash. 381 x 216 mm.

80. Pier Francesco Mola. *Rachel by the well.* Pen and bistre wash heightened in white. 233 x 274 mm.

81. Stefano della Bella. *Death rides in triumph over the battlefield.* Red and black chalk, pen and watercolor wash. 194 x 219 mm.

82. Il Volterrano. *Sketch for the road to Calvary.* Black and red chalk. 281 x 220 mm.

83. Mattia Preti. *John the Baptist.* Red chalk and red wash. 286 x 231 mm.

84. Il Grechetto. *Adoration of the Shepherds.* Brush and oil. 422 x 567 mm.

85. Salvator Rosa. *Contest between Apollo and Marsyas.* Black chalk, pen and wash. 248 x 308 mm.

86. Carlo Maratta. *Self-portrait.* Black and red chalk. 506 x 363 mm.

87. Baciccio. *Triumph of faith.* Black chalk, pen, wash, heightened in white. 324 x 182 mm.

88. Baciccio. *Armida steals the sleeping Rinaldo.* Red pencil, pen and wash. 186 x 232 mm.

89. Sebastiano Ricci. *Achilles gives Hector's dead body to Priam.* Pen and wash with white highlights. 224 x 311 mm.

90. Marco Ricci. *Riverside scene with large tree and mountains.* Pen and wash. 459 x 323 mm.

91. Giov. Battista Piazzetta. *Self-Portrait.* Charcoal with white highlights. 350 x 241 mm.

92. Alessio De Marchis. *Riverside scene with a herd of cows.* Red pencil and watercolor. 256 x 417 mm.

93. Carlo Innocenzo Carlone. *The Apotheosis of Bartolomeo Colleoni.* Pen and wash. 346 x 207 mm.

94. Gian Paolo Panini. *Portico with double Ionic columns and crumbling transept.* Pen and water-color. 357 x 252 mm.

95. Giov. Battista Tiepolo. *Saint Fidelis of Sigmaringen and Saint Giuseppe di Leonessa crushing Heresy.* Lead pencil, pen and watercolor with white highlights. 502 x 352 mm.

96. Giov. Battista Tiepolo. *Reclining Female Figure.* Pen and wash. 210 x 159 mm.

97. Giov. Domenico Tiepolo. *Horse at a trough.* Pen and wash. 184 x 250 mm.

98. Francesco Zuccarelli. *Landscape with shepherd and woman on horseback.* Pencil and charcoal with white highlights. 348 x 287 mm.

99. Francesco Guardi. *The Grand Canal beyond Rialto with the Ca' Pesaro in the distance on the left.* Pen and wash. 273 x 258 mm.

100. Ubaldo Gandolfi. *A Boy's Head.* Pastels. 291 x 204 mm.

THE BLACK AND WHITE AND
COLOR REPRODUCTIONS, THE
PRINTING AND THE BINDING
WERE CARRIED OUT IN THE
GRAPHIC ARTS WORKS OF
AMILCARE PIZZI S.p.A. CINI-
SELLO BALSAMO (MILANO).

Photographs by **MARIO CARRIERI**